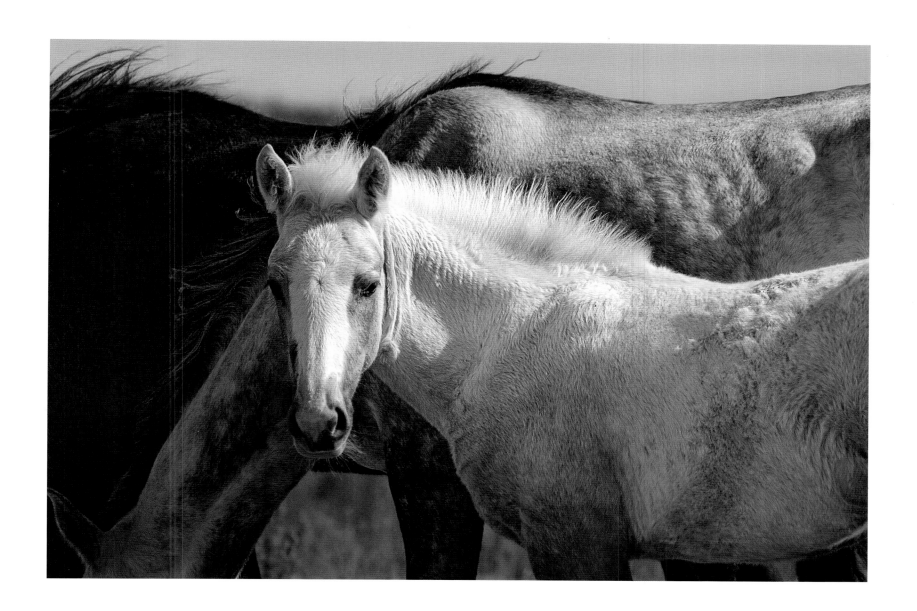

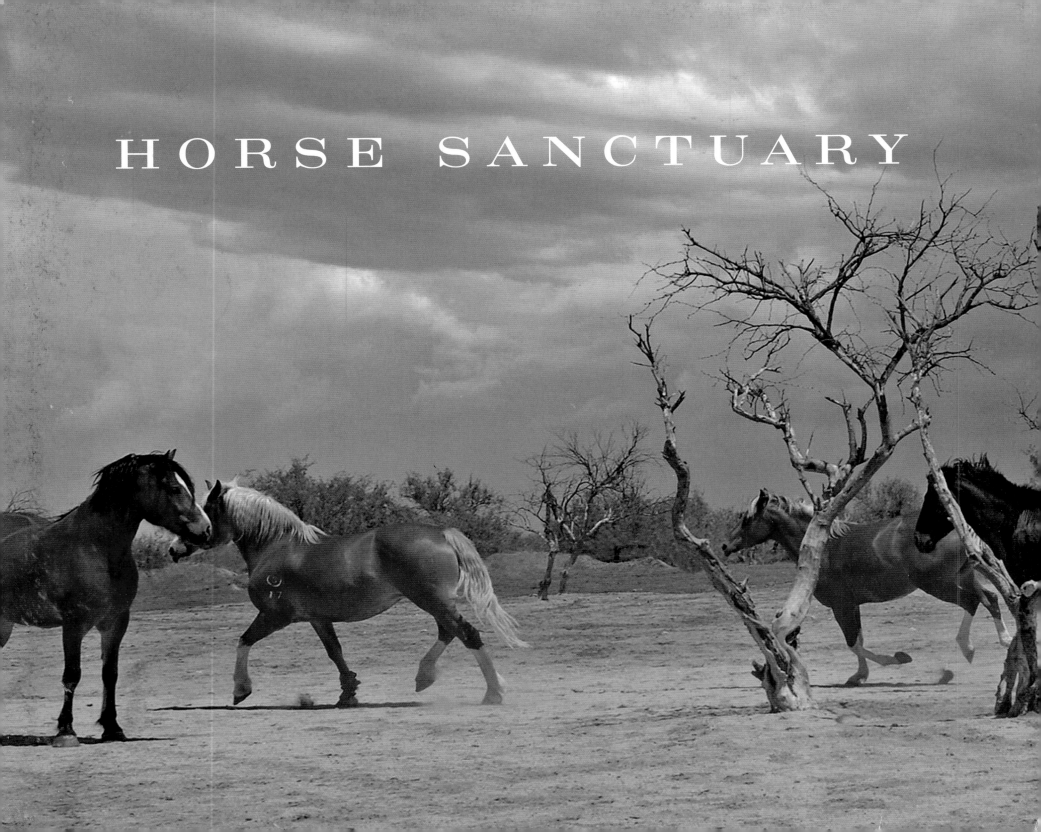

HORSE SANCTUARY

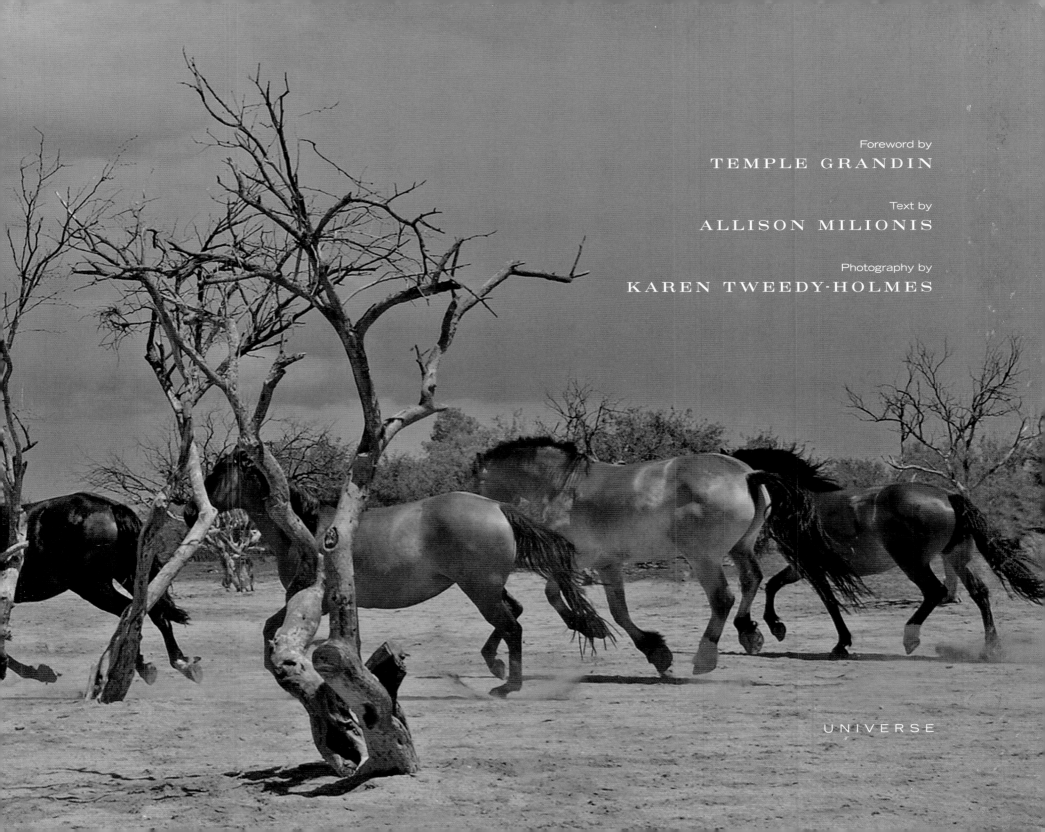

Foreword by
TEMPLE GRANDIN

Text by
ALLISON MILIONIS

Photography by
KAREN TWEEDY-HOLMES

UNIVERSE

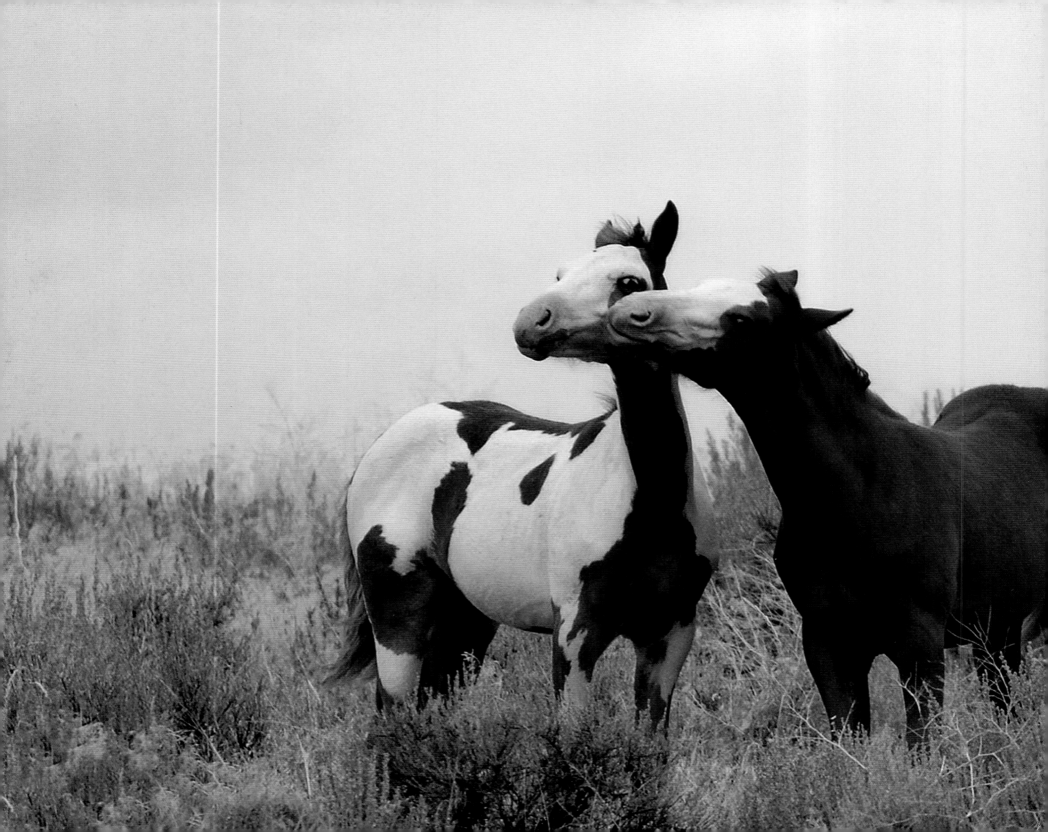

For my love and companion, Cameron Morgan, who believed in me and my vision for this book; for my parents, Connie Tetrault and George Milionis, who generously supported my childhood horse habit; for Grandma Meacham, an extraordinary seamstress who made my beautiful riding outfits with such care; and for my first equine loves, Frosty and Nick, who stirred my cowgirl heart.

—ALLISON MILIONIS

For my beloved husband and unwavering optionaire, Lou Grassi; for my mother, Virginia Tweedy Holmes, who supported my equine obsession; for my cousin, Larry Bolen, breeder and trainer of Morgan champions; and for the horses who have taught me and enriched my life—Do Tell, Mickey, Lady, Blue, and Cobalt—and two extraordinary palominos—Trigger, my first equine hero, and beloved Lucky, gone too soon.

—KAREN TWEEDY-HOLMES

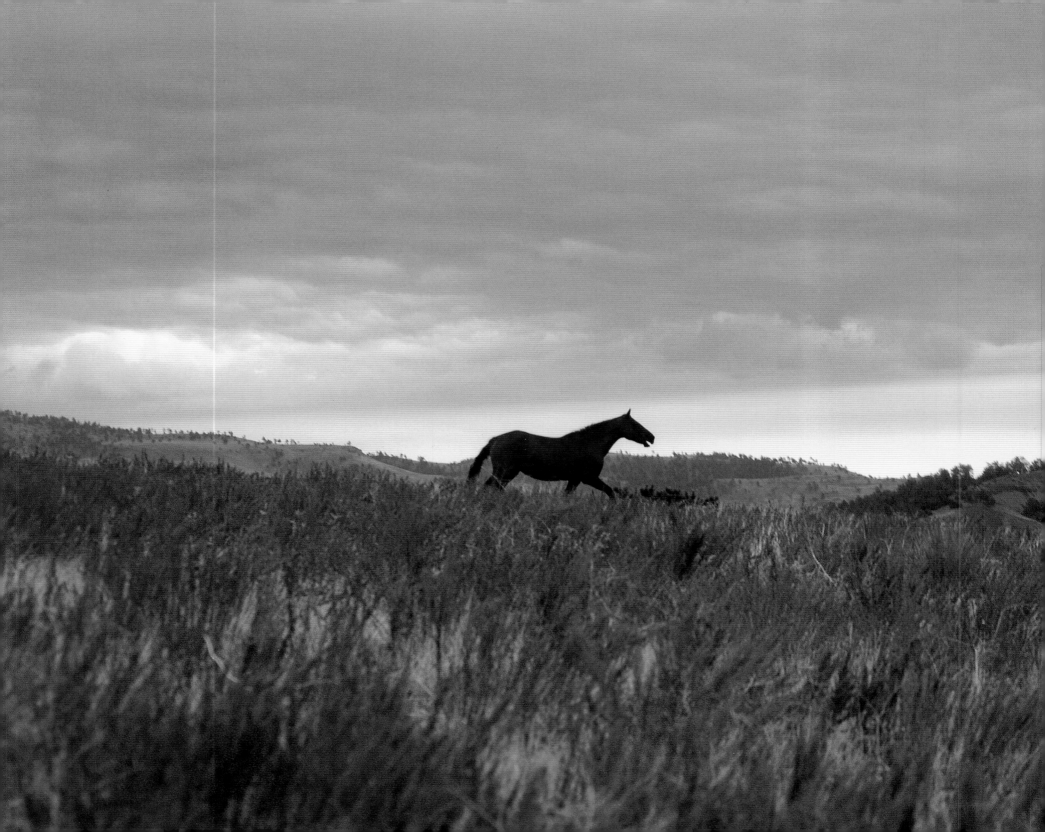

CONTENTS

FOREWORD

TEMPLE GRANDIN, PH.D.

*H*orse Sanctuary is a beautiful book about the relationship between people and horses. The rescue organizations and sanctuaries profiled are wonderful examples of the good work people are doing to help horses and donkeys that have come from terrible situations. Their efforts alleviate suffering caused by neglect and abuse, but also provide opportunities to educate the public on equine welfare. So much of the misery endured by horses and donkeys stems from a lack of understanding of their natural behaviors, such as what triggers a fear response. Some of the rescues profiled in *Horse Sanctuary* have excellent educational programs that teach well-rounded horsemanship skills. Young riders learn how to care for the health and well-being of horses, but also learn to understand why they behave the way they do.

There is an exchange that takes place at these organizations. The horses and donkeys are spared from suffering or an early death, and the volunteers who care for them, as well as others who come in contact with the rescued animals, personally benefit from the experience. One of the programs profiled in the book offers inmates a chance to work with retired racehorses. At Blackburn Correctional Complex, the men learn how to care for horses and work in a racing stable, but they also learn interpersonal skills from observing the horses' behaviors. Some of the men say that their time in the barn with the horses helps them to better cope with the stress of being in captivity.

Although equine rescues and sanctuaries are not a solution to the problem of neglect and abuse, their efforts are important and deserve attention and support. Raising money to do the work is not an easy task, and yet each of the organizations profiled have found creative ways to raise capital. Black Hills Wild Horse Sanctuary attracts tourists to its beautiful property in South Dakota, and it also raises cattle to sell. Catskill Animal Sanctuary in New York, which rescues horses as well as all types of farm animals, offers educational summer camps for children and vegan cooking programs. Horse Harbor Foundation in Washington has developed a therapeutic riding program. It has found that its rescued horses make excellent mounts for the students.

Rescue work and operating a sanctuary is a difficult job. Yet in spite of the daunting challenges, the people who devote their lives to the effort are doing so because they love the animals they help. The stories in this book provide good examples of what is possible when people decide they want to be a solution to a problem, not just a bystander. Although they know it is not possible to save every horse or donkey, their efforts make a difference to the ones that they are able to help.

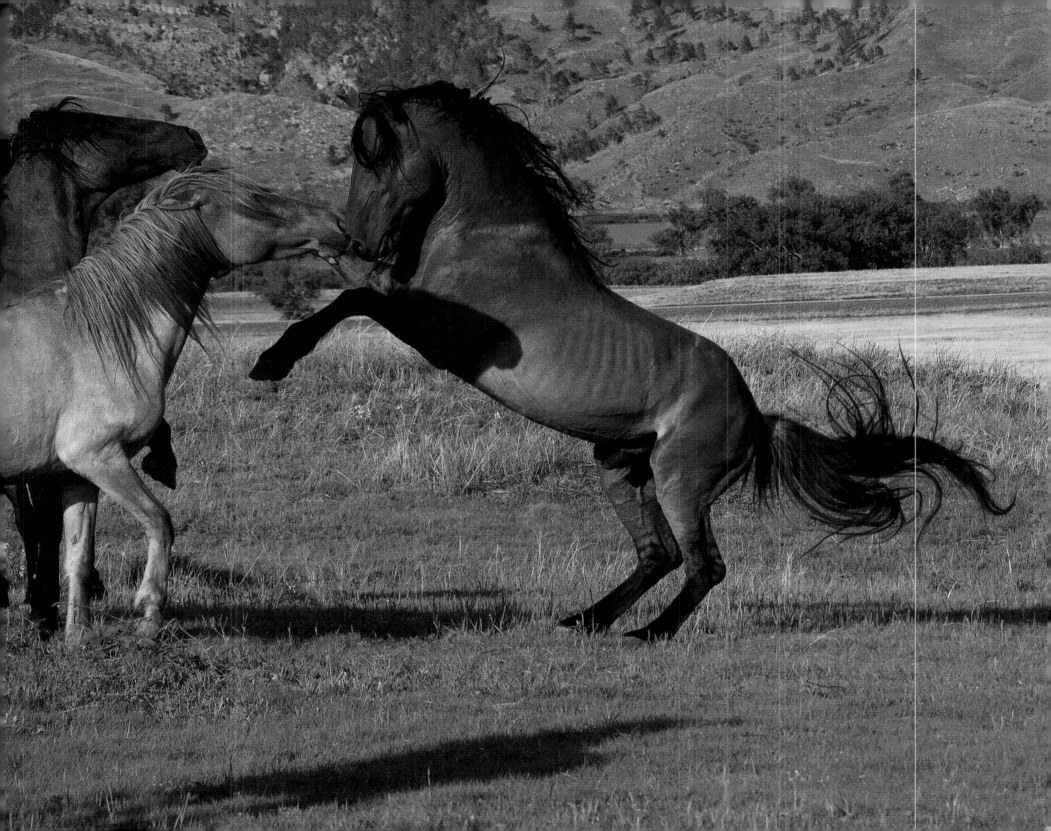

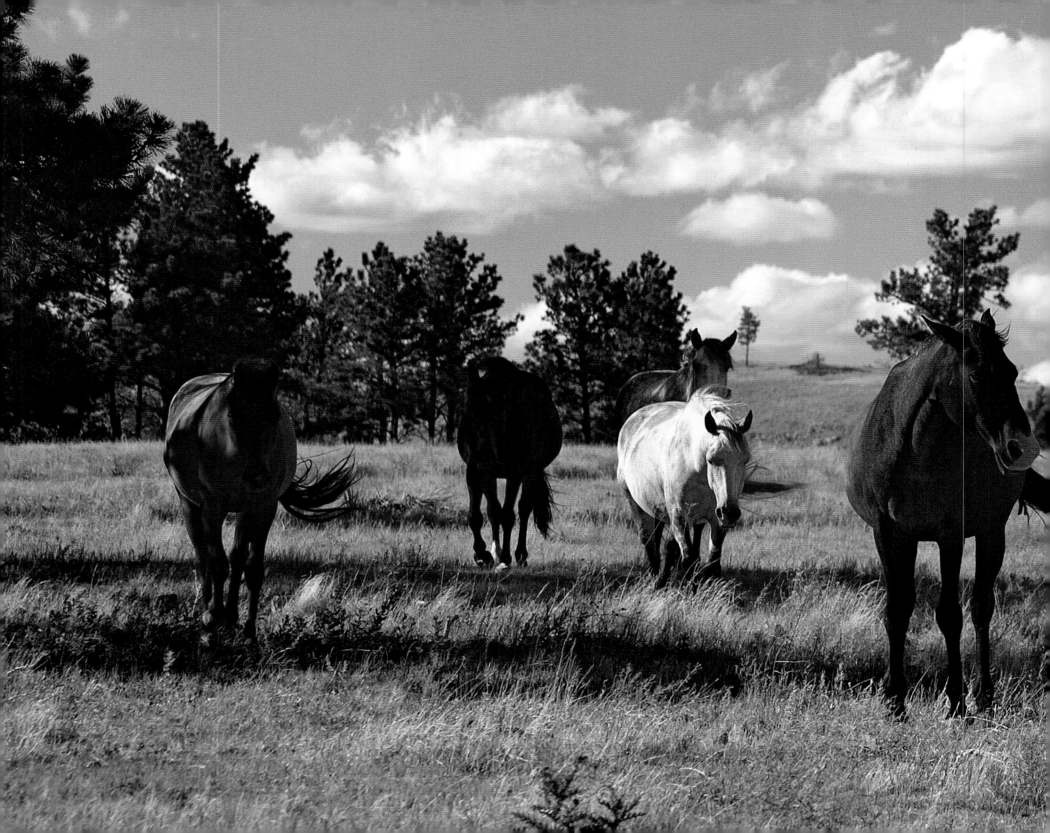

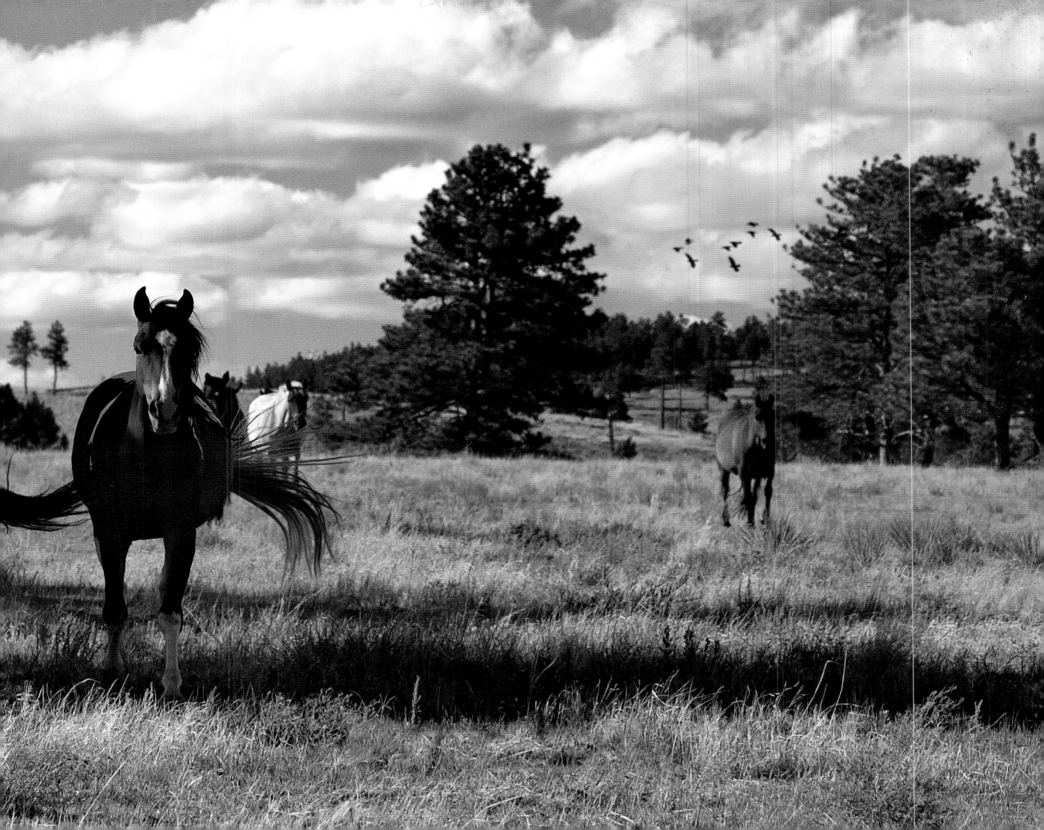

INTRODUCTION

 ALLISON MILIONIS

In early spring of 2012, Karen Tweedy-Holmes and I took a trip to Ohio, where we visited Last Chance Corral. Eight orphaned foals were living there, none more than a few weeks old. They had come from Kentucky nurse-mare farms, where foals are produced so that their lactating mothers can be leased to provide milk for the offspring of high-performance racehorses and show horses that are unable to nurse. Removed from their dams at birth, many of these newborns die within hours. Every spring, the staff members at Last Chance Corral do their best to save as many orphaned foals as possible, a complicated and difficult undertaking considering the amount of work and money required to nurse the fragile newborns to health.

The sun was shining on the day we visited. Several foals took advantage of the spring warmth to play in the paddock, chasing each other in circles and bravely nibbling on soggy leaves, twigs, and new shoots of grass. Three babies remained in the barn, too weak from bouts of diarrhea to play with their peers. Karen and I watched as a volunteer tube fed a mixture of vanilla yogurt, mare's milk formula, and ground oats to the ailing foals. Then, one by one, the foals in the paddock returned to the barn to lie down. They stretched their long limbs, one touching hoof or nose to the tail of another. Their connected bodies formed a beautiful chain in the wood shavings. I held my breath as Karen snapped dozens of photographs. They were so serene. We couldn't imagine that an industry in the United States was allowed to prosper by birthing these remarkable creatures solely for the purpose of making them orphans.

I fell under the spell of horses as a young girl, as did Karen, and when we met I had just embarked on a writing project; my subject was animal rescues and sanctuaries. I wanted to understand what defined a sanctuary, what motivated people to pursue rescue work, and how rescue organizations were changing to meet a growing need. Coincidentally, the subject of Karen's photography project at the time was animal sanctuaries, and because of this shared interest we became fast friends and collaborators. We have focused on equine rescues and sanctuaries not only because of our admiration for these animals, but also because we are aware that these are especially perilous times for horses, donkeys, and mules.

Equines have changed human history more than any other domestic animal. They have worked our fields, herded our cattle, carried us into battle, partnered us in sports, and served as our muses. The human-equine bond has endured, emerging from the industrial and technological revolutions to be one based less on dependence than on respect for *Equus caballus* as athlete, companion, and teacher.

Our bond with horses does not ensure them a comfortable life, however. Like all animals in close relationships with humans, horses are vulnerable to our greed, cruelty, and ignorance. Domestic horses endure abuse and neglect from people who are ill prepared to care for their physical and emotional needs. Racehorses and show horses often suffer debilitating injuries early in their lives and consequently are deemed of little or no financial value

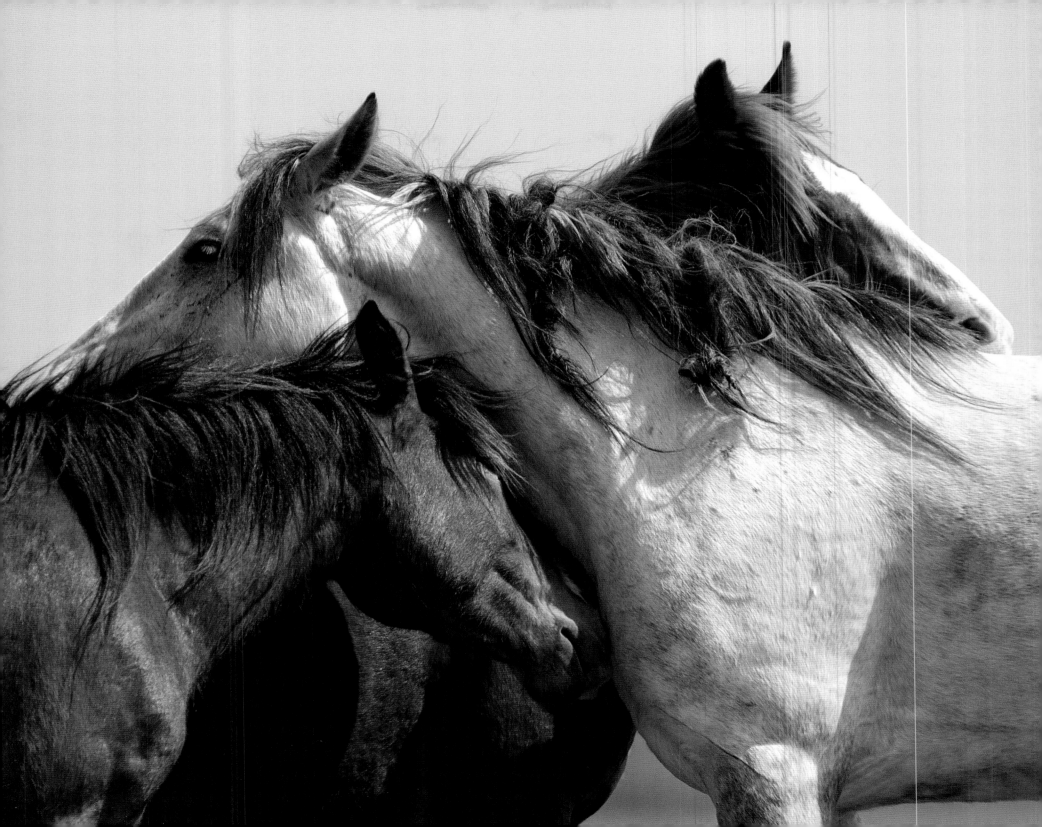

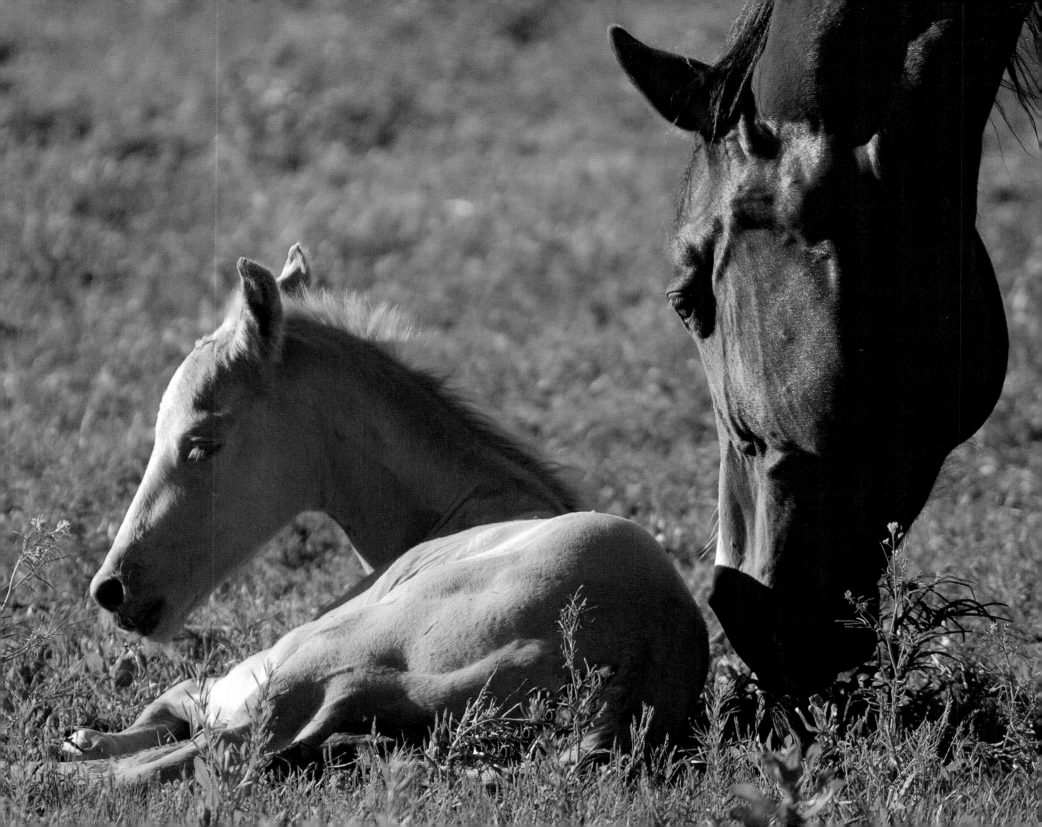

and sent to slaughter or abandoned. Mares repeatedly impregnated so that their urine can be used for hormone replacement therapy are deprived of movement for months at a time. Wild horses are currently rounded up and removed from public lands to languish in vast holding facilities for the remainder of their lives.

We embarked on this project to photograph and write about equines rescued from abusive situations. And we found them. Indeed, we met hundreds of equines that had endured unimaginable abuses: horses that were abandoned by drug smugglers in the Arizona desert and donkeys that were forced to walk painfully on their pastern joints because their hooves had been neglected. Kathy Stevens—founder of Catskill Animal Sanctuary in New York—told some of the most heart-wrenching stories: of starving horses held hostage by delusional hoarders together with dozens of other dead and dying animals in dark, rat-infested barns or hidden pastures. If we had allowed ourselves to focus solely on the horrors we learned about, this book would not exist. The sorrow can be crippling. Instead, we adopted the attitude shared by many of the rescuers we met—concern for the animal's present and future rather than its painful past.

Amazingly, most rescued horses are able to transcend traumatic past experiences. If they weren't, we would have encountered a great number of permanently scarred animals. In fact, despite what they had endured, few of the horses we met at the rescues and sanctuaries held grudges. Rebuilding their trust may take months or even years, but most heal from their physical and psychological wounds when knowledgeable and loving people are caring for them.

Donkeys, however, are not as quick as horses to relinquish the wariness resulting from bad treatment; they have a keen sense of self-preservation. Neither Karen nor I knew much about donkeys or mules before we began our project, but our introduction to these remarkable equines has made us admirers. Unlike horses, donkeys are not flight animals; they are curious, cautious, and independent thinkers. And so playful! In Oregon, at a satellite ranch of Peaceful Valley Donkey Rescue, we were introduced to a group of joyful donkeys that spent hours engaged in games of tug-of-war with rubber hoses, cones, and balls. Jojo, who had been used for roping practice before being rescued, would snatch the hat off the head of an unsuspecting visitor, while Eddie would deliver a playful nip on the visitor's behind if he wasn't receiving the attention he desired.

All of the animals we encountered would not have survived if it weren't for the tireless work of sanctuary rescuers and volunteers. This book is about them, the dedicated people who give equines in peril a second chance at life and the opportunity to heal from their emotional and physical wounds. We wanted to understand what compels their heroic efforts, why many abandon professional careers, financial security, and personal relationships to take on such an emotionally and physically taxing endeavor.

Naturally, no single motivation fires all of the women and men involved in equine rescue. Some have been involved with horses since childhood, whereas others fell in love with their first horse as an adult. As young men, brothers Leo and Frank Kuntz of Nokota Horse Conservancy in North Dakota purchased wild horses that were rounded up in Theodore Roosevelt National Park in order to save them from being annihilated. Ann Firestone of Save Your Ass Long Ear Rescue in New Hampshire has been saving various animals from dire fates since she was a little girl. Jai Rezac, owner of Lucky Horse Equine Rescue in Massachusetts, couldn't turn her back on the ill-fated horses and donkeys sent to stock auctions. Allen Warren of Horse Harbor Foundation in Washington hadn't planned on founding a rescue organization; he simply responded to a need in the area. Dayton O. Hyde of Black Hills Wild

Horse Sanctuary in South Dakota witnessed the suffering of wild horses in Bureau of Land Management holding facilities and decided he was going to do whatever he could to protect the future of the American mustang.

Operating an animal rescue and sanctuary is a daunting task in the best of times. The financial collapse of 2008 and its subsequent fallout presented sanctuary managers with enormous challenges. Not only have donations dropped off and grants become more difficult to obtain, the cost of feed has skyrocketed. Many rescue organizations don't survive in spite of their best efforts. Those that do must diversify the way they raise funds

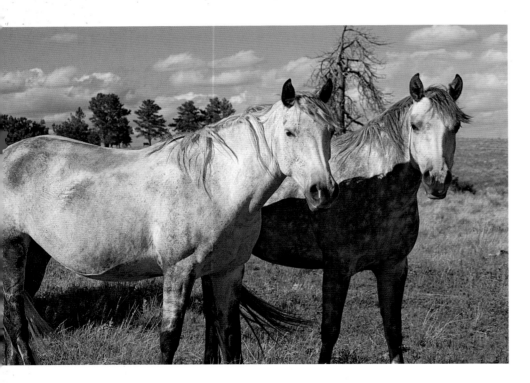

and, most important, resist the temptation to take in more animals than they can afford to care for despite the snowballing increase in neglect and abandonment cases in the United States.

The bottom dropped out of the horse market after the 2008 collapse, and although some signs of improvement have emerged, the market is not even close to what it was at the turn of the 21st century. Selling a horse, especially an older one or one with an injury or physical flaw, is not easy. Desperate owners often resort to auctions, where their horse is likely to be sold by the pound to a kill buyer. Many unscrupulous owners simply stop feeding their horses or abandon them in fields, assuming they can fend for themselves. Rescue organizations tell stories of horses being dumped in private pastures or appearing at their gates without warning. And calls and e-mails—sometimes 10 or more a day—come from owners, local authorities, and other organizations looking for a place that is willing and able to give proper care to a woefully neglected equine.

Networking, especially through social media, has become an invaluable tool for rescue organizations. It increases awareness and helps rescuers raise money quickly. The Internet is particularly useful for finding homes for animals in dire situations. Karen and I learned just how effective networking could be while working on this book. In November 2011, Equine Voices Rescue & Sanctuary in Arizona and a number of other rescue organizations received an urgent message from a woman in Utah with three mustang mares on her hands that she wanted to unload immediately. She said she was unable to feed them. Karen Pomroy, founder and director of Equine Voices, couldn't accept them because the sanctuary was preparing for the arrival of a number of endangered foals from a farm in Canada. Still, Karen felt that the mares were in an unstable environment, and she wanted to do what she could to help. She sent an e-mail to her colleagues and contacts, including me

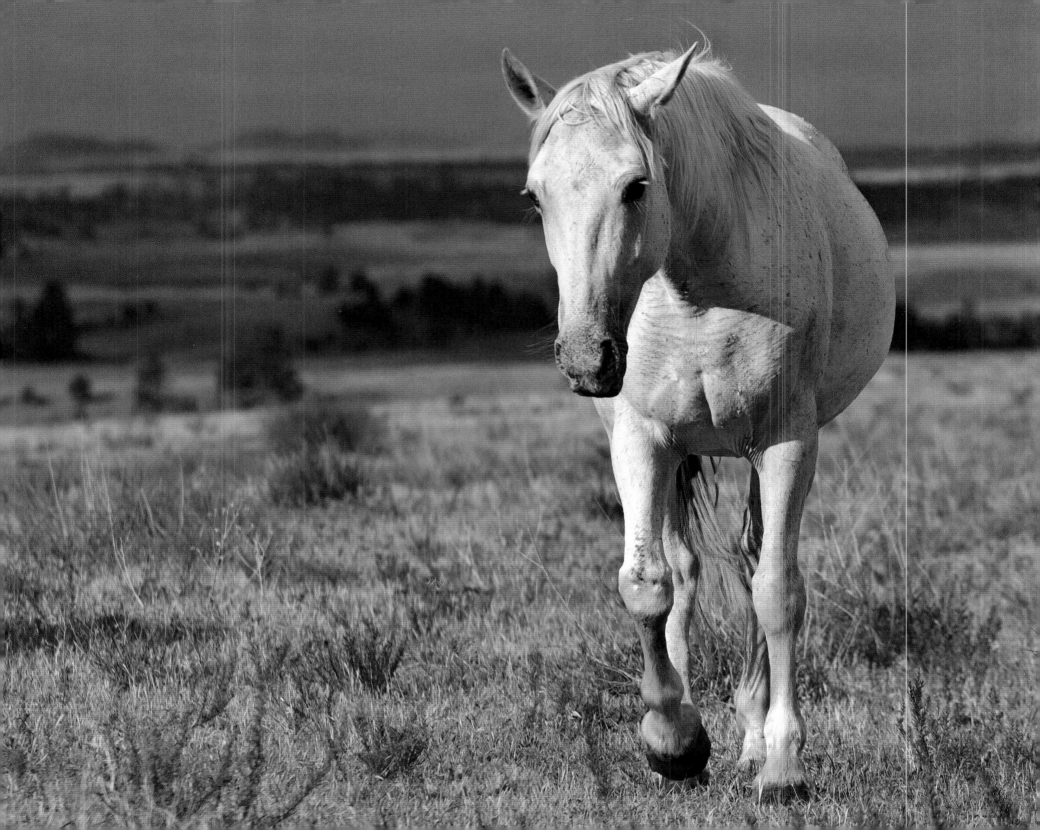

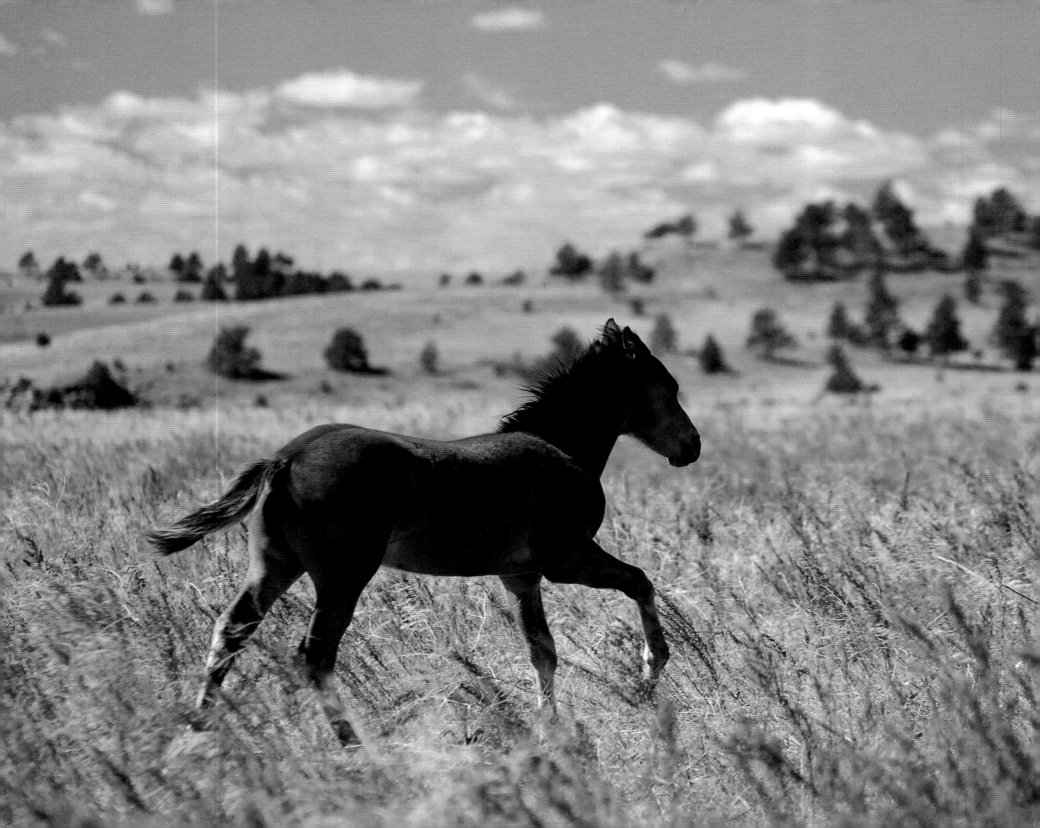

and Karen Tweedy-Holmes, asking if anyone had room for the mares or knew someone who could take them. Immediately, Karen passed the message on to Susan Watt, the director of program development at Black Hills Wild Horse Sanctuary, and without hesitation, Susan agreed to take the mares.

That was only the beginning of what became a three-month-long ordeal to save the mustangs. Just as Karen Pomroy secured a new home for the mares at Black Hills, they disappeared, and the woman who had reached out for help stopped responding to e-mails and phone calls. An Internet search located the mares at a Utah rescue facility that didn't want them. They were threatening to take the horses to auction. From her ranch in Tucson, Karen spent hours coordinating the rescue effort—with the assistance of other groups like Arkwatch Foundation and Best Friends Animal Society— against what seemed at times like impossible odds. When the mares finally made it safely to South Dakota, they were turned out with an established herd of mustangs on the 13,000-acre sanctuary. They will remain there for the rest of their lives, living free with minimal human contact.

We marveled at the speed with which the news of the mares' plight made it around the country and how many people responded who were willing to help or pass the word on to others who could. Persistence is essential for a rescue to succeed, as well as the ability to organize and maintain a wide network of contacts. Karen said it also takes a good dose of hope.

Allen Warren of Horse Harbor Foundation wishes his organization didn't have to exist at all. He would like to see a world where equines are ensured a lifetime of care, not treated like objects to be tossed aside, casualties of our throwaway society. All of the rescuers we met agreed that education is the only way to change cultural attitudes toward equines and that another generation may pass before such change is effected. All of the organizations we have profiled here include an educational component geared toward school-aged children, and a few are actively engaged in national campaigns to change laws and policies that endanger equines.

A certain amount of progress has been made: by Lynn Reardon and her volunteers at LoneStar Outreach to Place Ex-Racers (LOPE) in retraining discarded racehorses for new vocations; by Linda Dyer working with inmates at Blackburn Correctional Complex in Kentucky; by Alexis Ells with the Horse Soldiers program at The Equine Sanctuary in California; and by Hilary Wood at Front Range Equine Rescue in Colorado, who works on campaigns to end equine slaughter. But for every advance, the forces of greed and ignorance are close by, waiting to push back.

I look at Karen's photographs frequently, especially those of the orphaned foals at Last Chance Corral. These pictures have been a source of comfort to me while I've conducted research for this book. I know that thousands of newborns, unlike these few, won't survive a day beyond their birth. Focusing on the image of four long-legged foals lying serenely in a sanctuary barn in southern Ohio gives me hope that their story of survival will help fuel change, that awareness may bring an end to a cruel industry that creates orphans and cuts foals' lives short for profit. Additionally, Karen and I hope that wider awareness of the various ways equines are abused—pregnant mare urine (PMU) and nurse-mare farms, mustang roundups, the heartless discarding of retired sport and performance horses, and the abuse and abandonment of drug-trade horses—will end these cruelties. The more people who are made aware of the plight of equines and the more such people who are willing to speak out and act for change, the closer we may get to making Allen Warren's wish come true—a day when equine rescues and sanctuaries are no longer necessary. Until then, we celebrate the work of these 13 equine sanctuaries and their perseverance in the face of staggering challenges to do everything possible to alleviate the suffering of these magnificent animals.

BLACKBURN CORRECTIONAL COMPLEX

The Thoroughbred Retirement Fund (TRF) was established in 1982. Since it began, the nonprofit organization has saved more than 3,000 equine athletes from neglect or slaughter, many of which transitioned to new careers in adoptive homes. The horses that aren't adopted receive lifetime care at one of the TRF facilities. Depending on their financial circumstances, owners are urged to provide the sum required to care for the horse throughout its lifetime or, at minimum, $5 a day for the rest of the horse's life. In nearly three

decades, the TRF has grown to become the largest equine rescue organization in the world and a leader in promoting equine vocational programs for incarcerated men and women throughout the United States.

Early in the organization's history, Monique S. Koehler, founder and chairman of the board, negotiated an unusual agreement with the State of New York Department of Correctional Services after the estate of philanthropist Paul Mellon, owner–breeder of Kentucky Derby winner Sea Hero, endowed the program with $5 million. In exchange for land use and labor at the Wallkill Correctional Facility, the TRF would design, staff, and maintain a vocational training program in equine care and management for inmates. The foundation would also pay for the horses' feed and for all medical and farrier needs. The idea was to teach the inmates new skills that they could use outside of prison while retraining ex-racehorses for vocations off the track. The program, called Second Chances, was a success from the start, and within two decades the TRF program had been replicated at other correctional facilities around the country, including Blackburn Correctional Complex. Today, the program has more than 20 facilities in 13 states throughout the United States.

When we visited Blackburn, we met a horse named Sea of Red. The chestnut Thoroughbred, also known as Red or Big Red, was donated to Blackburn in 2011 through the TRF after leg injuries curtailed his professional career. His good nature and looks made him a favorite among the inmates

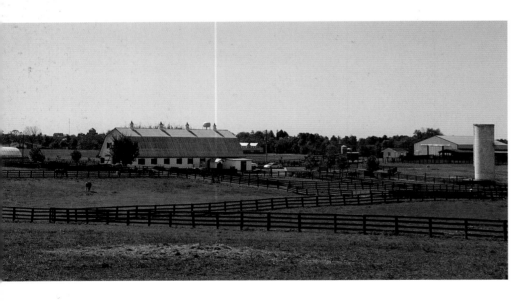

ABOVE: The renovated barn at Blackburn is set among 110 acres of rolling Kentucky bluegrass pastures. OPPOSITE: Sea of Red (Red) grazes peacefully after undergoing treatment for a hoof abscess.

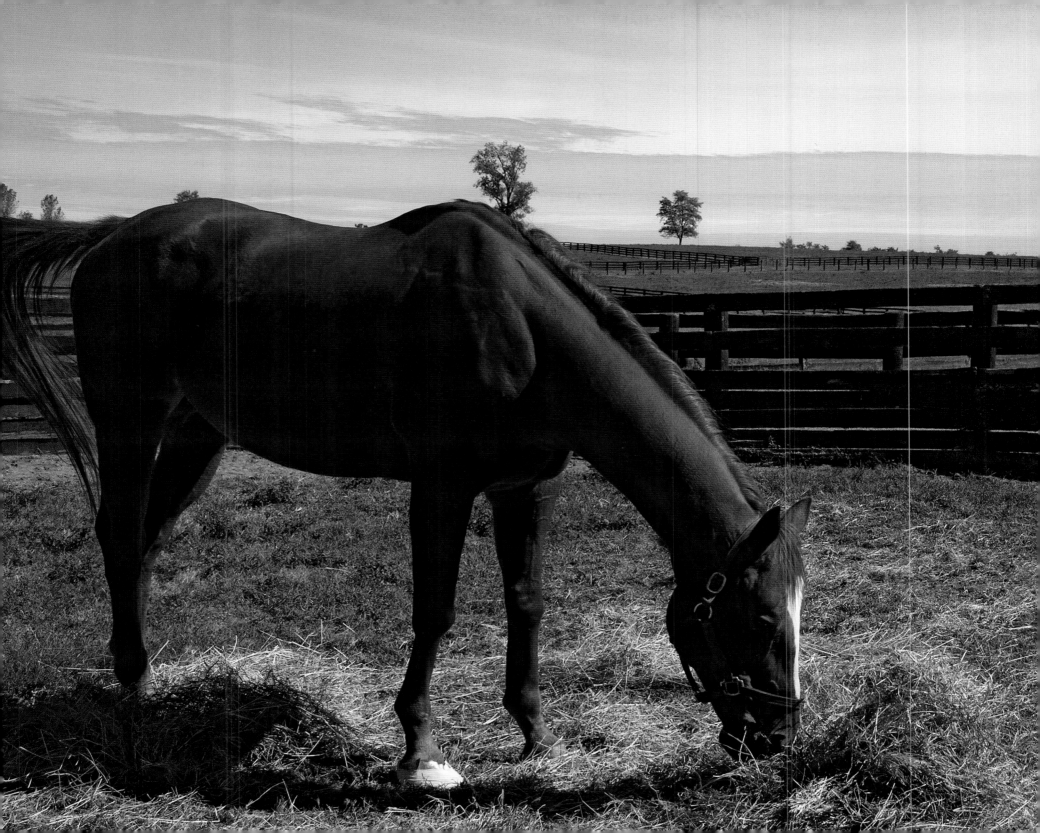

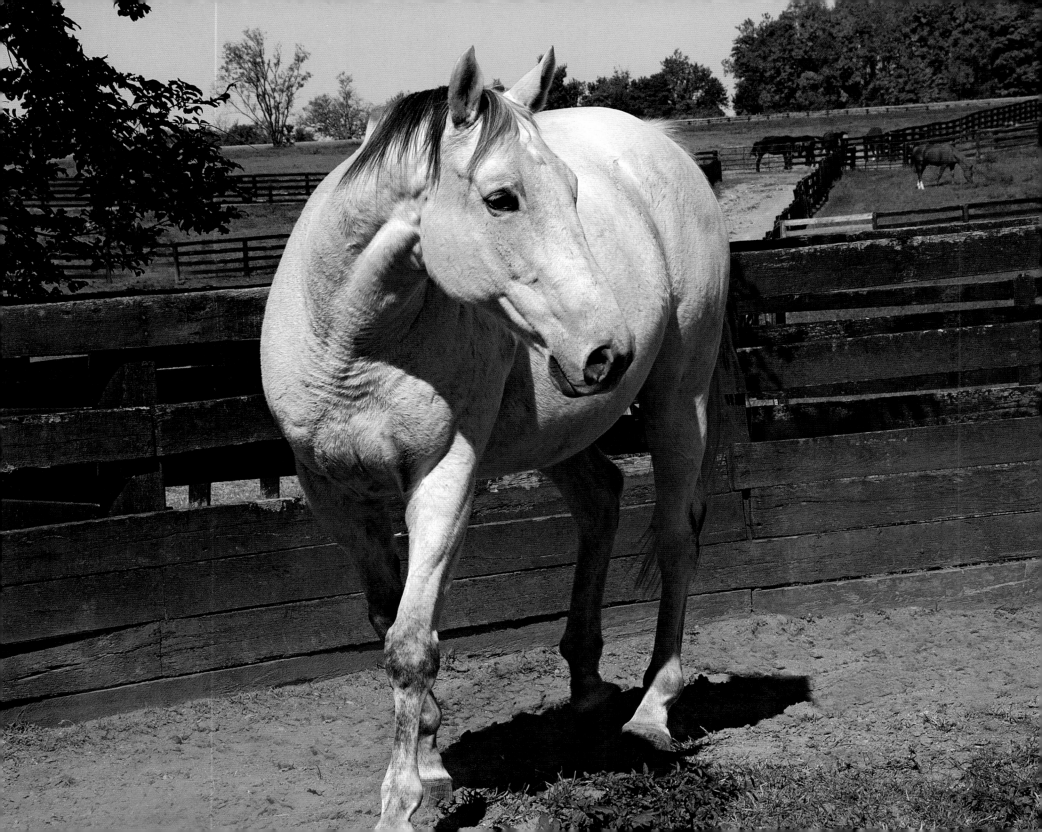

at the facility. On the day we visited, Red was resigned to standing in a cold Epsom salt bath, although occasionally he expressed his discomfort by shaking his head and transferring his weight from his right foot to his left. His caretakers patted his neck and encouraged him to remain still for a few more minutes. Several of the men stood outside his stall, admiring his quiet stoicism in light of the ordeal. They shook their heads, lamenting Red's condition.

Several X-rays taken earlier in the day showed that Red hadn't foundered as suspected; rather, he was suffering from an abscess. But the images revealed another surprise: two screws in one of his knees. It's not unusual for ex-racehorses to have one or more pieces of hardware in their bodies. Many TRF horses endured an injury at some point in their careers, affecting their ability to race and forcing their owners to retire them from the sport or risk a worse and debilitating injury. Once retired, the options are to send the horses to a breeding farm, demote them to racetrack lead-pony status, or arrange to have them trained for a new career as a performance or pleasure horse.

The worst scenario is for the owner to send the horse to auction, where the animal will likely fall into the hands of a kill buyer. Thousands of young, fit, and well-tempered racehorses are delivered to livestock auctions each year, and many of these doomed animals are trucked to slaughter in Mexico or Canada.

One of the most famous racehorses to die this way was Ferdinand, the 1986 Kentucky Derby winner and 1987 Horse of the Year. After retiring from racing and spending several leisurely years at stud in Kentucky, Ferdinand was sold to a Japanese breeding farm located in the northern island of Hokkaido. Eventually, he fell into the hands of a horse dealer, and in 2002, Ferdinand's life came to an undignified end in a slaughterhouse somewhere in Japan. When his fate was revealed, the news spread throughout the race world, angering owners, breeders, and enthusiasts. Although the knowledge of Ferdinand's death hasn't changed the outcome for many racehorses, it did bring to light the issue of slaughter in the racing industry, mobilizing equine advocates who have railed against breeders and owners for dumping their retired racehorses at stock auctions.

A CARETAKER FOR BLACKBURN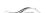

After 45 years of working around racehorses, Linda C. Dyer has witnessed nearly everything that can go wrong with a horse and handled hundreds of challenging situations. Most of her experience was gained on Lexington breeding farms—big, fancy facilities with extravagant barns and beautifully manicured gardens. She mingled with the elite of the Kentucky racing world, both people and horses, and was involved in race clubs and committees. Although she had an exciting profession, Linda left her career as a barn manager to secure work that would provide more stability and a retirement pension. She found both with the Kentucky State Police, where she worked for four and a half years.

Then, in 2005, a unique opportunity presented itself. The TRF program at Blackburn was having a difficult time finding the right manager for the job. Although there were plenty of capable people in the Lexington area with horse-farm experience, the job at Blackburn required a particularly gifted person, someone who could confidently handle retired racehorses and troubled men. "Linda has the right stuff," said Diana Pikulski, TRF director of external affairs. "The best horse people make the best corrections people. It's about being a leader, but leading through trust, confidence, and compassion."

As the TRF manager at Blackburn, Linda oversees the care of retired racehorses, as well as barn and pasture maintenance. The most challenging

Frightful pays attention to an inmate who asks him to trot to the right during a natural horsemanship training session in the roundpen.

aspect of her job is managing the inmates and preparing them for jobs outside of prison; the most rewarding is watching the horses change the men's lives. The inmates come from a wide range of backgrounds, some colorful, others tragic. Their crimes include burglary, assault, gunrunning, drug possession, and manslaughter. The youngest men are in their early 20s; the eldest is nearly 60. Blackburn inmates can choose from a number of vocational programs to learn new skills or brush up on old ones while cutting 90 days off their sentences. In addition to the equine program, there's a cattle farm and dog-training program, as well as training in masonry, carpentry, and horticulture. Inmates can take computer courses or work in the prison industries program.

There is a waiting list to get in to the TRF program, though, a clear testament to its popularity. Inmates may wait up to two months for one of the 18 coveted slots. A simple, one-page questionnaire requires a description of their background and why they are applying for the program. Some men say they want to work with horses, while others see it as an easy way to shorten their sentences. Having horse-barn experience is not a requirement, but Linda prefers to have a few men in the group with some exposure to equines. Once accepted, inmates work at the farm five days a week for six months, unless they request and are granted a longer stay. Work starts promptly at 8:00 a.m. The men work until noon, break for lunch and a routine check-in at the prison yard, then return for the afternoon shift. There is no overtime. In fact, staying after program hours is not allowed; even Linda isn't permitted to remain on the premises after her shift. However, because horse care is a round-the-clock responsibility, the warden does allow four inmates from the program to return to the barn in the evening for a final check and again on weekends to feed and water the horses. Linda handpicks the crew based on reliability, interest, experience, abilities, and compatibility with the other men in the program.

WORKING WITH THE INMATES

Located on the outskirts of Lexington, adjacent to a quiet middle-class neighborhood, the Blackburn facility includes 110 acres of rolling pasture and a charming dairy barn that was renovated and retrofitted with horse stalls, an office, a tidy tack room, and a classroom. There are more than 65 horses at the farm; some were big earners with fancy pedigrees, others were

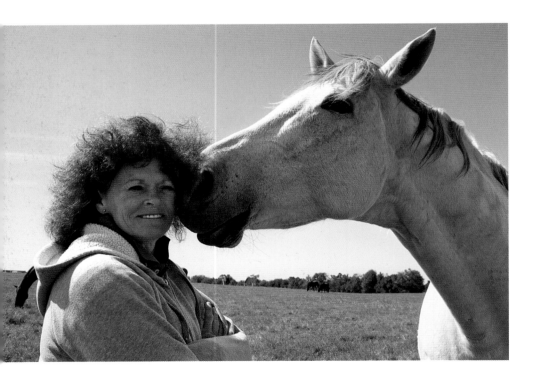

Linda Dyer, TRF manager at Blackburn, enjoys a nuzzle from Vive la Vie.

not as talented or lacked the desire to compete. Most horses are younger than 10 years old, but a few are nearing 30. Their personalities are as diverse as the inmates' personalities. Some, like Red, are calm, gentle, and dignified, while others are fiery and impulsive. According to Diana, Blackburn has the most challenging mix of horses because the foundation knows that Linda is capable of handling anything that comes her way.

Unless they are receiving medical care or undergoing training, the horses are out on pasture year-round. Once or twice a day, depending on the pasture conditions and needs of the horses, the inmates deliver hay and take grain to the elder horses or hard keepers (horses that don't easily maintain their weight). They're scanned for injuries or signs of illness, and—weather permitting—every horse is pulled aside, combed, and curried. Unlike the uncertainties facing the inmates, the life of a Blackburn horse is verifiable. Days of leisure are assured; so are meals, medical care, grooming, and appreciative hugs from their unlikely caretakers.

Some of the inmates consider individual time with the horses one of the most gratifying parts of the job. They get to know the horses' personalities and their distinct or charming traits. Some of the men talk to the horses, share their troubles, and express the frustrations of life as a captive. According to inmate Dexter Welch, time with the Thoroughbreds provides the only chance in prison to show affection. Dexter hugs the horses when he can; he finds it very calming. "It's good to come down to the barn and receive unconditional love," he said. "They really do hug on these horses a lot," Linda added. "Some of them just beam when a horse shows them individual affection."

Regardless of what's going on in the prison yard or the inmates' personal struggles, Linda reminds the men that while they're at the barn, the horses are their top priority. She requires they be present, focused, and willing to work with the horses or complete any one of the many maintenance chores. Although not all the men like each other, civility is essential. In the seven years that she has worked as the TRF manager, Linda said she has only had to break up one heated argument. She pointed to the aisle in front of her office where she planted her petite frame squarely between the two large men and demanded that they back down, halfway expecting to catch a misdirected fist. Luckily, her brave interference diffused the situation before it escalated into a fistfight.

That experience aside, Linda said that she's comfortable working in a male-dominated environment. She has been doing it for a long time, ever

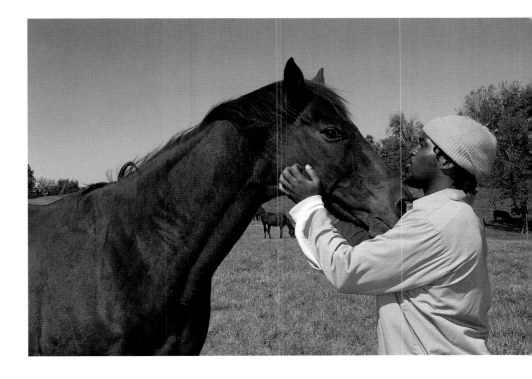

Playful Emperor receives an affectionate caress from DeWayne Wright.

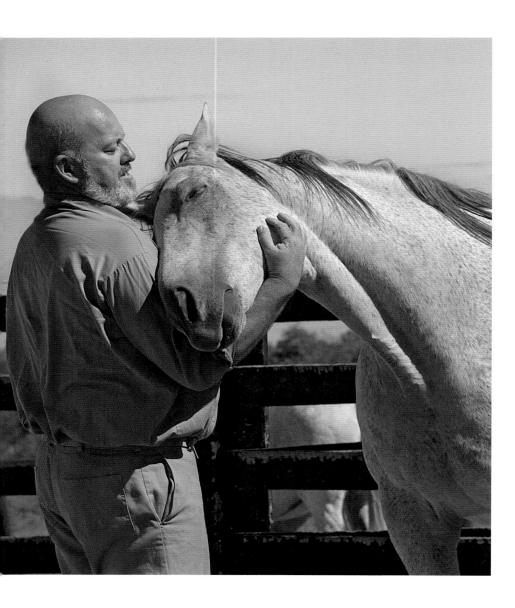

Randall Sorrell and Deacon have developed a strong bond.

since she first set foot in a racing barn. Most of these barns are owned and operated by men. At Blackburn, she manages her crews by balancing the right amount of authority with respect, and it seems to work. Linda is well liked and appreciated as much for her fairness as her horse skills. The men said her depth of knowledge is impressive. Linda teaches a mandatory class in which the men learn about equine history, health, behavior, and care. The classroom walls are covered with anatomical illustrations, charts, and images. There are stacks of horse magazines, DVDs, leg wraps, and tack used for demonstrations. Linda developed a comprehensive curriculum that culminates with a 285-question exam, which the men can take over a period of days. Their education also includes field trips to the Keeneland Thoroughbred sales and visits to local horse farms, where the men are given a tour and introduced to the various jobs they'd be qualified for after completing the Second Chances program.

Inmate Randall Sorrell has been one of Linda's better students. He takes a lot of detailed notes, is committed to his education, and is a reliable worker. A former Iowa resident with a background and formal education in livestock management, Randall said the first day he arrived at Blackburn he went straight to the barn and applied for the TRF vocational program, in part, he admitted, to have 90 days deducted from his sentence, but also because he wanted to give back in some way, to be a part of something bigger than himself. "It also takes the edge off of being incarcerated," he added.

Many of the other inmates in the program agree. Being away from the prison yard, which holds more than 600 inmates, provides a healthy outlet for their energy and a place to take their minds off their sentences and the strain of separation from family, loved ones, and friends. The men said the daily routine gives their lives some sense of normalcy, and the horses have taught them patience.

Although no formal research has been completed on the effects of equine vocational programs on inmates, anecdotal evidence suggests that the benefits are substantial. Keren Bachi is a Ph.D. candidate in Social Welfare at the Graduate Center of the City University of New York (CUNY) studying the behavioral and emotional effects of equine-facilitated interventions with inmates. She's the first to examine the TRF Second Chances program, and, in 2012, her work appeared in the journal *Society and Animals*. In the article, Keren provides a strong argument for the need to have more formal evaluation processes and developed theories to better understand the human-horse bond. She believes that having reliable data will help promote programs like the one at Blackburn in prisons throughout the world.

Formal data aside, the men described their work with the horses as "calming" and "relaxing." Some find inspiration in the horses' ability to overcome injury, change, and strife. Red, the big chestnut gelding recovering from an abscess, has touched a number of inmates' hearts. "Big Red doesn't give up," said Anthony Johnson, a self-described animal lover who grew up around horses. Anthony is trying to accumulate as much knowledge as possible while in the program, and when he gets out he hopes to apply what he has learned at a local horse farm. Nevertheless, even if a job at a barn doesn't pan out, he has gained some invaluable skills by working with the Thoroughbreds, and chances are he'll leave the center a different man from the one who went in.

UNLIKELY HORSEMEN

Often, it's the men with the least past exposure to horses—sometimes none at all—who prove to be the most natural horsemen. They arrive at the program without any pretenses, even a little fearful of horses, until they experience a breakthrough of some kind. Perhaps it's through treating a

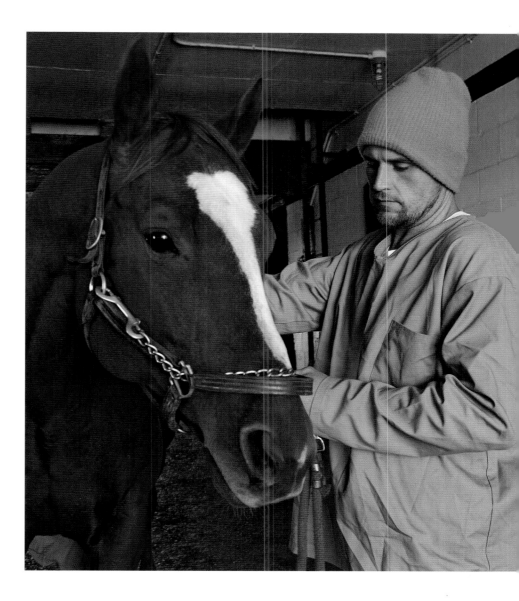

Anthony Johnson steadies Red for his hoof-abscess treatment.

horse suffering from an injury, or it might happen in the ring, where horses and men undergo training together. It could be as simple as connecting with a particular horse, establishing an emotional bond that transcends any other relationship they've ever had.

For example, Stephen Piercy grew up in a rough neighborhood in Louisville with no horse experience, but he's at home among the Thoroughbreds. He is also an attentive student in the classroom, which has paid off. He has earned a spot on the night and weekend crew, and Linda often calls on him to make foot packs; it's his specialty. She said Stephen exhibits both ease and confidence around the horses, traits that don't come

easily to all of the men. According to Stephen, working with the horses just requires using "common sense."

Employing natural horsemanship techniques—based on the Parelli Method, which forbids using force, punishment, and coercion—Linda encourages the men to build the horses' trust through patience and consistency. The method is effective in transitioning ex-racers off the track, but it also offers the inmates a new perspective in handling horses and themselves. Linda said the men become frustrated when the horse they're working with doesn't meet goals as quickly as they'd like. They're forced to exercise restraint, manage their impulse to bully, and try to understand why the horse is unwilling to respond to a new command. None of these behaviors comes easily for most inmates. When they finally achieve their goal, the reward is that much sweeter. "I think they really feel a huge sense of accomplishment and pride when they finally have a horse come around in training," said Linda. "This helps their self-esteem and shows how a little hard work can pay off in the end."

It's difficult to know how many of the men who have passed through the program have gone on to work with horses after leaving the prison. Second Chances doesn't track that information. Perhaps current research such as Keren's will provide hard data on how great an effect the program has on the lives of ex-convicts. Based on Linda's observations, it's probably significant. She has seen the program change behaviors; she has witnessed grown men talk to the horses as if they were babies and even sing to them. She mentioned one man who lay in the stall next to a horse, massaging the Thoroughbred's ankle in an effort to ease its pain. And then there's the inmate whose job, prior to going to prison, was to haul horses to kill buyers. After becoming attached to a TRF horse named Clever Book, he vowed he would never haul another horse to its death.

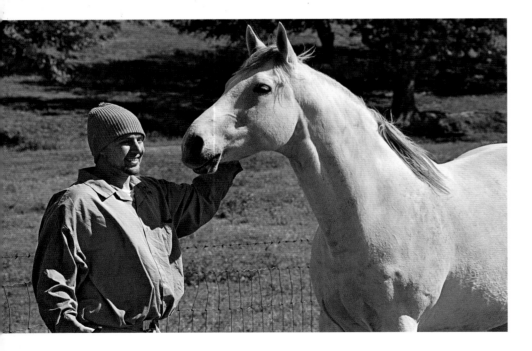

ABOVE: At Blackburn, Stephen Piercy (with Vive la Vie) has discovered that he has a talent for working with horses. OPPOSITE: Deacon and Direct Call are interested when Linda comes by their paddock to visit.

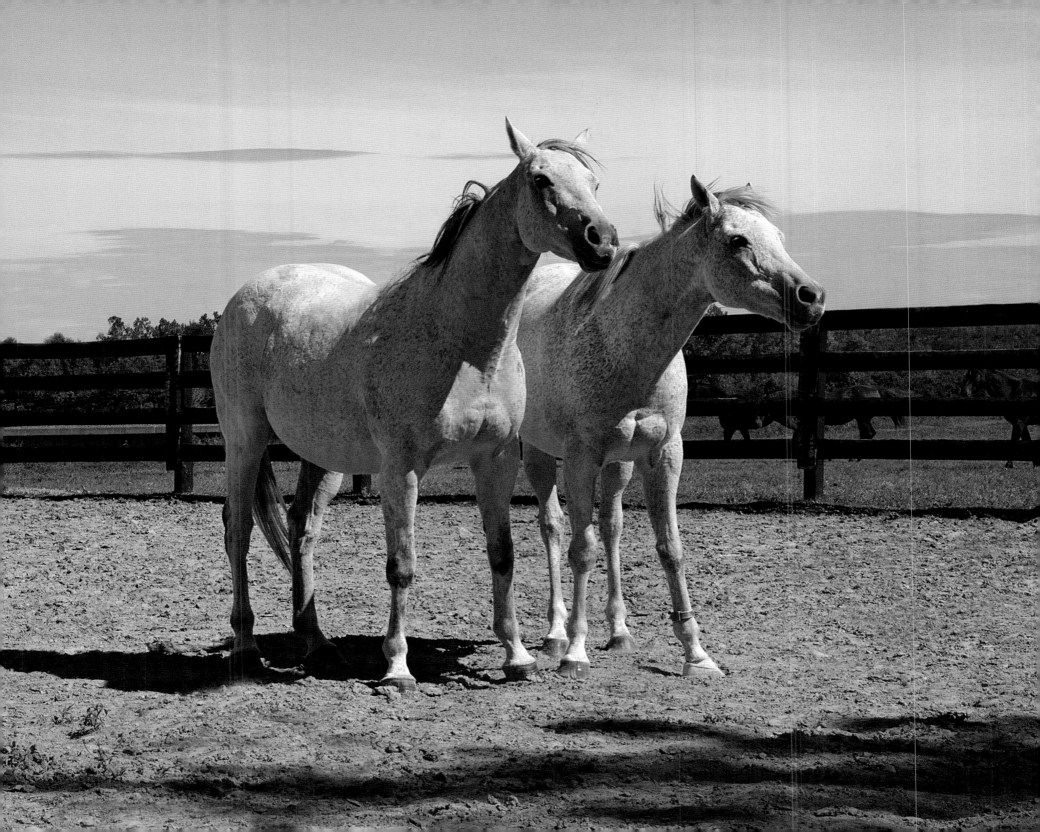

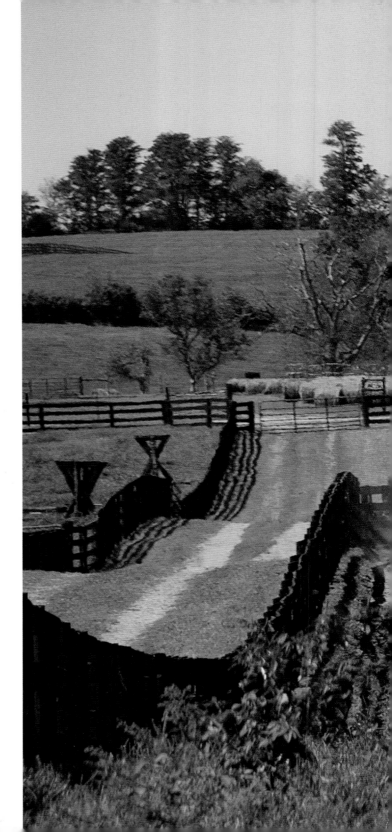

ABOVE: After an injury that ended his racing prospects, Kaufy Machine's
owners donated this elegant brown gelding to the Blackburn equine program.

OPPOSITE: The band in the far paddock gallops uphill to see visitors.

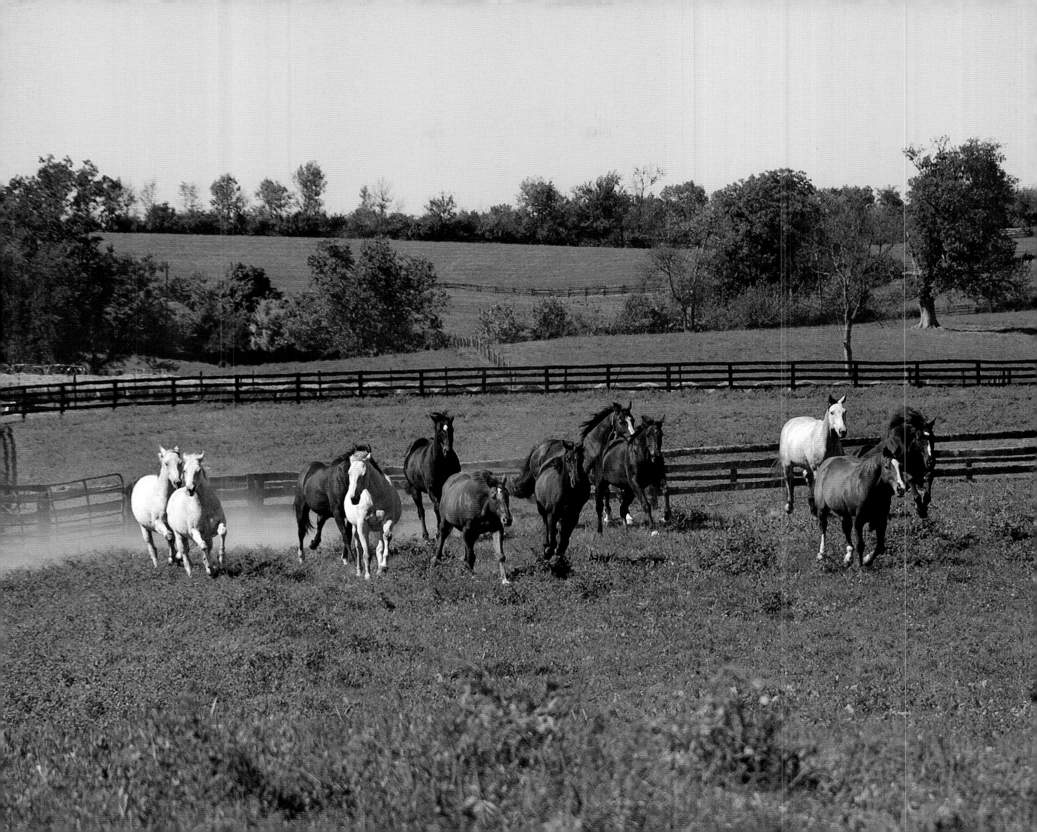

OPPOSITE: Ferdinand's barn name reflects his distinguished ancestry.

RIGHT: Native Ivory relaxes with his band in a pasture near the barn.

OVERLEAF: Wallinsky (left) provides a cowbird with a lunchtime perch. Sovereign Kit (right) dashes across his pasture.

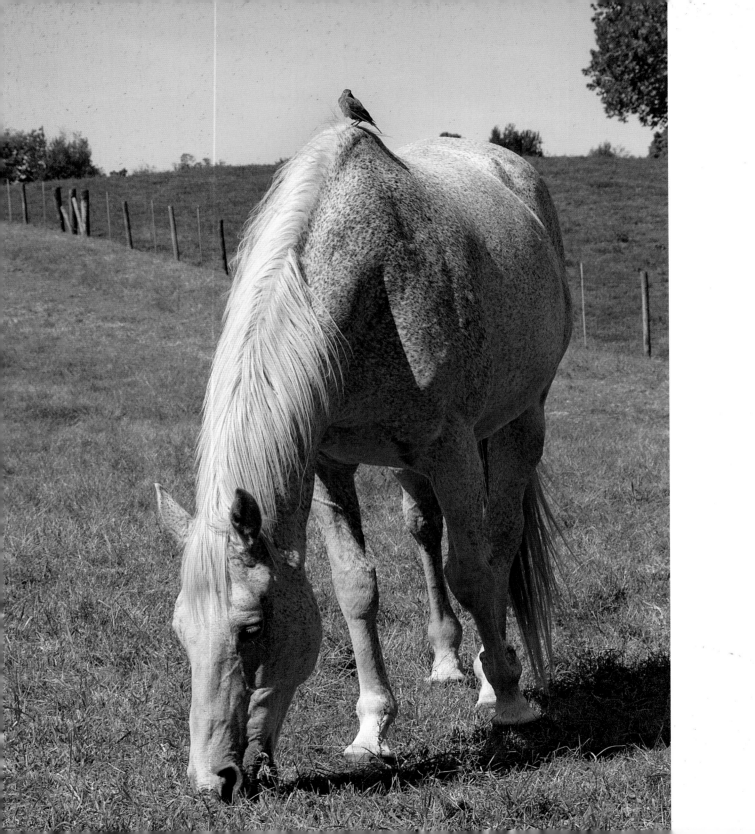

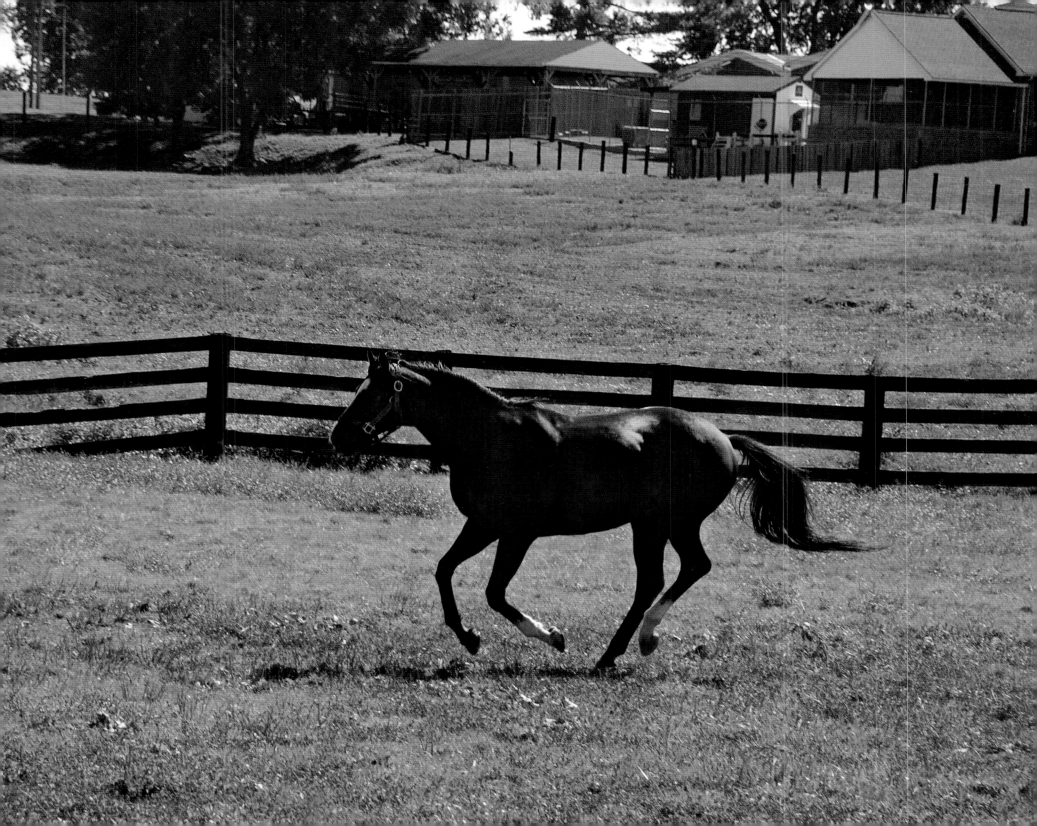

BLACK HILLS WILD HORSE SANCTUARY

We arrived at Black Hills Wild Horse Sanctuary after dusk on a warm October day. It was too dark to see the yearling fillies in the paddock across the road from our cabin, but we could hear them munching hay. We stood outside our rental car breathing in their scent, barely able to withstand the temptation to stumble along in the darkness to find them. But we waited until morning, enticing them to the fence just after dawn. We offered carrots and, although shy, they were willing to take them from our hands but refused our attempts to pat their silky necks.

The Black Hills Wild Horse Sanctuary, also known as IRAM (Institute of Range and American Mustang), is a short drive from Hot Springs, South Dakota, a quaint hillside town 53 miles south of Rapid City at the base of the Black Hills. Western moviemakers couldn't invent this landscape: windblown buffalo grass, groves of cottonwood trees, the meandering Cheyenne River, expansive sky, and bands of grazing horses. Paints, sorrels, buckskins, and bays roam land that was once home to early native tribes and, centuries earlier, the great Columbian and woolly mammoths. Prairie dogs abound, as well as mule deer, rabbits, and coyotes. On occasion, a bald eagle leaves her cliffside nest to soar over her prairie domain.

The sanctuary draws nearly 10,000 visitors each year. They come from around the world; most are urban dwellers that want to see and experience a bit of the "Wild West." The sanctuary has boosted the Hot Springs economy, much to the surprise of locals. When founder Dayton O. Hyde established the sanctuary in 1988, neighbors were outraged that the property was going to be used to support wild horses and predicted that the enterprise would fail. Now, they stop by the sanctuary to chat over a cup of coffee.

Had Dayton not purchased the land, it would be houses—not horses—dotting the landscape. In early 1988, a developer was eyeing the property for a residential subdivision. At the same time, Dayton was looking for the perfect piece of land for his wild horse sanctuary, an idea that came to him after witnessing mustangs languishing in Bureau of Land Management (BLM) holding pens. In his 2005 memoir, *The Pastures of Beyond*, Dayton described the moment he knew he had to do something about the plight of the American mustang. Dayton was in Lovelock, Nevada, to buy cattle, but was drawn to the BLM holding facilities. The pens were crowded with hundreds of anxious horses that had endured stressful helicopter roundups. "I stood outside the fence and saw the hurt and dejection in their eyes," he wrote. "I had grown up with wild horses on the ranges surrounding Yamsi [his 6,000-acre working cattle ranch in eastern Oregon]. I had a feeling that, somehow, I was meant to help the animals escape."

Dayton knew that the only way he could give mustangs a life that resembled the one taken from them by the BLM was to create a sanctuary. He took his idea to Washington, D.C., where he lobbied for nearly six months to win the support of Congress and the BLM. It was no small feat convincing the government that establishing a nonprofit sanctuary was in

Four wild mustang yearlings seek adventure on the prairie apart from their main band.

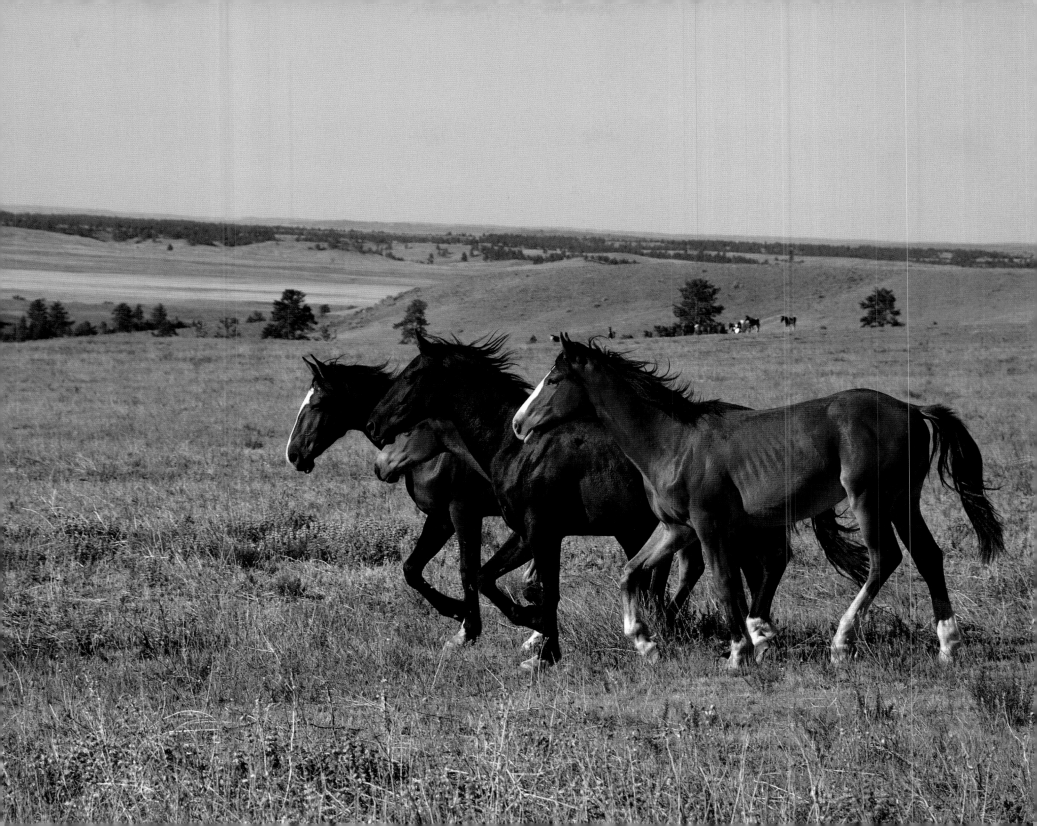

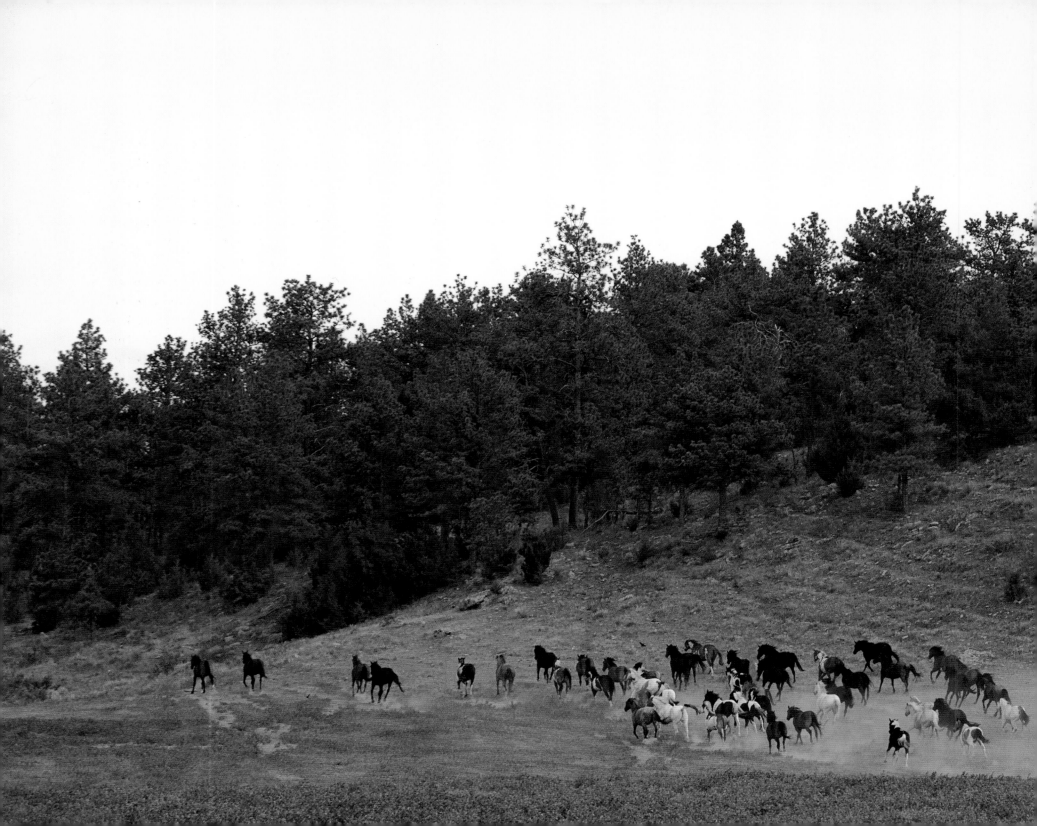

the best interest of the horses and U.S. taxpayers. Nonetheless, within a year Dayton had handed over responsibility of his Oregon ranch to his wife and sons and secured an 11,000-acre tract along the Cheyenne River. The trucks rolled in daily, delivering a total of 500 anxious mustangs from holding pens in northern California, Nebraska, Oregon, Nevada, and Wyoming. Upon release, they flew out of the loading chutes, dispersing over the land and forming a number of bands, many of which remain intact.

Today, the horses thrive on their protected range with little human interference. More than 500 horses roam the property, and Black Hills has grown from a modest operation to a fully operational ranch that offers year-round educational programs and tours. Visitors can stay overnight in a comfortable log cabin; two spaces are set aside for travel trailers; and a charming visitor center and gift shop doubles as the office. A large rock sculpture designed and constructed by Dayton marks the entrance of the sanctuary on Highway 71, and for several miles in either direction large billboards entice Black Hills tourists to "come see wild herds running free."

Dayton's initial plan was to sell foals born at the sanctuary, and for years these sales helped to raise a portion of the $890,000 required to care for the land and horses annually. Stallions were mated with mustang mares, their hardy and intelligent offspring advertised as a part of the "American West heritage." But the bottom has fallen out of the horse market. "You can't give a horse away," said Dayton as we bumped along over high meadows in his four-wheel-drive pickup. What was going to be a short interview over coffee at the visitor center became a four-hour expedition through field and river, much to our delight. A rancher, conservationist, and writer, Dayton pointed out the roaming bands of horses, describing in detail the personality traits of the lead mares and the origins of some of the unique markings on the yearlings. He told stories of

Disturbed by cattle being moved to a nearby pasture, the big herd near the ranch heads for the trees.

his first years on this land, when there was only a modest cabin, a corral, and the newly released horses. Stallions were free to travel with their harems, and each year brought a new group of foals.

These days, in order to manage the birth rate, Dayton and Black Hills ranch manager Susan Watt separate the stallions from their bands and use a birth-control method called porcine zona pellucida vaccine (PZP). This immunocontraceptive is lauded by Jay F. Kirkpatrick—director of the nonprofit science and conservation center at ZooMontana in Billings—as the best method for controlling wild horse populations. Mares are given a shot of PZP twice the first year and then once every year thereafter in the spring. To date, the program has worked well for the sanctuary in tandem with gelding (castrating) some stallions and keeping others in paddocks apart from the mares. But it's nearly impossible to inoculate all the mares; some are just too wild and wily. The BLM officials claim that this is the reason they haven't been as successful with the PZP birth-control method, which, aside from gelding stallions, is the only method the agency is using after trying a number of other ineffective or impractical contraceptive agents. Mustang mares are very difficult to catch for hand-held injections, and field darting—which entails shooting a projectile into the hip from afar—can be tricky.

Together, Dayton O. Hyde, founder and director, and Susan Watt, ranch manager, supervise all aspects of the sanctuary.

According to Susan, gelding stallions and then returning them to a band of mares is the most feasible management solution employed to date. The sanctuary has released more than 100 geldings on the property and they either form bachelor bands or act as stallions and form mare bands. "I personally think that is the simplest solution in the overall management plan," Susan said.

But gelding wild stallions is not without controversy. The BLM has attempted to manage the herds in holding facilities by gelding some of the stallions, but very few geldings have been released. Wild horse advocates are opposed to gelding stallions because it interrupts natural herd dynamics. Furthermore, the advocates argue that herd populations are well below the numbers suggested by the BLM and that gelding stallions is an underhanded effort to eradicate the presence of mustangs on public lands.

In December 2011, the BLM agreed to postpone its plans to replace 200 wild, free-roaming stallions with geldings at the Pancake Complex in Nevada in response to a lawsuit filed by a coalition of environmental and wild horse advocacy groups, which argued that the BLM's management approach was scientifically unsound, untested, and radical.

PROMOTING LAND CONSERVATION

A former teacher and Alabama native, Susan said that her work at the sanctuary is a social, emotional, and spiritual pursuit that began in a hot-air balloon hovering over a wild animal reserve in Africa. As she looked down on the land and animals, she recalled an interview with Dayton on the ABC show 20/20, and then it came to her as an epiphany. "I knew right then what I was going to do with the rest of my life," she recalled. When she returned to Alabama, she called Dayton and asked if he would teach her about wild horse management. He told her that if she wanted to learn about wild horses, she would have to learn the same way he did, through experience. Within a year she had moved to Hot Springs, opened a bed-and-breakfast, and was volunteering at the sanctuary.

Now, Susan heads the marketing effort, manages the day-to-day administrative operations, oversees the volunteers, and also helps care for the horses with Dayton and the ranch hands. Her vision for the future of the sanctuary includes adding more programs to increase revenue. The sanctuary entices international film companies to use its property for filming and has had some success. Several sanctuary locations appeared in *Hidalgo*

A wild mare accepts a greeting from Karla LaRive, the sanctuary's communications and marketing director.

(2004), *Into the Wild* (2007), and the 1996 TNT television movie *Crazy Horse*. In 2012, a film crew wrapped up work on a documentary that traces Dayton's life from his early childhood in Michigan to his adventures as a young cowboy in Oregon to his daily routine at the sanctuary as he nears the age of 90. The film, *Running Wild: The Life of Dayton O. Hyde*, is as much a celebration of Dayton the cowboy and conservationist as it is a testament to the power of single-minded determination in the face of obstructions and naysayers. Susan hopes that the film attracts more attention to Dayton's work, but also leaves viewers with a sense of urgency concerning the preservation of the land and the wild horses.

Over the years, Black Hills has placed ever-greater emphasis on the importance of land conservation, and the guides impress this priority on visitors. The sanctuary has become a habitat for a wide range of animals that had nearly disappeared from the area because of encroaching ranches and farms. Mountain sheep climb the rocky cliffs and cougars hunt in the deep canyons where people, even Black Hills staff, rarely wander. Some of the mustangs share these outlying areas with the wildlife. Dayton and Susan check on these horses, but many of them will never have contact with a human being. The horses are usually observed through a pair of binoculars from a high ridge.

Closer to the ranch are several bands of less reclusive mustangs. Visitors can admire and photograph them from a safe distance, but still get a sense of their wildness. The outing offers a glimpse of unspoiled land, the way it might have been when native people lived and thrived along the Cheyenne River. There are still Native American ceremonial sites intact, and a rocky cliff bears centuries-old petroglyphs and 19th-century carvings with the names of ranch families that once worked the land. Several lower pastures adjacent to Dayton's modest ranch house are reserved for a herd of registered quarter horses and paints with impressive bloodlines. For years, the domestic horses were bred and trained at the sanctuary for sale as pleasure horses or for ranch work, and the profits from quarter-horse sales helped fill the coffers. However, the breeding program is on hold until horse sales pick up again.

The sanctuary also raises and sells Red Angus cattle to help pay for a large portion of the hay that feeds the horses—more than 3,000 large round bales a year. (During the winter, when the snow is too deep for the horses to find forage on their own, the workers drop hay in several locations.) Because of a South Dakota tax law that favors cattle ranches, the bovines' presence at the sanctuary saves the organization $20,000 a year in property taxes.

Aside from the cattle sales, Black Hills relies primarily on donations and funding from grants. According to Susan, Black Hills is expanding its Educational Outreach Program to include a focus on the history of the wild horse, Native Americans, and pioneers of the local area. Her most recent program, Spanish Mustang Spirit of the Black Hills, draws attention to the sanctuary's exotic Spanish and Portuguese herds. Nearly 50 horses at Black Hills are Spanish Sulphur, Kiger, or Sorraia mustangs, their bloodlines tracing the historical routes of the Spanish explorers and conquistadors. The program's goal is to preserve these and also to educate the public about their contributions to American history. One of the few studs at Black Hills is a Sulphur–Sorraia mustang born wild in the mountains of Utah with all the primitive characteristics of his Portuguese ancestors. Don Juan-Colinas de Corazon (Sir John—Heart of the Hills) and his band of mares were rounded up by the BLM and in 2003 rescued by Black Hills. The stunning dun stallion, with his exotic zebra-striped legs, is the program's centerpiece and a remarkable subject for professional and amateur photographers, who catch sight of him in motion or standing with his admiring harem.

The magnificent Spanish mustang stallion Don Juan approaches his band of mares after a period spent apart from them.

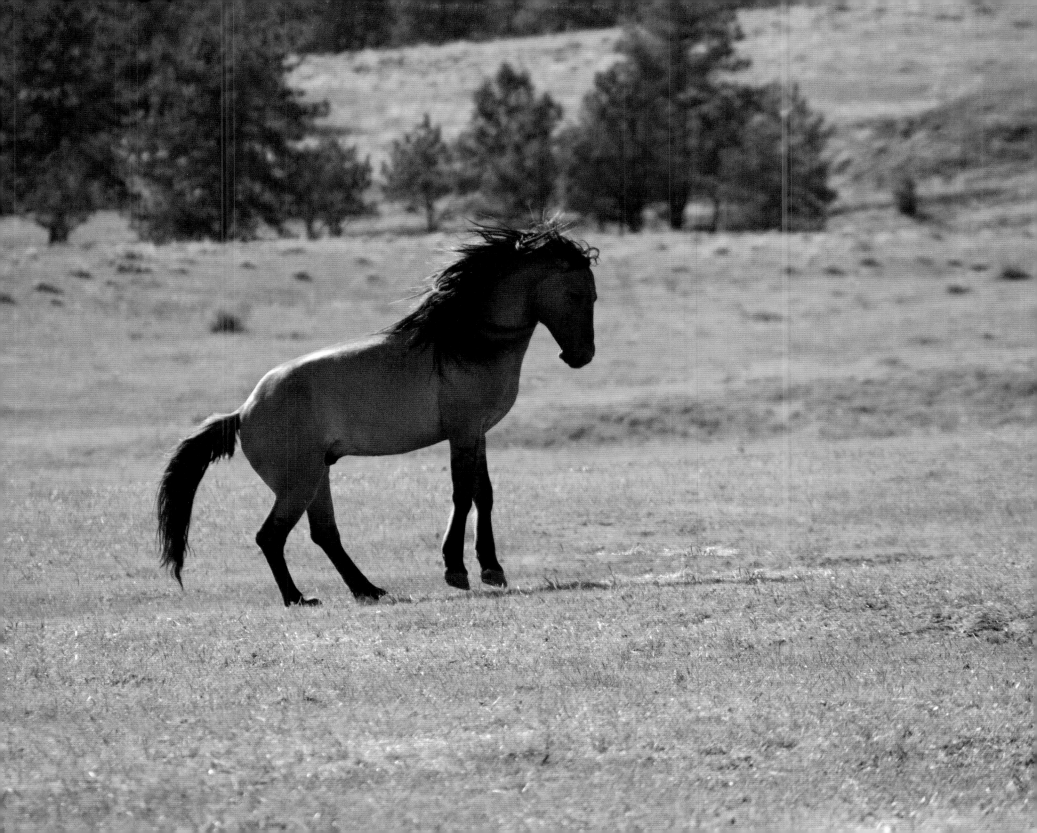

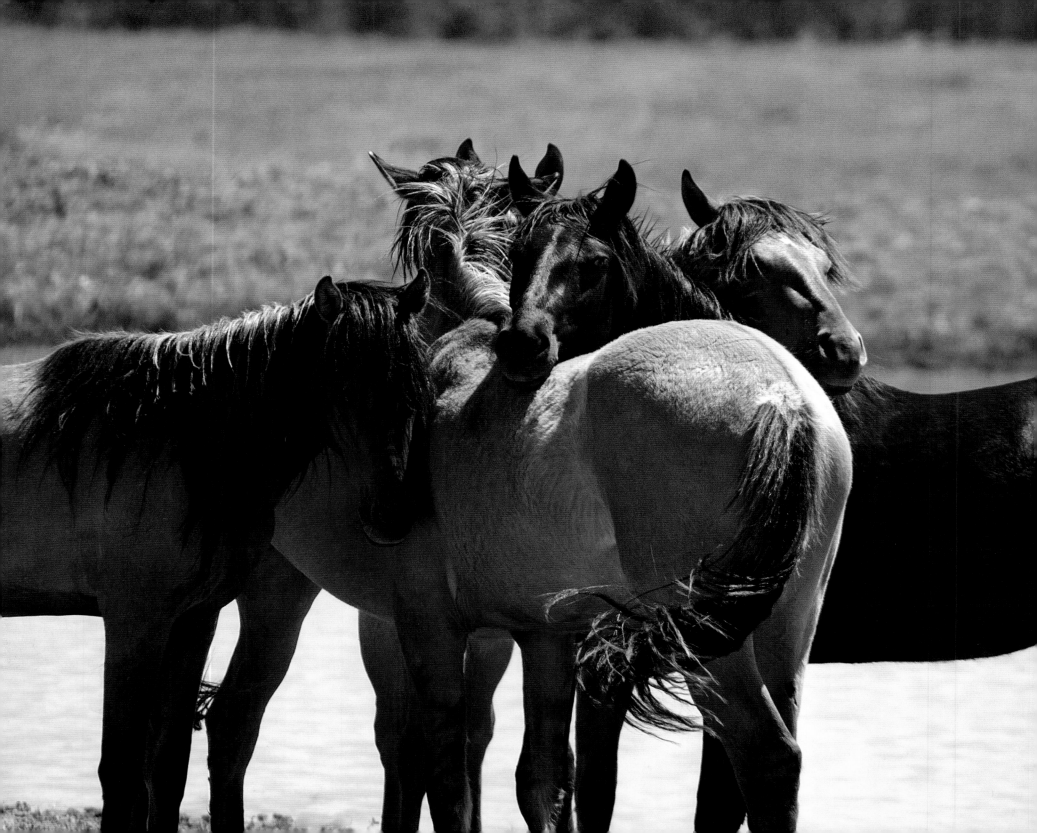

THE FUTURE OF WILD HORSES

Susan and Dayton are worried about the future of all of the wild horses in the United States. Without wider public support and major changes in land-management policies, wild horses face a grim future. The practice of managing populations with contraceptives is still being debated, and state governments are making unfounded claims that the mustangs are destroying prairie ecosystems. "The handwriting is on the wall," Susan said. "The land is being taken away, so it's important that there are more private sanctuaries." Increasing the number of sanctuaries may, in fact, be the only solution to the problem of dwindling public land, but according to Dayton and Susan, keeping a sanctuary running well is not an easy task. The work is physically hard, feeding horses is very expensive, and the pleas to rescue ill-fated herds of mustangs are never ending. Dayton's son, Dayton Hyde, Jr., helps at the ranch on occasion, but Susan would like to see him step into the role of spokesperson when his dad steps down. She said the organization needs to maintain the tradition of an elder rancher figure to present their case for the conservation of land and horses.

"But we're not a horror story; we're a happy story," Susan pointed out. She recited the lines the sanctuary uses in its promotional materials: "Imagine a place where you can view America as it was 300 years ago. Imagine a place where eagles fly. Imagine a place where horses run free." It is a wonderful image and a comfort to know that the horses will be there as long as the sanctuary exists. Dayton has made sure that the sanctuary's land will remain untouched long after he's gone, that mustangs will have a range where they can run free in South Dakota.

During our last evening at Black Hills, we took a walk along the paddock. Inside, the fillies stood together relaxed, seemingly content with their own company. Next year, they will be reintroduced to one of the wild bands on the sanctuary's expansive property. They will maintain their close friendships and live out their days without the threat of a BLM roundup. "High on the ridges above the Cheyenne River, I see wild horses running in pure joy," wrote Dayton in *The Pastures of Beyond*. "I have been able to give the wild horses over ten thousand horse years of freedom, but what is really important is this. There are still some of us who care."

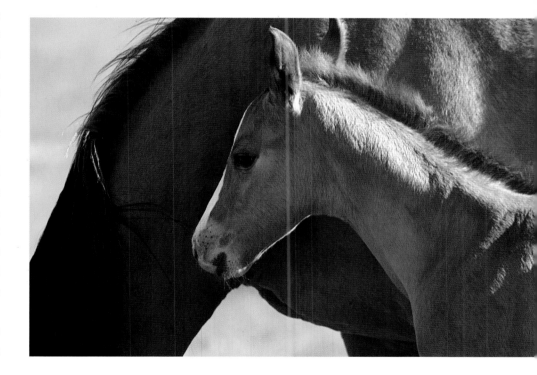

OPPOSITE: Five mustangs huddle together near a pond to present a smaller target for thousands of biting flies. ABOVE: A newborn foal stays close to her dam.

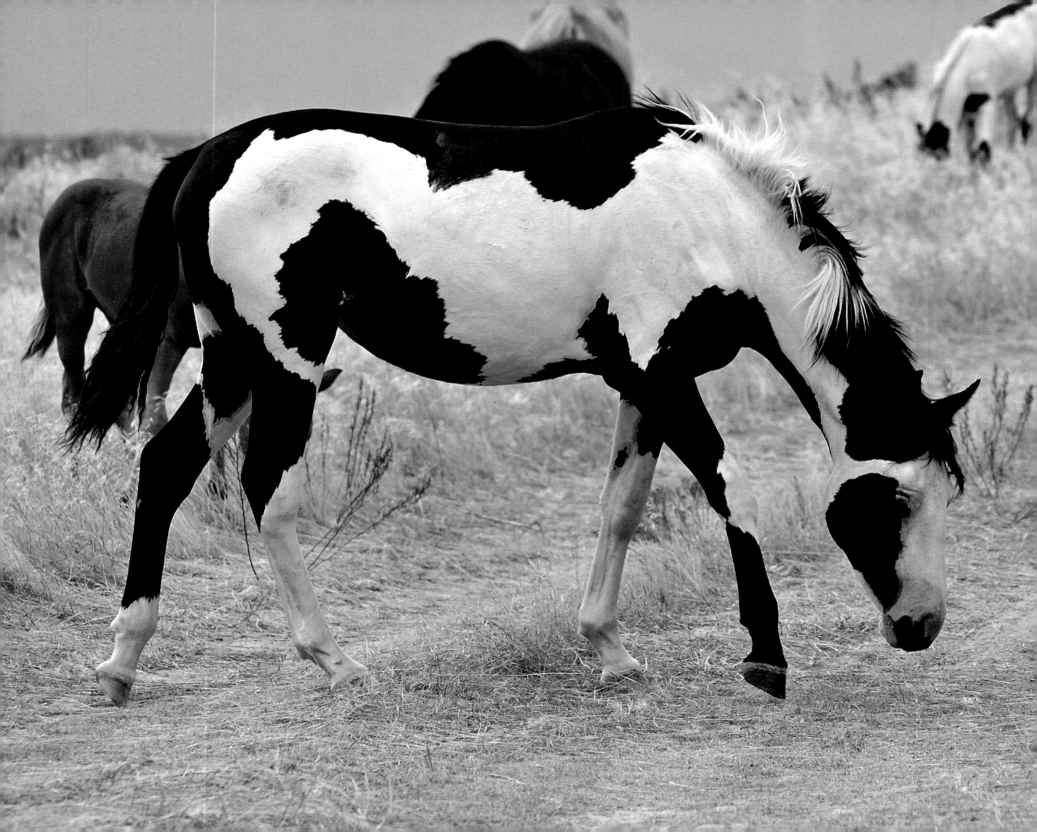

OPPOSITE: This young pinto mare is a striking example of the overo color pattern.

RIGHT: A magnificent mare looks up from her grazing.

OVERLEAF: A chorus line of pintos moves across the prairie as one.

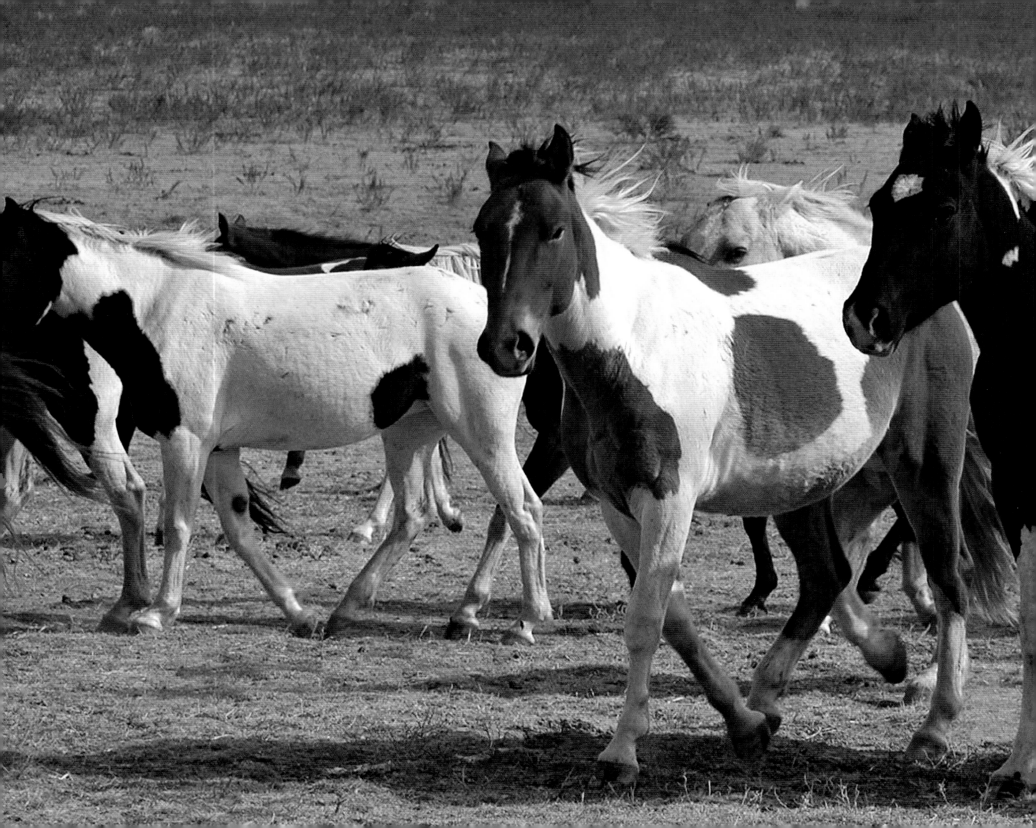

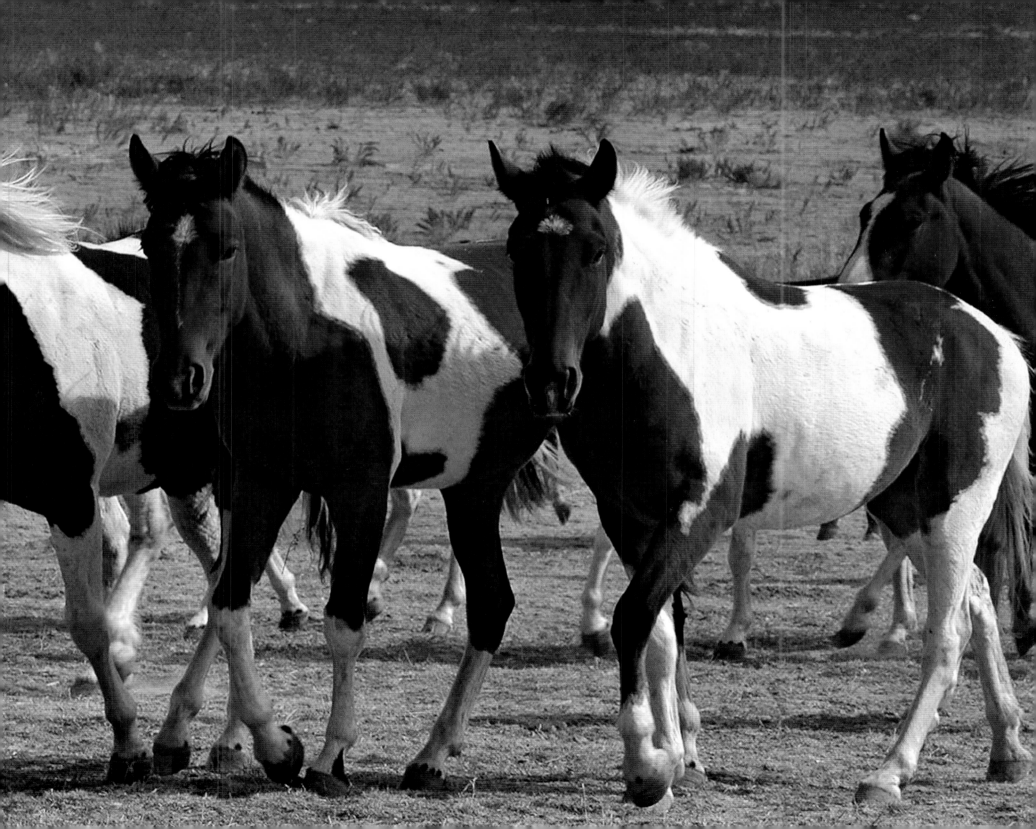

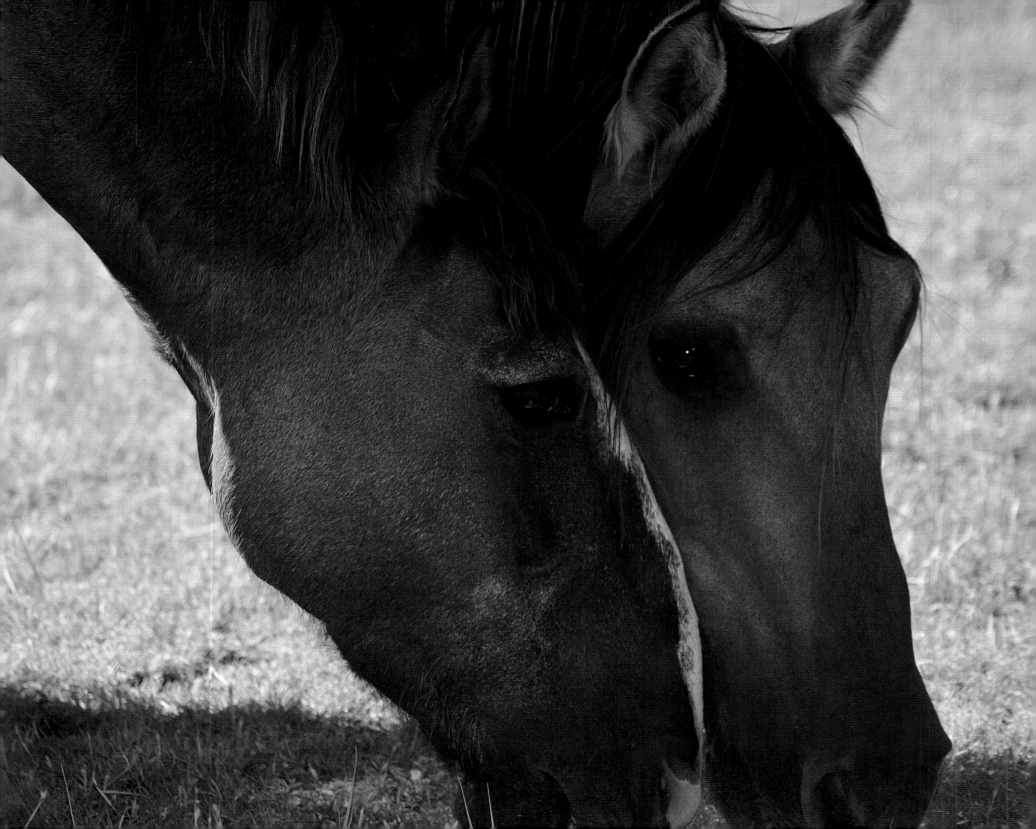

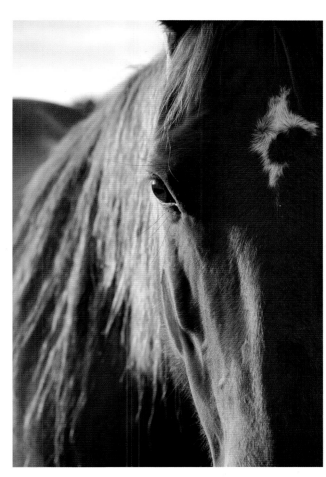

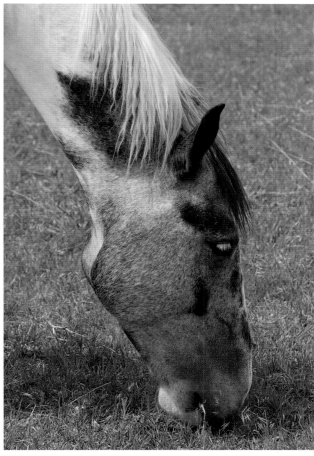

OPPOSITE: An aged Sorraia mare (right) grazes with her two-year-old filly, who, although grown to adulthood, rarely leaves her side. ABOVE: Among mustangs, eye color varies considerably.

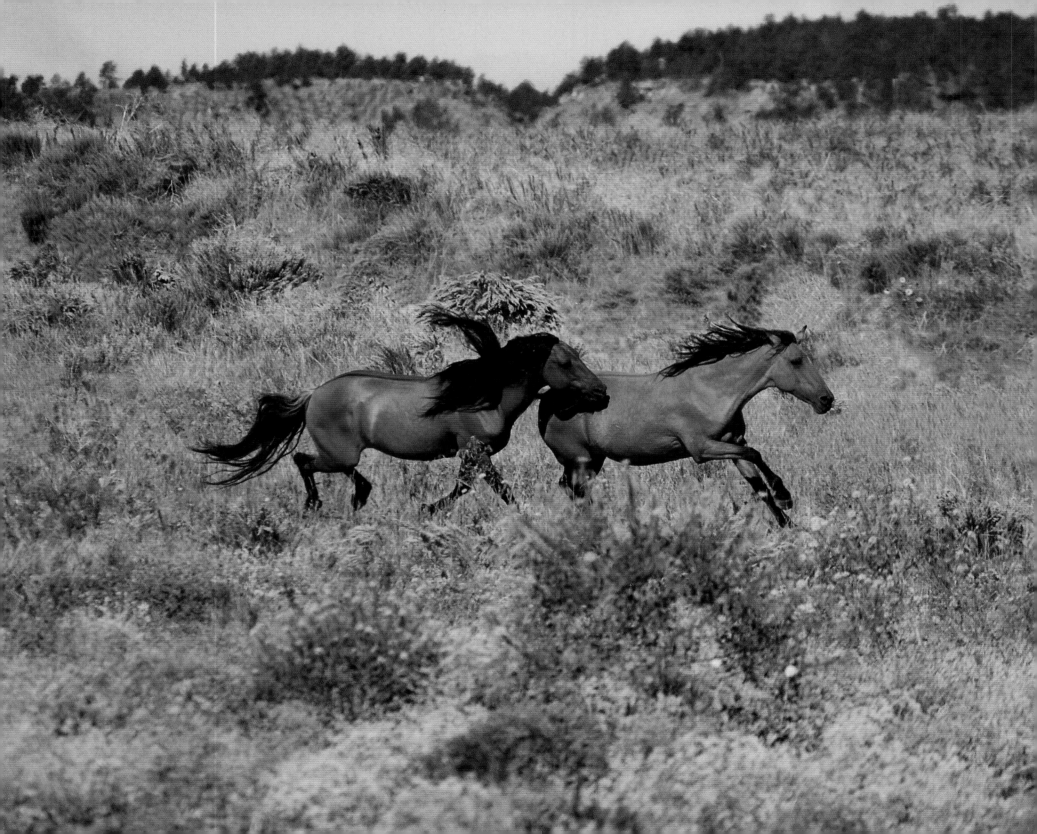

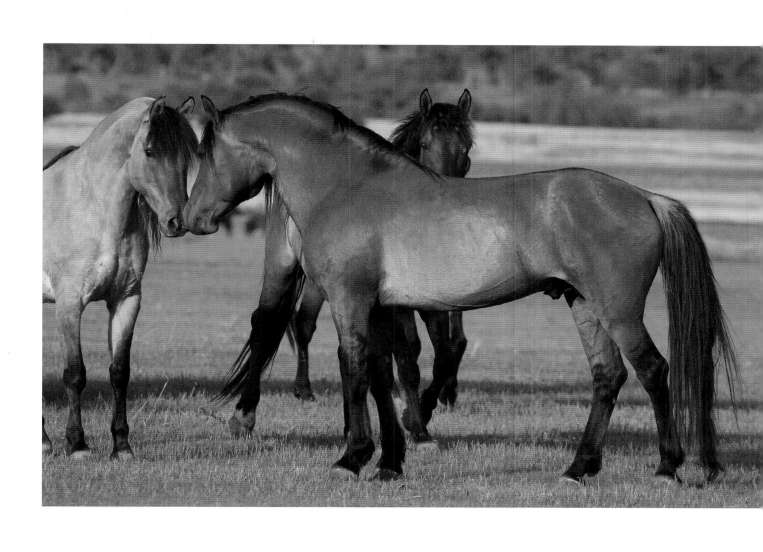

OPPOSITE: The stallion Don Juan "snakes" one of his mares to head her back to his band. ABOVE: Don Juan greets a buckskin mare as a grulla mare looks on.

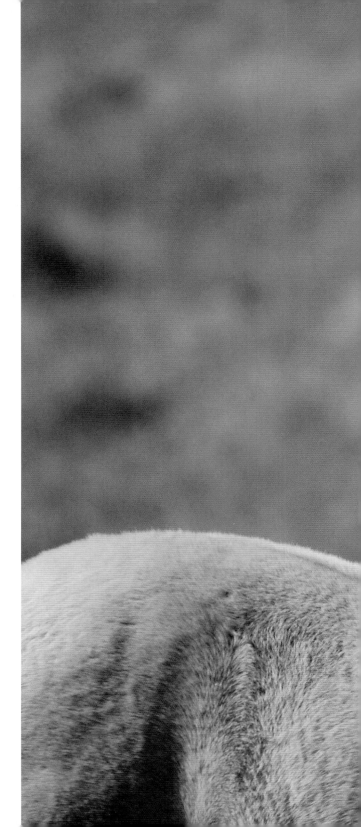

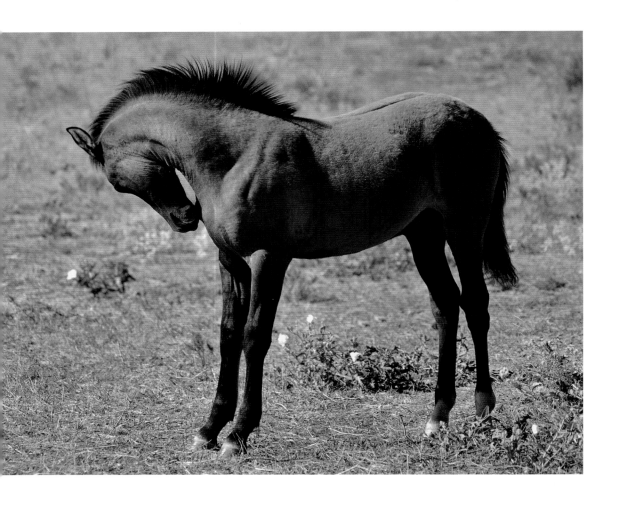

ABOVE: A Sorraia foal rubs at a fly bite.

OPPOSITE: A pair of Sorraia foals engages in mutual grooming.

OVERLEAF: A colorful band of mustangs exhibits a wide variety of patterns.

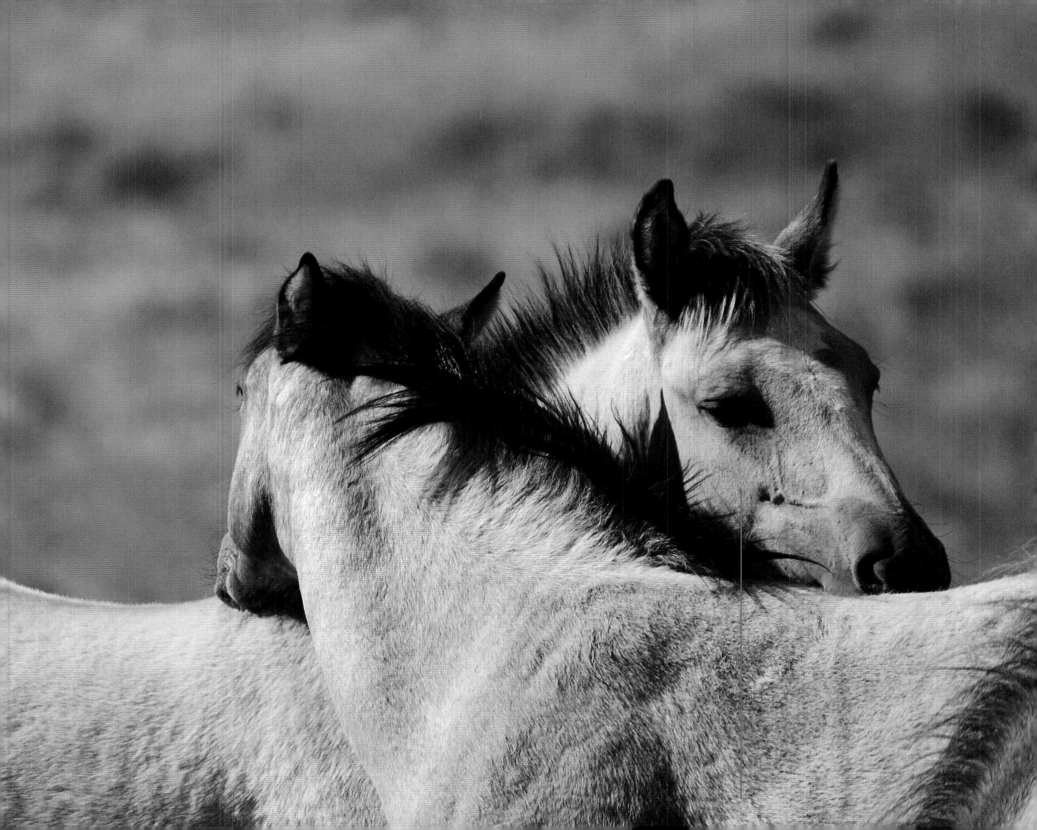

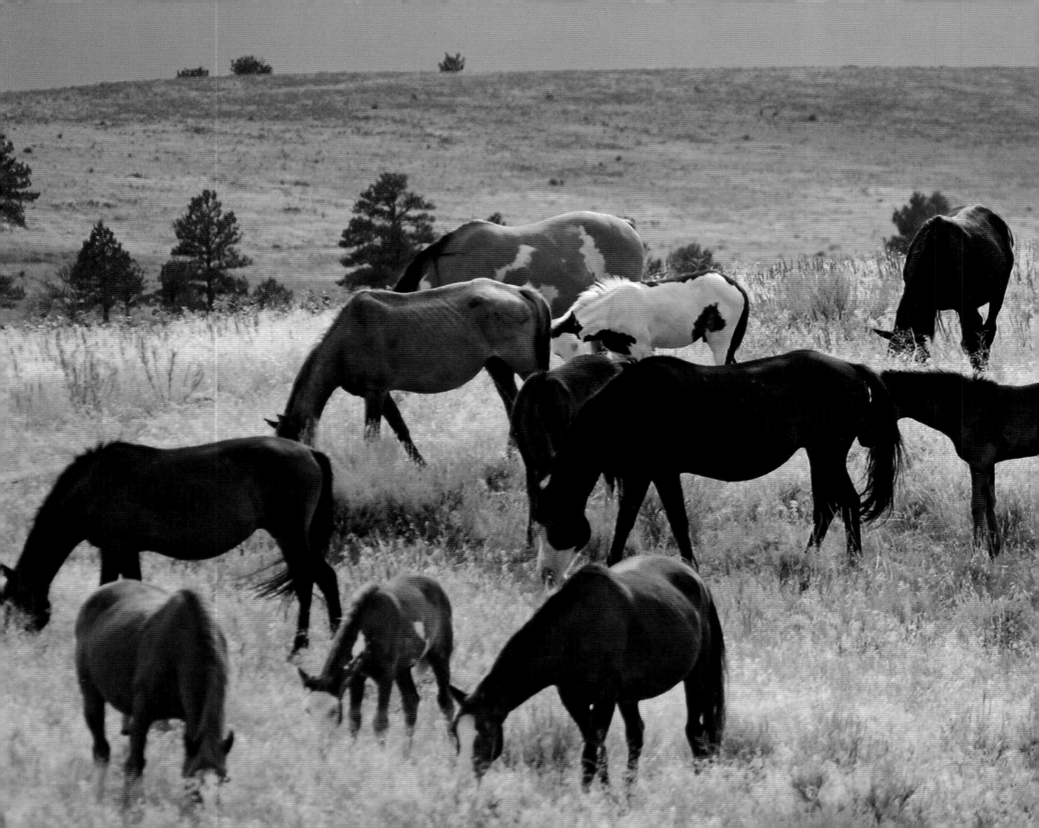

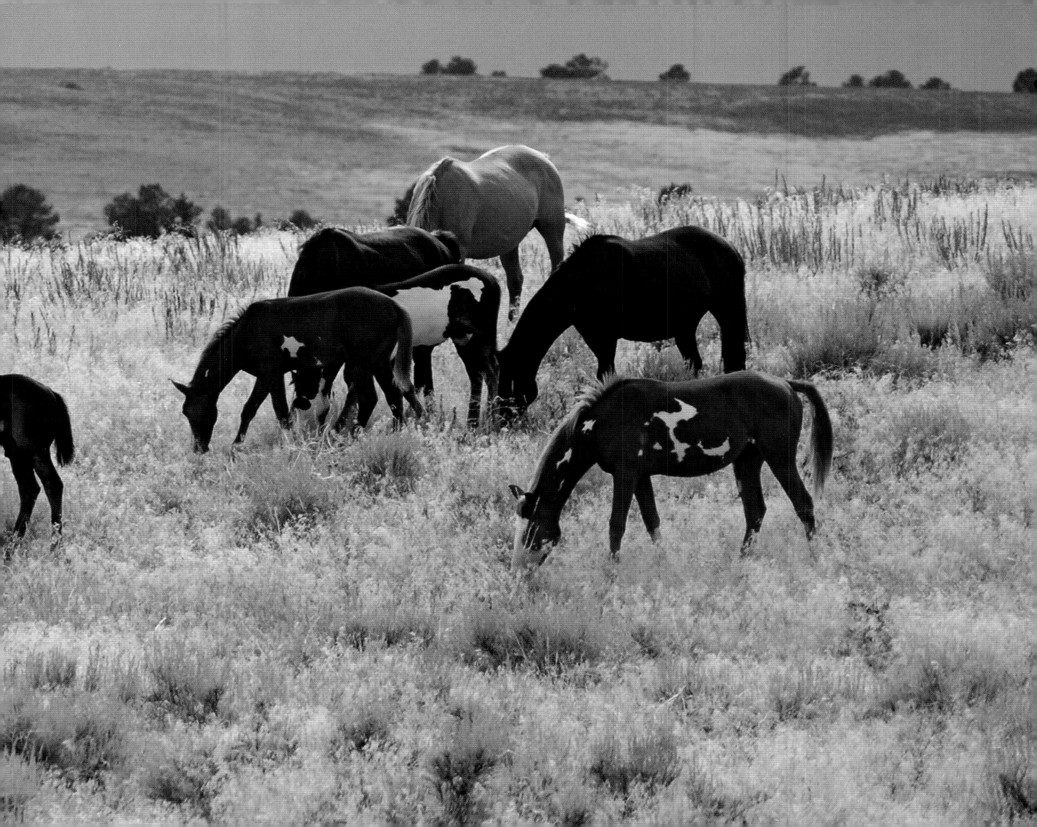

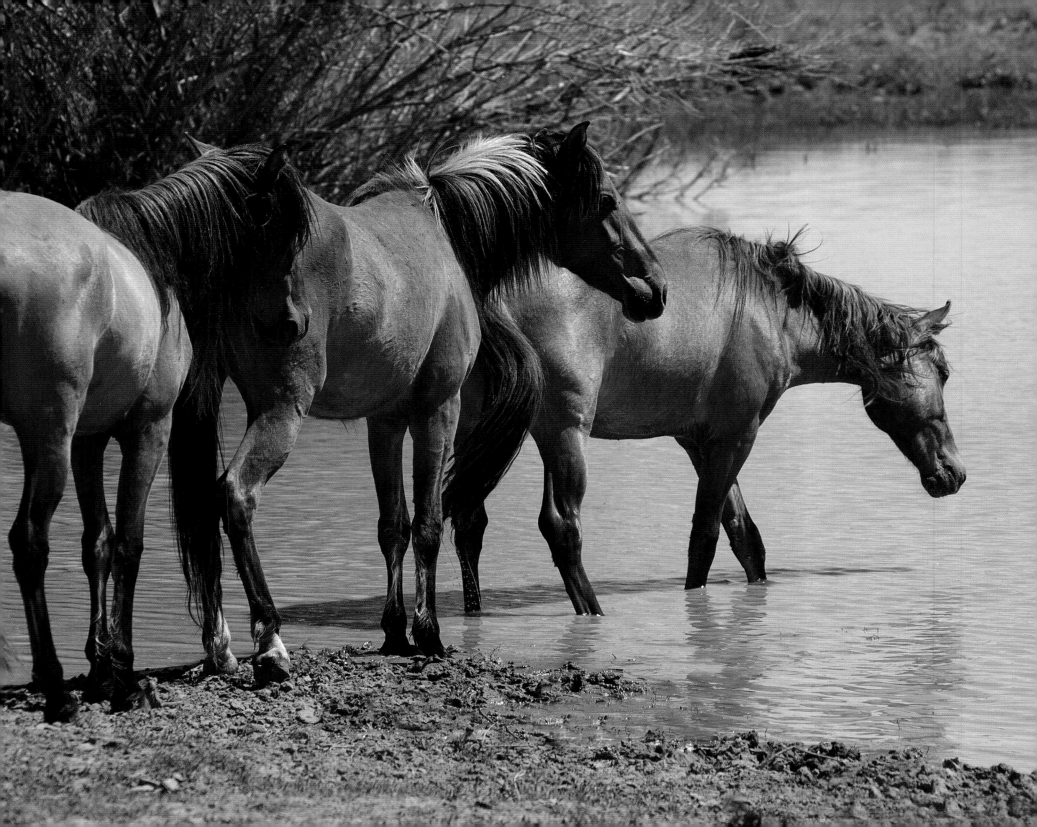

OPPOSITE: Three Spanish mustangs enter a pond to avoid pesky flies.

RIGHT: Two mares nibble buffalo grass in crisscross fashion.

OVERLEAF: A foal hosts three cowbirds (left). North of the Cheyenne River, a mustang faces the sun (right).

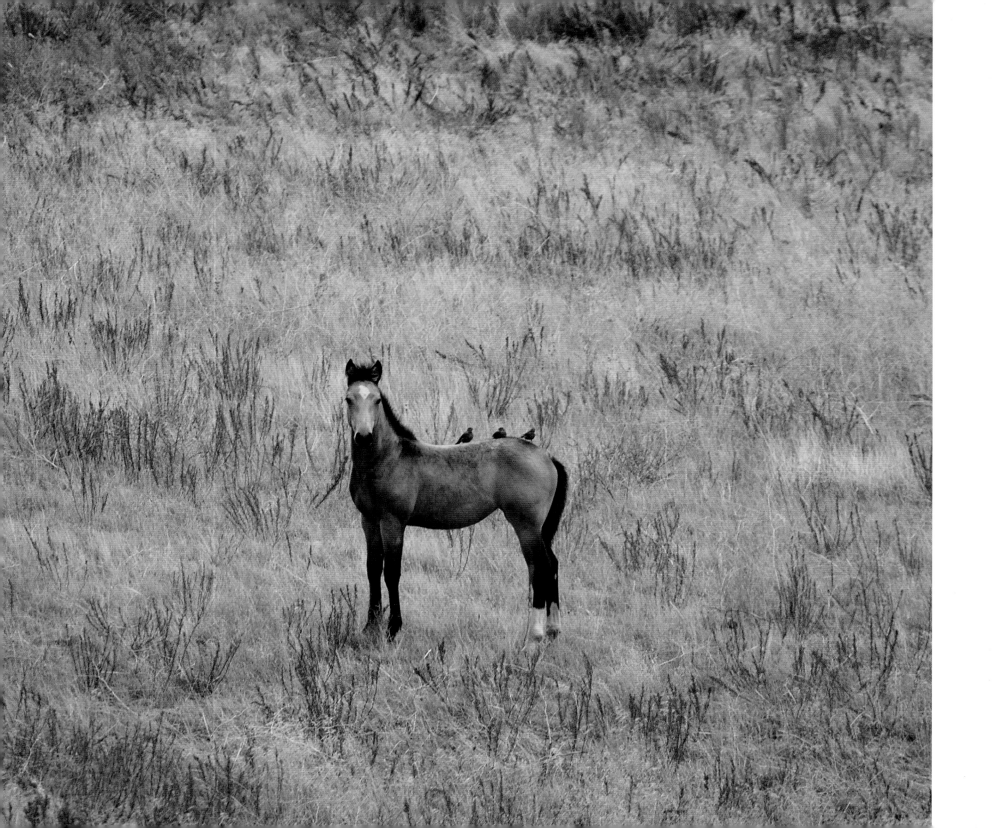

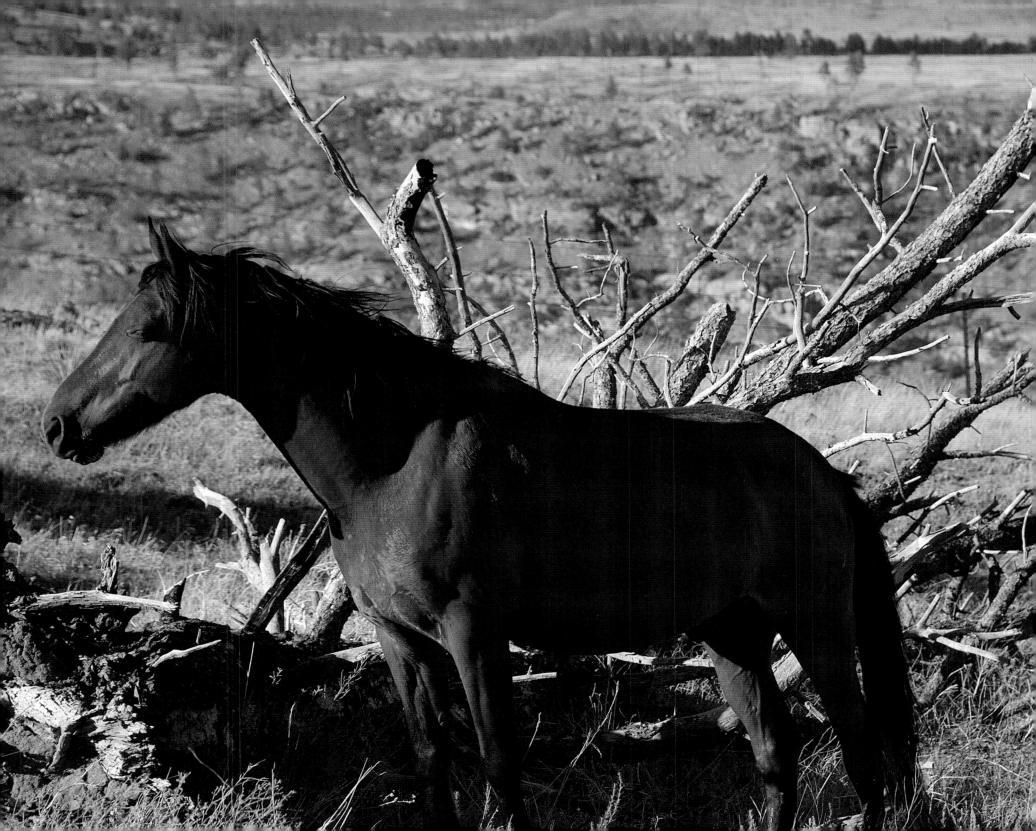

CATSKILL ANIMAL SANCTUARY

"Birds, birds!" Kathy Stevens called out to a group of chickens pecking in the dust outside a freshly painted barn. "How are my chickens?" A few looked up at her as we passed by and then returned to the business of searching for seeds and bugs. Kathy led us along the length of the building, stopping every few yards so that she could emphasize a point or direct our attention to one of the animals in her care. In the distance, a group of black potbellied piglets galloped exuberantly toward a destination beyond a large weeping willow tree.

The founder, director, and heart of Catskill Animal Sanctuary in Saugerties, New York, Kathy is a slim woman with electric vitality that propels her around the farm at breakneck speed. She manages the business of running and promoting the sanctuary, yet somehow also finds time to pen books, the first of which was the popular account of the farm, *Where the Blind Horse Sings*. The second, *Animal Camp*, picks up where the first book left off, with more tales of life at the sanctuary. Kathy knows every animal's story and how he or she ended up at the sanctuary, including Franklin, the pig from a local pork producer who was left to die in a "throwaway" pile because he was the runt of his litter; Speckles, a Nubian goat removed with 13 others from a hoarder's property; Lumpy, an elderly Merino sheep afflicted with hair-follicle abscesses that incessantly itch; and Noah, a beautiful chestnut gelding imprisoned in a dilapidated barn crawling with rats. He was weak from starvation, and his hooves were so overgrown and twisted that it took an entire afternoon for his rescuers to load him onto the trailer. "He virtually crawled out," said Kathy. Noah and the other residents at Catskill Animal Sanctuary are the lucky ones, and from the way they respond to Kathy's voice and nurturing touch, it's clear that they fully understand their good fortune.

The approach to the sanctuary is by way of a long serpentine driveway. The setting is picturesque: a broad swath of meadow is dotted with green outbuildings and tidy barns. Enormous weeping willow trees edge a

ABOVE: The solar-powered barn, seen from across the duck pond, is a haven for rescued animals and the hub of myriad sanctuary activities. OPPOSITE: Crystal grazes in a pasture near the barn.

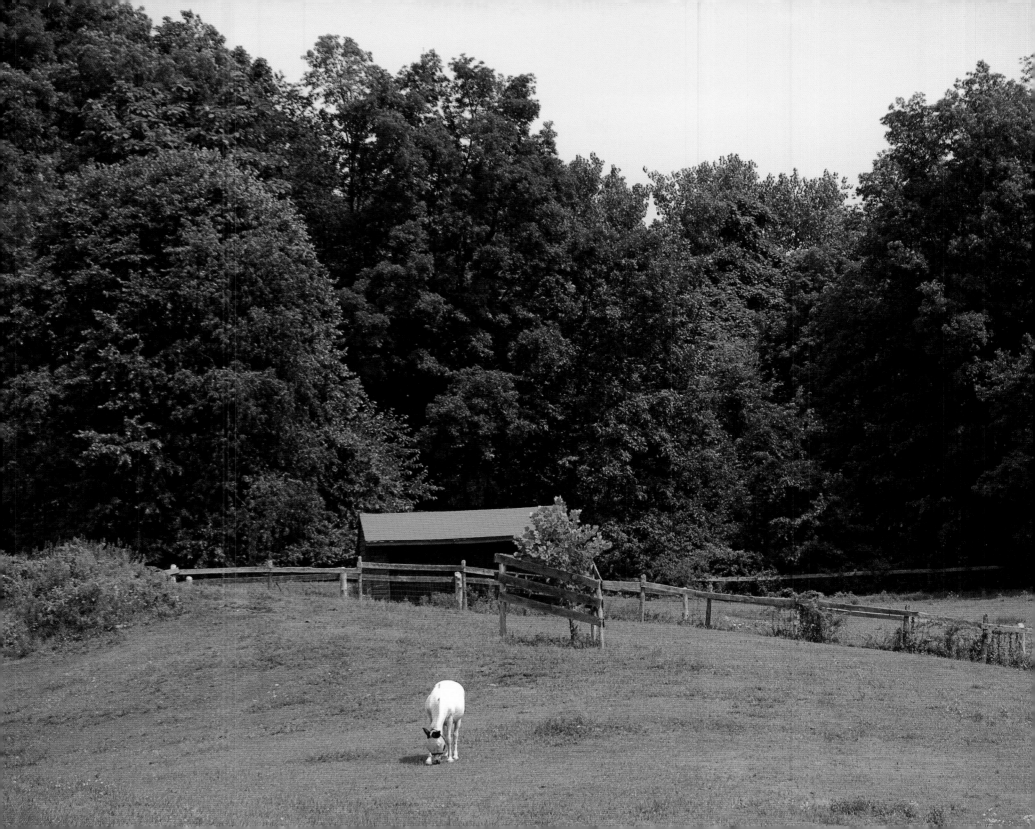

duck pond. Beyond, low-lying hills forested with oak, maple, hemlock, and pine trees provide a striking backdrop. It's hard to imagine, but when Kathy purchased the property in 2003 it was littered with tons of junk and overgrown with burdock and nettles.

Now, the 80-acre property is home to 200 or more rescued animals representing 12 species. The main part of the sanctuary was converted to solar power in early 2010—perhaps the first sanctuary in the United States to make the switch. Reflecting her profound respect for farm animals, Kathy developed an on-site vegan-cooking program, another first for a sanctuary. She hired a vegan chef to head workshops, added recipes to the sanctuary's newsletter, and recommended cookbooks on its website. The sanctuary's

staff members work long hours in every kind of weather, not because it's their job, but because they're committed to the cause. It is their calling in the same way that some people are attracted to humanitarian aid and others to environmental conservation.

Kathy heard the same call. She had been teaching high school English near Boston when she was offered a position as principal of a new charter school. As tempting as it was, she said that her heart was not in the job. She was at a professional crossroads, and after much thought and many long "soul-searching" walks with her dog, Murphy, she concluded that she wanted to devote her life to helping animals through education. She stumbled upon information about sanctuaries while doing research and noticed that there were only a few places that cared for abused farm animals, advocated on their behalf, or offered educational programs. "That's when I decided that I was going to start a teaching sanctuary," she said.

Within months, she and her partner, Jesse Moore, had started a non-profit organization, attracted volunteers, and found a temporary farm near her residence. It was an enormous change in lifestyle with a steep learning curve. Although she had been reared on a horse farm and exposed to a wide variety of animals, she had much to learn about the behavior of angry sheep, the common ailments of pigs, and the special needs of turkeys whose beaks had been cut off by factory farmers.

RAMBO AND FRIENDS

In the aisle of the main barn, Rambo the sheep lay in a soft bed of straw next to his unlikely companion, a "broiler" hen named Barbie, who was found huddled under a car in Brooklyn, likely an escapee from a nearby live poultry market. One of the first residents at Catskill Animal Sanctuary, Rambo was

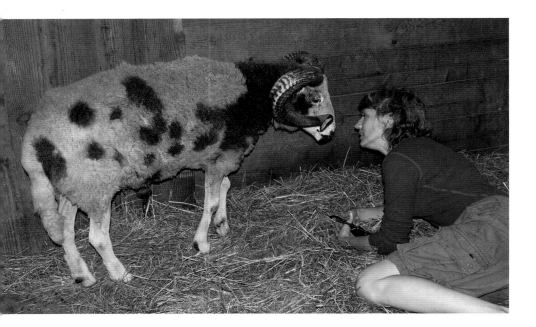

Kathy Stevens, founder and director, communes with her beloved friend and mentor, Rambo.

aggressive and very angry after spending years crammed into a filthy stall with 18 other animals at the home of an animal hoarder. He challenged the Catskill crew both physically and psychologically, but they decided to let him heal from his trauma in his own way and in his own time. If this meant avoiding his angry headbutts for years, they were prepared to do it.

Indeed, it took nearly two years—and he remained fiercely independent and would not be confined—but the strategy paid off. Rambo softened and then fully accepted his life of comfort and safety at the sanctuary. Sadly, Rambo died in 2012, but throughout his life he possessed an uncanny leadership quality that attracted many unlikely friends. They all hovered around him—the other sheep, pigs, goats, horses, chickens, and turkeys. Kathy believed that he took on the entire farm as his flock and considered it his job to protect them. "Some may call that anthropomorphism, but we witnessed him do some amazing things," she said.

THE HORSES

The odor of the main barn is the perfect combination of hay and horse manure; the wide center aisle is lined at intervals with shovels, rakes, wheelbarrows, and bales of straw. Nearly every stall in the barn has a resident horse, and several leaned over their doors to watch the activity in the aisle. Abby, a pretty gray mare, was one of 12 Thoroughbreds rescued from a backyard breeder who made the cruel decision to withhold feed from horses that couldn't race or breed. Abby was so ill and crippled from overgrown hooves that a vet recommended she be euthanized. But Kathy said she showed a desire to live, heaving herself onto the rescue trailer through sheer will. "You size up the animals who logically shouldn't be alive after what they've endured, and you know the ones who will fight. Abby wanted to fight," she said.

Abby, a Thoroughbred, starving and near death, struggled to climb onto the rescue trailer. After years of expert loving care at Catskill, she is thriving.

Like Noah, the chestnut gelding, Freedom, a dark bay Thoroughbred, was removed with 21 other equines from the property of a hoarder who lived in squalor among the rotting corpses of cats, llamas, dogs, and horses. A gentle chestnut gelding named Beyond was taken from a fraudulent nonprofit rescue that charged $40,000 to owners who thought they were retiring their horses to a peaceful sanctuary. When the animals were reported to be dying from starvation, Catskill Animal Sanctuary pitched in and, luckily, was able to save Beyond and three others. Mirage, a sweet-natured Appaloosa gelding, and one of many blind animals at the sanctuary, stood in his stall patiently anticipating our arrival and a chance to touch our hands and clothing with his soft muzzle. The animals without sight are especially tactile; they rely on their mouths to familiarize themselves with visitors and objects.

Across the aisle stood Buddy, perhaps the best-known sanctuary resident after Rambo. The elderly blind gelding played a major role in Kathy's first book and appeared in the cover photograph with her. Now in his early 30s, Buddy has come a long way since his arrival in 2001, when he reluctantly backed out of a trailer, terrified to move. His former owner was convinced he'd given up on life, but all he needed was the encouragement, patience, and love that Catskill was willing to provide.

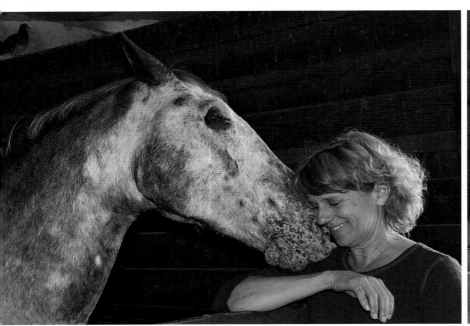

Kathy greets an Appaloosa, the second blind horse named Buddy to call the sanctuary home (left). Mirage, part Appaloosa, is also blind (right).

In October 2011, Catskill Animal Sanctuary responded to a call from local authorities. In Saratoga County, New York, 34 malnourished horses were living on the property of a woman with a long record of animal cruelty. Some of the horses were 400 pounds underweight from prolonged starvation, and most of them suffered from anemia, skin fungus, and hoof problems from standing in knee-deep mud without shelter.

With help from many volunteers, Catskill took in 14 of the horses, transporting them from these appalling conditions to the safety of the sanctuary, where they were lavished with attention and painstakingly nursed back to health. Six months after authorities seized the horses, the owner was convicted of 19 counts of failure to provide food, shelter, and vet care to her horses. The judge also required that the woman undergo a mental health evaluation to determine if she suffered from an obsessive-compulsive disorder that contributes to animal hoarding.

Catskill Animal Sanctuary is all too familiar with the cruelty imposed on animals by hoarders; more than half of their wards have come from tragic hoarding situations. Hoarders take on more animals than they can support, believing that they are providing sufficient care. Often, after animals are seized, hoarders repeat the behavior, bringing more animals into terrible situations until authorities are alerted by a passerby or concerned citizen. "The laws are so weak when it comes to animal protection," Kathy said.

SECURING HOMES AND SPONSORS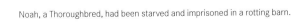

Most of the sanctuary's horses live at the farm; however, a number live at foster homes. Although Kathy would like most of her wards to go to forever homes, finding the right fit can take months. The application and inspection process is rigorous, and frequent follow-up visits from adoption coordinator

Noah, a Thoroughbred, had been starved and imprisoned in a rotting barn.

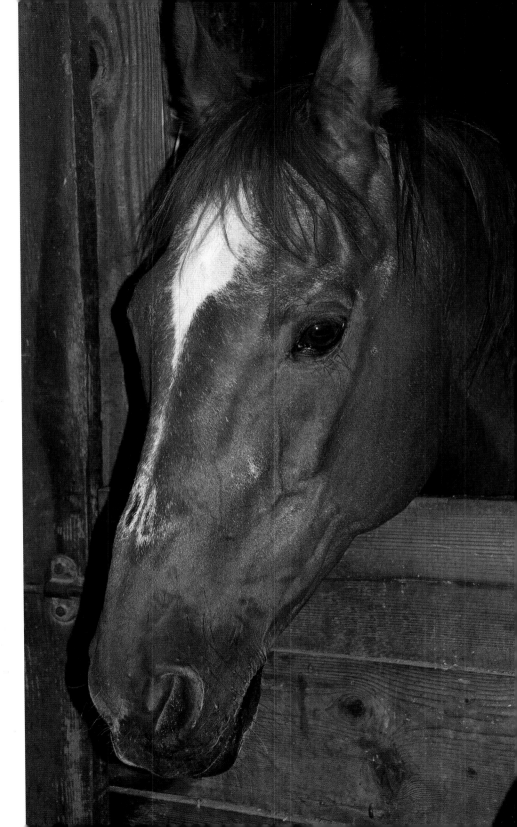

Robyn Welty ensure that the adopted horses are in good hands. Naturally, the elderly and disabled are permanent residents of the farm, and then there's Mary Jane—she simply refuses to leave. Twice she was chosen for adoption, and both times when the horse trailer arrived the Thoroughbred sat back on her haunches like a dog, refusing to budge. Kathy said they tried to load Mary Jane on the trailer on five different occasions and each time she'd plant her rump on the ground in protest. They even brought in a horse whisperer to help. "Oh, he was here all day. All day!" Kathy exclaimed. But even he couldn't get her to load. So Mary Jane stays.

Aside from adoption, the sponsorship program is one of the many means Catskill Animal Sanctuary employs to fund its work. Supporters may sponsor an animal on a monthly basis, with donations ranging from $100 per month for a horse to $10 per month for a chicken. And because education is one of the most important components of the organization, the sanctuary offers tours on weekends from April through October. It takes a lot of people power to manage the farm and the crowds. Luckily, volunteers are plentiful; many drive from as far away as New York City to spend a weekend mucking barns or fixing fences. Volunteer Teddy Blake is at the farm two or three times a week during his summer break. At age 15, he already knows that he wants to be an equine veterinarian. Naturally, his favorite part of volunteering is working with the horses. Longtime volunteer Carol Sas also has an affinity for horses, but her construction skills are highly prized, so she spends most of her time at the farm with a tool in her hand. She doesn't mind. Now that she has retired, her mantra is to not do anything she doesn't like to do. "This gives me a chance to work with my hands and be with the animals," she said.

When Kathy is not at the sanctuary tending to business, she is taking it on the road, which is part of her overall vision of what Catskill can

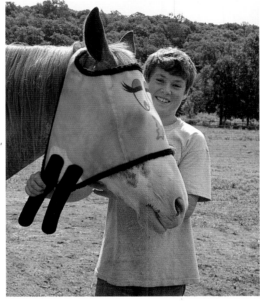

accomplish toward the healing of animals and people. An average of once per week, she speaks at schools, conferences, festivals, and community organizations about the emotional lives of her residents and the challenges of running a sanctuary. In 2010, the sanctuary launched Camp Kindness as part of the farm's education program for children. The weeklong day camp is offered five times during the summer. Kids aged eight to 13 meet and help care for the animals. Each day is dedicated to a particular species, and the campers participate in gardening and vegetarian cooking and become familiar with the benefits that a vegetarian diet offers to animals, people, and the planet. Camp counselors also emphasize the similarities between animals and people and the importance of treating animals humanely.

OPPOSITE: Mary Jane has twice refused to leave with adopters. ABOVE: Teddy Blake, volunteer and future veterinarian, adjusts Socks's flymask (left). Carol Sas, construction volunteer, takes a break to hug Crystal (right).

THE FUTURE OF THE SANCTUARY

After 10 years, Kathy and her staff have learned a lot about running an animal rescue. They have witnessed the suffering caused by feeble animal-protection laws and the pervasiveness of ignorance. Now, they are looking forward to and strategizing for the next 10 years. In many ways Catskill Animal Sanctuary will look similar, but Kathy anticipates expanding the education effort to help increase awareness of animal suffering and adding more cooking programs to keep pace with changing societal interests and needs. In December 2011, the sanctuary purchased an abandoned farm within three miles of the current property. Although the buildings and fences need much work, the additional 32 acres, consisting of rolling pastureland and three barns, will fill a tremendous need as a result of the increased numbers of animals in peril because of the flagging U.S. economy. In addition to the new farm—referred to as CAS at 32—Catskill also opened the doors of The Homestead, a 200-year-old newly renovated house perched on the hill above the sanctuary. The guesthouse will help generate additional income, but it will also provide lodging for visitors who want to stay close for several days and make multiple visits to the sanctuary.

"Oh, look at our newest babies," said Kathy as we neared the end of our walk around the sanctuary. She pointed to a grassy hill where two black lambs were frolicking around a group of young volunteers. The lambs kicked up their back feet and dashed up the hill, stopping to nibble at the straps of a volunteer's backpack lying on the ground. Everyone laughed with delight at the sight. From the barnyard came the gleeful squeal of the piglets as they barreled down a path toward the pond, followed by the crowing of a strutting rooster. Inside the barn a horse whinnied, possibly Abby asking for her afternoon pasture time. Their combined vocals were harmonious, the perfect blend of contentment and joy.

In winter, Icy stands atop a wooded hill with her companion, Hazelnut.

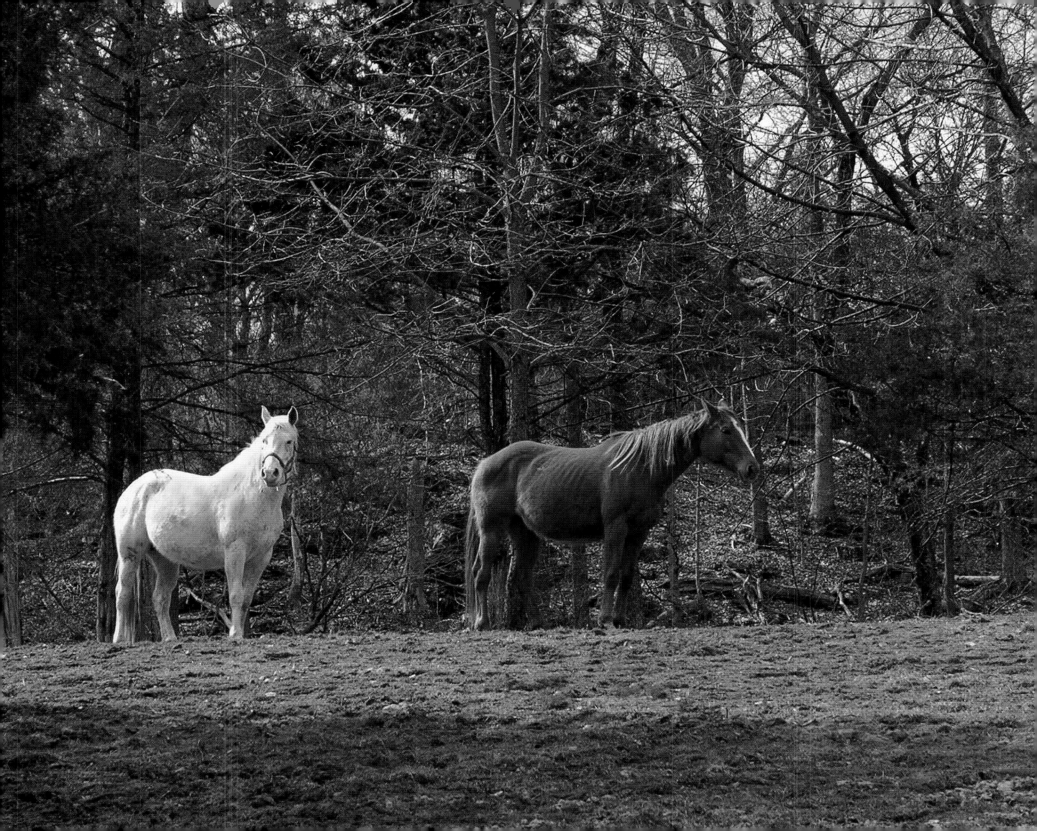

ABOVE: Thoroughbred mares, rescued from a breeder, enjoy the summer pasture. OPPOSITE: Freedom, a Thoroughbred gelding rescued in 2004, was the victim of a hoarder.

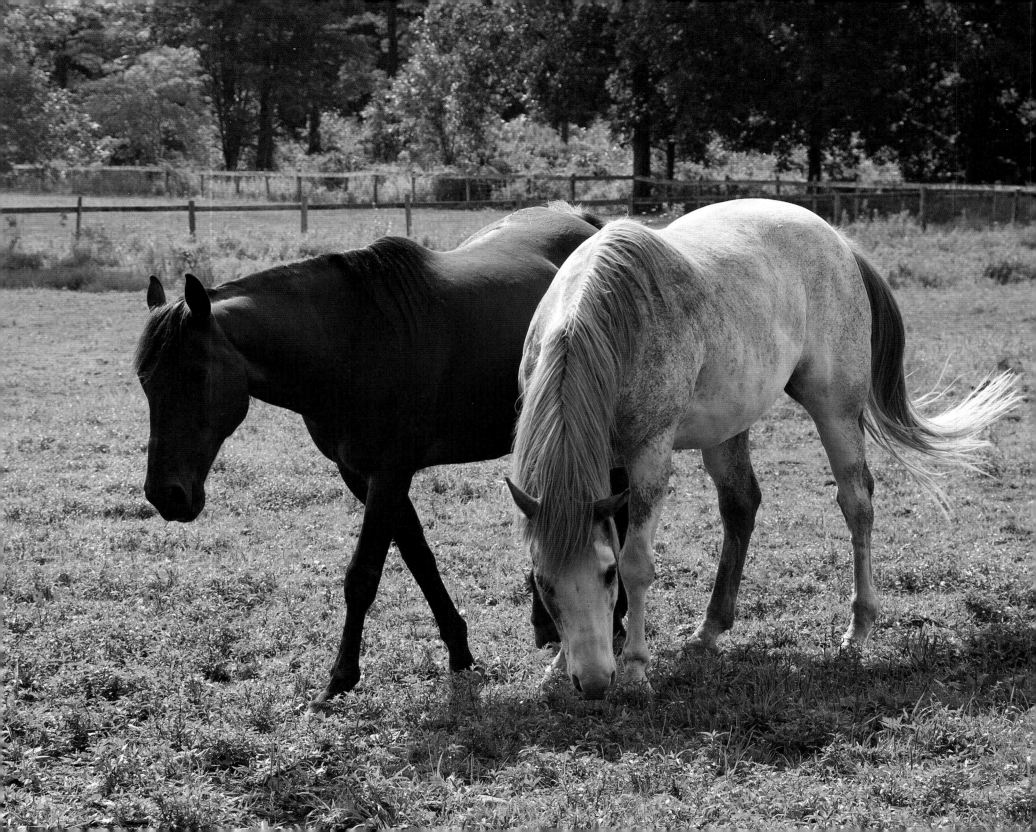

OPPOSITE: Freedom and Socks spend the summer together. ABOVE: Freedom and Chilipepper are winter companions.

THE EQUINE SANCTUARY

A short drive north of Los Angeles and within an hour southeast of Santa Barbara lies the mystical Ojai Valley. Citrus groves and palm and eucalyptus trees line curving country roads, and the hills glow pinkish orange at dusk. In 2000, lifelong equine advocate and rehabilitation specialist Alexis Ells was hunting for horse property when she spotted a dilapidated ranch with a deteriorating barn and pastures on the outskirts of Ojai. In spite of its poor condition, Alexis said she knew it was the ideal place to create the sanctuary that she'd dreamed about since childhood. Nestled between fragrant orange groves with an intoxicating view of the Topa Topa Mountains, the property needed a lot of work when Alexis set her sights on it. Her friends said she was crazy. But Alexis had a vision: she could see in her mind's eye the layout of the paddocks, arena, barn, and gardens; it was the perfect place to practice her healing arts and provide sanctuary for wounded horses and people.

Now, more than 100 white rose bushes line the drive along the outer paddocks. There are pepper trees, southwestern clay pots overflowing with native flowers, garden statues, and wind chimes that produce calming sound effects. On the west side of the property, a pool that the sanctuary maintains for the benefit of its volunteers and their dogs glitters in the sun. The modern two-story ranch-style home, which also serves as the office, conference center, volunteer station, and tack room, has large front windows and an expansive deck overlooking the arena and paddocks.

From this vantage point, Alexis keeps a trained eye on her Good Will Ambassadors, a group of horses that were rescued from a life of competitive sport and retrained to help human beings recover from illness, injury, and stress. Although they are highly trained and skilled athletes with impressive pedigrees and accomplishments, these horses would have met premature

ABOVE: A volunteer grazes Elegante as Angel gazes across the roses. OPPOSITE: Angel, 12, is nearly healed after suffering an attack by a mountain lion.

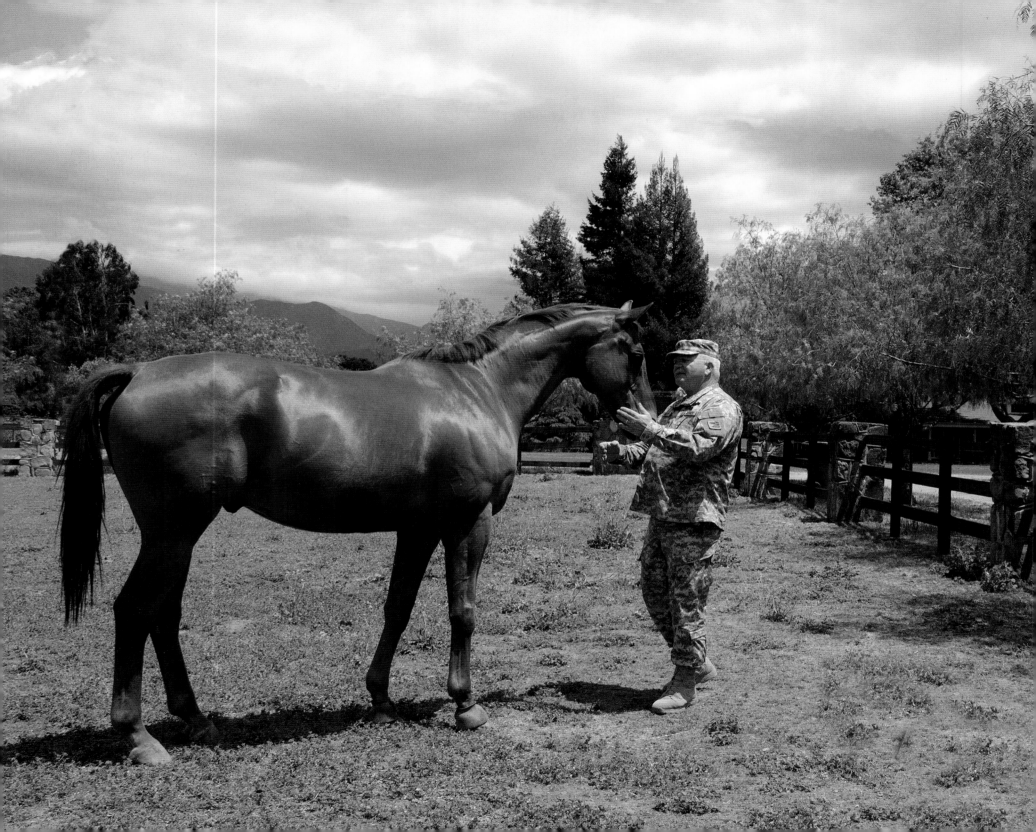

and unnecessary deaths had The Equine Sanctuary not intervened. In addition, 22 other rescued Thoroughbreds that live in foster care at a nearby training barn would have met a similar fate, as well as the rescues The Equine Sanctuary saves from kill pens throughout the country. The horses that call the sanctuary home are permanent residents; their only job is to be emissaries of good will. It's a dignified role and one well deserved by these exquisite creatures that were pushed to the brink of their demise.

A PLACE FOR HEALING

The Equine Sanctuary is a place for the healing of both horses and human beings. There are therapy riding classes for children and adults with disabilities, youth-leadership and mentoring, and student community-service programs. Recent studies show that horses make exceptional therapy animals because of their ability to mirror human feelings and provide nonverbal feedback. Like human beings, they are social animals with a wide range of emotions, yet they establish clear boundaries and have no hidden agendas. They are also very intuitive. Because of these traits, an effective therapy riding class or groundwork can teach students self-awareness, honest communication, and trust.

Perhaps because of their traumatic pasts, The Equine Sanctuary's Good Will Ambassadors have proven to be exceptional therapy horses. Their transitions from highly competitive and stressed-out lives as performance and sport horses to tranquil, happy lives at the sanctuary are inspirational to the children and adults who visit or attend the many classes available.

One of the most ambitious programs, Horse Soldiers, has been especially helpful for war veterans returning from deployment with post-traumatic stress disorder (PTSD) and traumatic brain injuries (TBI). Time spent with the therapy horses helped many veterans regain relationship skills such as communication and trust, which contribute to their ability to successfully rebuild their lives. Just having an opportunity to sit in quiet with another being that has also experienced trauma forges a symbiotic bond and calms jangled nerves. Some veterans have noted that time spent with the horses helped diminish the persistent noises in their heads and helped them manage tempers that flare with little provocation. Many have observed that time with the therapy horses helped them reach a deeper state of sleep, a natural function that can be maddeningly elusive to people suffering from PTSD and TBI.

Michael Kelly, a staff sergeant with the National Guard, returned to California with post-concussive injuries and PTSD after serving in Iraq. He has been participating in Horse Soldiers since it launched and has been an enthusiastic advocate for the program. Although he spent most of his life around horses, he said that working with rescued horses had a profound effect on his well-being and helped him cope with the most vexing symptoms of PTSD.

The youth programs at The Equine Sanctuary have also been well received by the community. Children with disabilities, youth groups, local school groups, and children from inner-city areas arrive each week to meet the horses and hear their inspiring stories. Alexis impresses on her visitors that overcoming obstacles is a choice they can make rather than accepting undesirable circumstances. "I explain that you either become a victim of your circumstances or you choose to make a better life for yourself and participate in the solution," she said. "Every horse came here following a tragedy; they were scared, alone, and in pain, but they got a second chance at life. Now these magnificent animals help traumatized people learn to trust again."

Michael Kelly, whose military service in Iraq resulted in post-traumatic stress disorder, has formed a special bond with Hansel and is a strong advocate for the sanctuary's Horse Soldiers program.

At 17.2 hands, Hansel is one of the largest horses at The Equine Sanctuary. He's also beautiful and devilishly charming. His relaxed responses to Alexis's cues suggest he has never had a troubled day in his life, but nothing could be further from the truth. Before Hansel arrived at the sanctuary he'd been declared a "dangerous rogue" and was slated for slaughter; his reputation overshadowed his good looks and pedigree.

Although he boasts impressive bloodlines—he's the son of a Preakness and Belmont Stakes winner—Hansel's willful temperament and desire to run tested his former owner and anyone else who climbed on his back or attempted to work with him. He had become notorious for breaking away from anyone who tried to lead him—until he met Alexis. Although he was a handful when he arrived, Alexis listened to Hansel and watched how he reacted to different objects, horses, and people. She calmly guided him through his groundwork and riding exercises; she was consistent, patient, and attentive. He responded to her methodology, and after two years of hard work Hansel, the incorrigible "bad boy," became an outstanding Good Will Ambassador and a favorite with the volunteers and military veterans.

Alexis spent countless hours on Hansel's training and rehabilitation, and she and the volunteers give the same amount of attention to every horse at the sanctuary. Some require less retraining but have extensive injuries, whereas others arrive at the sanctuary with both psychological and physical damage. Stylin' was an Olympic-level three-day-event horse until he had a nervous breakdown, attacked his rider, and was considered too dangerous to continue in competition. After months of diagnostics and pasture rest his owner decided euthanasia was the only solution to his "unexplainable" condition. A veterinarian colleague suggested that Stylin' be sent to The Equine Sanctuary for rehabilitation with Alexis, and now he's a therapy horse for children with disabilities. He loves his job and his special students

GROUNDWORK

Hansel came to a complete stop, tossed his head, and waited for Alexis to give him the next cue as the dust settled around his large hooves. It was late in the afternoon but unusually warm for a spring day in the Ojai Valley. We admired Hansel as he shifted his weight from one foot to the other, his muscles rippling through his glossy chestnut coat. Alexis gave him a quiet verbal command and with a slight toss of his gingerbread-colored mane, he was off again, effortlessly transitioning into a canter around her.

ABOVE: Visitors greet Stylin', who provides therapy for children with disabilities. OPPOSITE: Alexis Ells, the sanctuary's founder and director, demonstrates Hansel's ability to back perfectly between parallel rods.

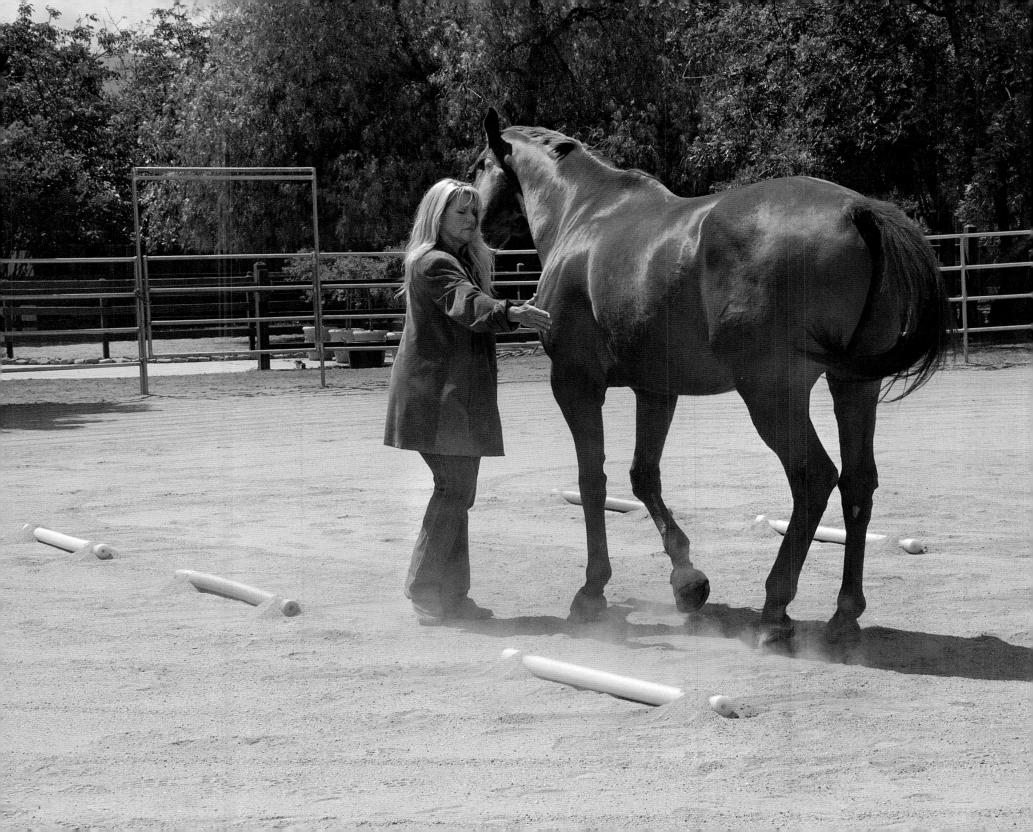

Sir Thomas, 50, a Thoroughbred polo pony living at the sanctuary for 14 years, enjoys a remarkable old age.

adore him. Alexis told a story of his first student, a boy with autism that never uttered a word. Then, one day after his lesson, the boy affectionately patted his mount and with much enthusiasm said, "Stylin.'" It was the boy's first word and launched his effort to speak. His parents later told Alexis that he interjected the horse's name into every sentence for months.

Elegante, a strawberry blonde supermodel of the horse world, was an international champion polo pony until she fell during a match, causing irreparable damage to her front leg that required six permanent pins for stabilization. Sir Thomas, the sanctuary's elder statesman at age 50, was a professional polo pony imported from Argentina in his youth. When Alexis found him, he was languishing in a field, underweight and in poor health with a thinning tail and knotted mane. Now, the elder gelding is the epitome of good health; his coat maintains a lovely sheen and the sparkle in his eye belies his years.

Most of the horses Alexis rescues require some form of ongoing medical care throughout their lives, a constant strain on the sanctuary's resources. That's where Alexis's gift as a healer combined with years of practice using both allopathic and alternative therapies proves to be an essential resource. She does all the day-to-day administration of health care, such as stitching and dressing wounds, administering intravenous fluids, wrapping legs, and checking vital signs, as well as using her skills in preventative care. Her knowledge of biomechanics, structural integration, acupuncture, and trigger-point and laser therapies serves her well and she implements it on her mid-morning rounds. All the horses receive organic whole food supplements and homeopathic medicines from The Equine Sanctuary's sponsoring company, Terra Oceana. When a horse is very ill or injured, Alexis plays special chants and classical music on a compact disc player to aid the healing process.

Alexis makes every effort to address the unique needs of each horse so that he or she is able to reach optimal health and complete emotional well-being. Several times a day, the horses are moved from one paddock to another, released out to pasture to graze, or allowed to remain in their covered shade corrals in extreme weather conditions. Rocks, branches, and manure are removed from paddocks in the morning, and buckets are scrubbed clean every day. Although the tireless ranch hand, Eddie, and the volunteers handle most of these chores, Alexis is never far away, watching the horses for changes in their behavior or health, keeping her eye out for small, newly unearthed rocks that could break a coffin bone.

MANY ARE CALLED; FEW ARE CHOSEN

On Saturdays, volunteer Rhonda Tyacke drives nearly an hour from her home following a long week at her job. She has been volunteering at The Equine Sanctuary for eight years, and her consistency has rewarded her with strong bonds to all the horses. From the moment she arrives until she leaves, Rhonda quietly moves from one chore to the next. She prefers to work alone, finding companionship in the horses as she mucks stalls, rakes paddocks, and grooms. The work gives her mind a rest, but it also gives her the satisfaction of knowing that she is contributing to the well-being of the horses.

Like most nonprofit organizations, The Equine Sanctuary relies on volunteers to help keep the ranch going. Although their numbers fluctuate, Alexis can count on a core group of volunteers to be at the ranch every day from dawn until after dusk, all of them content to perform the mundane but important (and meditative) chores of stable maintenance and horse care.

"I was brought up to give back what you can when you can," said another volunteer, Sandy Horning. She and her dog, Nemo, drive to Ojai

Prince Charles, 39, a Thoroughbred, is missing his lower teeth as the result of severe abuse.

from Malibu every week, arriving early in the morning and working without a break until the early afternoon. An experienced rider with a horse of her own, Sandy prefers the physical labor. She said it has been therapeutic. She's also deeply committed to helping animals. "I think of my time here with Alexis and the horses as a way to give and to receive," she said.

Before 2008, The Equine Sanctuary successfully placed many rescued Thoroughbreds in adoptive homes through a rigorous background check and matchmaking process. But the economic downturn of that year and the rising costs of hay and grain have made it more difficult to place horses in adoptive homes. "It is heartbreaking because we cannot help all the horses in need. It's just a matter of getting the message out. With a supporter like Thoroughbred Charities of America committed to the betterment of the equine world, I believe there is tremendous hope," said Alexis.

In spite of the challenges, Alexis focuses on doing the best she can for the horses in her care and sharing their unique stories of survival and transformation with others. She campaigns against horse slaughter and against overbreeding, which she blames in part for the widespread need for rescue facilities such as The Equine Sanctuary, and impresses on students and visitors the importance of commitment to and consistency of care for all animals.

"We would love to have this be a legacy that goes on," said Alexis, as she looked out over a paddock where a big bay gelding named L. B. stood in repose. Regardless of what changes occur, Alexis plans on being present and involved with the horses. "I would like to help shift the paradigm of human-animal relations and awareness; to make a greater impact on people to show how it is a reflection of consciousness that we bring solutions and compassion to help horses and all those in need."

Maka Nani, a rescued Rhodesian Ridgeback, relaxes in the shade with her companions Sir Thomas and Elegante.

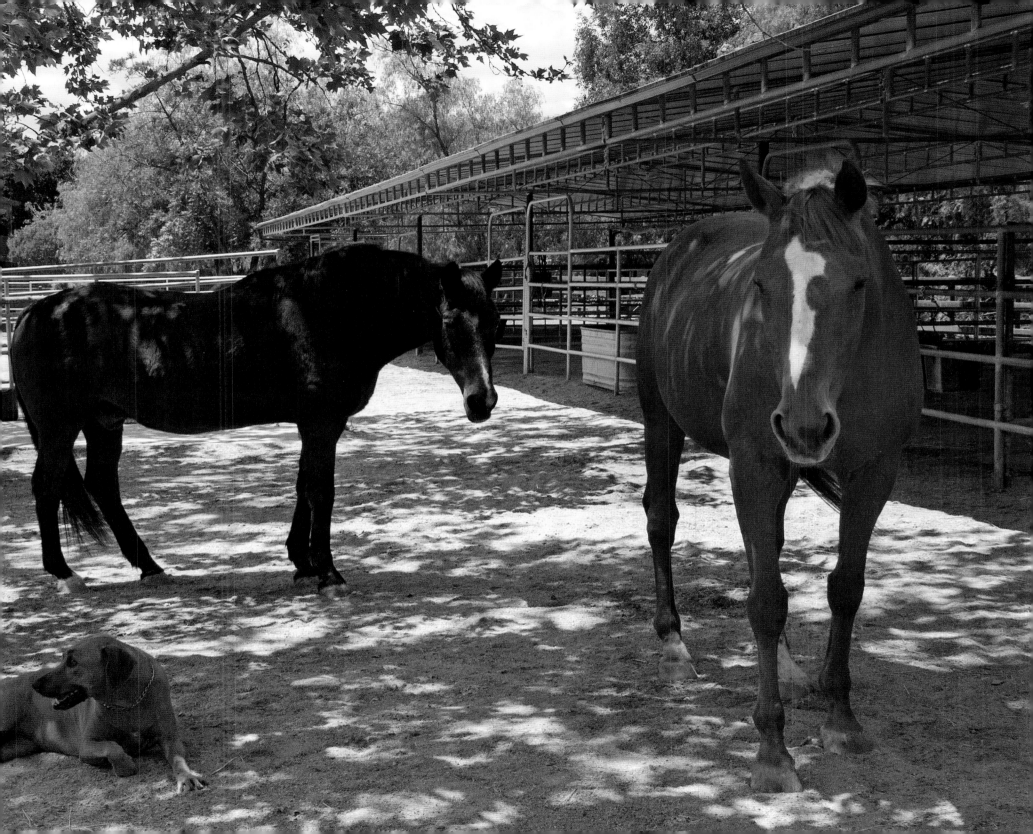

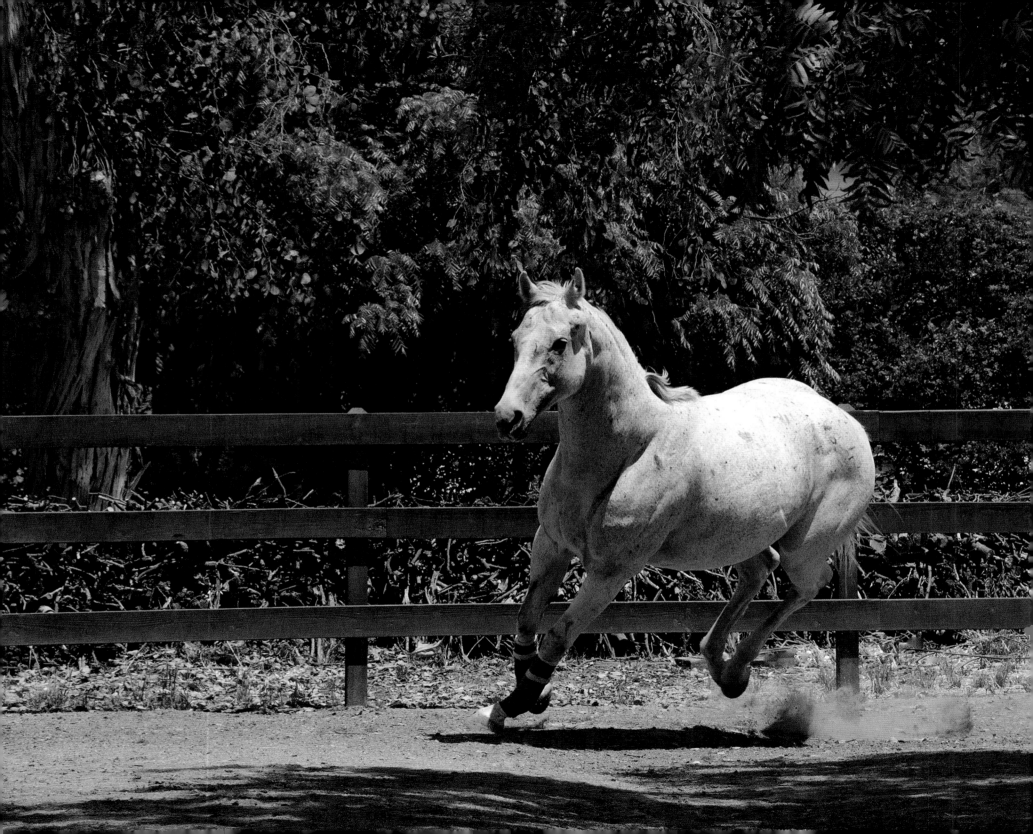

Angel lopes freely around her paddock.

ABOVE: Hansel, once described as "a dangerous rogue," gazes with a kind eye.

OPPOSITE: A dramatic mountain landscape frames the beautifully maintained Equine Sanctuary.

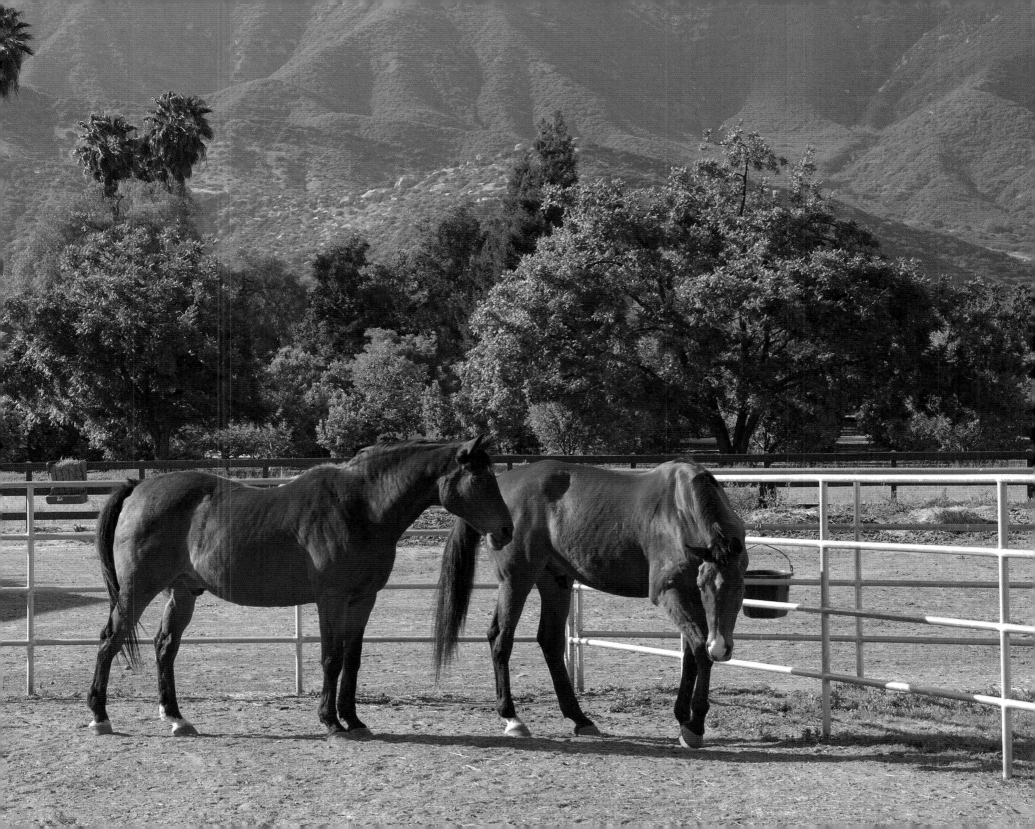

EQUINE VOICES RESCUE & SANCTUARY

Karen Pomroy crossed a large corral to greet a group of horses standing around a galvanized trough. It was late afternoon in mid-June, the hottest month of the year in the Arizona desert. The horses were big—most were draft crosses—and as she approached, they pulled their great heads out of the

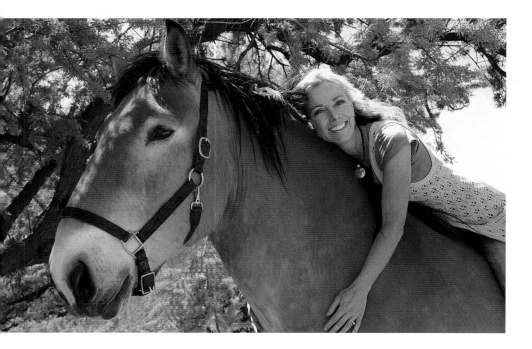

trough in unison to acknowledge her. Gulliver, a huge buckskin gelding with a black mane and tail and feathery hooves, extended his nose toward Karen to receive an affectionate rub. "This is Gulliver," she said, introducing him to us.

Gulliver is the darling and official mascot of Equine Voices Rescue & Sanctuary, which is located on the property of Jumpin' Jack Ranch. His image is found on anything related to the organization, including a line of merchandise sold online and in Gulliver's Gift Shop at the ranch. An impressive horse with a gentle disposition, Gulliver was one of the first horses Karen rescued from a North Dakota farm in May 2004, after the farmer lost his contract to produce pregnant mare urine (PMU) for Wyeth, the pharmaceutical company that first produced Premarin. (In 2009, Wyeth was acquired by Pfizer, which now markets the drug.) The farmer was desperate to find homes for seven foals born to mares that had been impregnated in order to collect their estrogen-rich urine. Karen learned about them through an online rescue site, and although her intention was to adopt just one, she actually chose four—Deuce, Bella, Spanky, and Gulliver.

Gulliver and his friends were transported south to New Mexico, where they stayed for several weeks until Karen found and settled into Jumpin' Jack Ranch with her rescued Arabian gelding, Spirit, and his companion, Big Bud. Shortly after the foals arrived at their new desert home, Karen stood in the corral with her small band of adopted horses and had an epiphany: "I looked at Gulliver and said, 'I can do more.'" She vowed that she would

ABOVE: Karen Pomroy, founder and director, relaxes atop Gulliver, 8, the sanctuary's beloved mascot, whom she rescued from a PMU farm at 11 months. OPPOSITE: Gulliver on the move shakes the earth.

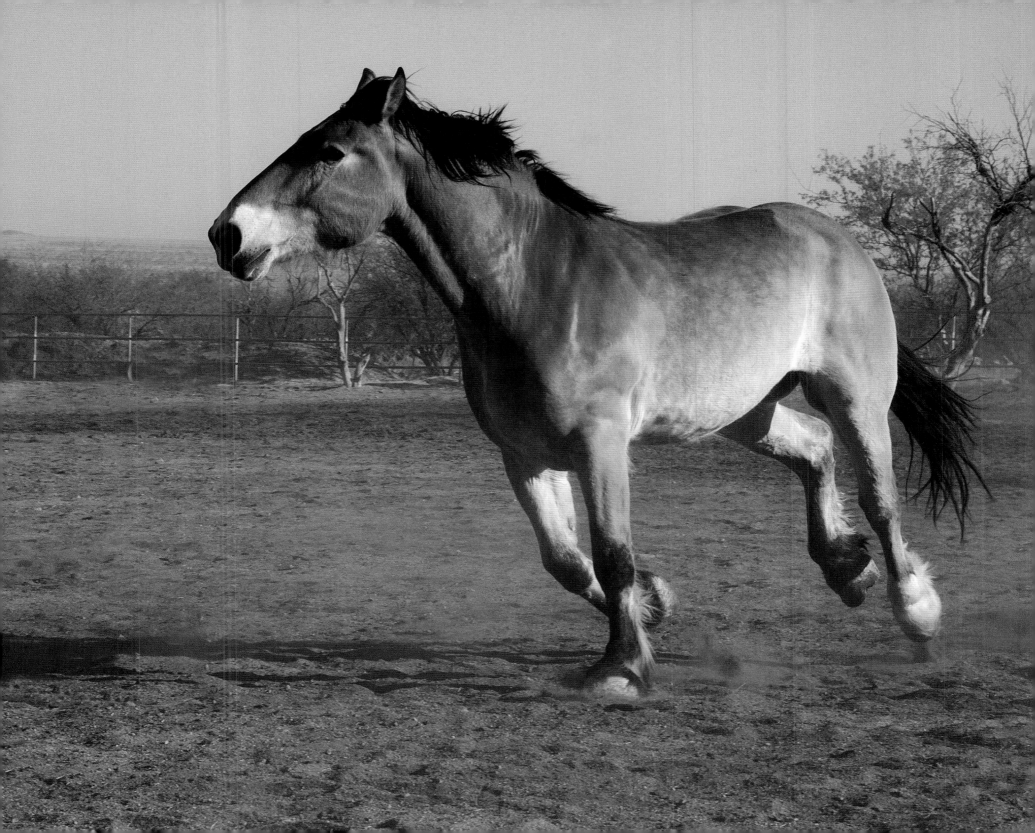

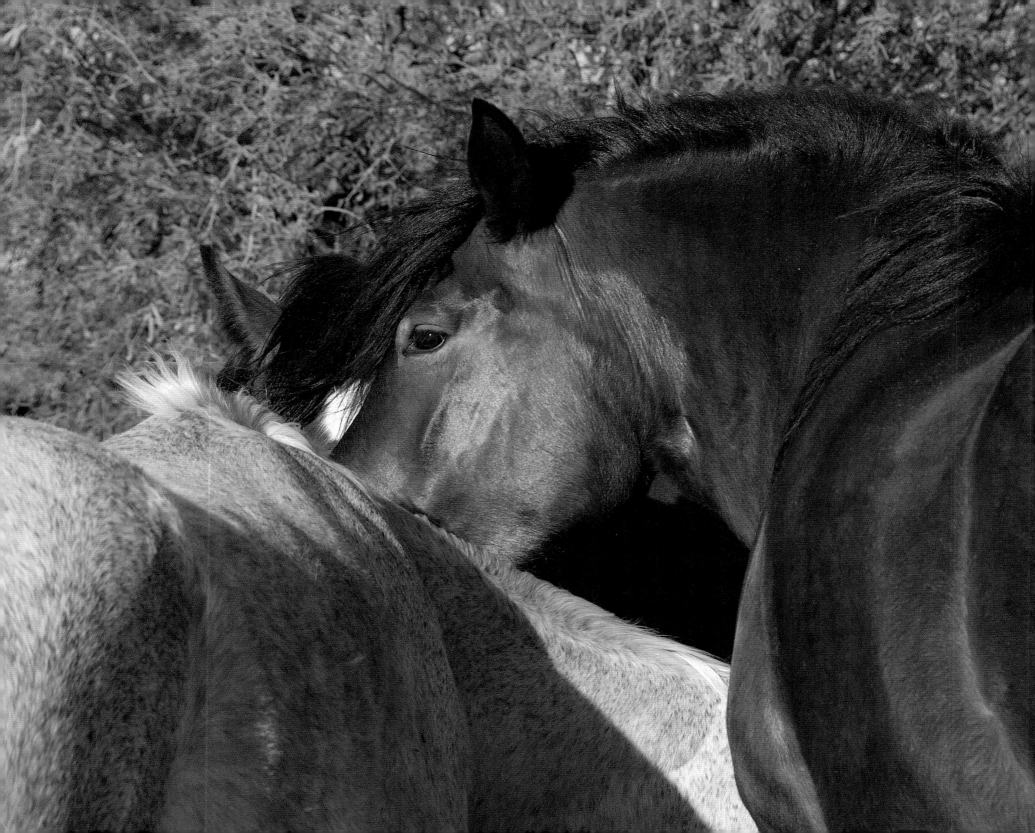

do what she could to help others like him. "I decided that I was not going to keep my head in the sand," she said. "I had to make a difference."

Tucked into the arid landscape near the base of the Santa Rita Mountains, Equine Voices provides sanctuary to nearly 50 rescued horses. They are survivors of abandonment, physical abuse, fire, corporate greed, and ignorance. Some were found wandering in the desert; others were transported from Canada just days before their scheduled slaughter. Although most of the horses are eventually adopted and moved to new homes after recovering from their ordeals, some remain at Equine Voices as permanent residents—a fortunate few of the horses in need of a safe haven.

One of the most astonishing and endearing qualities of the desert where Equine Voices is located is the ability to produce an enormous array of glorious flowers. In this harsh environment, *Agave palmeri*, Mariposa lilies, and thousands of other colorful beauties thrive. Their formula for success is moisture; just the tiniest amount is all a desert flower needs to flourish. Equine Voices is a special variety of desert bloom. Starting with so little, this ambitious rescue organization has flourished, offering an abundance of care and hope for horses that have suffered from neglect and abuse.

ROUGH START

In 2004, the 10-acre ranch near Green Valley, Arizona—south of Tucson—was the ideal place for Karen to launch her sanctuary. Although located in a grassless desert landscape, there were shade trees and plenty of acreage for corrals and barns. Karen filed for 501(c)(3) nonprofit status, and established a board of directors and a mission statement. Once the wheels were in motion, the number of horses rescued grew quickly. An online rescue site posted a notice about 15 sick and malnourished foals that were being held in a feedlot

in North Dakota. They'd been slated for ponyskin, the soft leather used for shoes, handbags, and other high-fashion accessories. These foals were to be shipped to Canada for slaughter unless someone stepped in to save them. Karen worked fast and within days had an offer from a volunteer who would bring the foals to her desert oasis. The quiet ranch quickly transformed into a round-the-clock nursery to provide crucial care for the foals' survival. "They were all so sick," recalled Karen. "Most had strangles [a highly contagious infection of the upper respiratory tract] and they were so skinny." Sadly, one tiny foal died shortly after arriving at the sanctuary.

It was a challenging time, made even more difficult after Karen's husband left her with nothing but $1,000 in the bank, a bale of hay in the barn, and 20 horses to feed. "I just knew I couldn't give up," said Karen. Taking a waitressing job at night to help pay the bills, Karen worked all day on the ranch—feeding, mucking, grooming, and managing the books. She had a website built and devoted as much time as possible to raising funds and finding volunteers.

Karen credited the community for rallying behind her, and cited the support she received from Diana Madaras, an artist working in Tucson, and from her own parents and sister, as the reason she was able to stay afloat. Looking back on the early days of Equine Voices, Karen admitted that the effort required to keep the sanctuary functioning was taxing. "It nearly killed me, I was so stressed. But something kept me going, and because of my core intention, good things did start to happen," she said.

After nearly three exhausting years, Karen had raised and secured enough donations to leave the waitressing job and focus entirely on her burgeoning sanctuary. By then, she had taken in dozens of horses and established a core group of volunteers. She began building a database from her personal contacts and frequently updated her website with news of

Bella, rescued as a foal at the same time as Gulliver, stands at the trough with Spirit, Karen's elderly Arabian gelding and riding partner.

rescued horses and profiles of those up for adoption. Word spread in the Tucson area about the horse sanctuary in the desert—the first equine rescue facility in southern Arizona—and donations trickled in. Equine Voices was on its way.

Since it opened, Equine Voices has placed more than 500 horses in new homes. Nearly every inch of the property is functional and organized. There are several barns, corrals, a tidy tack and feed room, Gulliver's Gift Shop, a visitor and community center, and a landscaped Memory Garden where donors can buy and place a plaque with the name of their beloved two- or four-legged friend. Karen shares a modest home on the ranch with her partner, Tom O'Neil, three dogs, and four cats. There are 150 volunteers and always more waiting in the wings to attend the volunteer orientation and five-step intensive training program that prepares them to work around the horses.

Karen walks to the paddocks every morning to help with chores and visit her wards, but now that she has a ranch manager and can rely on many experienced volunteers, she spends most of the day managing administrative and fund-raising operations. She rarely rides and leaves the training up to a professional, Carol Grubb, who is also on the sanctuary's advisory board.

In the first year of operations, Karen raised $65,000 almost entirely by herself. Since then, Equine Voices has raised more than $1.4 million. Although there has been a drop in the past couple of years for a variety of reasons, Karen isn't troubled. Her response is to diversify fund-raising efforts as with a financial portfolio and employ savvy marketing methods. "You have to run this like a business," she said. "There has to be a plan in place, and your mission has to be clear. A good board of directors is also key."

Like Karen, Jerry Tucker, chairman of the board, is an energetic fund-raiser. His business savvy and commitment to the horses are two of the reasons that Karen is glad to have him on her side. Jerry is also an animal

ABOVE: Deuce, also rescued with Gulliver, stands quietly with Tom O'Neil, Karen's partner and sanctuary volunteer. OPPOSITE: Carol Grubb enjoys an affectionate moment with Gulliver during a training session.

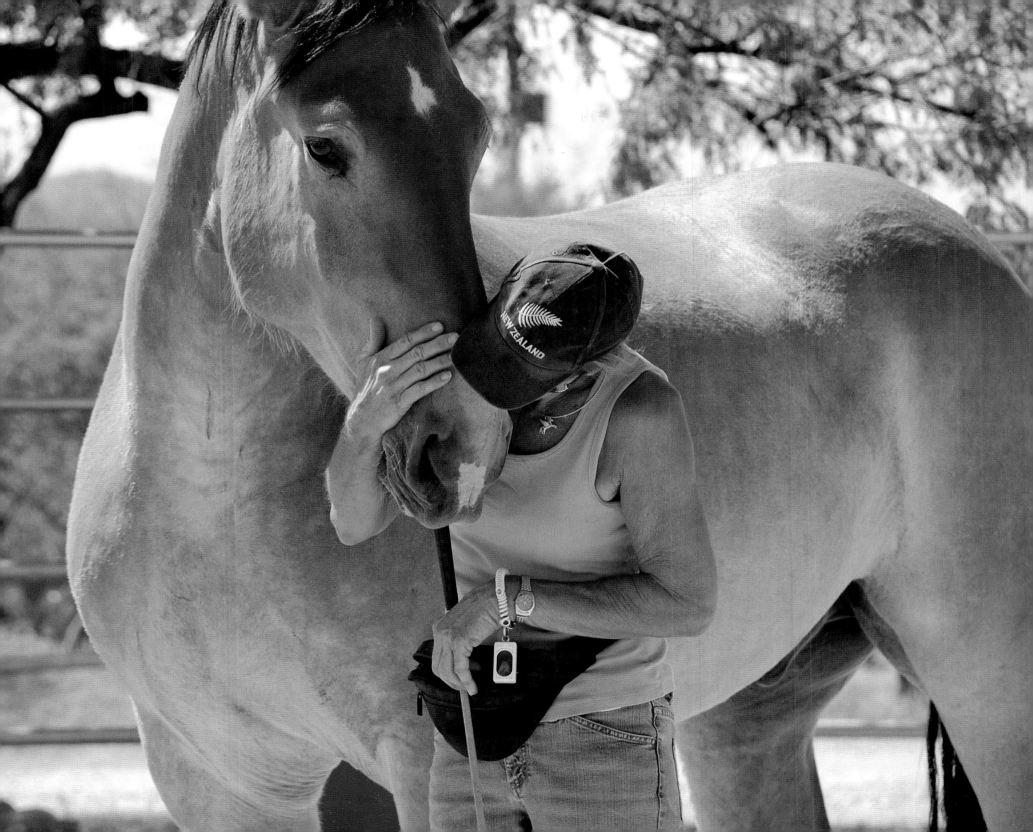

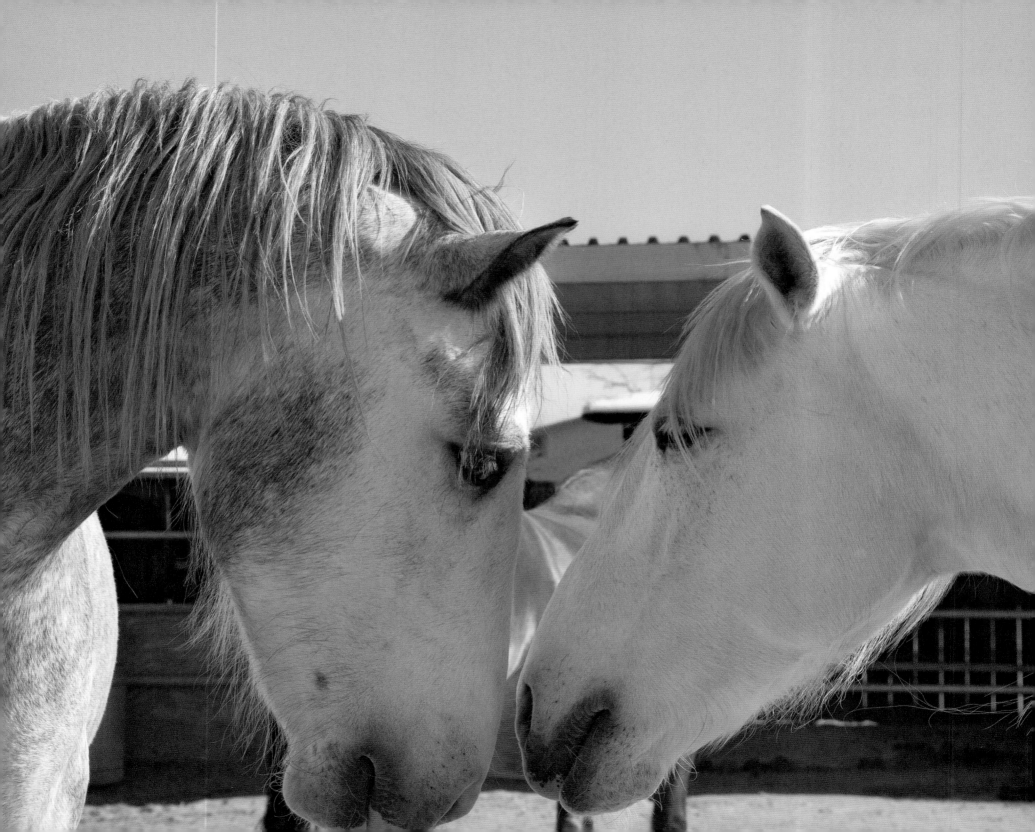

advocate, assisting his wife with greyhound rescue. He owns five acres of Jumpin' Jack Ranch and spends several days a month there, driving more than an hour each way to help work on projects such as the Memory Garden or brainstorm fund-raising ideas with Karen.

THE PREGNANT MARE URINE INDUSTRY

Karen opens her sanctuary gates to many horses in need of rescue, but she founded Equine Voices in 2004 with a specific purpose: to save mares and foals from the pregnant mare urine industry from slaughter, and to educate the public about their plight. At PMU farms, mares endure a cycle of pregnancy, birth, and separation from their foals. Tied in narrow stalls throughout most of their gestation period, the mares are fitted with catheters held in place by a system of pulleys that collect nearly a gallon of urine each day. The concentrated levels of estrogen in the mares' urine make it useful in hormonal replacement therapies (HRT) such as Premarin and Prempro, which are prescribed for menopausal and postmenopausal women to reduce some of the symptoms of menopause or to stave off osteoporosis.

After four months, the PMU foals are weaned from their mothers and most are sold at auction. They may be purchased by a private buyer and trained for competition or pleasure riding, but many end up in a kill buyer's trailer. Nearly all PMU farms are located in Canada, where horses continue to be slaughtered for human consumption. Although some of the horsemeat is sold in Canada, most of it is exported to Asia and Europe.

Many of the horses at Equine Voices are rescues from PMU farms—mares that stood in pee lines and geldings born to PMU mares and then weaned before they were emotionally mature. Several of the PMU rescues were born at the ranch, their dams transported to Arizona while pregnant. Although the foals born at Equine Voices are socialized and trusting of people, many of their mothers remain wary.

Mystic was one of several pregnant mares rescued from a Canadian PMU farm in 2007. An elegant draft cross with a thick, glamorous white mane and tail, Mystic was transported with her colt, Kodiak (also known as Raja), and gave birth to Wyatt at Equine Voices in 2008. Emotionally scarred from her years of abuse at the PMU farm, Mystic was a highly protective mother and wouldn't let anyone, including Karen, stand between her and Wyatt. But after several years of patient work to build her trust, Mystic began to soften. Now she will accept the halter and grooming, and will even stand still to have her hooves trimmed. In 2011, Wyatt was adopted by a couple in Valley Verde, Arizona; he is being trained for trail riding.

Karen's tireless advocacy on behalf of PMU mares and foals, as well as her promotion of natural alternatives to Premarin, has catapulted her to the forefront of PMU rescue. She is frequently asked to give talks on the subject at local rotaries, network groups, and conferences. In 2011, she was invited to speak at the fifth annual Homes for Horses Coalition (HHC) in Orlando, Florida. The coalition is an international group of professionals who work together to promote the welfare and protection of equines.

Recently, Karen's mission has expanded beyond the rescue of PMU horses to include saving and caring for horses used in drug trafficking along the United States–Mexico border. Smugglers overburden their horses with drug packs so heavy that they cause severe injuries, and after reaching their destinations they abandon the horses in the desert without food and water. These horses are lucky to survive even a few days in the heat. Very few are noticed and rescued.

Raja, a draft-cross gelding, greets Mystic, his dam. A PMU mare, Mystic was pregnant and nearly unapproachable when she arrived at the sanctuary. She is now being trained under saddle.

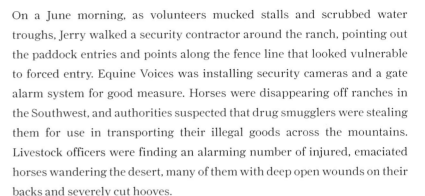

On a June morning, as volunteers mucked stalls and scrubbed water troughs, Jerry walked a security contractor around the ranch, pointing out the paddock entries and points along the fence line that looked vulnerable to forced entry. Equine Voices was installing security cameras and a gate alarm system for good measure. Horses were disappearing off ranches in the Southwest, and authorities suspected that drug smugglers were stealing them for use in transporting their illegal goods across the mountains. Livestock officers were finding an alarming number of injured, emaciated horses wandering the desert, many of them with deep open wounds on their backs and severely cut hooves.

In the past two years, Equine Voices has taken in 20 drug-transport horses found by authorities in the southern Arizona desert. All of the animals were in poor health, and most had severe wounds on their backs. Diamond Rio, a gorgeous sorrel gelding with a diamond-shaped blaze, was found wandering in the desert in January 2009 with a serious leg injury. His condition indicated that he'd been used to carry drugs from Mexico. Lorenzo, Jazz, and Valentino are three geldings rescued from the same situation. In May 2011, Karen received a call from livestock officers about a palomino gelding discovered by the U.S. Border Patrol with more than 300 pounds of drugs strapped to his back. When Equine Voices picked up Sundance from a holding facility, he had open sores on his body and gashes on his legs. Although Sundance was responsive and loaded into the trailer with ease, his eyes were dull and vacant. "They check out after enduring so much," Karen explained.

Many of the horses that arrive at Equine Voices share the same empty expression. The spark does return, but in most cases it takes months of physical and emotional healing. The horses must feel secure in their

Jean Welch, ranch manager, works with a dedicated group of volunteers to heal rescued horses' wounds.

surroundings, know they can rely on regular meals, and trust the people who care for them. "But they do find their voice again. It never ceases to amaze me. I see miracles happen here all the time—with the horses, volunteers, the people that visit," said Karen.

THE VALUE OF PERSPECTIVE

Ranch manager Jean Hamilton Welch—one of the only paid employees at Equine Voices—pulled a chair out and sat down with a long sigh. She had been in constant motion since arriving at 7:00 a.m.; it was past lunchtime and there was still a laundry list of chores to complete before the end of the day. "I learn something here every day from the horses and the volunteers. They really are awesome," said Jean, smiling. A native of Connecticut with a long, successful career in the engineering field, Jean got most of her prior experience with horses in show barns where she boarded her Morgan horse. At one time, she even managed a barn for Hunter's Glen Morgans in Cheshire, Connecticut. Although that skill set has proven to be useful at Equine Voices, the two jobs couldn't be more different. The horses at Hunter's Glen were high-performance show horses undergoing rigorous training regimens. Now, Jean works with as many as 15 volunteers at a time—not boarders and trainers—and the only requirement of the horses in her care is to heal from physical and emotional wounds.

In addition to managing the daily ranch chores, Jean tends to the wounded—for example, rubbing salve on the back of Nicholas, the sole survivor of a barn fire whose burnt and infected flesh went untreated for three years before he arrived at Equine Voices. She mixes formulas for the horses with special dietary needs—three days in advance just in case she can't get to work—and makes every step around the ranch count.

Although it is worlds away from her previous work environment, Jean said that taking the job at Equine Voices was the best thing that ever happened to her, and it has taught her that slower is the fastest way to do things when working with horses. "When I'm rushed and what I'm doing isn't working, I step back and do it their way," she said. "You just can't expect horses to adapt to you."

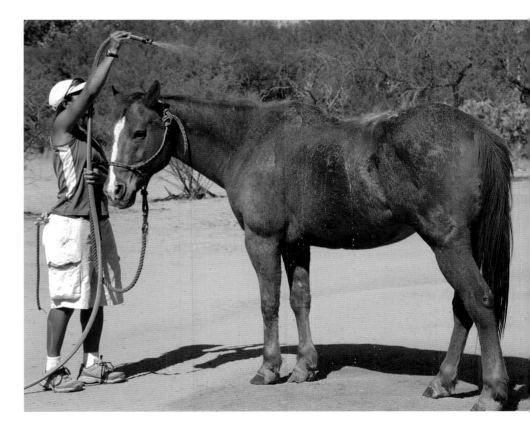

Kristin Carrington, volunteer, gently sprays Nicholas's burns, part of his complex, costly, long-term treatment.

THE FUTURE OF EQUINE VOICES

A number of horses at Equine Voices are permanent residents: the original four PMU foals; Karen's own Arabian, Spirit; Nicholas, the barn-fire survivor; and an elderly mustang gelding named Smokey Joe, just to name a few. Many more need long-term medical care or training before they're ready for adoption. The sanctuary receives daily calls from despondent owners who haven't been able to find homes for their horses or have found an abandoned horse in their pasture or wandering in the desert. It seems never ending, the number of horses that are in desperate need of assistance. Karen knows she can't help them all, but she does what she can by offering resources and guidance.

Karen is an advocate of humane euthanasia over slaughter or neglect and has set up a fund specifically designed to assist individuals who may not be able to afford the cost of putting their horse down. The Equine Voices Humane Euthanasia Fund has helped ease the suffering of many sick, starving, or permanently injured horses. In some cases, owners asked the sanctuary for assistance, but there have also been severe abuse cases—too severe for any hope of recovery—brought to the attention of Equine Voices by law-enforcement agencies. For those, the most humane aid the sanctuary can provide is a dignified death surrounded by people who truly care.

Even with all of the sanctuary's success, Karen has many more ideas for the future. "I would love a ranch with pastures," she said, as she looked out over the corral where Gulliver stood surrounded by his closest companions. "I would like an indoor arena so that we could offer more clinics and open a program for people in Europe who want to experience a working ranch and learn more about the PMU issue." Karen has her eye on a dream facility east of the Santa Rita Mountains. The pasture and barn space would allow her to bring more rescued PMU mares and their foals to Arizona. Equine Voices needs $2.4 million for the property. It's a reachable goal, but Karen is realistic—growth has to be backed with adequate finances. These are tough economic times, and she will not take leaps of faith without a financial net.

In July 2011, Equine Voices received national attention following a moving story about its work that aired on *NBC Nightly News with Brian Williams*. The report focused on the horses left behind in the desert by drug smugglers, employing compelling before-and-after images of one such horse named Cash. At the end of the segment, the reporter noted that Cash recovered and was adopted by a local family. Following the story, the phone rang off the hook for days and Karen's e-mail inbox overflowed with messages from friends, supporters, and well-wishers who were touched and moved to help.

In addition to the positive media attention, Karen said that being accredited by the Global Federation of Animal Sanctuaries (GFAS) in 2010 is one of her proudest achievements. She and many volunteers spent long hours putting together the 80-page GFAS application, but she feels that accreditation was worth the effort. Not only is it a significant indicator of a sanctuary's worthiness, it also forces an organization to define itself. Beyond the mission statement, which is required when filing for 501(3)(c) tax status with the Internal Revenue Service, Karen said the GFAS application showed her where there were holes in the organization.

"I learned so much from the process," said Karen, as she looked over her shoulder at Diamond Rio, who was becoming antsy, anticipating his 4:00 p.m. dinner. "I want to be the best that I can be for the horses and make sure they get what they need." She gestured toward the barn behind her, every stall housing a rescued horse. "It's a collective effort, and I couldn't do it without the community, donors, volunteers, and Jerry," she said. "And it's all for these incredible, sentient beings."

Smokey Joe, 22, was 250 pounds underweight with his hooves curling upward when he was rescued in 2009. Restored to health, he roams the ranch at will.

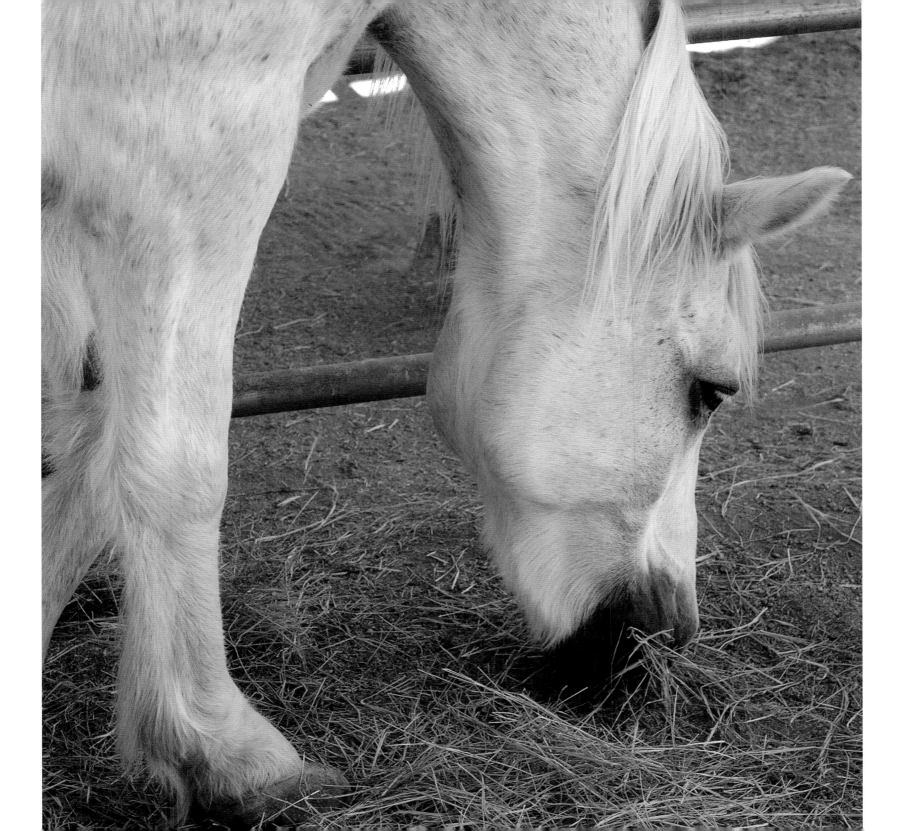

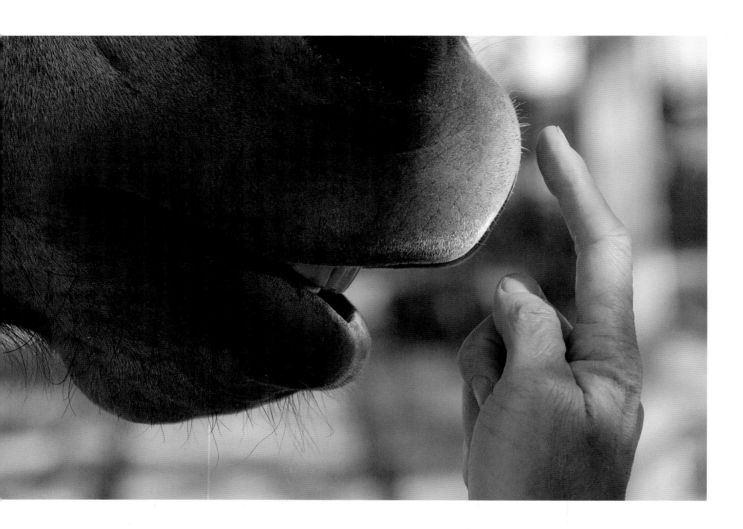

ABOVE: Karen bonds with Little Deuce. OPPOSITE: Deuce lopes with the band across the big paddock.

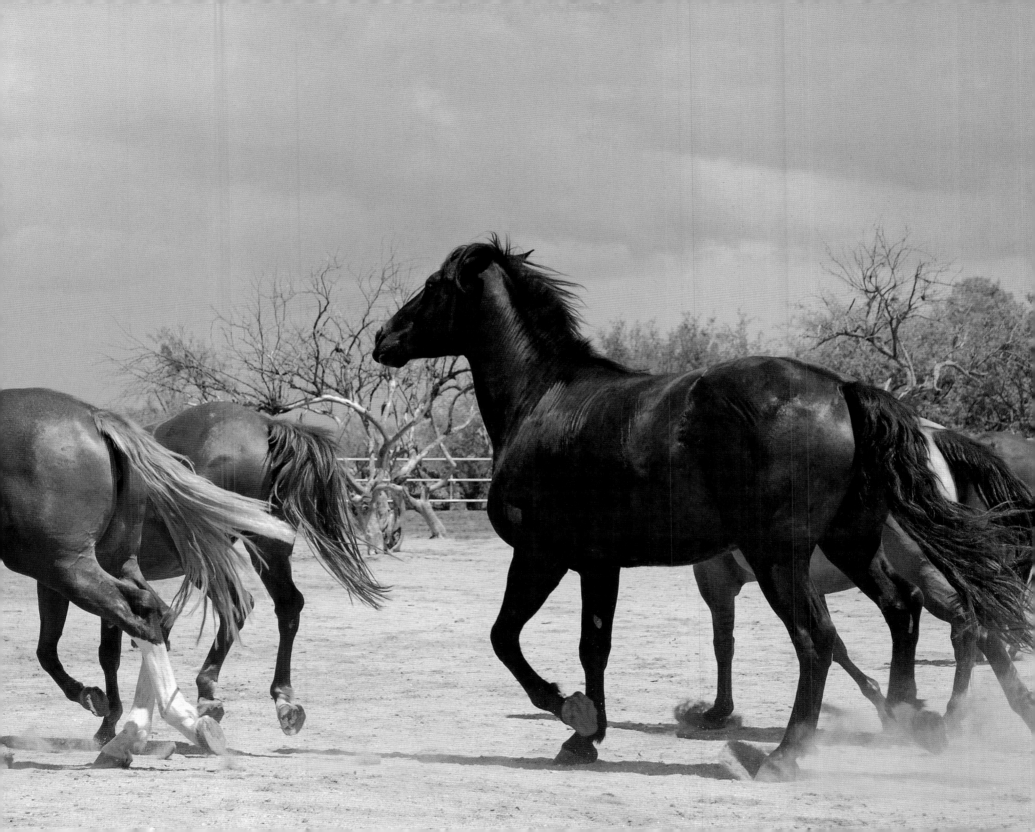

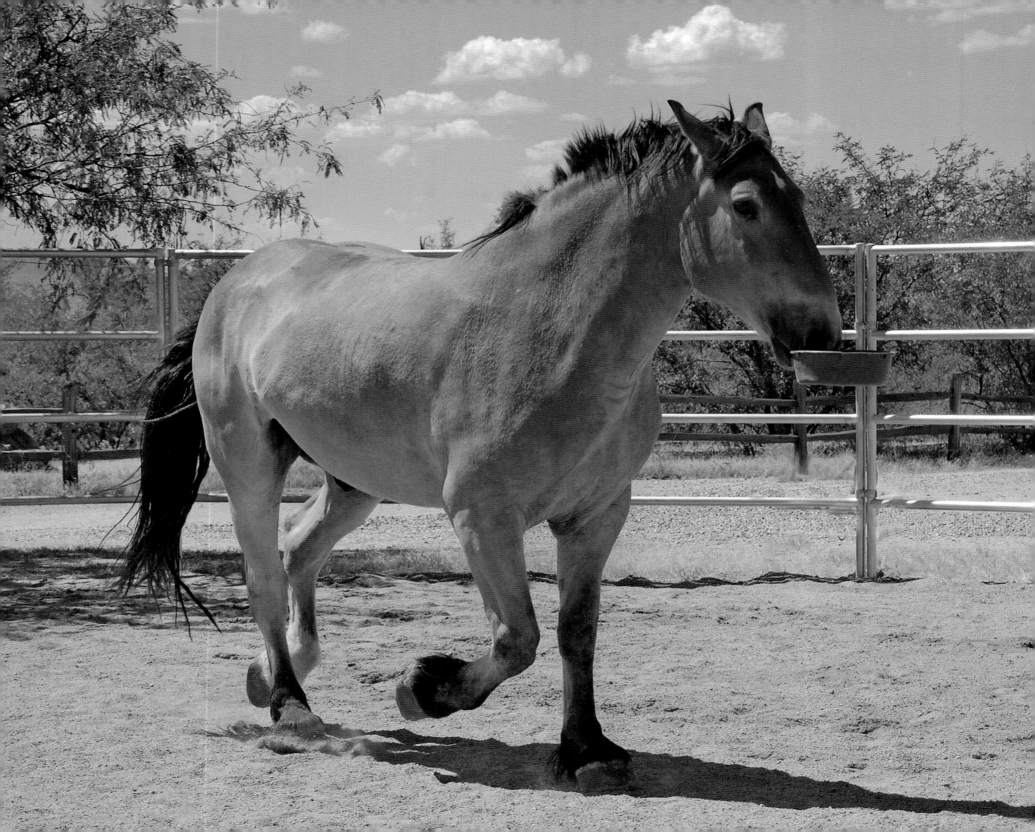

OPPOSITE: Gulliver carries a dish to his trainer.

ABOVE: On a scorching day, Gracie, a Clydesdale and PMU mare, takes a cooling drink.

OVERLEAF: The yearling Durango stands his ground (left). Raja nudges Mystic (right).

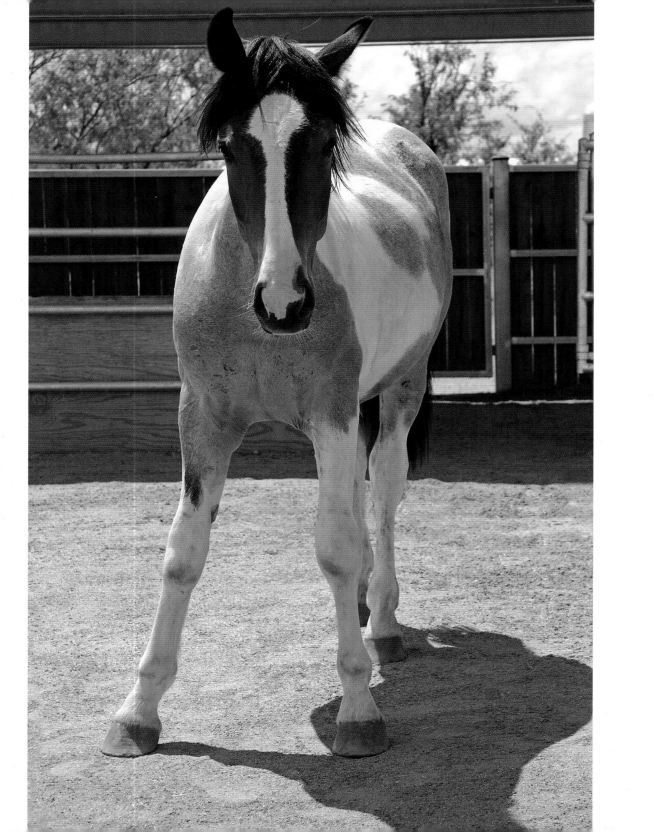

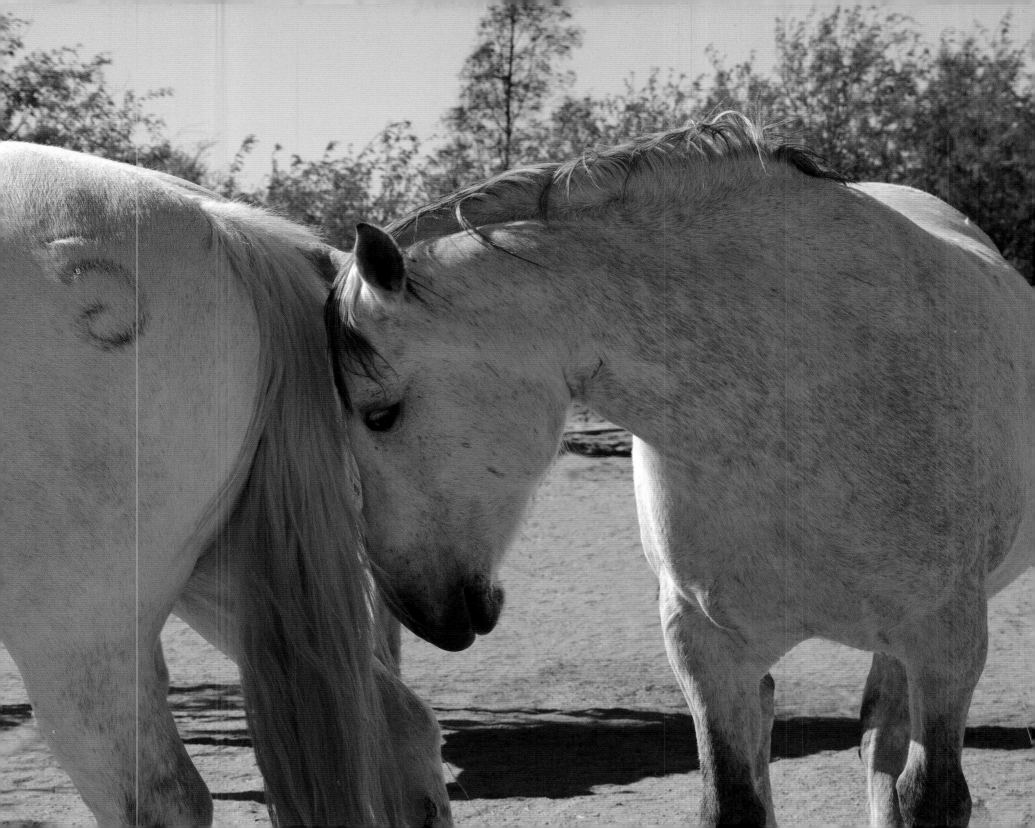

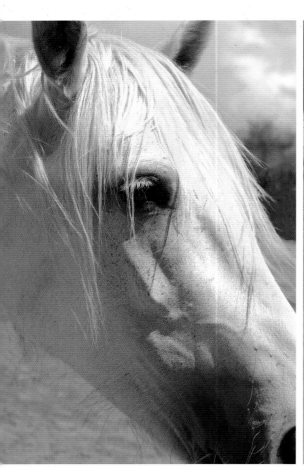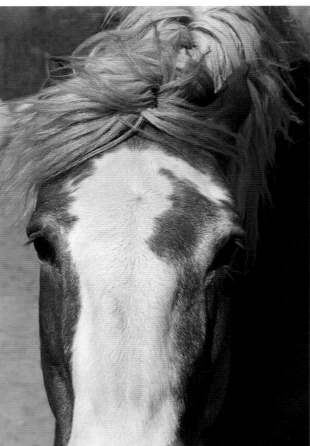

These four mares rescued from abuse now thrive at Equine Voices: Mystic, Little Miss, and blue-eyed Leyla (above, left to right), and the tricolor beauty Illusion (opposite).

OPPOSITE: Gulliver challenges Spanky in their ongoing friendly rivalry.

RIGHT: Desert Breeze, pregnant and with a foal beside her, was rescued from a Canadian kill pen.

OVERLEAF: Kachina, survivor of horrific violence, has learned to trust again (left). She waits at the tail of the dinner lineup (right).

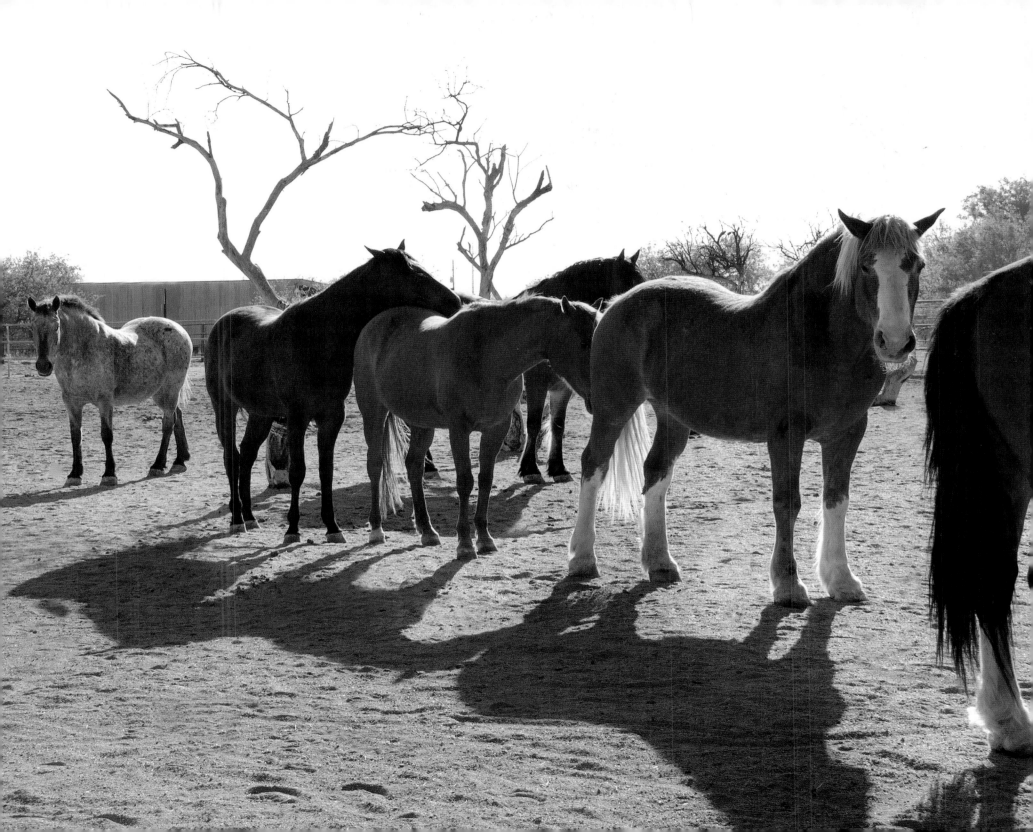

FRONT RANGE EQUINE RESCUE

It was mid-morning and the temperature was quickly rising, ensuring that it would be another hot June day in Larkspur, Colorado. A sudden wind whipped dust into a small funnel. It whirled around one corner of the corral then dissipated, leaving bits of grass hay fluttering to the ground.

"Rescue work is heartwarming, heartbreaking, and backbreaking all at the same time," said Hilary Wood, founder of Front Range Equine Rescue, as she opened the door to a large pole barn and ushered us inside. "I take it very seriously." It was cool inside, and quiet, save for the soft sounds of chewing and the occasional swish of a tail chasing off a bothersome fly.

Eddie, a mustang-pony cross, gingerly walked to the front of the stall to consider the reason for our visit. We stopped to admire his petite, well-proportioned body and dainty head. In the stall next to Eddie was a Curly Horse named Charming, followed by a mustang named Logan, then a pretty Thoroughbred named Andy, and finally Orion, whose busy mouth lingered over a pile of hay.

"You wouldn't have recognized him at all," said Michelle Conner, head of the Front Range adoption and training program and a professional trainer. "He was real skinny, had ratty hair and lice." Michelle is also Hilary's partner on most rescue missions. Orion has been at Front Range since April 2011 and in two months gained most of his weight back. Michelle and Hilary picked him up at an auction outside of Colorado Springs, outbidding a kill buyer. "All he needed was groceries," said Michelle,

patting Orion on his long neck. "And his teeth fixed." The veterinarian guessed his age to be around 20.

Orion's neighbor in the last stall, a gentle bay roan mustang named Princeton, is also in his 20s. Princeton spent many years as a summer camp horse before he was surrendered to Front Range because of an arthritic knee joint. "These horses in their 20s are fabulous," said Hilary. "They're some of the best horses for people to adopt."

Front Range horses represent a broad palette of colors, sizes, shapes, and ages, and they arrive through very different means. Some are abused and neglected, found by Colorado Animal Control; others are bought off the kill lot, a dismal holding area for livestock being sent to slaughter. Many Front Range horses come from local auctions. Hilary and Michelle attend at least one auction per month in the Denver area, and the number of horses they purchase at a time depends on their budget and how much room they have available in the barns.

The horses that go home with Hilary and Michelle on auction days are usually underweight, malnourished, or injured. Many have worms and lice; all are in need of grooming. The farrier works on hooves, and the veterinarian checks teeth and tends to wounds or any other medical needs. Within weeks to a few short months, under the doting care of Front Range staff, the horses gain some—if not all—of their weight back and the luster returns to their coats. They establish relationships with others in the herd

Like most of the rescued Thoroughbreds at the sanctuary, Simon arrived severely malnourished. He is now gaining weight and his spirit is renewed.

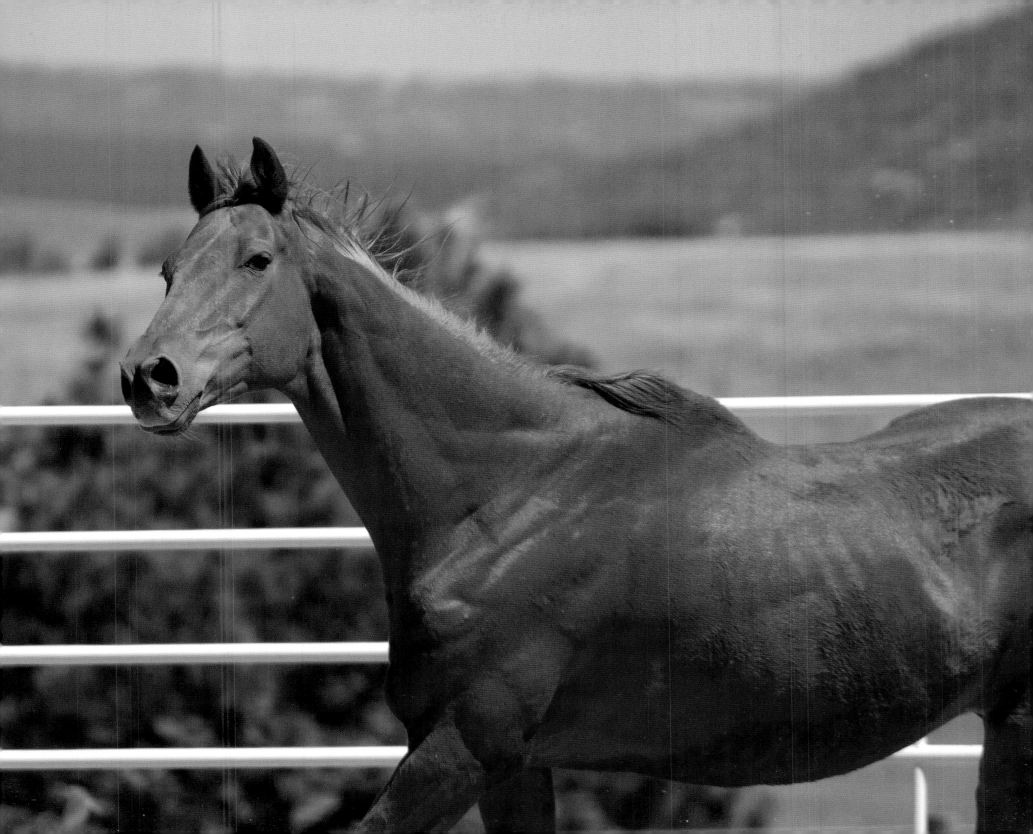

and most relax into their transitional home. Eventually, they'll be assessed to determine their level of training and ability to cope in a wide range of situations. Each horse requires a significant commitment of physical, emotional, and financial resources, but the payoff is a healthy, well-adjusted horse that will have another chance at a good life. In Hilary's book, that's worth every ounce of energy and every penny.

Since Front Range was launched in 1997, about 800 of the approximately 1,100 horses that have come through the rescue program have been adopted. Several of the horses have become permanent residents at Front Range, and others have been humanely euthanized due to debilitating illness or injury.

"It's safe to say that 60 to 90 horses are adopted every year," said Michelle. As head of the adoption program, she reviews applications,

makes home visits, and, with Hilary's input, determines whether a horse and its potential adopter are a good match. But finding homes for horses is only one part of Front Range's mission. "You feel really good about the 60 or more horses that find homes," said Michelle. "But in that same year, we passed out 500 or more brochures that might re-home other horses and help educate people on what slaughter really is. We're educating people on how to properly take care of a horse and what is really required to own one. Front Range emphasizes all of those things."

THE SPRING VALLEY FACILITY

Standing in a large, newly constructed indoor arena at the 81-acre Spring Valley property—an addition to the original property in Larkspur—Hilary explained that the horses are released indoors for exercise on winter days when deep snow and bone-chilling winds make pastures unsafe. One side of the arena is dedicated to corrals, and Hilary has a mental blueprint for laying out temporary stalls in case of emergency situations. This is the type of thing Hilary has to think about. Planning for emergencies is critical to surviving Colorado's extreme and erratic weather conditions. That fact couldn't have hit home any harder than it did during the Hayman Fire in 2002. Hilary was part of an impromptu animal-evacuation team that moved horses and livestock from homes and farms to evacuation centers throughout the region. The experience was unsettling and exhausting, but it also honed her evacuation skills and impressed on her the importance of planning ahead—for anything.

Because of a major gift campaign, Front Range was able to purchase the Spring Valley facility in 2009 as an extension of the 40-acre Larkspur ranch that also serves as Front Range's head office. During the warm months,

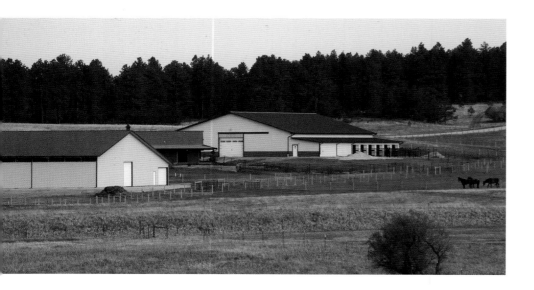

The new Spring Valley complex is viewed from the dirt-and-gravel road between the two sanctuary locations.

Hilary keeps as many as 20 horses on the Larkspur property, but during the winter, high snowdrifts and merciless winds make it nearly impossible to navigate the corrals and pastures, and the county road leading to the property is sometimes impassible. At the first sign of winter, Hilary moves most of the horses to the Spring Valley facility or to Michelle's property east of Colorado Springs. The thought that something could happen to one of the horses when roads are impassible scares her more than anything.

And Hilary doesn't scare easily. She's a risk taker, and her passion for saving horses has moved her to take on and overcome extraordinary challenges. Since leaving her home state of Virginia in 1994—as well as a professional career with medical coverage and a retirement plan—Hilary has stared down the uncertainty of launching a nonprofit to grow Front Range from a small rescue with no property to the large, multi-facility organization that it is today.

THE FIRST HORSE

"You're seeing something that was not planned out to be what it is today," said Hilary. "I started based on the notion that if I can help one horse a year I'm going to start a rescue." No one specific event shifted the trajectory of Hilary's life, but instead a series of events and realizations guided her like signposts toward rescue work. She remembered reading Anna Sewell's novel, *Black Beauty*, when she was young. A particular line resonated with her, even as a child: "To stand by and do nothing makes us sharers in the guilt."

Then came Dancer.

"What I realize now is that Dancer was the horse I was destined to find and rescue, never thinking in terms of 'rescue' when I bought him," Hilary

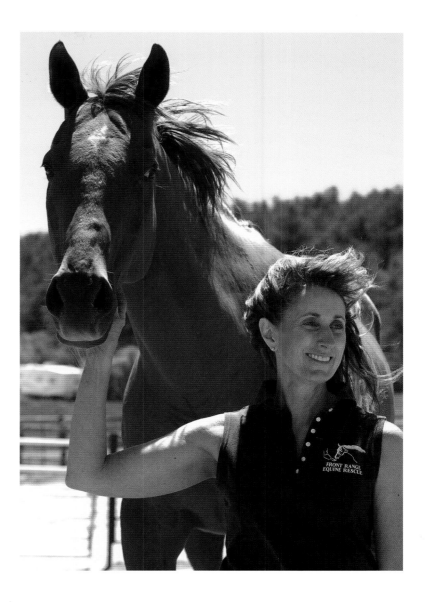

Hilary Wood, founder and director, sits next to Rocky.

explained. "He came from a filthy, run-down rental facility in Virginia, not far from where I was working at the time. His condition and what would have happened to him eventually [if I hadn't intervened] led me onto this path. It also opened my eyes to the suffering of equines. It's not dissimilar to what Anna Sewell described so well in *Black Beauty*."

Dancer was with Hilary when she launched Front Range and for the next four challenging years. Then, in 2001, Dancer died unexpectedly. "One of the most significant losses of my life was the day I found Dancer dead in the pasture. He gave no sign of being sick or that anything was wrong. I didn't want to go on without him, but Dancer's purpose in my life was more than just being my horse," said Hilary. In his honor, she carried on with the rescue.

FUND-RAISING EFFORTS

Considering its humble beginnings, Front Range consistently raises more than $1.5 million a year, a portion of which goes to emergency savings. Since being reviewed by Charity Navigator, the organization has earned a four-star rating two years in a row, with more than 85 percent of expenses going toward programs. In 2003, the organization launched a direct-mail campaign that has grown to almost a million pieces of mail per year with a three percent return rate. Although Front Range has received a number of generous foundation grants and donations over the years, it also takes a grassroots approach to fund-raising, including tabling at various events, clinics, and fairs. In the early days of the organization, volunteers offered gift wrapping at a major bookstore chain during the holidays and even sold homemade baked goods in front of grocery stores as ways to earn extra money. Sitting behind their understated folding table, the volunteers used

the opportunity to tell shoppers about the work of Front Range and the many adoptable horses in need of a good home.

Although Front Range still has a presence at many of these events, it also organizes annual clinics, seminars, and education days. After many years of driving to Denver for a horse expo, Hilary started a new equine expo closer to Larkspur. The sponsored event features a range of educational demonstrations, and a variety of vendors sell food and goods. The exposure helps Front Range and promotes its work. According to Hilary, though, it's the monthly donations from people throughout the United States that make up the bulk of the organization's yearly earnings. Surprisingly, these aren't large donations, but modest amounts of $50 or less.

"If you're running a nonprofit, you'd better have funding, and it shouldn't come from one source," said Hilary. "I'd rather have a lot of people who give $5 a month than one person who gives a large amount only once. Our bread-and-butter is in the $25 to $50 donation range. Some people can only give $5 to $10, and that's as important as the person who can give that rare larger gift."

Hilary pursues a few grants and solicits corporate donations, but in reality only nine to 10 percent of her time is allocated to raising money. The bulk of her day is spent on the programs. She's up before dawn seven days a week to take her dog, Nala, out for her morning walk. Then, she makes the rounds at the barn—feeding, watering, and tending to a dozen other chores—before returning to the office for administrative duties. Front Range has a small group of volunteers who help with barn chores and events, but Hilary and the Spring Valley barn manager, Andrea Ver Meer, shoulder the majority of daily responsibilities. Although Michelle drives to Larkspur from her prairie home at least once a week, her time is mainly devoted to the Front Range horses in her care, up to 36 at a time, plus the 10

Michelle Conner, trainer, works with young Pip, rescued from severe abuse, to relieve his fear of being touched on the face and head.

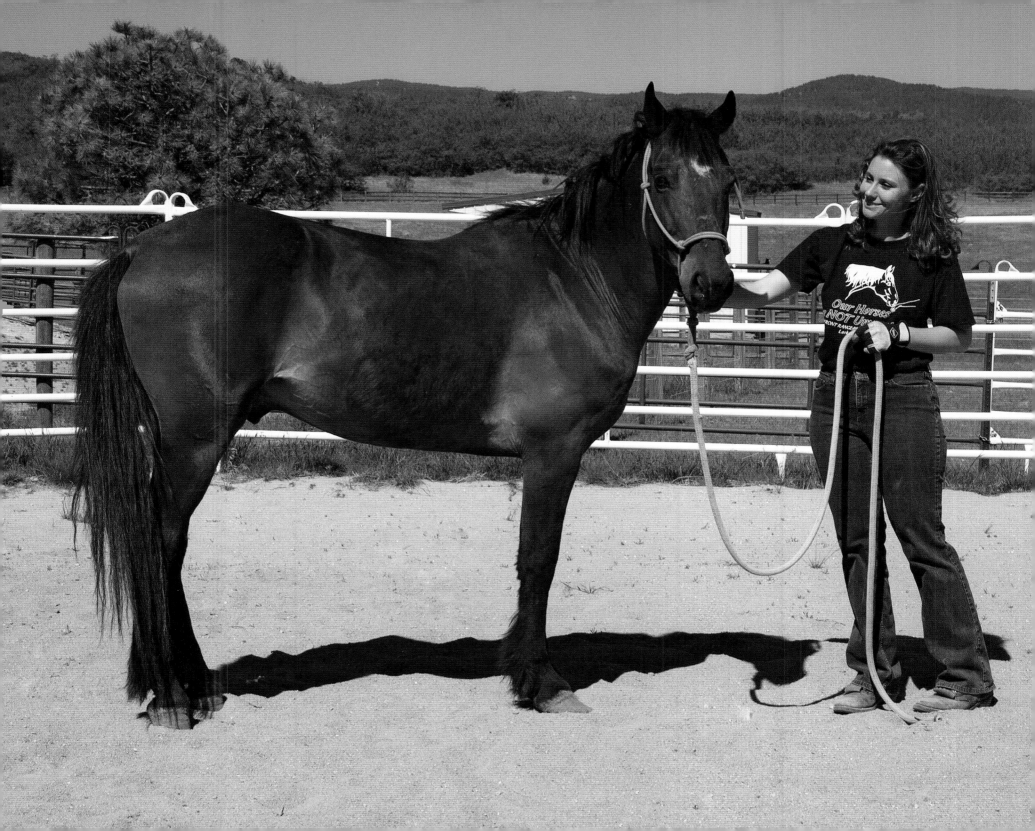

horses of her own at her boarding and training facility, Lasting Partnership Training Center. There's a lot to manage in the course of a day, but there is no doubt that Michelle is just as committed as Hilary to do the important work of Front Range.

A MAJOR RESCUE

Mr. Bates—named after the character in the British television show *Downton Abbey*—was very relaxed. His head hung heavy; his body swayed as his weight shifted from one leg to the other. Dr. Randy Parker prepared his instruments as vet technician Leslie Norvell looked on. She kept a soft grip on Mr. Bates's lead and reassured him with a rub along the top of his neck. His head dipped a little lower, his eyes closed. Nobody knew for sure what had happened to Mr. Bates's left eye, but what they did know was he was hurt and nobody had tended to his wound. His eye could have been saved, but instead it retreated into the socket. Without a proper eyeball to protect, the soft tissue inside the eyelid hung limp and was in danger of becoming infected. Health concerns aside, it was not one of Mr. Bates's finer aesthetic attributes. As the doctor approached with scalpel in hand, Leslie gently pulled the horse's head up and swiped at a stubborn fly. The doctor worked fast and clean. Within 15 minutes, he had removed the soft pink tissue from Mr. Bates's eyelid. He expected the incision to heal quickly, but asked Michelle to administer drops in the horse's eye several times a day for at least two weeks. As if relieved it was over, Mr. Bates took a deep breath, stretching thin skin over his ribcage.

Like the others that traveled with him two days earlier, Mr. Bates was underweight; his bones protruded from his large, Belgian body where there should have been muscle and fat. Seized by the Wyoming Livestock Board in May from a Lincoln County property, Mr. Bates was housed at Cheyenne Stockyards with nearly 100 horses of varying ages, sizes, and stages of malnourishment. Many were suffering from severe neglect, and others had untreated injuries. Because the owner failed to post bond, the horses became wards of the state. At the stockyards, veterinarians and local welfare organizations provided the horses with rehabilitative care while the Humane Society of the United States (HSUS) scrambled to quickly place as many as possible in foster or permanent homes.

In early June, Heidi Hopkins, Wyoming state director for the HSUS, contacted Hilary. Would Front Range be willing and able to take some of the horses? Naturally, Hilary's answer was yes. Two weeks later, she and Michelle drove to Wyoming to assess the situation and choose the first group of horses to be transported to Front Range. They narrowed their choices to seven for the first delivery to Michelle's facility. In early July, another eight were transported and safely delivered, increasing the number of Front Range horses to 70. Although the second group had gained some weight while rehabilitating in Cheyenne, they all required varying degrees of medical treatment, hoof trimming, and dental work after they arrived in Colorado. The initial cost of care for the Wyoming horses was estimated to be more than $6,000 in the first month, and some of the horses required ongoing medical care.

"Early on, we had success with many alternative therapies such as magnets and infrared light therapy," said Hilary, explaining the different types of care Front Range horses receive. She trained as an equine sports massage therapist before moving to Colorado and supports complimentary therapies for horses like chiropractic, acupuncture, homeopathic therapy, and herbal treatments, as well as the use of magnets or light therapy, all of which can help alleviate pain and encourage healing.

Miley eyes a visitor as she heads to her stall for dinner.

Several miles east of the Front Range facilities, in the Black Forest, Marion Nagle was teaching a group of kids about the role horses have played in American history. An educator for nearly 30 years, Marion has volunteered with Front Range since 1998 and fostered more than 30 horses. She is also Front Range's education coordinator, a part-time position that keeps her busy in warmer months working on events, volunteer coordination, and education program development. Every summer, she runs a series of daylong to weeklong camps at her home. Kids from eight years old and older study horse anatomy, breeds, behavior, care, and other related issues. Although it is not a riding camp, students have contact with some of the Front Range foster horses, which gives Marion and her daughter, Amara, the perfect opportunity to talk firsthand about neglect and abuse.

Similar topics are presented at all Front Range educational events, particularly the annual Equine Education Day, which features talks by special guests such as Debbie Bibb, a local trainer, and Ginger Kathrens, volunteer executive director of The Cloud Foundation and an award-winning producer and filmmaker.

Front Range emphasizes education as a means of ending horse abuse and neglect, including slaughter, but the organization has also developed programs to help owners who find themselves in a precarious financial or personal situation and can't feed or care for their horses. In desperate situations, Front Range provides one-time hay and grain grants and on occasion accepts a surrendered horse, but mainly it helps owners learn how to find new permanent homes for their animals.

In 2002, Front Range established a national program to deter "backyard breeders" by offering a partial reimbursement—approximately 30 percent—for castration of stud colts and stallions. A complimentary program poignantly called Trails End assists owners with the cost of humane, veterinarian-assisted euthanasia. In dire situations, it is the sick, crippled, elderly, or injured horses that end up in the auction ring and ultimately languish in a kill lot. The Trails End program provides a humane option for owners who are struggling financially and emotionally with the staggering decision to put their horse down.

"Sometimes rescue means making the hardest decision of all, taking a life in the most humane way you can," said Hilary. Although it doesn't happen often, there are occasions when Hilary and Michelle attend an auction or visit a kill lot and find a horse that is suffering from severe injuries or illness, and where recovery is not possible or would be unnecessarily grueling for the horse, they make the purchase, create a comfortable, safe environment, and humanely euthanize the horse by an injection administered by a veterinarian. This is not a decision Hilary and Michelle make lightly, but they are willing to make it if it means the animal is spared further suffering. Clearly, this is not the type of rescue Front Range wants to do on a regular basis, but sometimes it is the most loving gift it can offer.

"I know that whatever we bring home from the auction on a given day, we'll be able to help to the best of our abilities. And we'll do what is best for that horse, whether rehabilitating, euthanizing, or adopting out. I think you have to keep that in mind," said Michelle. When wrestling with the emotional trials of rescue work, she likes to think about the starfish story in which a person combing a beach full of starfish throws one back into the sea at a time. "No, you can't save them all, but it means the world to that one horse that we can save," she said.

An Arabian and a Thoroughbred in the front pasture lie down to roll in the summer grass.

ABOVE: Sherman, 19, relieves an itch with a fencepost.

OPPOSITE: Sherman gallops at liberty in the roundpen.

OVERLEAF: Deedee uses a convenient pine to scratch her rump (left). Pete and Pip groom each other (right).

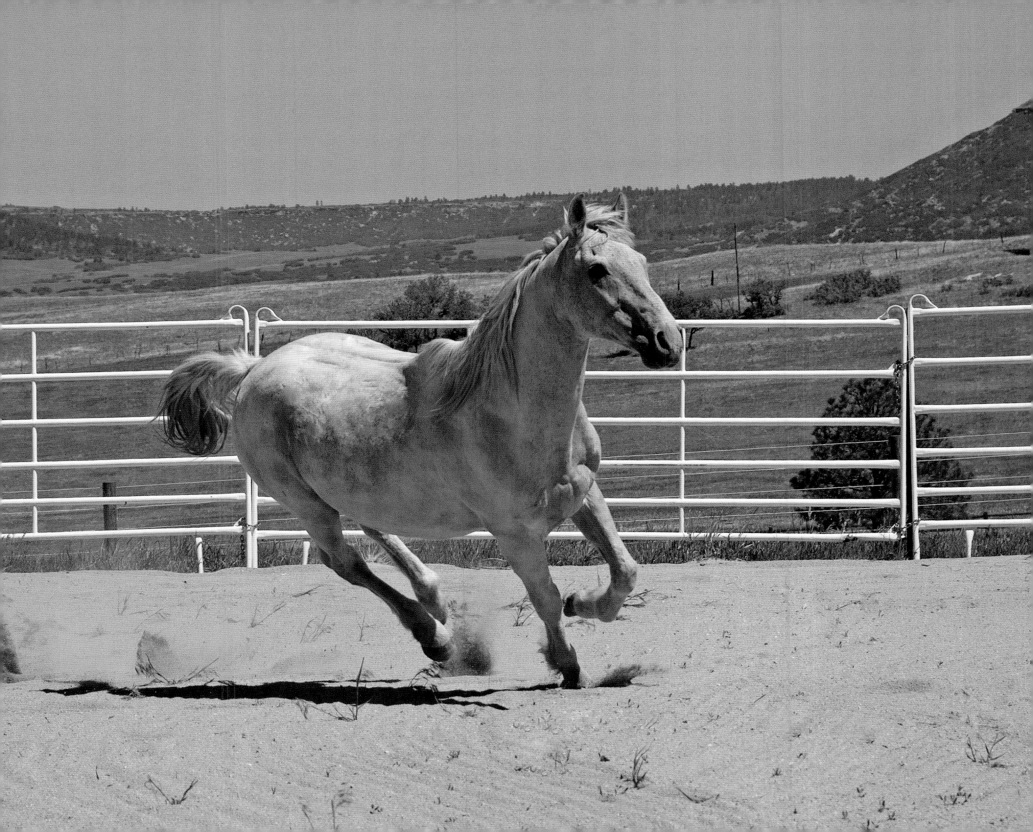

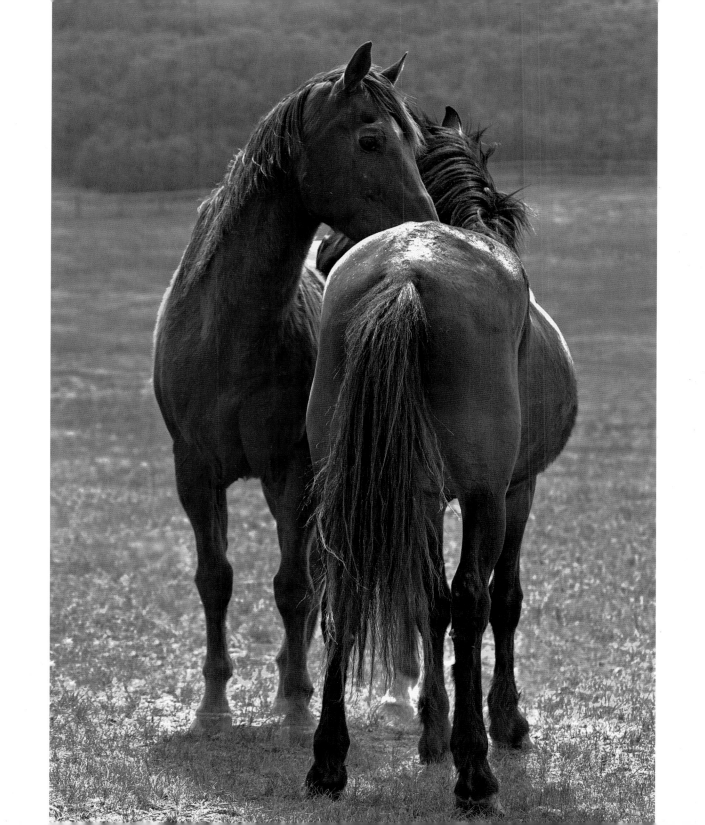

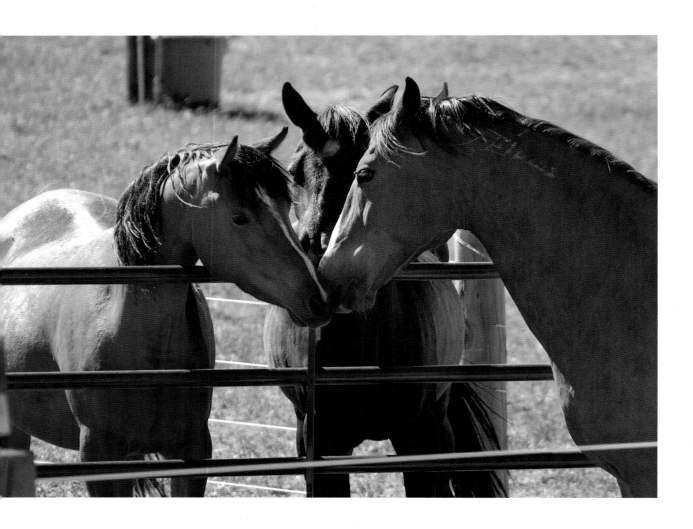

ABOVE: Miley (left) meets two companions by a pasture gate at the Spring Valley property.

OPPOSITE: Near the wooded area close to the ranch house on the main property lie well-tended pastures for rescued horses.

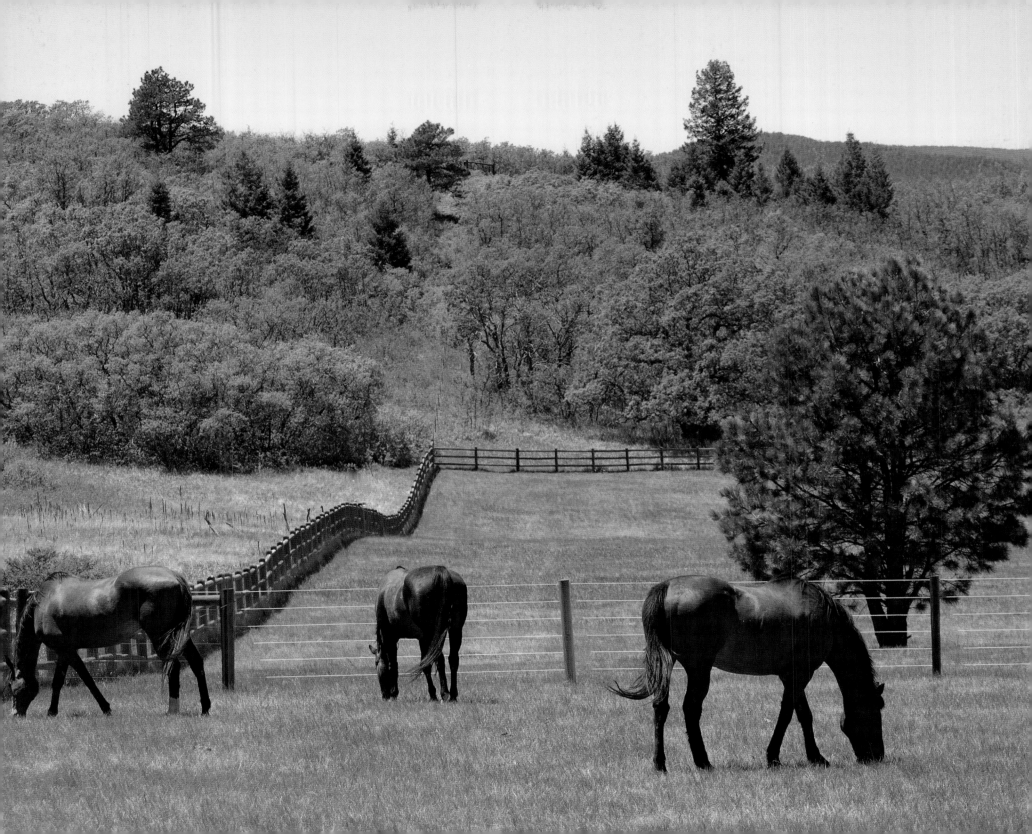

HORSE HARBOR FOUNDATION

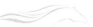

The metal gate swung open and Saint Samantha bolted onto the field. Choco tried to stay close, but his cautious pace put him at a disadvantage, and within seconds Saint Samantha, or Sam, gained several lengths on him. She abruptly veered to the right, slowed to a trot, and then came to a

complete stop at the far corner of the field where patches of new grass grew velvety soft, still dripping from the morning rain. Without the sound of Sam's steps to guide him, Choco stopped to get his bearings. He cocked his ears, and then turned to the left, walking gingerly until his front feet met the thorny vines of an encroaching blackberry bush. His sensitive ears picked up the sound of Sam chewing; he turned and walked toward her until his gray muzzle touched her haunch. Having found his companion, Choco relaxed. He dropped his head and began to graze at her side.

This is the pair's daily routine. Allen Warren, founder and executive director of Horse Harbor Foundation at Harmony Farm, said it's a short reprieve for Sam, evading Choco. Both horses are in their mid-30s, and they've been stablemates since Choco lost his sight. Like all of the horses at Horse Harbor, Choco came to the farm in need of a permanent home. Although he was only partially blind when he arrived, a genetic defect claimed the rest of his sight within two years. Knowing that Sam would make a caring companion, Allen introduced the two and moved them into a shared stall and paddock. Now Choco is rarely more than a few feet from Sam. He relies as much on her eyesight as on her generous, nurturing spirit.

Founded in 1994, Horse Harbor Foundation in Poulsbo, Washington, provides a permanent home to more than 30 horses, many of them elderly, disabled, or suffering from health problems. Some were seized by the county humane society and had no possibility of being adopted because

ABOVE: Allen Warren, founder and executive director, rubs noses with S'Mores, a new filly at the sanctuary. OPPOSITE: Darlyn scratched her right hind leg and received prompt attention.

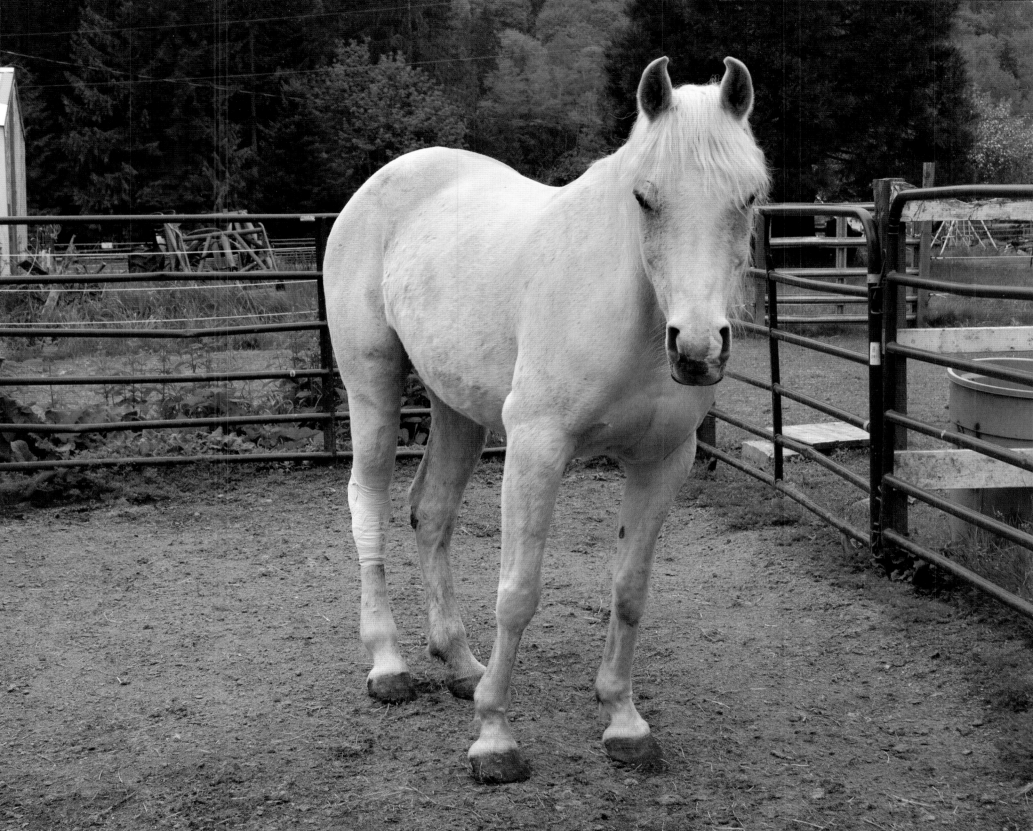

of their age or condition. At Horse Harbor, all horses are given a chance to thrive and be pampered for the remainder of their lives. "We rescue horses that otherwise cannot be placed and make sure they live out their lives in peace, comfort, dignity, and love," said Allen. "We want their last years here to be the best of their lives."

The sanctuary is on the grounds of a former dairy farm, a beautiful setting at the base of wooded hills dense with moss-covered fir trees and thick patches of ferns. The surrounding pastures are always colored a deep green from frequent rainfall, which contributes to the lush landscape, but poses a terrible problem for low-lying fields. Initially, flooding was a

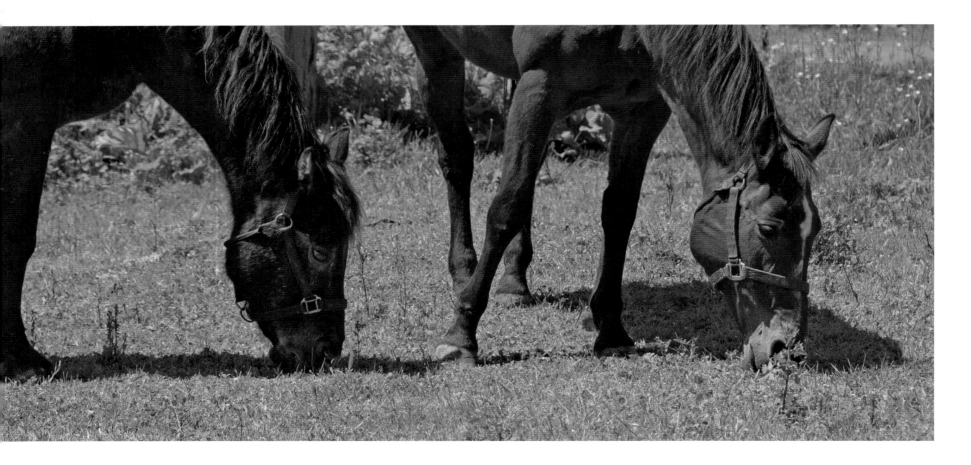

Nine horses at Horse Harbor are older than 30, including Choco (left), who is blind, and his ever-near companion, Saint Samantha.

constant threat to the stables until the foundation acquired the property in 2005 and enlisted help from the Kitsap Conservation District to create a bioswale, perhaps the first of its kind designed for a sanctuary. By catching, filtering, and dispersing runoff—not only from the hills, but also from the barn and paddocks—the bioswale—in addition to a recently installed modern manure-management system (also created with the help of the Conservation District)—has greatly improved conditions at the farm.

In a field opposite the one where Sam and Choco were grazing was a group of geldings and mares, their muzzles deep in spring grass. Allen knows the details of their pasts, personalities, and lengthy medical charts. A striking Morgan gelding named Chance has stringhalt, a rare condition from inhaling toxins. It causes involuntary flexing of his back legs, which his previous owner considered unacceptable. Lovable Johnnie has Cushing's disease, an incurable hormonal affliction similar to diabetes; and Meesha, whose former owner had terminal cancer, has permanent damage to her front hooves from a long battle with laminitis.

The rescue of abused, neglected, and abandoned horses is the mission of Horse Harbor Foundation, but the nonprofit organization also provides horsemanship and riding lessons, summer camps, clinics, and equine therapy classes. Allen explained that providing educational opportunities serves a dual purpose: it's a steady source of income to help support the rescue work, but it also develops the skills and knowledge base of future horse owners and trainers. Many of the rescues arrive at Horse Harbor with little training. Most, like Meesha and Tiger, a well-trained Arabian-quarter horse cross in his mid-30s, are retired because of age or prior injuries. Younger horses and sound ones with solid training become mounts for riding students, and the most gentle and patient of that group become therapy horses for riders with disabilities.

Four therapy classes are offered each week, with 10 general riding classes for beginning to advanced riders. Students pay a monthly membership fee of $120, which includes four lessons per month, regular access to the stable, and volunteer opportunities. Allen and his wife, Maryann Peachey-Warren, teach a classic style of riding that encourages students to develop a partnership with their horses. Kicking, striking, yanking, or yelling is not tolerated, and students don't use stirrups until they learn how to move in rhythm with the horses' gaits. Horsemanship fundamentals are central to the program: training in horse care, first aid, handling, and stable management begins in the barn aisle, where each

Chance, who suffers from stringhalt, rolls in the pasture near elderly Tiger.

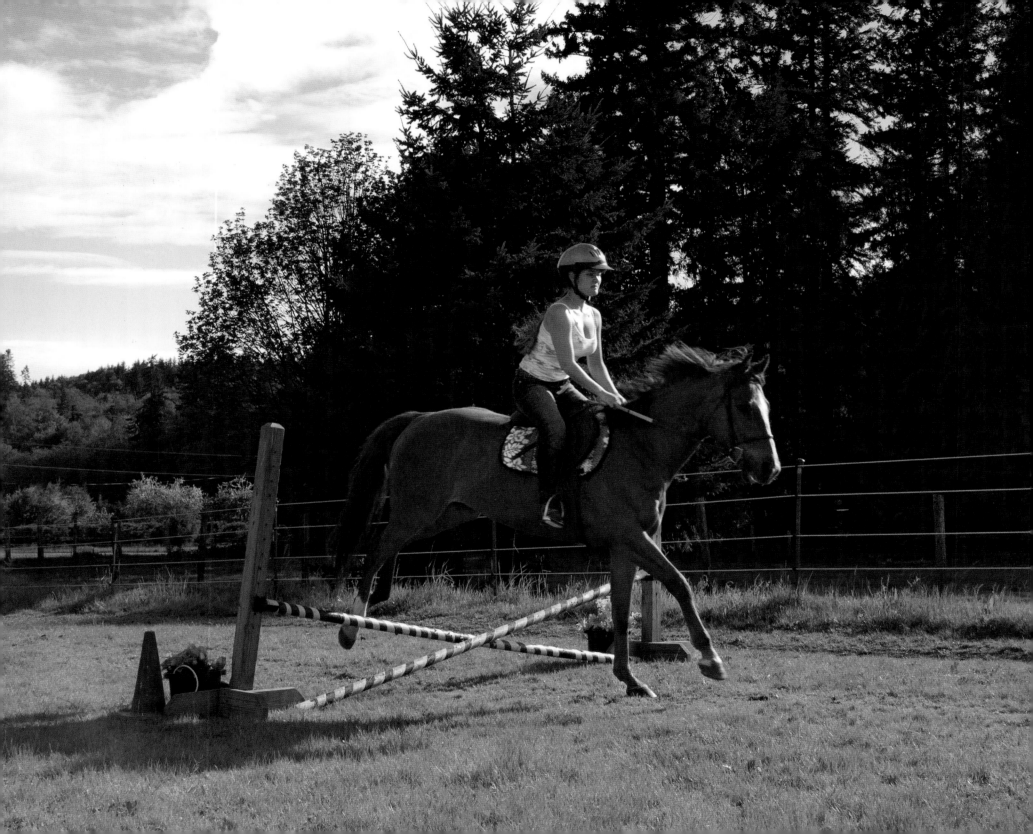

student must groom and perform a seven-point health check before saddling his or her mount for a lesson. Students inspect the horses' legs for wounds, abscesses, or tenderness and their coats for abrasions. Riders even check their horses' teeth and listen to their digestive tract for unusual rumblings that might indicate the onset of colic. Although all of the horses benefit from the daily health checks, it's especially important to keep a watchful eye on older horses that are more likely to suffer from arthritis or other inflammations of the joints.

VOLUNTEERS

On most afternoons the barn is filled with the voices of volunteers, most of them young women and girls who work up to 12 hours a week in addition to taking riding lessons. Some of the members have been regulars at Horse Harbor for years. Their laughter reverberates through the metal barn as they groom horses, muck stalls, and scrub the dirt off tack. Allen and Maryann affectionately refer to the regulars as "barn rats," a title the members are happy to claim. An old office in the hay barn serves as a private clubroom. The walls are lined with framed photographs of smiling riders on horses groomed to the nines. During the summer, some of the girls spend the night there, falling asleep to the sounds and scents of the horses, as well as those of Horse Harbor's resident rescued goat, Bob, who shares an adjacent paddock with the ponies. Bob is a carrier of CAE, a virus similar to HIV that can be transmitted to other goats but not to other animals. This condition, in addition to his size and easygoing temperament, make him an ideal companion for the ponies.

Senior volunteer Kristin Vining was only seven years old when she enrolled in her first riding class at Horse Harbor. An exceptionally small

child, Allen admired her earnest determination to help around the barn, so he let her shadow him in the arena as he taught riding classes. "She was so small that I didn't know what she could do to help," he recalled. By age 14, Kristin was mentoring other riding students, and at 17 she was assisting with horse training. Now an astute instructor, Kristin shares teaching responsibilities with Allen and Maryann. "Horses are the teachers until the rider reaches a certain point," she said. "After that point, the roles are reversed and the rider becomes the teacher. You learn something new every day, and you learn something new every time you get on a horse."

Kristin and other members take more than riding and training skills away from their experience at Horse Harbor. The volunteers that remain involved in the organization for several years learn practical management skills; they become mentors to younger volunteers, and, if interested, can earn a position as an instructor's assistant. As she prepares for college,

OPPOSITE: Kristin Vining, senior volunteer, student, and riding instructor, schools Maggie over a jump. ABOVE: A dressage class for young people with disabilities practices a drill, riding without stirrups to attain good balance.

Kristin has a tool chest of skills to access as she navigates life's challenges—skills that she gained from the various roles she has played at Horse Harbor. "I've learned leadership, patience, problem solving, teamwork, and social and communication skills," she said. "And because Horse Harbor is a rescue, I've also learned to enjoy everything you have, and that happiness can come from even the smallest things."

THE BEGINNING

Hanging on a wall in the modest barn office are a number of framed newspaper articles. There are new and old stories about Horse Harbor from local newspapers, as well as a photo taken in 1957 featuring a young Allen sitting in a small cart behind a petite chestnut horse at a horse show. Although the horse in the photograph is the size of a pony, Allen said it was actually a six-month-old colt that he had trained to harness before it was old enough to ride. "Those pony people were pretty upset because we won the blue ribbon in their class and this wasn't a pony. But the entry requirements didn't mention breed, just size," he said with a laugh.

Above the photo of Allen is a yellowed and creased clipping from 1956 featuring Peyton Randolph, a North Carolina master horse trainer who used a technique called "gentling," which relies on clear communication and understanding of an animal. The news clipping shows both a buffalo and a Brahma bull he had trained as proof to naysayers that using kindness over dominance works on any animal. Although it is more commonplace now, Allen explained that gentling was a new and controversial technique at the time. Nonetheless, the gentle approach resonated with him, and he gleaned what he could from the horse trainer's teachings, practicing it on the animals at his family farm. To this day, Allen remains an advocate of gentling and uses

it to correct bad habits or to train the sanctuary horses. More importantly, he passes the philosophy on to his students. "Mr. Randolph always used to say that if you break a horse, you end up with a broken horse," said Allen. "Here, we train the horse to be a willing partner for its rider, not a beast of burden."

Eventually, an insatiable curiosity and wanderlust got the best of Allen, and in 1963 he said good-bye to his rural North Carolina roots to head to college in New York. He stayed in the Northeast until the late 1970s, working in New York City as a trade-association executive, far away from farming and horses. When he reached the top of that profession and "either achieved all [his] goals or forgot what they were in the first place," he decided he'd had enough of city life and moved to the open plains of eastern Montana. There, he purchased Sam, a spirited and bright two-year-old range filly, and Dandy, a stunning six-year-old palomino mare. One year later, Allen relocated to Spokane, Washington, and shortly thereafter picked up again to move further west, eventually reaching the rain-soaked Kitsap Peninsula with his two mares. Soon after the move, Sam gave birth to Wild Irish Rose, or Rosie for short. Though Dandy passed away from cancer in 1996, Sam remains an important part of Allen's life; he still considers her his oldest friend, and Rosie his baby, even though the pretty bay is almost 30 years old now. The two are the only non-rescued horses at the sanctuary; Allen lovingly refers to them as his Horse Harbor Foundation co-founders.

Allen had not planned on launching a rescue and sanctuary; he did so in response to clear need. As one of the most experienced and respected horsemen in the county, he was frequently called upon by the Humane Society of Kitsap County to help horses in dire situations. He took in his first rescue, an elderly half-blind mare, in 1993, when her owners could no longer care for her. The next year, he rescued two elderly horses abandoned in a pasture. The educational mission of Horse Harbor also evolved when

it became evident that far too many horse owners—many of them well intentioned—lacked knowledge of proper horse care. "I can't say I planned to go into the rescue business; it's more like I was led to it. I've done a lot of things in my life, but I am blessed that this last chapter has been the most rewarding, as sad as it is sometimes," Allen said. When asked about the most important attribute a horse rescuer needs besides compassion, Allen laughed. "You just have to have trouble pronouncing the word 'no,'" he said.

THERAPEUTIC LESSONS

We watched as Maryann walked Blackjack (also known as Jack) and Philip, a young man with autism, around the perimeter of the covered arena, prompting horse and rider to stop, turn, and walk. Philip kept a light hold on the reins, his feet dangling at Jack's sides. Cathy Grisdale, Philip's mother, watched from the viewing deck. She said that Philip has always been attracted to horses. She put him on the back of a horse at the age of two. He had taken countless therapeutic lessons, but had never been given the chance to guide the lesson horse on his own until he started riding at Horse Harbor. He was just led around by a handler. Maryann took a different approach: she encouraged Philip to rein Jack in different directions. She cued him to walk and stop. He was resistant at first, but over time he became comfortable and willing to engage in the lesson. "It took Maryann's great warmth and skill to make him totally comfortable and help him to realize that he has control of the situation," said Cathy. "The simple understanding of cause and effect has made a difference in his daily life."

Philip doesn't speak, but lately he has attempted to form new words and has even started to string a few together. His family has also noticed an improvement in his mood. Cathy attributed the positive changes to his

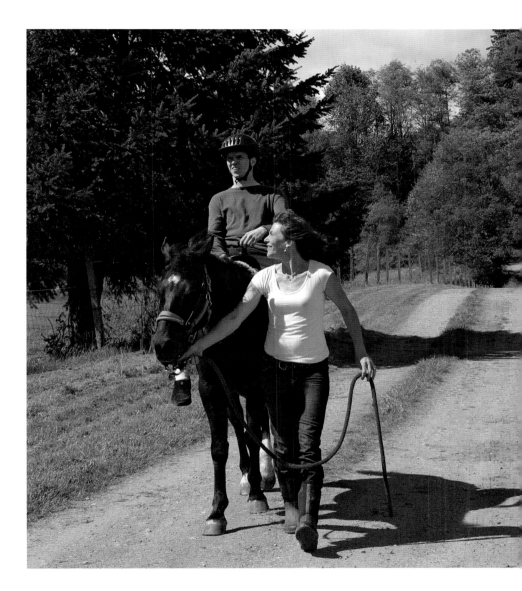

Maryann Peachey-Warren, associate director and head instructor, leads Blackjack and Philip Grisdale on the wooded farm road alongside the sanctuary pastures.

weekly lessons at Horse Harbor, which are more about building confidence than about riding. Just like other students, Philip is required to help groom and saddle his lesson horse. Although his ability to focus for more than a few seconds at a time makes even the simplest task a challenge, Maryann remains patient, encouraging Philip to continue brushing Jack in small, gentle circles. Even when his attention strays, she's right there, guiding his hand and brush back to Jack's side.

Maryann's abilities as an instructor were not recognizable to her until she started working with horses and children with disabilities six years ago. Her background in parks and recreation administration and social work developed her communication and management style, but life experiences and education unexpectedly shaped and cultivated her role as Horse Harbor's senior equine therapy instructor. In 2012, she attained certification as a therapeutic riding instructor with PATH International, an organization that offers training courses for people interested in working with individuals with disabilities. Maryann's certification allowed Horse Harbor to build up its therapeutic riding program. "My style of teaching is to meet students where they are and get to know their unique learning style, whether it's visual, experiential, or auditory," she said.

PROJECT SAFETY NET

In 2010, Horse Harbor Foundation earned accreditation with the Global Federation of Animal Sanctuaries (GFAS). This was a significant achievement for this relatively small rescue, and it was the first sanctuary on the West Coast to be certified by GFAS. Patty Finch, executive director of GFAS, noted that one of the outstanding qualities of Horse Harbor is its ability to generate operating revenue through its various programs. She also applauded Allen for his generous outreach to other equine rescue organizations, providing mentoring and support when their needs outweighed finances. In 2009, Allen headed the creation of a much-needed free community hay bank to help low-income horse owners during the long Pacific Northwest winters. Then, in 2010, he launched Project Safety Net for Horses, a more comprehensive owner-assistance program designed to help committed but struggling horse owners to keep and care for their horses properly. The overwhelming success of this effort led to the development of a nationwide pilot program with the potential of saving thousands of horses from neglect, abandonment, or the horrors of the slaughterhouse.

In its first year, Project Safety Net, funded with a private grant, helped keep 63 horses in their homes. Allen knows that many more owners in the area won't be able to feed their animals, and by partnering with two other rescues in his three-county service area, he hopes to expand the program tenfold in the future. He would be happy if a dozen more equine rescue organizations emerged in the region—the need is there. But that's unlikely to happen, so Horse Harbor does its best to help horse owners with an approach Allen calls "in-place rescue," which calls for sharing resources, providing education, or offering moral support when necessary. These strategies all fall under the umbrella of rescue work. "You have to be willing to work beyond your own front gate in equine rescue if you really want to make a difference," he said.

Allen stood at the gate to the pasture where Choco and Sam grazed, content to be together on a warm spring day. Beyond the barn in another pasture, a group of horses broke into a collective run. Their playful antics belied age, injuries, and health problems. They were just having a good time being horses and perhaps even joyfully expressing their great fortune at being given a second chance. Allen said this sight is what keeps him going.

Onyx, a newly arrived Thoroughbred, is finding her place in the established pasture band.

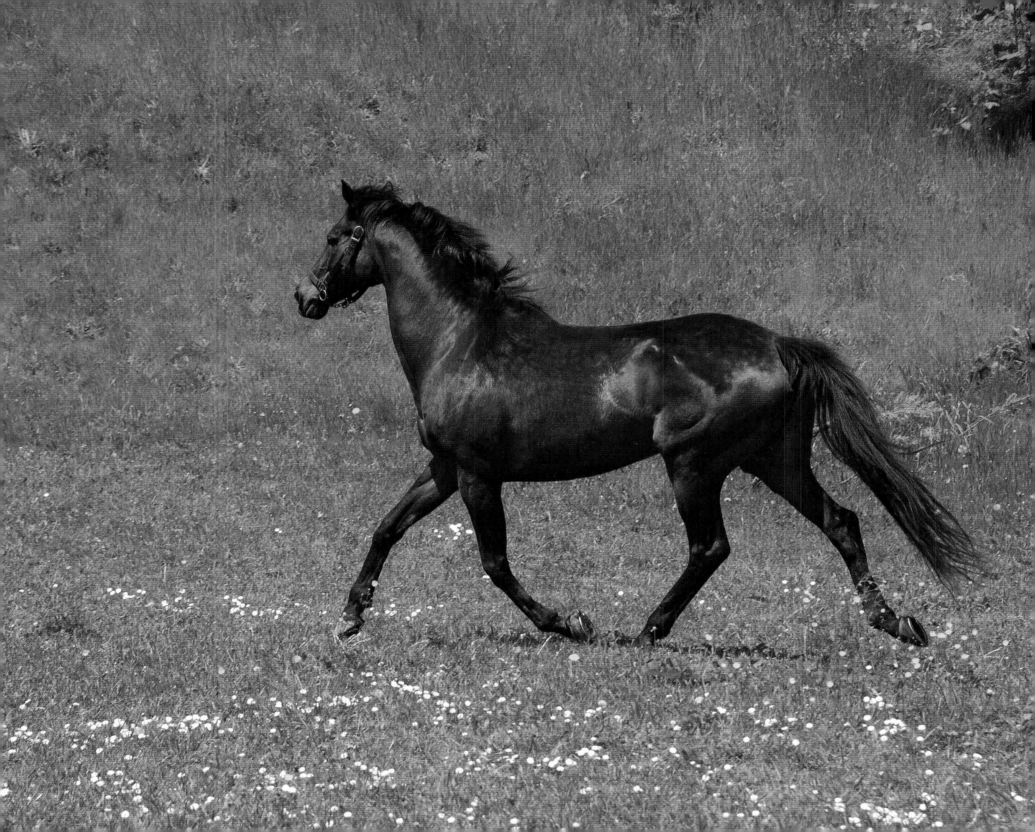

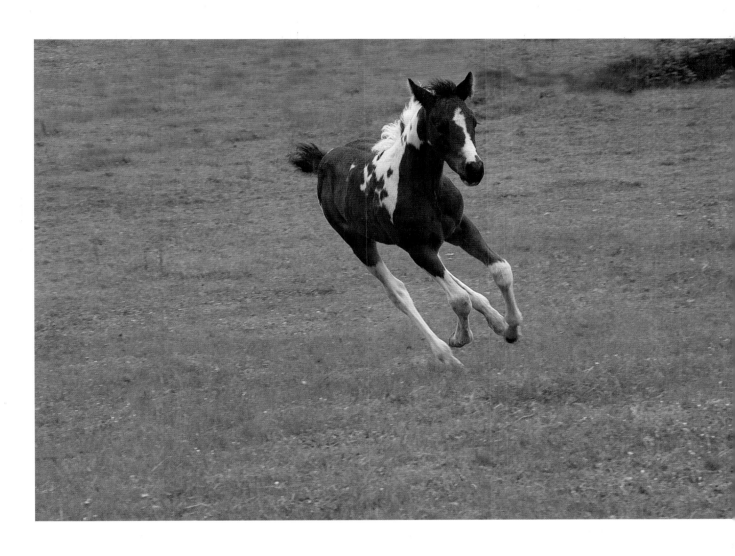

OPPOSITE: Fay and Honey, elderly former racehorses who suffered abuse and neglect, receive exceptional lifetime care at Horse Harbor, including daily turnout.

ABOVE: S'Mores enjoys an exuberant romp in the front pasture.

RIGHT: Mona Lisa dashes uphill through the pasture to join her band.

OVERLEAF: Dancer, a miniature pinto, grazes near the barn (left). Orion uses a shed support as a scratching post (right).

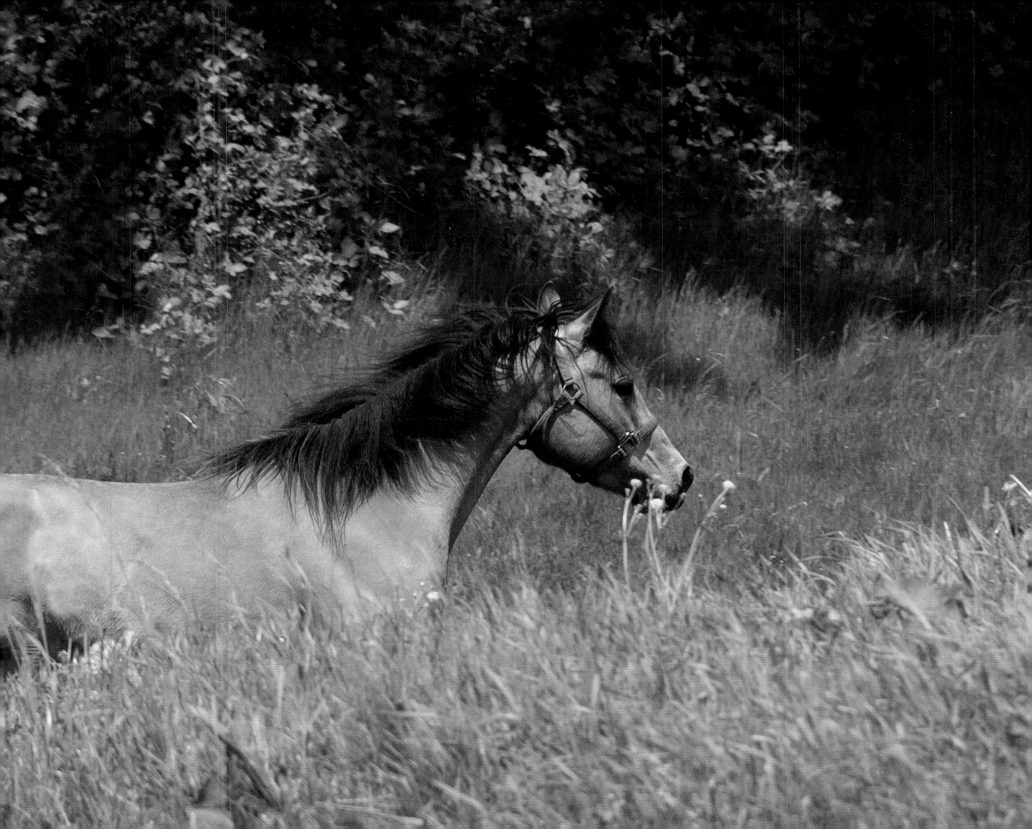

LAST CHANCE CORRAL

From her second-floor bedroom, Victoria Goss can look down into the foal barn. For six months of the year having that vantage point is important, as it can make the difference between life and death for a sick foal. Victoria rarely sleeps between January and June, when the foal barn is filled to capacity with newborns. There are usually 15 in the barn at a time, sometimes as many as 20, plus Last Chance Corral volunteers who work around the clock to give life and hope to the newborns.

Last Chance Corral, located outside of Athens, Ohio, is the largest orphan foal rescue in the United States, maybe in the world. Since 1986, Victoria and her volunteers have worked tirelessly to save the lives of foals from nurse-mare farms in Kentucky. The rescue program consistently maintains a four percent mortality rate. In 2011, that number dropped to just two percent—impressive, considering the endless health challenges faced by foals torn from their mothers at birth. Victoria said the reason for the sanctuary's success is the 24-hour care and affection it provides. Foals are held, hugged, and swaddled in blankets. Body contact is important for establishing a sense of well-being, as is proper nutrition and a squeaky-clean environment to fend off bacteria and viruses waiting to attack the foals' weakened immune systems.

Most nurse-mare farms are established near Thoroughbred breeding farms in Kentucky, although the use of nurse mares is certainly not limited to the racing industry. A nurse mare is bred to produce milk for another's foal, usually a more expensive brood mare that must be rebred within seven to 10 days after giving birth or a performance horse that can't be allowed time out to nurse a foal. When a nurse mare is hired and transported to a breeding farm, her own foal is left behind. Some farms raise the foals by hand, but many send the newborns to auction.

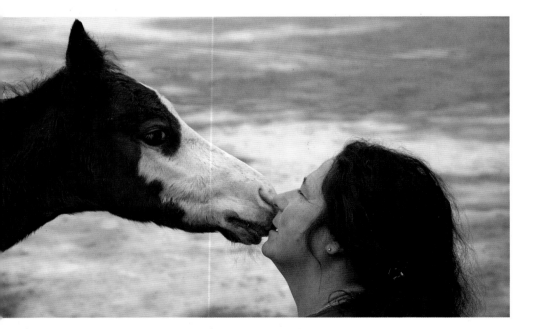

ABOVE: Victoria Goss, founder and director, comforts Happy, an orphaned nurse-mare foal. OPPOSITE: Roland and Happy needed round-the-clock care to keep them alive and enable them to thrive.

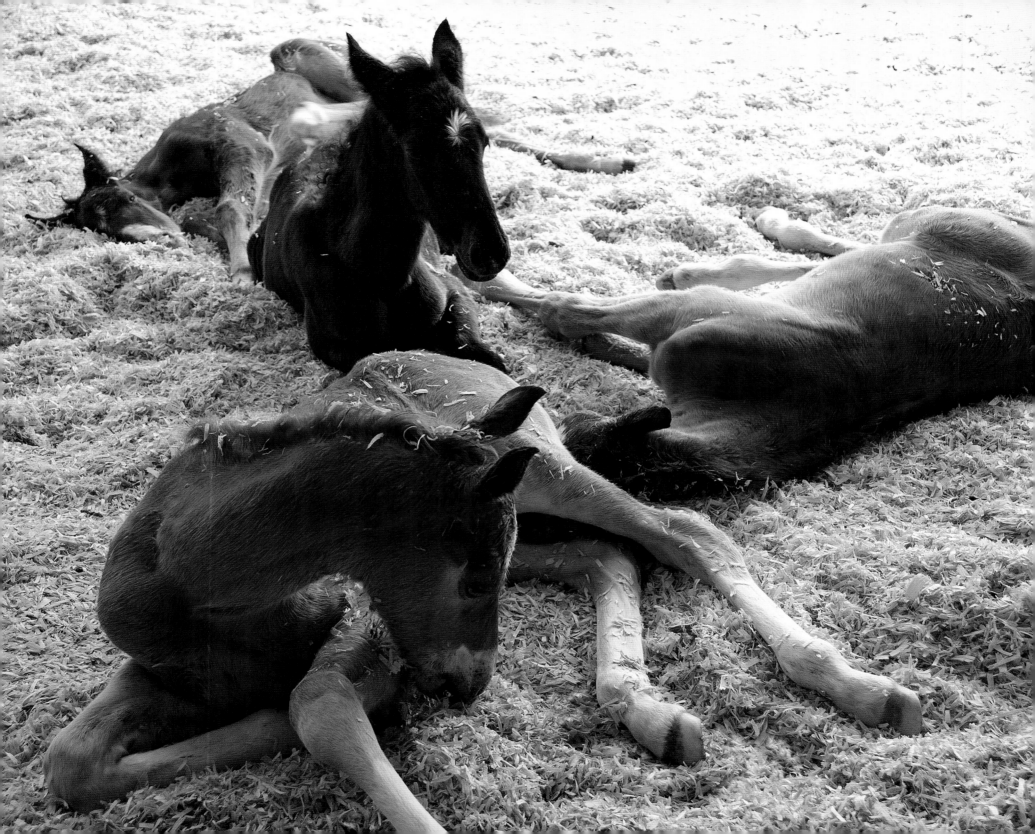

A foal's hide, also known as ponyskin, is a valuable commodity, especially in the fashion industry, where it is used in pricey shoes, bags, and other accessories. The more colorful or distinctive the foal's coat, the more the ponyskin is worth on the market. Although Victoria has been involved in the horse industry most of her life, she was 30 years old before she knew the definition of "ponyskin." A vendor at a Native American powwow in Rhode Island was hawking a stack of foal skins, and when she inquired, the vendor's ambiguous response raised a red flag. "He said something about a government program, and that the foals had all died. I knew there was something wrong with that answer," she said. She researched ponyskin and discovered it was a by-product of nurse-mare farms, many of which were located within 200 miles of her farm in Athens.

THE BEGINNING

The first foal Victoria rescued was close to death when she found him stretched over a pile of refuse at a nurse-mare farm outside of Lexington, Kentucky. The owners assumed he was near death so they removed him from the stall and discarded him like trash. Victoria picked his tiny body off the ground, paid the owners $150, and loaded him into her Jeep along with her rescued wolf (named The Wolf). She recalled that difficult drive home to Athens—a sickly foal in the backseat, a rambunctious wolf, and a terrible snowstorm. She kept the foal in her kitchen for the first few weeks as she nursed him to health. "It was something else," she said. A month later, she cobbled together donations and returned to Kentucky to rescue more orphan foals.

That first year, Victoria and a handful of volunteers rescued and saved 76 foals. The knowledge and skills she had gained in veterinary school and while working as a vet technician were invaluable, but she also had the support of a local veterinarian, Dr. Pete Smith, who taught her how to recognize and treat problems unique to newborn foals. It was a steep learning curve, but Victoria and the volunteers still managed to save 80 percent of the babies that year. The experience prepared them to expect anything and assume nothing.

By its second year, Last Chance Corral had a system in place, and contributions from supporters poured in for the purchase of more equipment, blankets, towels, bedding, and food. Each year thereafter, Victoria and her tireless volunteers became more adept at providing care and anticipating trouble. One year, they were able to purchase a washer and dryer for the five to seven loads of towels and rags that are soiled each day. Victoria secured a deal with the leading manufacturer of mare's-milk replacer so that the sanctuary could purchase 100-pound bags at a discount. The local grocer gave her a break on tubs of yogurt. Victoria said that at the height of foal season, the sanctuary goes through $300 worth of vanilla yogurt a week. A newborn foal's digestive tract requires the perfect balance of bacteria to prevent diarrhea. The active cultures and enzymes in yogurt help to maintain that balance; the vanilla flavor is Victoria's trick for enticing the foals to eat it.

Volunteers come from as far away as Columbus; some are students of veterinary medicine at Ohio State University who are anxious to get hands-on experience saving lives. Several times during foal season, 4-H groups and youths from community-service programs help for a day. Regular volunteers spend long days and nights together over the course of six months. They learn how to tube feed and give injections, in addition to the seemingly endless cycle of towel laundering, bucket scrubbing, foal bathing, and barn mucking.

When a trailer of babies arrives, the crew is ready and waiting to document each foal's approximate age by hours or days, color, sex, and condition. The strongest ones are released into the foal barn to explore their temporary home; the sick and injured are blanketed and placed in heated

A black Tennessee Walker colt and a trio of equally fortunate nurse-mare foals were rescued together.

stalls. Treatments begin immediately. For the first few days, and in some cases weeks, the foals undergo a rigorous feeding and monitoring schedule. Volunteers check temperatures, nutrient intake, weight, bowel movements, respiration, and heart rate. The foals eat many times a day; some require tube feedings, and the very sick receive intravenous fluids and enemas. Often, blood transfusions are required. Most nurse-mare foals' immune systems are fragile from being denied colostrum, the first milk produced by the dam prior to foaling. Antibodies in colostrum protect the foal during the first few months of life until its own immune system matures. When a foal is denied colostrum or doesn't receive adequate amounts within 12 hours after birth, it's susceptible to life-threatening diseases.

"This is emotionally and financially devastating work," said Victoria. Even when she's not in the foal barn, she's mulling over the various health conditions that threaten the foals, always trying to find the right solution. "I'm constantly challenging myself to consider every possible way to help them," she said.

VICTORIA'S STORY

It may not be a coincidence that one of the 19th-century barns that Victoria tore down and rebuilt on her property was once a dairy farm in Athens. She grew up on a New England dairy, one of seven daughters. In the third grade, Victoria was given her first pony and a warning from her parents that she would lose him if she failed to provide proper care. Victoria's parents had already gone through the "pony phase" with the eldest daughters with poor results. Although Victoria lavished attention and care on her pony, at three different times she fed him late in the day, which fell under her parents' definition of neglect. She said her parents weren't cruel; in fact, they had very high standards of animal care and required that their daughters abide by those standards. Shortly thereafter, her parents sold the pony to a neighbor.

Although losing her pony was a painful learning experience, it made a lasting impression on Victoria, and by age 12 she had two ponies that she showed regularly in 4-H club shows. That same year, she discovered a starving horse at a nearby farm and begged her father to let her purchase him—she couldn't bear to witness the suffering. Eventually, her father gave in to her passionate pleas, and Victoria emptied her piggy bank, paying $50 for the gelding. After several months of proper care and feeding, his weight

Dr. Ryan Rutter floats (files) the rough edges that have developed on Lucky's teeth as Pamela Martin, his assistant, steadies the mare.

was back to normal and the luster had returned to his black coat. A year later, Victoria sold the horse for $50 to a neighbor who adored him; he lived a long life and died of old age.

The successful rescue and rehabilitation of the black gelding gave Victoria a boost of confidence and a taste for rescue work. For many years, while working as a trainer and rider, she rescued one or two horses at a time, and in 1986, she established Last Chance Corral. With an organization, barns, and paddocks in place, Victoria could provide refuge for many more neglected and abused horses. Although she established the sanctuary in Rhode Island, eventually she moved it to the Appalachian region of southern Ohio, where she believed the need for an equine rescue organization was much greater than in her native New England.

THE FARM

Victoria's hillside farm is a modest two and a half acres tucked in the curve of a well-traveled winding road. Nearly every inch of land is accounted for and every structure has multiple purposes. Although the farm lies at the base of a soggy hill, Victoria diligently battles mud—and wins. There are three barns, a shed, several paddocks, a pasture, and Victoria's rustic log cabin (one of the oldest structures in the region), which has been expanded to include a kitchen, office, second-floor bedroom, and two decks. The spaces are filled with hand-carved antique furnishings and a lived-in sofa and chairs that she shares with her dogs, Rex and Valkry, and elderly cats, Miss Kitty and 99. There are racks of donated clothing for Last Chance to sell, and various pieces of tack, including an enormous collection of bits that hangs from the living-room ceiling. Some resemble torture devices, the reason why Victoria refers to this unusual display as her "hall of shame."

The well-conceived foal barn is attached to the cabin and is significantly larger. In the adjacent milk and medicine room, shelves are lined with medicine bottles, wraps, syringes, Karo syrup, ointments, shampoo, and rolls of towels stacked several layers deep. There are three heated isolation stalls for treating the very sick, steel siding for easy scouring, rubber flooring with an advanced drainage system, and an outdoor corral for frolicking. During foal season, a thick layer of wood shavings covers the floor to make a soft bed for foals and for volunteers who curl up next to the newborns to provide comfort and catch a quick nap.

The Hope dairy barn has been restored as a stable.

Nearly everything on the farm is repurposed; Victoria has a knack for reusing, retooling, and renovating objects, materials, and buildings. In fact, all three barns at Last Chance Corral were torn down, moved, and rebuilt by Victoria and volunteers. They fit so well in their surroundings that it's hard to imagine they had a long life serving other purposes. Victoria said that reusing structures is not only about saving money; it also reflects her admiration and respect for historic objects. She proudly pointed out the brick tiles she laid in the center aisle of the former Hope Dairy barn, the hand-sawn beams, and the appropriate sign painted above the door: "Hope." And she knows the buildings' histories. For example, the recovery barn—which was built with large stalls for horses recovering from injuries or surgery—was originally constructed in 1893 by Harlow Calvert, an escapee from a prisoner-of-war camp in Andersonville, Georgia. Although she was unable to save the barn's original stone foundation, Victoria salvaged the cornerstone with the date and Harlow's initials chiseled into the surface. The stone is displayed at the entrance to the barn, a nod to the man and his handiwork.

RESCUING ADULT HORSES

During our visit, a group of horses milled about, scratched their chins on the stone wall, napped in the shade, or stood at the gate keeping a hopeful eye on the barn where farm manager Leni Sheeks—the sanctuary's only paid employee—was mucking stalls. In the center, a gray roan yearling named Wander stood alone, clearly enjoying the early autumn sun on his back. Wander is a nurse-mare foal from 2010, a tough little survivor who lingered close to death for many days. Victoria would like to make him a Last Chance Corral ambassador, and he would be a natural. In spite of his rough start in life, the attention lavished on him by volunteers instilled in him a sense

of trust and gentleness. Most of the foals raised by hand share those same qualities, which is especially appealing to people who want to raise and train their own horses.

In the past, Last Chance Corral had no difficulty finding homes for the 150 to 200 foals that came through its barn each season. But according to Victoria, the area has become saturated, and the tough economy has made it more difficult to place the babies. Last Chance is expanding its reach by showcasing foals at annual events like Equine Affaire in Columbus, Ohio, where it has an opportunity to share information about nurse-mare orphans with a wider audience. It also uses the event as a way to raise funds through sales of used tack donated by supporters.

OPPOSITE: Wander dozes in the geldings' paddock at the edge of the farm. ABOVE: Leni Sheeks, barn manager, holds Lacey, who greets Lucky, a palomino mare whose left ear bears a bullet-sized hole.

Saving nurse-mare foals consumes a significant portion of Victoria's energy during half of the year, but she also rescues neglected and abandoned horses and ponies, many of them from regional auctions. Although Victoria tries to keep the number of adult horses down to eight during foal season, in recent years, it has not been unusual for that number to tick upward to 12. As quickly as one horse is adopted, another shows up to take its place. The cost of feed has risen beyond the means of many horse owners in the region, so they're feeding less or not at all. Victoria receives many calls a day asking if Last Chance Corral has room to take another horse. Some owners mistakenly trust auctions to find a good home for their family horse or pony. A network of people associated with Last Chance frequents the sales, vigilant scouts looking for horses they know or ones that the sanctuary would be able to quickly place.

During a 2010 visit to the notorious Sugarcreek auction in Ohio, where an estimated 97 percent of horses go to meat buyers, the scouts saw a horse that had been adopted from Last Chance Corral a year earlier. Luckily, they were able to reclaim the horse and return him safely to Virginia. In September 2011, a friend of the sanctuary recognized a horse standing in a kill pen at a local stock auction. Knowing the history of the horse, later renamed Target, the volunteer immediately contacted Victoria. Naturally, she agreed to take him in. Target had been raised, loved, and ridden as a trail horse by his former owner before he was taken to the auction. Had he not been pulled out of the kill buyer's pen, he would have been loaded on a truck headed to a Canadian slaughterhouse. Victoria's associate purchased Target for nearly three times what the kill buyer paid for him. It angered Victoria that the gelding's owner so willingly abandoned him at a stock sale without attempting to find him a home.

Target has a home at Last Chance until someone adopts him, and Victoria is confident that it won't take long. His adoption fee is $2,500, which is reasonable considering his lineage, education, and good looks. There are several horses at the sanctuary that have slightly higher adoption fees and several that are adoptable for free, depending on the circumstances. These are sound horses with impressive pedigrees and professional training. According to Victoria, there is nothing wrong with them; they were just in bad situations. Although some, like Target, have been rescued from auctions, several have been donated to the sanctuary by owners who had to surrender their performance horse, perhaps to guarantee that the horse would be placed in a safe home or perhaps for a tax write-off. No matter the reasons, Victoria looks at it as a win-win situation for all involved.

In 2001, Last Chance Corral was recognized by the American Veterinary Medical Association (AVMA) with an award for "doing the most with the least." The rescue also received a Humane Award and a Rio Vista Hank Award for Outstanding Animal Rescue. Victoria is proud of the honors, especially the AVMA award. With only one paid employee, two seasonal employees to help pitch and spread hay, and a few dedicated volunteers, Victoria operates Last Chance Corral on a pauper's budget, using creativity and an industrious spirit to handle nearly every challenge that faces her sanctuary. "I have to be realistic," she said. "I've seen too many cases where people want to do good but they don't limit the number of rescues." Victoria keeps no permanent residents at Last Chance, nor does she keep any of the horses or foals for herself, no matter how hard they tug on her heartstrings. "If I had a couple of my own, that would be 10 to 20 horses a year that wouldn't get a chance," she said. "I've 'owned' a good many horses in my time. Now I realize that they were never mine to own anyway. Only mine to love and steward."

Smokey and Evander stroll across the geldings' paddock.

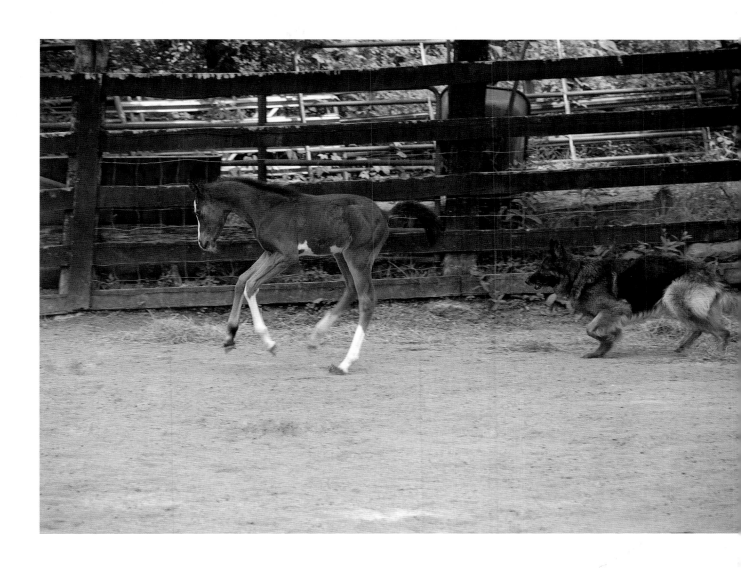

OPPOSITE: The foals sprint uphill together toward the foal barn. ABOVE: Valkry chases Happy as he bucks around the paddock.

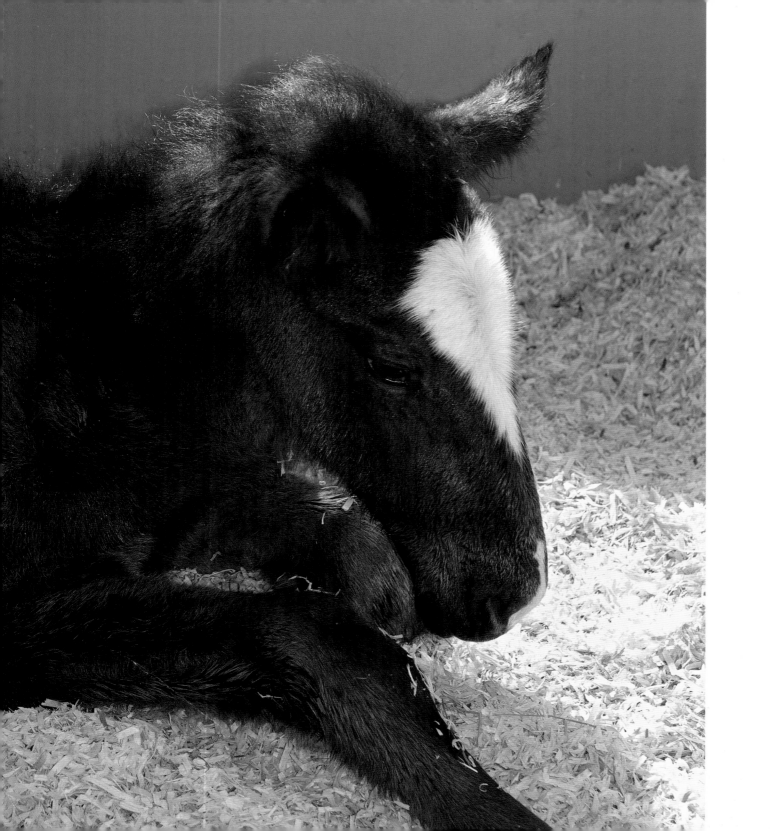

LEFT: Diplomat, a sickly Percheron foal, receives frequent tube feedings and is recovering.

OPPOSITE: Two foals nap after an energetic romp.

OVERLEAF: Cassie, Lacey, and Lucky watch as visitors arrive (left). Cassie checks out the visitors (right).

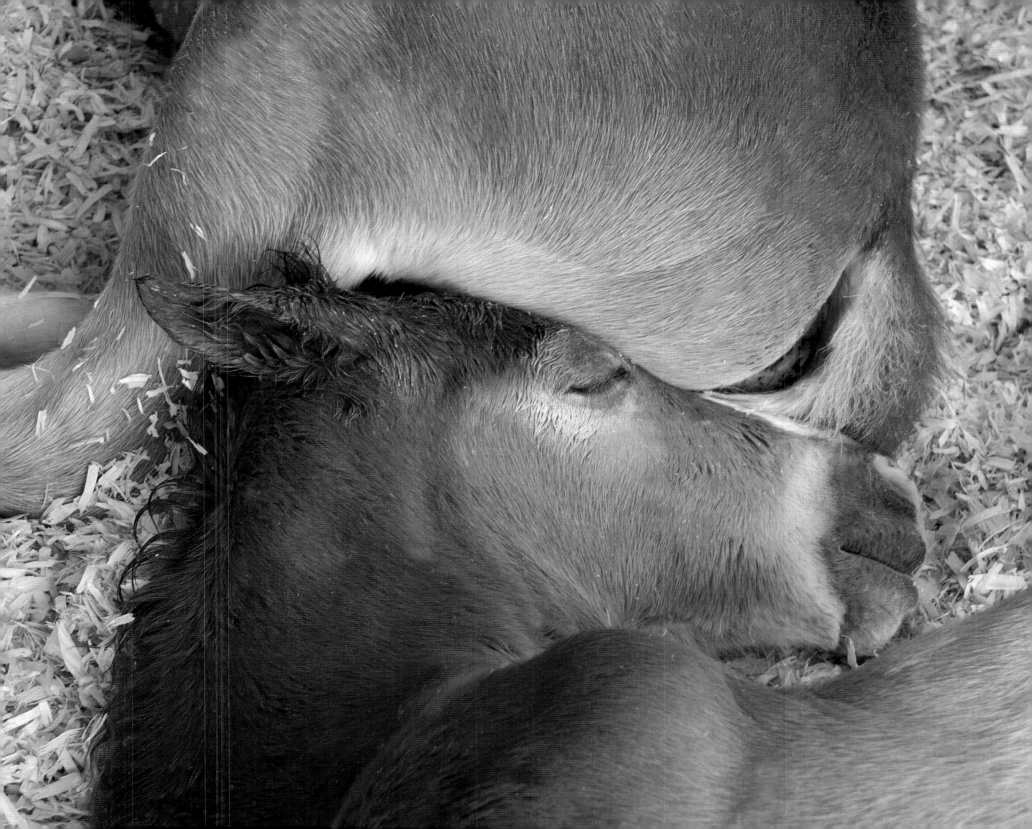

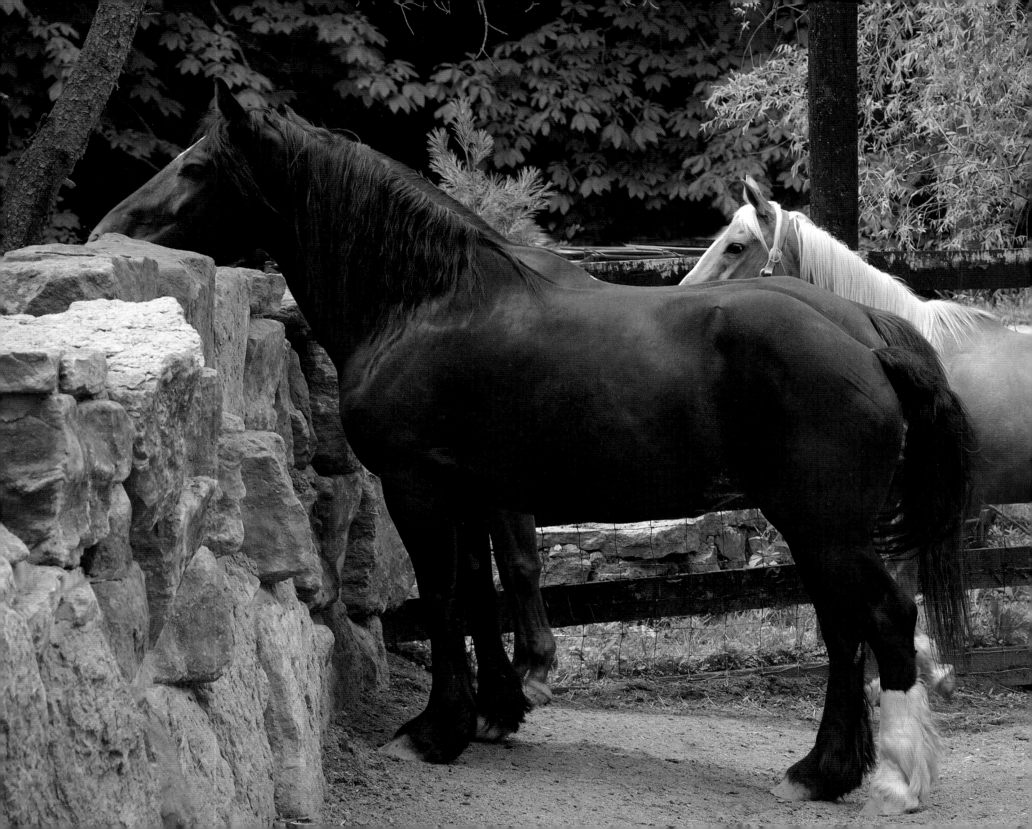

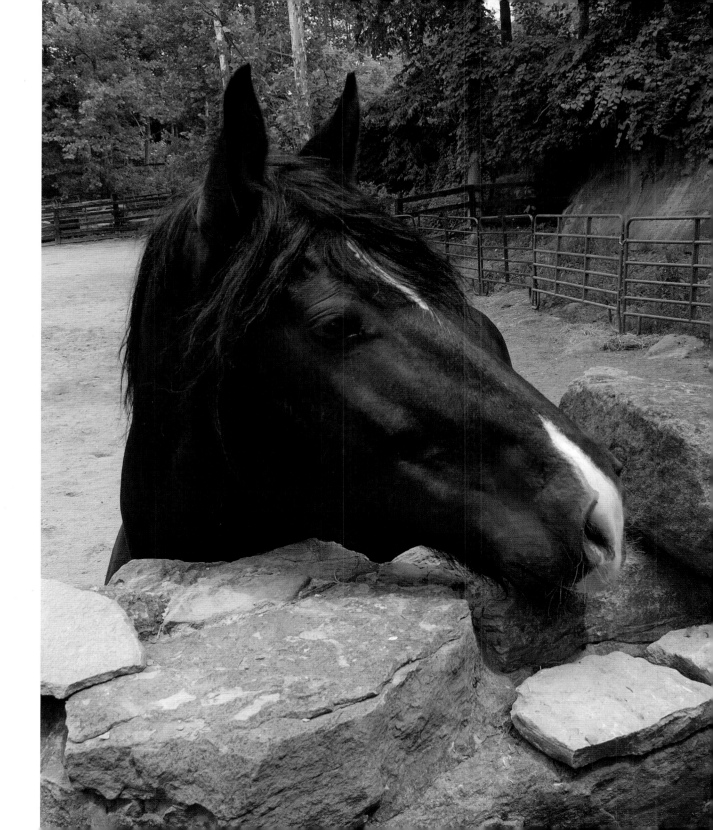

LOPE TEXAS

From the front porch of her modest ranch cottage, where we sat with Lynn Reardon and her dog, Sophie, we could see the small herd of lanky Thoroughbreds grazing in the Texas heat. A warm breeze rustled the leaves of the giant oak tree; a red cardinal landed momentarily on a low branch before flitting off in pursuit of his elusive companion. It was a calm, restorative setting, exactly the opposite of the backside of a racetrack.

But that's just the type of environment Lynn wants for her retired racers. She believes they need downtime, a chance to be "just horses" in a

pasture where they can socialize, roll in the dirt, and snooze in the shade of a tree. This is their transitional period between the track and future roles as jumpers or dressage, trail, or pleasure horses. It's also a place to heal from race-related injuries, the kind that might have condemned some of the horses in Lynn's care to untimely deaths.

LoneStar Outreach to Place Ex-Racers, or LOPE, opened the nonprofit adoption ranch facility in Cedar Creek, Texas, as a natural extension of the online placement service for ex-racehorses that Lynn founded in 2003. The free service offers racehorse trainers, breeders, and owners a place to list their retired Thoroughbreds, quarter horses, and Arabians for sale to non-racing homes. There's also an urgent e-mail network service that will help place at-risk racehorses in a secure home within days or even hours of the alert. Although the program has proved to be extremely successful, it took months of persistence to convince skeptical trainers and owners that Lynn was the real deal and that her services were beneficial to them and their horses. "I had to prove myself," she said. "I had to show that I really want to do a good job and I'm not flaky. If I said I was going to show up, I'd show up. I think I passed an unspoken test with these guys."

LOPE's seeds were sown long before Lynn and her husband, Tom, left their accounting and economics careers in Washington, D.C., for a quieter life in the Texas Hill Country. An avid horse enthusiast and rider, Lynn volunteered with the nonprofit racehorse placement program CANTER

ABOVE: The ranch house rests by a circular driveway beneath aged shade trees. OPPOSITE: Fred and two chestnut companions graze in the pasture nearest to the ranch house.

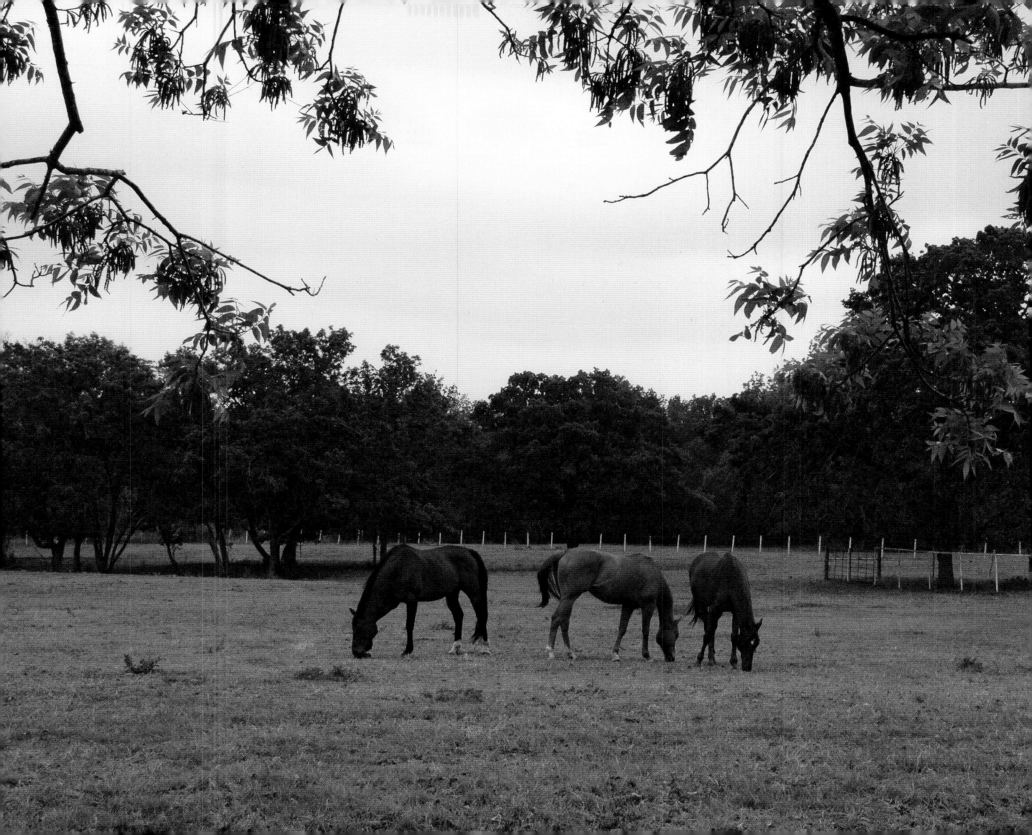

Lynn Reardon, founder and director, looks over her shoulder at Lightning Ball.

(Communication Alliance to Network Thoroughbred Ex-Racehorses), which operates highly effective placement chapters throughout the country. Spending every Saturday for two months at mid-Atlantic area racetracks, Lynn learned the idiosyncrasies of track culture, how to approach barn-seasoned trainers, and the fine art of photographing racehorses for online listings. Soon thereafter, she and Tom relocated to Texas, but she took what she learned from CANTER with her and within a year had launched LOPE's online placement service and garnered support from the Texas Horseman's Partnership and the three largest racetracks in the state.

As word spread about LOPE's services, calls from Texas race trainers and owners started to come in, at first a trickle, then a deluge. Lynn was overwhelmed, but pleased that her fledgling program was underway. Older racehorses that had lost the desire to run or had slowed down, as well as young ones with "couch potato" attitudes, were finding new homes and careers off the track. The biggest problem facing trainers and owners was finding homes for injured horses. Often, they just needed downtime and managed care to recover from their race injuries, but unfortunately the backside of a track—where competitive horses are stabled and trained—isn't suited for convalescent care. These were the horses in danger of going to auction, and with the Mexican border so close, the odds that they would go to a sympathetic buyer were not in their favor.

THE RANCH

Initially, Lynn hadn't intended on managing her own ranch of ex-racers, but a series of events—including an unplanned adoption of an injured horse named Tulsa Mambo—directed her course of action. By 2004, Lynn and Tom were not only Texas ranch owners, but also caretakers of three

Thoroughbreds—Tulsa, Peanut, and Boomer. "We were hooked on the place," said Lynn about the Austin-area property. They scraped together $185,000—a steal considering the land prices they had encountered in Washington, D.C.—and along with the seed money from an anonymous donor were able to establish the ranch adoption program.

Although the ranch purchase and the expansion of LOPE's adoption services seemed to happen in a landslide moment, according to Lynn it was a matter of "small steady actions" that contributed to the growth spurt. Parked along the gravel driveway near the cottage, a red 1941 tractor and a shredder sat idle in newly cut grass. Several yards beyond was a small roundpen, and farther down the driveway was a new, five-stall barn, a donation made in support of LOPE's Homestretch Heroes Rehab Program, which covers the costs of surgery and long-term recovery for horses with extensive injuries. The barn was built on a concrete foundation rather than the more commonly used packed earth. LOPE opted for the poured flooring for sanitary reasons; surgery and emergency procedures are not unusual occurrences at the ranch, and Lynn needed to be able to wash and sterilize the indoor spaces.

With 26 acres of grassy pastures, Lynn is able to take in horses that need recovery time or relaxation before making the transition to new careers. They are donated by trainers or owners who can't afford to keep them, but who haven't found a buyer and don't have the heart to send them to auction. The ranch also gives Lynn a place to work with horses that have little training or that have behavior quirks that might inhibit their adoption. Although she had very little experience training horses and no ranching skills to speak of when she launched LOPE, Lynn was willing to learn on her feet for the sake of the horses. What Lynn lacked in experience, she made up for with determination and savvy.

A permanent caution for visitors is wired to the gate.

In her book, *Beyond the Homestretch: What Saving Racehorses Taught Me about Starting Over, Facing Fear and Finding My Inner Cowgirl*, Lynn described her early experiences at a Washington, D.C., polo barn where she fell in love with hot-off-the-track Thoroughbreds training for new careers as polo ponies. "They [the ex-racers] had powerful physiques, intelligent eyes, and dangerous reputat ions—the epitome of the kind of horse I should avoid," she wrote. "Naturally, I was desperate to ride them."

After spending time around racehorses at the polo barn and track, Lynn realized that their reputation for being devilishly impetuous was only partially true. They were often anxious (which was understandable considering the frenetic environment of the backside of a track), but also capable of becoming steady, reliable mounts. And although their legs and feet were susceptible to repetitive injury on the track, when given enough time to heal and proper care, most horses could recover and adapt well to less demanding careers. She also observed their insatiable desire to perform and please. "They're bred to work, like a border collie. They need a purpose," she said. "It doesn't have to be a major purpose, but they need to interact with people and feel a sense of accomplishment in their work." That enthusiasm is often misunderstood as bad behavior. "You get a horse off the track and ask them to do something and their response is, 'Yes, ma'am, I will do that, times 10!'" she said.

THE HORSES AND THEIR CARETAKER

Meg Tanner shows up at LOPE by 7:30 a.m. Aside from Lynn, who receives a small yearly stipend, she is LOPE's only paid employee. Although she only works 10 hours per week because of budget limitations, Meg accomplishes a lot during her quiet mornings at the ranch—feeding, cleaning water troughs, mucking stalls, and grooming. Sometimes she makes a run to the feed store or bathes one of the 11 LOPE horses.

A third-year student at Texas State University–San Marcos, Meg still can't believe she landed the job. "I love it so much," she said, as she took a scrub brush along the sides of a black rubber water trough. "I can't believe I get paid to do this." Although she has never been involved in equine rescue, Meg has spent her life around horses. As a young girl, she got a taste for competition, pursuing barrel racing, dressage, and jumping. She joined the university equestrian team and was chasing blue ribbons with gusto until a health condition forced her to take a short leave.

In the barn, three curious geldings encircled Meg as she sat her tack box down in the center aisle. Zuper watched the activity with mild interest from his stall, where he was enduring forced rest while an abscess in his hoof healed. Zuper is Lynn's four-legged "ranch manager," one of the first horses to arrive at the ranch and a permanent resident. A handsome bay with an air of calm authority, Zuper was given to LOPE by his trainer in 2004 after hurting his ankle in a race at Sam Houston Race Park. His three companions—Louie, Fred, and Tulsa—are never beyond earshot of his stall and paddock.

Fred reached for a plastic container of horse cookies in the tack box, grabbing the lid between his teeth. Meg shooed him away before taking a brush to Tulsa, who had managed to accumulate a significant amount of Texas dust on his dark coat. Meg admitted she has grown fond of every horse at the ranch, but gentle, goofy Fred is her favorite. (She would adopt him if she weren't still in school.) She talked about all of the horses with a sense of awe, explaining that her time with the ex-racers has reconnected her to horses. As a competitor, Meg thought of her mount as a tool that would contribute to or detract from her performance. At the ranch, she sees each

Zuper, the equine ranch manager, has lived at LOPE since 2004.

horse's unique personality, how they communicate with each other, their likes and dislikes. She has learned about their histories and their ailments. The quiet mornings spent in the barn or delivering hay and grain to the pastures along the driveway give her time to observe and listen.

Lynn is glad that LOPE can provide Meg with a job. Although 10 hours a week isn't much, it's a tremendous help, considering Lynn had been solely responsible for mucking, feeding, and scrubbing, among the myriad other tasks that keep the rescue going. Veterinarian care takes an enormous chunk of LOPE's budget, and that's after a generous discount from their vet sponsor, Austin Equine Associates. "Our veterinarians, along with the property, are key to LOPE," said Lynn. "They've made a huge difference, first of all because of who they are as veterinarians, but also as philanthropists and animal lovers. And they're willing to train and educate."

They're also interested in the most challenging cases, which is why LOPE can take in horses with particularly acute injuries like a sesamoid fracture. (The sesamoid bone lies behind the bones of the fetlock and is attached to suspensory tendons and ligaments.) Lynn likes the challenge of difficult cases as well, acknowledging that LOPE is extremely risk tolerant. It's not that she has an insatiable taste for high-adrenaline drama; it's that she believes the horses deserve the same level of toughness and commitment they exhibited in their racing careers. When she gets a call from a trainer with a beloved but severely injured horse that needs a second chance, Lynn takes great pleasure in saying, "Hell yes, we can take him."

There are plenty of people eager to assist at the ranch, but Lynn limits volunteer help to special events, foster care for horses, transport, or soliciting donations from manufacturers and merchants. It's not that she doesn't appreciate their earnest desire to work, it's just that she sees operations at LOPE as straightforward and most of the work as tedious labor that she would rather pay someone to do. Professional internships will be offered in the future because, according to Lynn, they provide an exchange of services. And, truth be told, Lynn prefers that there be little activity on her quiet ranch, aside from the comings and goings of wildlife, for the sake of the horses. "It's pretty quiet here, but that works for the horses. They had a lot of bustle at the track," she said.

Indeed, the LOPE ranch is a remarkably quiet facility, but it manages to accomplish a lot, perhaps because of its peacefulness. Or maybe it's because Lynn literally subscribes to her mantra: "Slow down, do less, accomplish

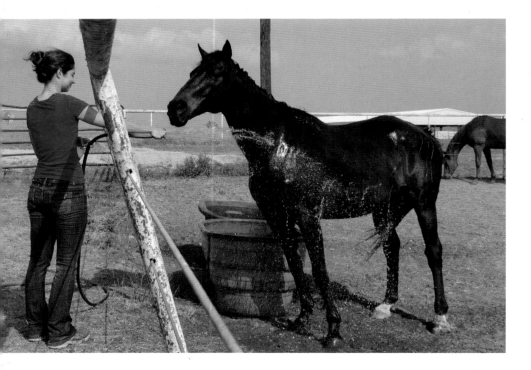

ABOVE: Suzanne Whitman, volunteering before she begins her college term, cools Tulsa Mambo. OPPOSITE: Fred sits up after a satisfying roll in the grass.

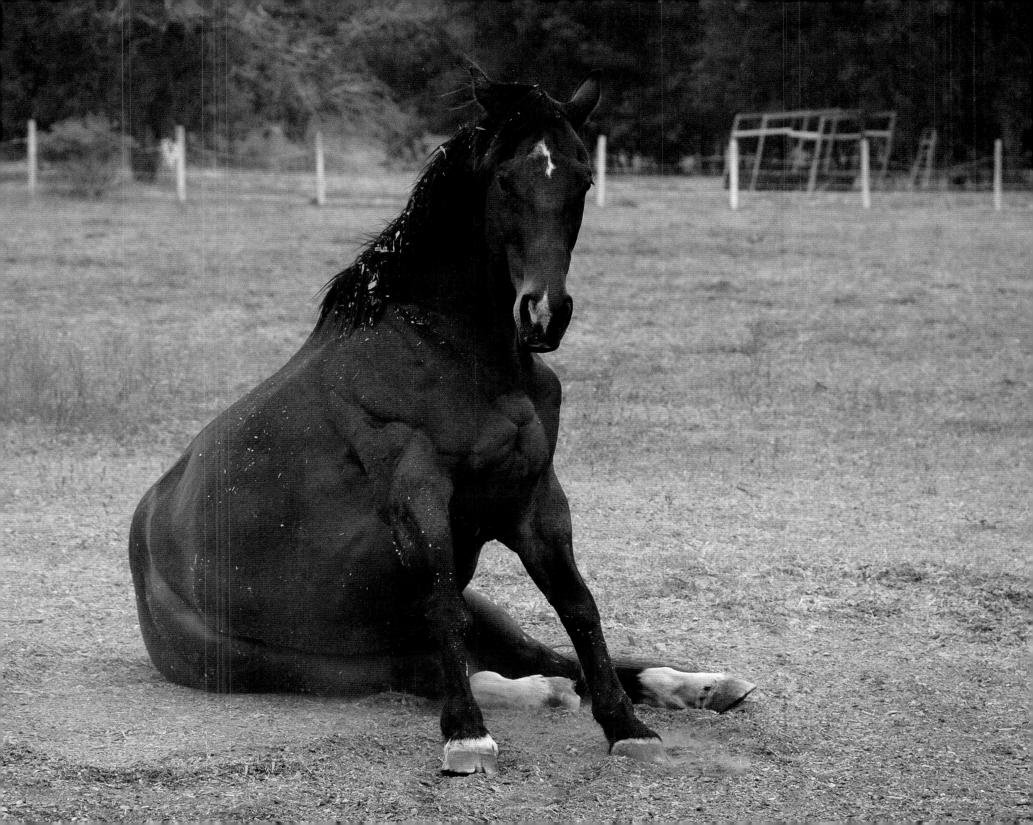

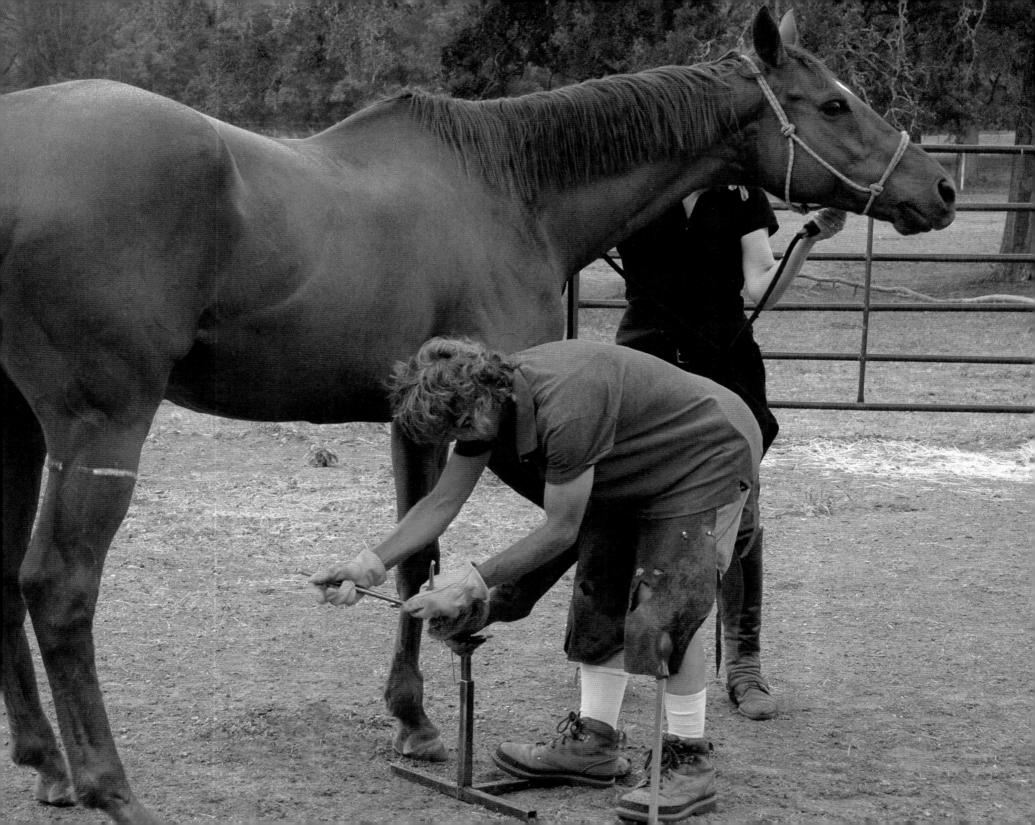

more." There are no frills—just well-cared for and well-adjusted horses that prove Lynn's argument that ex-racers, when given time to unwind, are not angst-ridden and unruly. In fact, she's making a concerted effort to showcase them as excellent pleasure and trail horses, certainly an unconventional career change for a Thoroughbred, but a natural fit for the region and Texas's western market. This is a savvy move on LOPE's part, but that's one of the organization's unique strengths.

Lynn's book has helped direct attention to LOPE and has attracted national media coverage, which added to the organization's credentials and spread its name widely. LOPE has also managed to attract the support and respect of the Texas racing industry, in part because of Lynn's affable, no-nonsense personality, but mainly because LOPE provides a valuable service—and does it well.

THE FUTURE OF LOPE

In addition to fund-raisers like silent auctions, clinics, and a yearly benefit show, LOPE offers the Founder's Circle, a donor program for those able to give a yearly contribution of $8,000. Lynn also seeks out grants and solicits donations or sponsorships from manufacturers and merchants to meet the $80,000 to $90,000 budget needed to keep the organization going each year. Adoption fees are nominal, and there is a return policy if the horse's injuries continue to be a problem or the adopter and horse turn out to be a poor match. Although it doesn't happen often, Lynn said a problem can arise if a couple of horses come back to LOPE when she's at full capacity. That's part of her motivation for wanting to expand the property or buy another facility. But the immediate growth Lynn would like to see is the networking capabilities that LOPE fosters between the trainers and the equestrian

market. By expanding its reach and screening capabilities, trainers will be better able to find homes for their horses. Lynn thinks of it as "building the network of inspiration," inspiring more people to find solutions for the horses. It might also bridge the inherent gap between racetrack and equestrian cultures. "They both love horses," said Lynn. "So let's put them together as much as we can to effect change."

Since LOPE was launched, more than 800 ex-racehorses have found new homes and landed new careers. Yet, Lynn doesn't consider LOPE a rescue organization, but instead a placement agency for horses and an education program. "We don't run in and rescue horses from the fire, but we're the ones who install the smoke detectors," she said.

OPPOSITE: Marcia Hermann, farrier to barefoot horses, trims and shapes Double Again's hoof while Lynn holds him still. ABOVE: Chaplin empties his feed bucket.

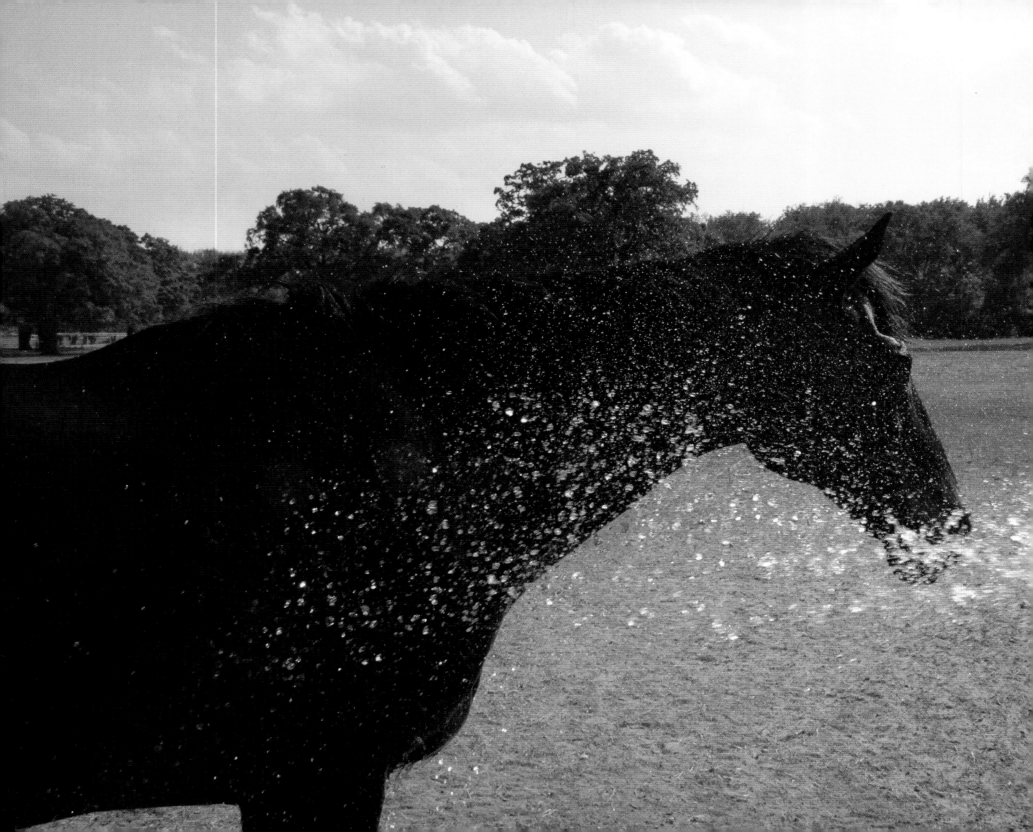

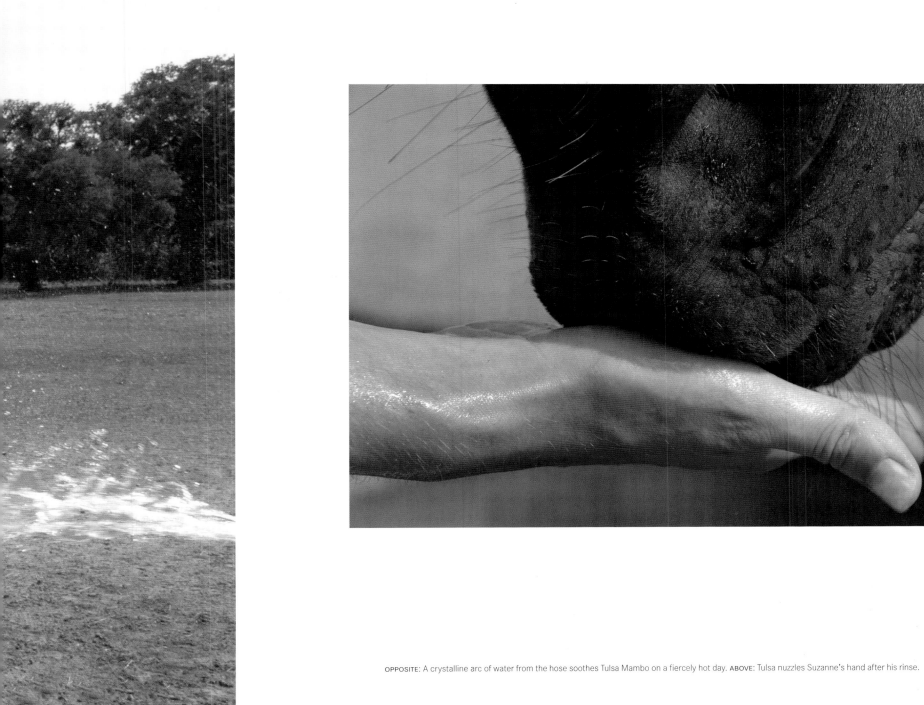

OPPOSITE: A crystalline arc of water from the hose soothes Tulsa Mambo on a fiercely hot day. ABOVE: Tulsa nuzzles Suzanne's hand after his rinse.

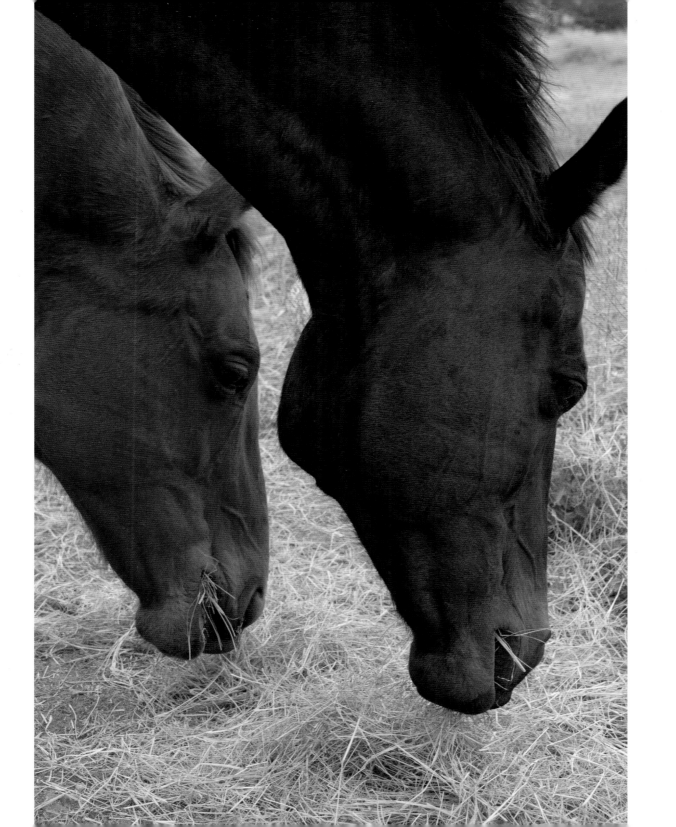

LEFT: Linny and Sugar concentrate on their dinnertime hay.

OPPOSITE: The geldings are lined up at their grain buckets according to the hierarchy they have established, which Lynn maintains to avoid ructions.

OPPOSITE: Double Again, a striking chestnut, cavorts with his pasturemates near the ranch house. ABOVE: Fred browses at a tall tree by the paddock fence.

LUCKY HORSE EQUINE RESCUE

Since it launched in 2009, Lucky Horse Equine Rescue, a 100 percent volunteer-run nonprofit organization, has rescued hundreds of horses and foals and placed most of them in new homes. The facility specializes in rescuing pleasure horses and ponies, but founder and president Jai Rezac has a soft spot for all creatures in dire situations; she has been known to leave a livestock auction with an assortment of two- and four-legged animals. Sometimes the organization's vice president, Jenifer Vickery, accompanies Jai to these auctions, even though it's not her favorite job. Nonetheless, she's compelled to help because she knows that every animal they bring back to Lucky Horse is one fewer leaving on a kill buyer's truck.

In October 2011, Jai and Jenifer pulled their trailer into the parking lot of a nearby auction, spotting several stock trucks parked near the back. It's an ominous sign to see one stock truck at an equine auction; the sight of several trucks sent their hearts racing. Inside the dark barn their fears were confirmed—horses were tied flank-to-flank with baling twine or packed into stalls. Weanlings, miniatures, elderly horses, and a Thoroughbred with perfect conformation were released into or walked around the ring without representation; they had been left at the auction by their owners to be sold to anonymous buyers. There was a group of gentle trail horses discarded by a dude ranch that had gone under, and there were healthy pregnant mares as well. That night, more than 200 horses were auctioned off to a handful of bidders, many of whom Jai and Jenifer knew to be kill buyers.

"We were prepared, but it was really bad. The sheer number of horses We wanted to save them all, but we only had one trailer," said Jenifer. Lucky Horse supporters had donated enough money to purchase three horses, so the women weaved their way through the barn to get a better

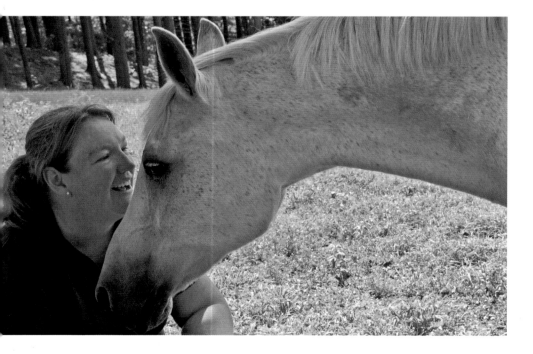

ABOVE: Jai Rezac, founder and director, takes time out from work to keep company with Winter, an aged pony. OPPOSITE: Blue-eyed Sprite, a yearling mini rescued from a kill pen, investigates the minis' paddock fence.

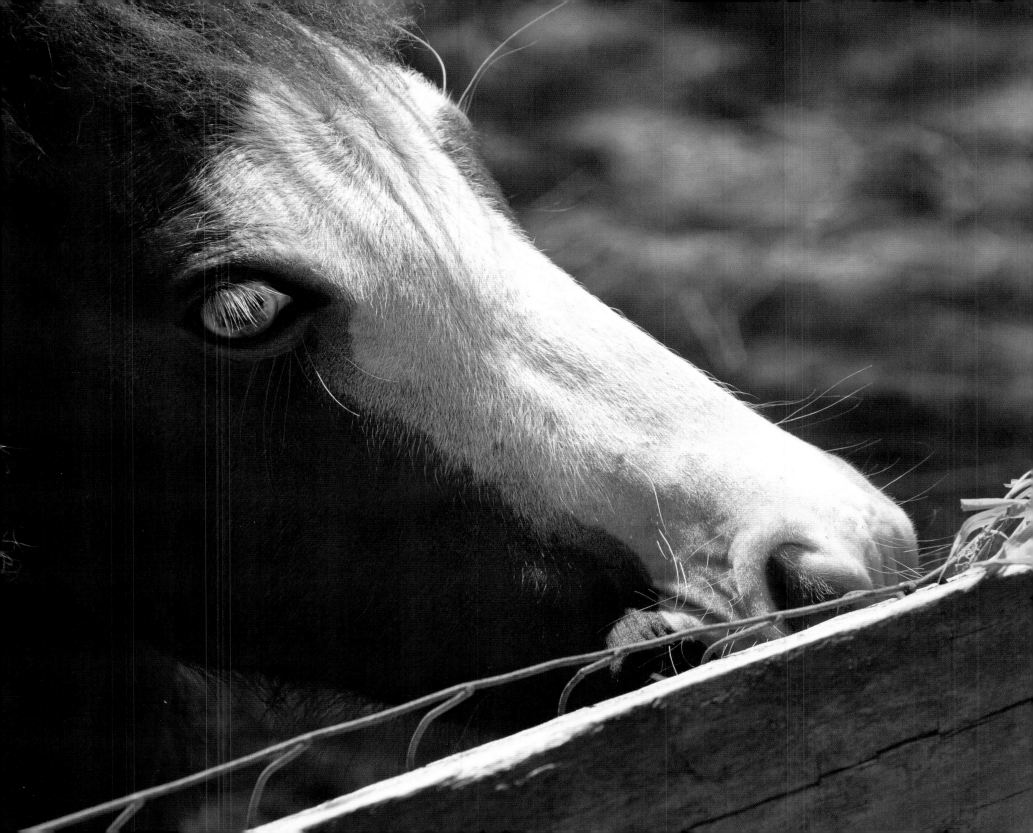

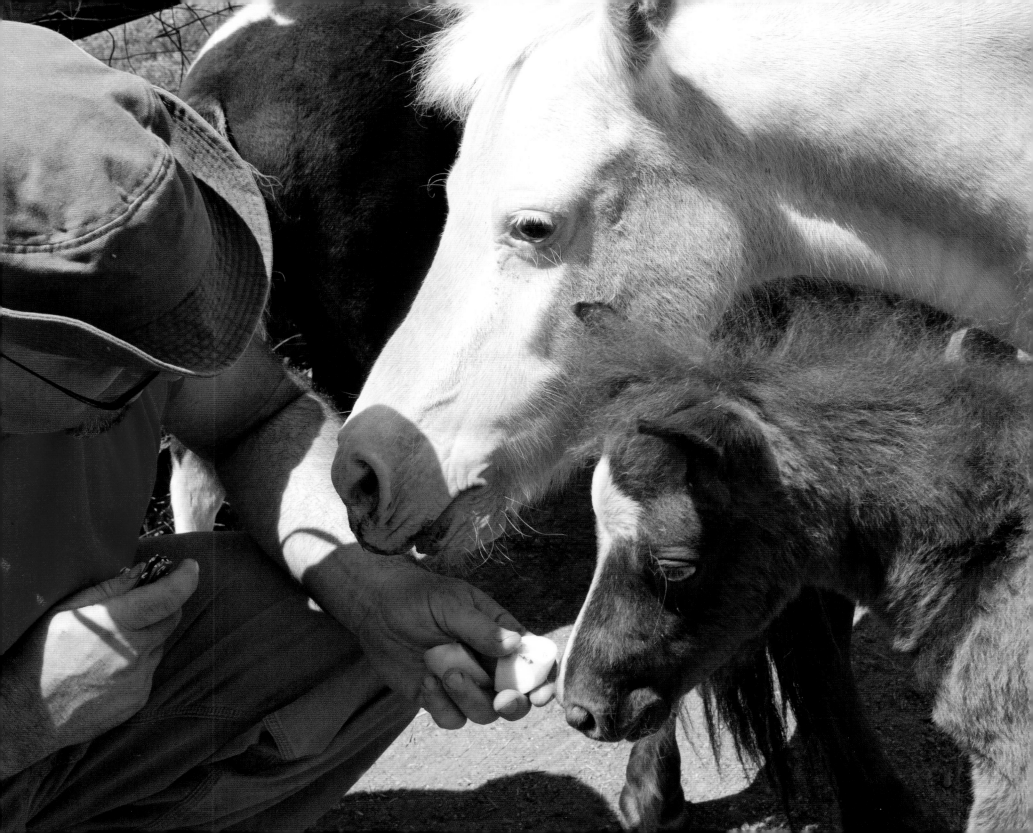

look. Jenifer handed out peppermints, a simple expression of kindness to animals that were probably doomed. At one point, Jenifer had to leave the barn to cry behind the trailer. Inside, Jai grew angrier. She had never seen so many perfectly good saddle horses at an auction. "I have been doing this a long time, and I got in the truck that night feeling so sad. Even though we saved six, we weren't even making a dent. Those poor horses," she said.

At the end of the night, Jai and Jenifer left with their six horses—four in the trailer, and a miniature named Molly snug in the tack compartment. Jenifer paid from her own pocket to have an elderly and severely malnourished Appaloosa named Joey transported to a nearby farm where volunteers later picked him up. Joey, in their estimation, was the most tragic and saddest case at the auction; they couldn't bear to leave him behind. Though Joey lived only one month after being rescued, he received a daily deluge of pampering and attention, most likely more kindness than he'd experienced in years. Longtime volunteer Christine M. Peters and her husband took Joey in and cared for him until he died. "Joey has a permanent place in our hearts," she said. "He was such a gentle soul and he had so many stories to tell. But he was just too tired, so he would say thank you with his soft nicker and a nuzzle."

Months earlier, Jai had returned from an auction with five miniature horses in tow. Again, they hadn't planned to buy miniatures, but she couldn't help herself after witnessing a brave little mare named Lily take cruel punches to the head by a man administering a Coggins test while her tiny foal stood by crying out in fear. In a nearby stall, another miniature named Twinkle hovered over her seriously ill and terrified newborn. Jai took those two as well. Then, just when she thought the trailer couldn't hold another animal, she spotted Sprite, a gorgeous little yearling with a laceration on his cornea. She made room in the tack compartment of the trailer and loaded

him in. In the truck cab, she shared her seat with six rabbits that had also been slated for slaughter.

The miniatures spent the first few weeks in quarantine under the care of volunteer Cindy Stevens. Every day, sometimes twice, Cindy went to the quarantine barn to feed and muck stalls. She also spent a lot of time sitting nearby, coaxing them toward her outstretched hand. Although the horses weren't feral, they were shy and wary of people. "You'd raise your arm and they would cower, expecting to be hit," Cindy said. Her consistent kindness paid off. Within days, they were responding to her visits with happy whinnies, and the foals were falling asleep in her lap.

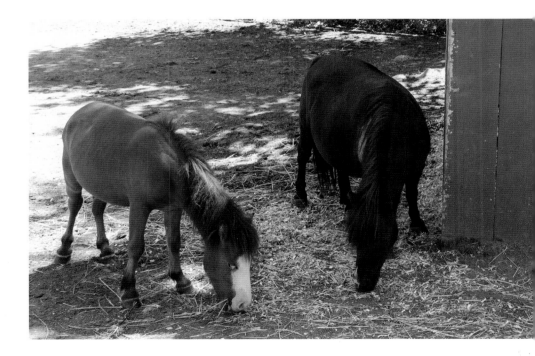

OPPOSITE: Bill Stevens, volunteer, offers apple slices to Twinkle and her foal, Baby, who, with loving attention, have overcome their distrust of human beings. ABOVE: Sprite and Lily have lunch beside the mini shed.

When the miniatures were ready to leave the quarantine barn, Cindy enlisted her husband, Bill Stevens, to help her move them to and from a paddock across the street. It wasn't long before Bill was accompanying Cindy on evening visits, just for a chance to see the miniatures and fawn over his favorite, Pippen. Now, Bill is a regular volunteer.

Pippen is particularly fond of the attention he receives from all the volunteers—a scratch on his tiny head, a full-body hug, anything will do. Jenifer told us that he may be a candidate for an equine therapy program, and several volunteers have expressed interest in training him for that

purpose. If it's successful, equine therapy could be another component of what Lucky Horse provides.

"I love it. If I could be here all day, I would," Cindy said. She has years of horse experience under her belt, but hasn't owned a horse since she married. "When I was younger, I got paid for this type of work," she said. "Never did I think that I would do it for free and work harder. But it's really nice to know that I'm doing a good thing."

TYPES OF RESCUES

Lucky Horse rescues are defined by three categories: urgent rescues, such as the miniatures purchased from the kill pen; private surrenders; and fund-raisers. Although it would prefer to help owners find a new home for their horses if possible, Lucky Horse will accept horses surrendered by owners who can't afford to pay for feed and care, or who discover that their horse is not a good fit for them. Fund-raisers are high-level performance horses donated to Lucky Horse by their owners. The adoption fee for these horses—$2,000 to $3,500, considerably less than their value—supports the urgent rescue effort, and in return, the owner earns a tax write-off and peace of mind. Fund-raiser horses receive lifetime protection from Lucky Horse and a guarantee that they will be matched with their ideal home.

Rescuing educated performance horses from kill pens dispels the myth that all horses going to slaughter are sick, old, untrained, or unfit for training. Ruby, a lovely mare with a sweet disposition and a lot of smarts, is an excellent example. Jai pulled Ruby out of a kill pen minutes before she was to be loaded onto a truck headed to a slaughterhouse. Although her past is unknown, Ruby's charming personality and gentle spirit was apparent in the photographs posted on the Lucky Horse adoption site. Within several

ABOVE: Cindy Stevens, volunteer, caresses Baby. OPPOSITE: Pippen, Lily's foal, hunts for an overlooked slice of apple.

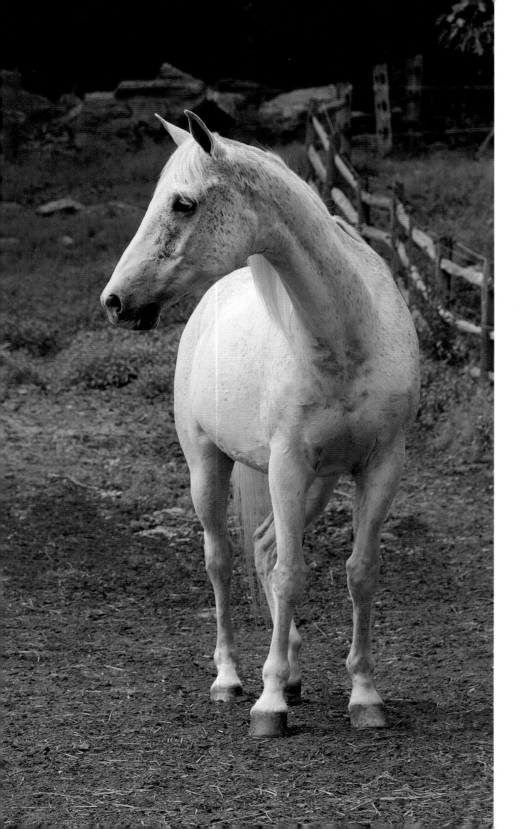

weeks of arriving at the sanctuary, Ruby was on her way to a new home. Her former pasturemate at Lucky Horse, Europa, is in the fund-raiser category, with an impressive pedigree and a national saddle seat championship to his credit. When his previous owners switched disciplines, they wanted to find a home where Europa would thrive. His good looks, experience, and education make him very alluring to potential adopters, and an ideal poster boy for Lucky Horse. Most important, Europa's adoption fee of $2,500 will go toward saving equines in desperate situations, like Ruby.

CENTURY MILL AND THE VOLUNTEERS

Most of the animals rescued by or donated to Lucky Horse live at the host barn, Century Mill Stables, which is owned and operated by Jai and her husband, Ron. The facility incorporates a wooded hillside with generous turnouts and sheds, paddocks, and a large riding ring bordered by deciduous trees and pines. An 18th-century New England barn painted bright red with white trim has a wide center aisle lined with clean, bright stalls. There are tack rooms, an office, and a viewing room overlooking a newly rebuilt indoor arena with clerestory windows and skylights. In addition to managing administrative tasks, Jai is also a trainer and an experienced instructor in a number of disciplines.

Century Mill Stables donates four stalls, a quarantine barn, turnouts, and arena time for all rescued horses. Jai's initial goal was to take in 10 or fewer rescues at a time. However, usually 15 or more are in residence, some at nearby foster homes. Lucky Horse rescues and volunteers all benefit from the exceptional care, resources, and trainers offered to boarders. For example, through the Lucky Rider Program, volunteers can take lessons from a professional instructor on a rescued horse once a week for a fee, and in return, ride

the same horse throughout the week at no cost. Lessons are a requirement for volunteers who want to work one-on-one with a rescued horse.

"It's a really nice program because if you can't afford a horse, you're almost getting a lease," said Jenifer, an accomplished rider and trainer. She has been working with horses since the age of nine, and owned a racehorse at one point. "The program also benefits the horses because they're being handled in a consistent manner," she pointed out.

Each month, volunteers can participate in a course called Barn Basics. For the more experienced, weekly Natural Horsemanship classes are offered for a nominal fee. The classes provide an opportunity for volunteers to gain valuable handling skills; at the same time, they benefit rescued horses that may have less formal training or that may have developed bad habits from former owners and riders.

Unless they are pointed out, there is no way to differentiate rescued horses from the boarded jumpers and show ponies. And aside from setting themselves apart by wearing T-shirts with the Lucky Horse logo, volunteers move around the facility with the same ease as boarders, caring for their barn buddy—a specific rescued horse in their care—checking on the dozen or so Lucky Horse wards, or taking a break in the viewing room above the indoor arena. They exhibit a true sense of responsibility, camaraderie, and pride, and it's not uncommon for some of the volunteers to spend the majority of their free time at the barn.

The organization is adept at using each volunteer's unique skills to manage all facets of the rescue. Jenifer teaches the Natural Horsemanship classes, in addition to other responsibilities, while Christine, who adopted a stunning gelding named No Autographs Please (Charlie, for short), is director of adoptions. Each morning before work, Christine checks her Lucky Horse e-mail, answering questions and forwarding messages to

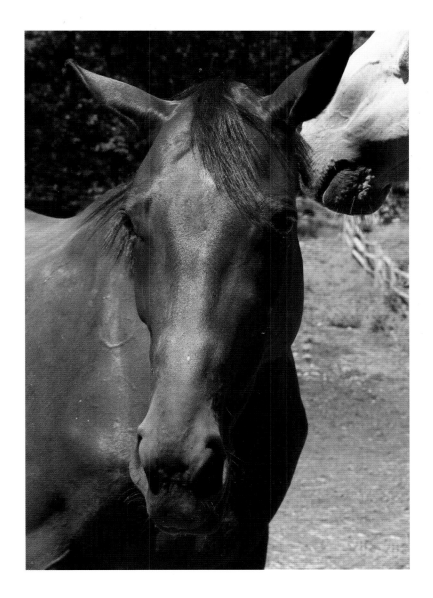

OPPOSITE: A former champion show horse, the Arabian Europa brought in a substantial adoption fee to help fund more rescues. ABOVE: Ruby, a kindly, talented mare rescued from imminent slaughter, bonds with Europa.

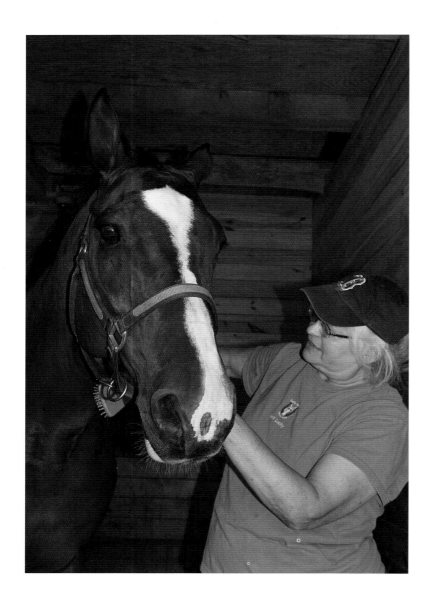

Volunteer and Joplin's special friend, Ellie Kittler administers his diabetes medication.

others. She contacts potential adopters, and if they pass the rigorous barn inspection and reference and background checks, she is the first one to thank them for saving two horses—the one they are adopting and the rescued horse that will fill its spot at the sanctuary.

April Clow-Gelina is director of volunteers. Like Christine, she has been with Lucky Horse since the organization was founded, and in 2009, she adopted one of its first rescues: a handsome black Morgan fittingly named Black Tye Affair. "Tye's a Lucky Horse success story," she said. The gelding was abused by a former owner during his early training and became terribly fearful of people, to the extent that he would shake at the slightest touch. At first, April acclimated Tye to daily grooming and attention, and then he was trained by Century Mill Stables professionals. April made the most progress with Tye in the Natural Horsemanship program, and today he is one of the superstars of the stable and a very pampered horse.

NURSE-MARE FARM ORPHANS

In 2009, Lucky Horse heard about a group of nine orphaned nurse-mare foals going to auction in a neighboring state. It responded without hesitation, making room at the stables for the babies, some of them just days old, and divvying up around-the-clock caregiving shifts among volunteers. Among the foals was a seriously ill palomino; it was rumored that his dam's labor was induced so that she could provide milk to the foal of a paying customer. The volunteers named the tiny foal Jimmy, and they worked through many frigid nights to keep him alive. On his worst days, they doubted that he would survive until sundown.

But the plucky Jimmy lived. To showcase the little foal, Lucky Horse took him to the 2010 Equine Affaire in Massachusetts, where his good looks

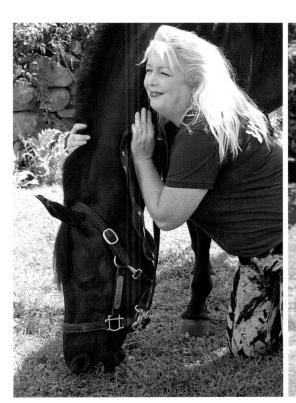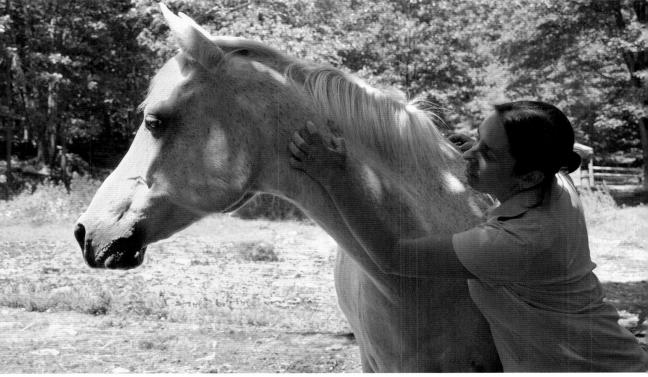

and sweet demeanor made an impression on visitors. His presence gave volunteers the opportunity to talk to visitors about nurse-mare orphans, their efforts to save such foals, and the atrocities carried out by nurse-mare farms every year.

Nurse-mare farms are designed to aid the race and performance horse industries by providing an endless supply of lactating mares. Mares are impregnated every year to induce lactation, and when their foals are born, the mares are leased and transported to provide sustenance to another foal, often one who has been rejected by its dam or who has been orphaned. Because equines are not able to nurse two foals at once, the lactating mare's foal is taken away from her and, in the best-case scenario, reared by hand and then sold or adopted. But few foals born to nurse mares are so lucky. Leasing the mares is a profitable business, and foals are considered an unwanted by-product. Many do not survive because of illness or malnutrition. Most are sold to kill

April Clow-Gelina, director of volunteers and horse-care coordinator, hugs her adopted Morgan, Black Tye Affair (left). Winter receives affectionate attention from Jenifer Vickery, vice president (right).

buyers for slaughter in Canada or Mexico because their care is costly and requires more time than the farms are willing to give. Their soft coats, called ponyskin, are used to produce high-fashion shoes and accessories, and their flesh is still served as a delicacy in several European and Asian countries.

Confident that it could do more to help nurse-mare foals, Lucky Horse rescued 26 more in the spring of 2010. By giving them the same level of care that Jimmy received a year earlier, all the foals survived and were adopted out to caring homes. The success of the program is a huge source of pride for Jai and the volunteers who nursed the foals through their most difficult days. Jai also credited the veterinarians for going "above and beyond the call of duty," donating hours of their time to help keep the foals alive. She said farriers and the local grain store also pitched in to help. "Newborn foals are very difficult and expensive to raise," she said. "It can cost more than $5,000 to raise an orphan foal."

Lucky Horse was poised to continue the program in 2011, but an archaic Massachusetts law that made newborn foal rescue illegal stopped them in their tracks. They had never heard of the law until they were contacted by the Massachusetts Department of Agriculture. If Lucky Horse had continued to rescue foals younger than five months old and adopt them out (which the law considers a sale), the department would have shut down the entire organization. According to Massachusetts Law, Section 78A, foals younger than five months old, unless accompanied by their mothers, can only be sold for the "purpose of slaughter or humane killing." Risking closure and the reputation of its host barn, Lucky Horse put a temporary hold on the orphan-foal rescue program. In 2011, State Representative Kate Hogan took an interest in the issue on behalf of Lucky Horse and other orphan-foal rescues, and challenged Section 78A. She proposed a bill that would update the existing language, making the transfer of foals to rescue

barns and eventually to adoptive homes legal in Massachusetts. As soon as the law is changed, Lucky Horse will return to the task of saving orphaned foals from nurse-mare farms.

"If I had all the time in the world, I'd like to go around to nurse-mare farms to inspect and approve," said Jai. Those that passed her inspection would receive a "Lucky Horse Approved" designation. She believes that there is a place for nurse mares, but sees no reason why a foal should be a discarded by-product. Because Lucky Horse considers education the best weapon for combatting the nurse-mare problem, it continues to tell the story of Jimmy and his orphaned peers at equine events and through social media. It points out how well adjusted the foals are in their adoptive homes and the ease with which they take to their training.

"These are good horses," said Jai. "They deserve more than the label 'by-product' or 'unwanted.'" These terms are often used to describe the animals that end up in crisis situations, like tiny Pippen, Ruby, and 50 Thoroughbred mares and foals that languished in a field after their owner died. Jai received a call about these mares in July 2011, asking if Lucky Horse could take them. There was no space available at Century Mill Stables, but Jai put the word out through the rescue network. "I hear about one of these cases every week. It's hard because these horses end up in a kill pen. But you've got to pick and choose to determine where you can do the best work," she said.

This heartbreaking dilemma forces rescue organizations to revisit their mission frequently, to question the limits of their resources, as well as the emotional and physical endurance of their volunteers. Yet, none of that matters to the animals in their care. To the five miniatures grazing in the afternoon sun, the retired show gelding, and the mare rescued from an unimaginable fate, Lucky Horse always does the "best work."

The elegant pony Daisy, owned by the sanctuary's host organization, Century Mill Stables, is a favorite with young riders and an experienced and patient schoolmistress.

LEFT: On a hot day, Lollipop spends an hour sipping from her automatic water fountain.

OPPOSITE: Winter grazes at liberty on the pasture above the barn.

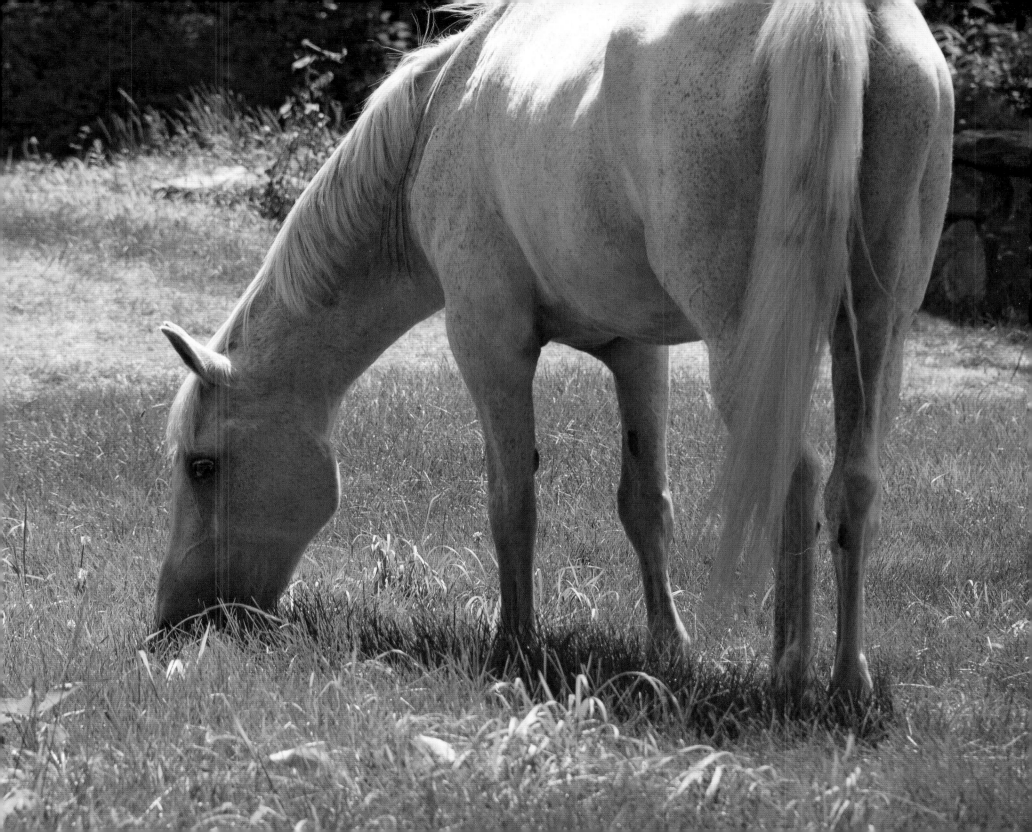

NOKOTA HORSE CONSERVANCY

LINTON, NORTH DAKOTA

Before the landscape was a patchwork of fenced pastures and sunflower and wheat fields and the horizon line was marked by silos and telephone poles, the Northern Plains were home to great herds of roaming bison, nomadic tribes of Native Americans, and a type of horse perfectly adapted to the rugged topography and harsh climate. As much a part of the landscape as the prairie dogs and pronghorns, the Northern Plains horses were fast, resilient, and exceptionally intelligent. Indeed, these horses—now called Nokotas—reflect the rich, complex, and tragic history of the region.

The Nokota Horse Conservancy in Linton, North Dakota, formed in 1999, has made great strides in showcasing these horses' unique qualities and providing sufficient research in support of their heritage and the history they intimately share with native peoples of the Plains. The conservancy's sophisticated breed registry traces the bloodlines of more than 1,000 Nokotas related to a herd confined to Theodore Roosevelt National Park during the mid-1900s. Decades of brutal roundups almost annihilated the herd, and if not for the foresight and compassion of brothers Leo and Frank Kuntz and researcher Dr. Castle McLaughlin, the Nokotas would be another casualty in a long history of crimes against humanity and ecology.

HORSES OF THE NORTHERN PLAINS

Prior to the western expansion of Euro-Americans, native peoples such as the Lakota, Mandan, and Crow developed their herds of Northern Plains horses, which were used for hunting and mobility, by breeding their most virile stallions to robust mares and raiding other tribes' stock. Possessing large numbers of horses gave them a military and political edge, as well as ample trading stock. By the late 1800s, however, most Native Americans had been forced onto reservations, their cultures nearly destroyed and their

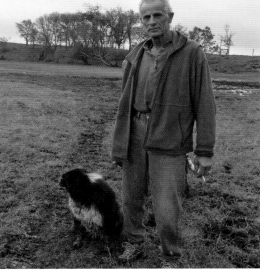

ABOVE: Frank Kuntz, cofounder and vice president, pauses in the broodmare pasture (left). Leo Kuntz, cofounder and president, and Phooey are about to herd stallions on foot. OPPOSITE: Nokota mares move at speed.

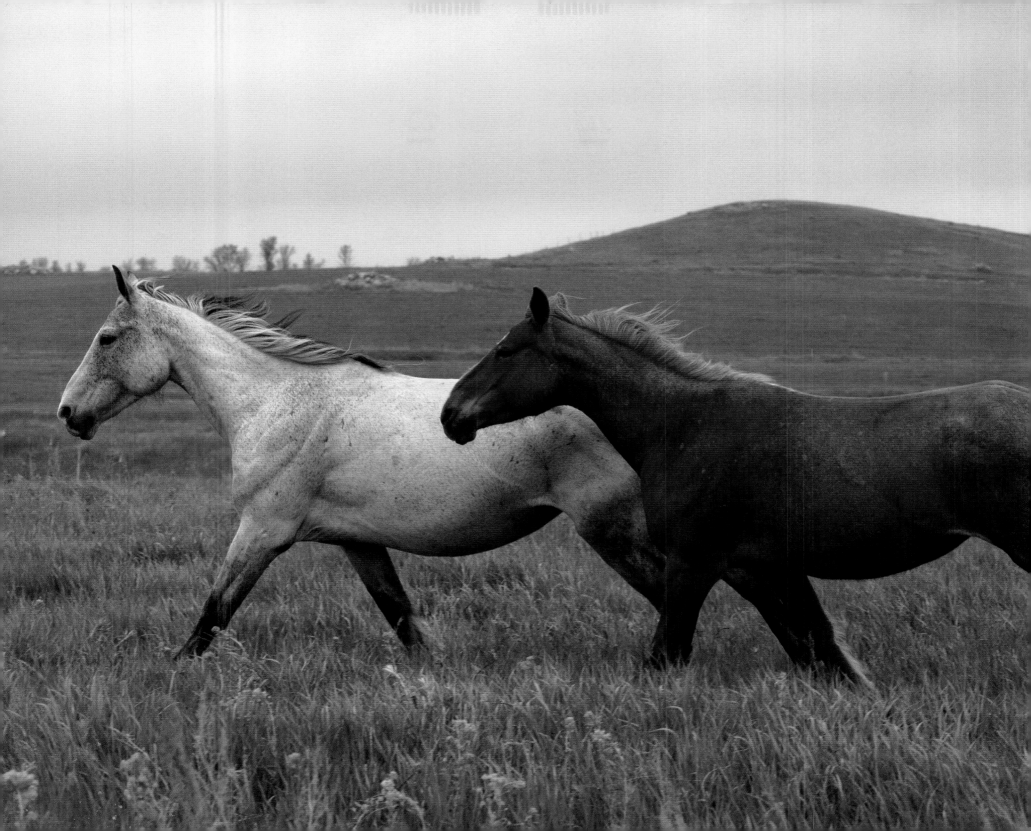

beloved horses confiscated or killed. The U.S. Army and local ranchers had little interest in preserving the confiscated horses because of their slighter stature, coat colors, and features, which were considered unattractive by discriminating traders. To remedy their perceived lack of appeal, the Indian horses were crossbred with domestic breeds and subsequently worked on farms and ranches. A. C. Huidekoper—a rancher and breeder who operated a ranch of epic scale in Amidon, North Dakota, until the early 20th century—bred a number of mares that originated from a Lakota herd to his Percheron and Thoroughbred stallions, then marketed them as "American" horses for saddle, racing, and polo to East Coast buyers.

Not everyone wanted to change the distinct traits and qualities of the Northern Plains horses, though. In the early 1880s, the Marquis de Mores, a French aristocrat and rancher, and his American-born wife, Medora, purchased 250 horses from a trader—the same post trader that bought 350 horses confiscated from Chief Sitting Bull and his followers—for their cattle ranch in the Little Missouri Badlands. They greatly admired the horses,

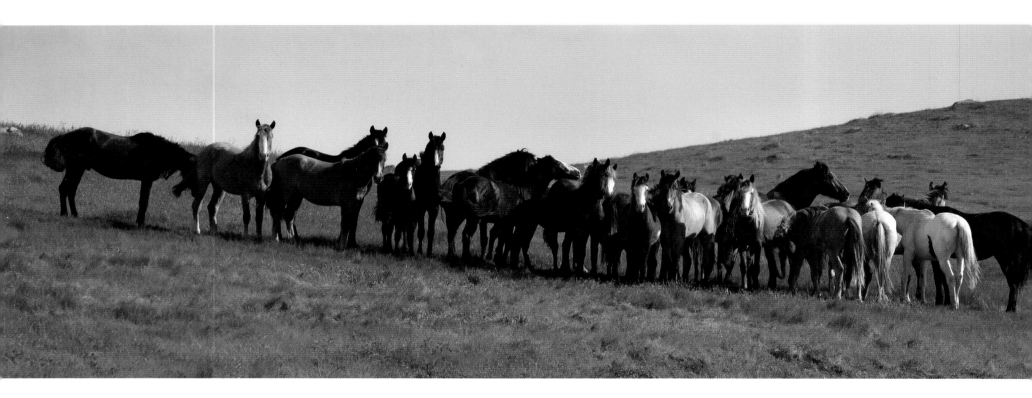

Young Nokota stallions gather along a rise on leased grassland.

keeping a few at the ranch for saddle and work and releasing the rest on their open rangeland to propagate. When their ranch folded shortly after 1887, many of the horses weren't recovered from the land. Eventually, they joined other wild bands and ranch horses that had wandered freely beyond unfenced boundaries and into the badlands.

During the staggering economic and ecological devastation of the 1930s, the wild horses of the Plains experienced another era of harassment and cruelty, this time by men so desperate for money that they shamelessly sold the horses to canneries for pet food. Systematic roundups continued through the 1940s, orchestrated by government agencies that were anxious to eradicate all wild horses from western North Dakota. Considered competition for domestic livestock, the horses were ruthlessly shot from aircraft, decimating entire bands. Shortly thereafter, a surviving band of wild horses was inadvertently fenced into the newly constructed 70,467-acre Theodore Roosevelt National Park. Yet, even on public land the horses were not allowed their peace. From the 1950s through the 1980s, the park horses were frequently rounded up and sold for slaughter. Outside the park, wild and free-roaming equines gained federal protection through the Wild and Free-Roaming Horses and Burros Act of 1971. However, the National Park Service (NPS) successfully fought inclusion of the law in the parks—essentially *carte blanche* from the U.S. government to continue harassing and killing Northern Plains horses for two more decades.

KUNTZES AND CASTLE MCLAUGHLIN

In 1979, Leo L. Kuntz was looking for a tenacious, durable, and intelligent mount to crossbreed with the family saddle horses for the Great American Horse Race, a cross-country competition that tested the skill and endurance of horse and rider. He found these traits in Luppy and Bad Toe, badland horses caught by local ranchers near Medora, South Dakota. Leo was so impressed by the horses' physical characteristics, intuition, and temperament that he traveled to Theodore Roosevelt National Park two years later to purchase several more of the wild horses at a roundup. Although the NPS gave in to public pressure to maintain a "historical demonstration herd" at the park, the agency limited the number of horses by holding regular roundups and auctions, which were attended by both local ranchers and kill buyers (who sold the U.S. taxpayer-supported horses to slaughterhouses).

Leo returned to the park again in 1986, this time with his younger brother, Frank, and instead of just a few, the brothers returned with 52 horses, most of them yearlings or younger. The park horses had never been touched or confined, had never even tasted hay. Included in the band up for auction was a fierce blue roan stallion. Castle McLaughlin—then a park employee hired to work the roundup—had watched the stallion bravely challenge his captors. Moved by his spirit and will to survive, she purchased the horse at the auction. It was also at this auction that she met Leo and Frank, and learned about their effort to save the park horses from going to slaughter. She ended up sending the stallion, named Nocona, to Linton with them.

The small herd provided a foundation for the Kuntzes to preserve and rebuild the breed as the NPS continued to destroy the wild Plains horses by replacing the park stallions with "an Arabian, quarter horses, two feral BLM stallions, and a part-Shire bucking horse." In her article "Nokota History in Brief," Castle noted that the explanation the NPS gave for replacing the original park horses with domestics was to "improve their appearance and sale value at auction." From her home on the East Coast, where she is associate curator of North American ethnography at Harvard's Peabody Museum of

Archaeology and Ethnology, Castle remains involved with the Nokota Horse Conservancy as historian, documentarian, scribe, and advocate.

The serendipitous meeting of Castle, Leo, and Frank—and the brutality they witnessed at the roundup—changed the trajectories of their lives. That day at the park, they made a commitment to preserve the breed—which Leo eventually designated as Nokota, in reference to its North Dakota origins—and to make certain that the NPS would recognize its historical significance to the region and to the native peoples of the Plains. Now, 25 years later, the Kuntz brothers are still trying to give the Nokota horses a future that looks better than their past. Leo and Frank devote their physical, emotional, and financial all to the effort, sometimes at the expense of their other relationships, and possess few material comforts to show for their years of arduous work. They've been called crazy more times than they can count. Leo, the more reserved of the two, has always been the breeder (Castle said he has an "incredible eye for identifying breeding prospects"), whereas the more outspoken Frank has had a knack for passionately conveying the Nokotas' history and plight. He said that if he and Leo had been more similar in nature, they probably wouldn't have come as far as they have. It's their distinct, often opposing personalities that truly work in their favor.

As the face of the Nokota Horse Conservancy, Frank speaks to the public and the press; lobbies the park and the state government; attends events such as Equine Affaire, a yearly national equine exposition held in Massachusetts and Ohio; and holds colt-starting clinics. In 2011, the conservancy held its first annual Nokota Horse Round-Up, where participants paid to help drive horses in from their summer pastures scattered throughout the county to winter pastures and paddocks close to the Kuntz ranch.

The brothers are not entirely alone in their fight, however. Unlike most nonprofit organizations, the Nokota Horse Conservancy doesn't offer a formal volunteer program, though every year it receives calls from interested individuals—usually college students—who want to help in exchange for the experience and exposure to horses. There are no funds to pay for hired help, but the Kuntzes do have a large, supportive circle of friends and family members who frequently lend a hand at the ranches or at promotional events. Several of their siblings own Nokotas as pleasure horses, and one sister, Felicia Rocholl, owns, breeds, and shows Nokotas with her daughters, Destiney and Fate, in Minnesota. Their presence in show rings has been a tremendous help in attracting attention to the breed outside of North Dakota.

Frank's wife, Shelly Hauge, shares his tenacious spirit and love of horses. Articulate and warm, she is an equally gifted promoter and often accompanies Frank on trips. Over the years, she has taken on the bulk of administrative duties, serving as executive director, secretary, and treasurer of the conservancy, while also overseeing the website and marketing materials. Frank's daughters, Dawn Hager, Alecia Kuntz, and Christa Kuntz Small, have taken an interest in the Nokotas and have become active in promotions and events. Brandon Deile, Frank and Leo's nephew and a gifted horseman, has shown potential to step into his uncles' boots one day.

ESTABLISHING THE CONSERVANCY

The Nokota Horse Conservancy, a nonprofit 501(c)(3) organization, was founded in 1999 with the encouragement and help of Charlie and Blair Fleischmann, horse owners and enthusiasts who first encountered and became intrigued with Nokotas while vacationing in Montana. Currently, the Nokota Horse Conservancy has more than 100 horses, and there are several hundred more in herds privately owned by Leo and Frank, making up half of the population of Nokotas worldwide. The remaining horses are owned by a

This grulla (blue roan) Nokota stallion embodies the breed's characteristics: strong legs and hooves, angular shoulders with prominent withers, and a distinctly sloped croup and low tail set.

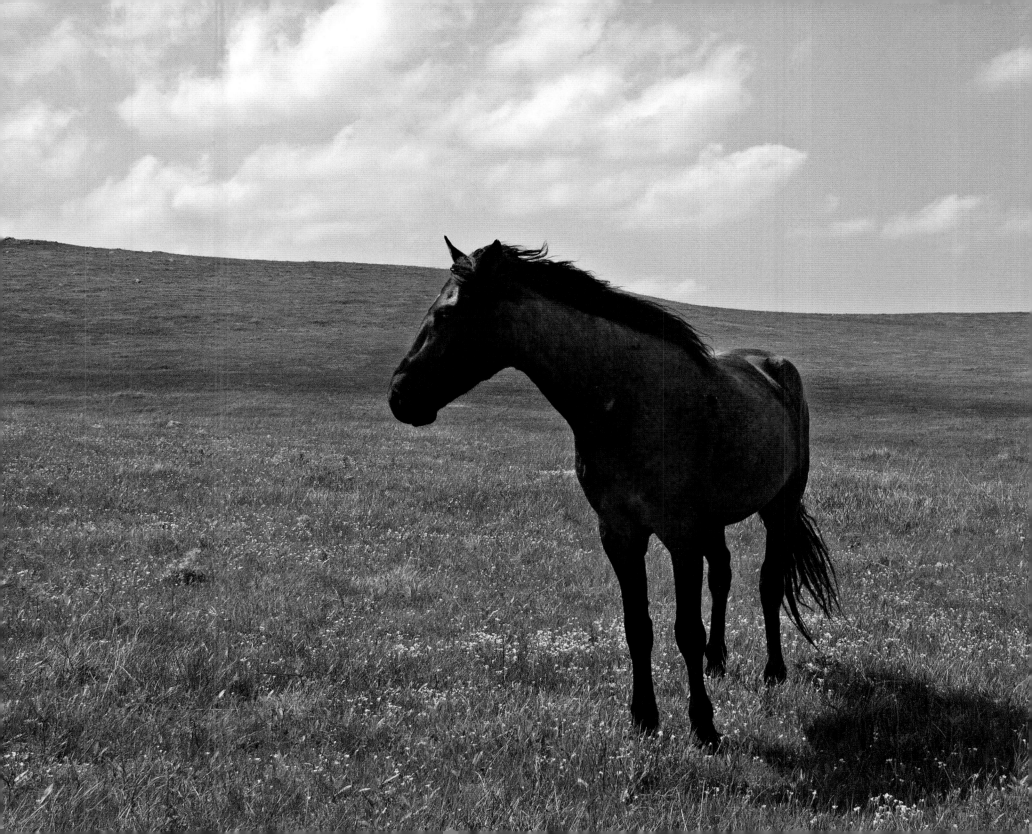

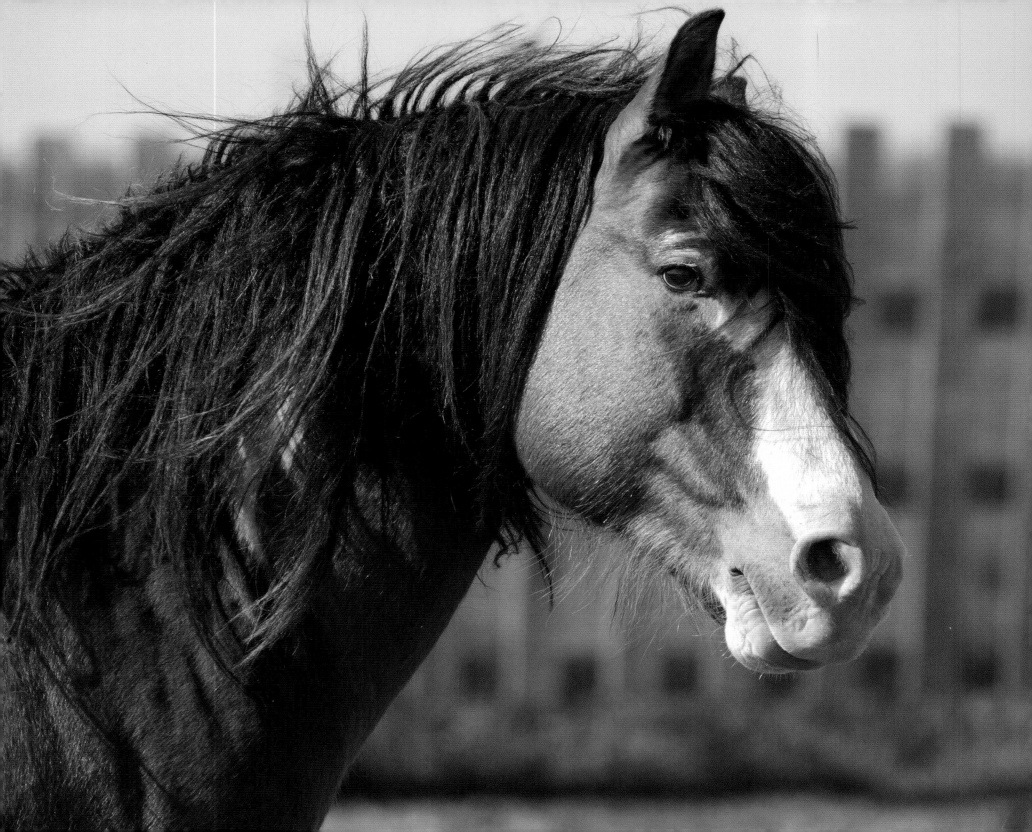

handful of breeders in the United States and Europe. Throughout the 1990s, the brothers lobbied the state government to formally recognize the Nokotas as historically significant and return them to Theodore Roosevelt National Park for posterity. They received considerable media attention as a result; in 1996, *ABC World News with Peter Jennings*, along with a number of other news organizations throughout the United States and Europe, detailed their struggle. Although they won the battle to have the Nokota horse designated "North Dakota's Honorary Equine," they were not able to stop the roundups at the park, which continued through 2009, until the last wild Northern Plains horse had been removed. The small band of horses that now roams the park is a product of the NPS breeding program—more docile, with quarter-horse coloring and conformation—rather than the original Northern Plains horses.

THE RANCHES

Linton, North Dakota, is a small farming community south of Bismarck. It's home to cattle ranchers and wheat farmers, although a growing number now plant their fields with sunflowers, a lucrative crop that produces seeds and oil used in a wide range of products. The Kuntz brothers and their 10 siblings grew up several miles outside of Linton. Their home on the prairie was one of many small farms worked by large families of European descent. Everyone had horses, and it was not uncommon for children to ride them to school, social events, high-school games, and church. The modest homestead where the Kuntzes' parents reared their family is still standing, as are the barns, loading chutes, and corrals, albeit weathered and worn from decades of use. Today, Leo lives there with his dogs and several hundred Nokota horses, which he rotates between corrals and summer pastures that bear markers of the native people who once thrived on the prairie.

Frank's ranch is a few miles south of the Kuntz homestead, cradled in the folds of low-lying hills. The property is small but efficient, with several barns, a toolshed, a farmhouse, a windmill, and numerous paddocks. When we visited the ranch, a group of geldings and young studs stood together in a tight circle, swishing flies off one another's backs. Across the driveway, Papa Smoke stood proudly in his paddock with two mares, a magnificent dun overo stallion with direct lineage to the first group of Nokotas that the Kuntzes purchased from the national park.

Six months out of the year, conservancy mares, foals, and geldings live with minimal human interference on 1,500 acres of leased pastures throughout the county. Near the end of October, the horses are rounded up and taken to Frank's ranch to spend the winter protected from the harsh weather. They are fed hay—approximately 1,700 pounds per horse—that Frank has cut, baled, and stacked in preparation. The Nokota Horse Conservancy pays Frank $3,500 a month to feed and care for its horses, but that amount barely covers expenses and doesn't leave a dime for Frank's own living expenses. Because Leo doesn't care for any conservancy horses at his ranch, he receives no funding from the organization. The brothers pay for the feed and care of their own herds from yearly foal sales and supplement the sales with their checks from the Veterans Administration (at the expense of their own welfare).

NOKOTAS IN EUROPE

In a perfect world, the Nokota Horse Conservancy would own and operate a large preserve where wild Nokotas could exist in self-sustaining and naturally evolving herds. There would be an educational component, and programs to reconnect Native Americans to the horses of their lost culture.

Papa Smoke, a Nokota foundation sire, is now blind.

To date, no land has been donated for that purpose, and the conservancy doesn't have the funds to purchase it. Instead, the conservancy focuses primarily on the preservation of the Nokotas through breeding and promotion. Yearly sales, mainly to other breeders, have supported the effort, but even those purchases have slowed to a trickle, so the conservancy is trying out new strategies. In addition to promoting the versatility of Nokota horses on the East Coast for hunting, jumping, dressage, and other sports, the conservancy is developing breeding programs in Europe. The breed registry is essential to this effort. The Nokota Horse Conservancy diligently maintains contact with all breeders in the United States and Europe, particularly "preservation breeders," who commit to maintaining the historical bloodlines.

Seth Zeigler, registrar for the Nokota Horse Conservancy, and his wife, Emma, play an important role in helping the Nokota horse take hold and thrive in Europe. After working for 10 years alongside Leo and Frank in Linton, Seth knows almost as much as there is to know about the Nokota horses and feels as strongly about preserving the breed as the Kuntz family does. In Sweden, where he and Emma moved to raise a family, they launched a breeding program from their farm designed to create and sustain a healthy population of Nokotas outside of North Dakota. They suspect that the horses will be popular; Europeans have a keen interest in Native American peoples and an appreciation for their place in American history. They are equally attracted to the Nokotas' size, durability, and levelheaded nature. People that have come in contact with the Zeiglers' stallion, Buckbrush, have commented that he resembles the native Swedish draft horse, although smaller and more refined, while others have pointed out similarities to Icelandic horses.

Seth Zeigler leads a foal temporarily separated from its dam to find her among the mares behind the house.

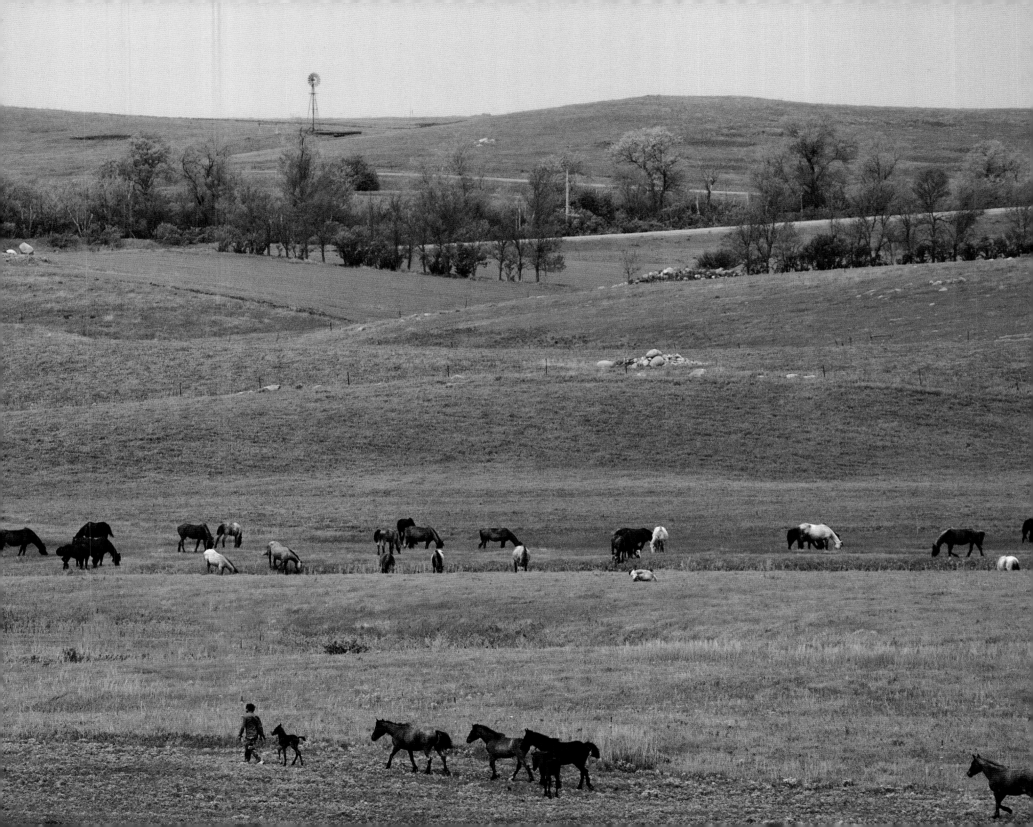

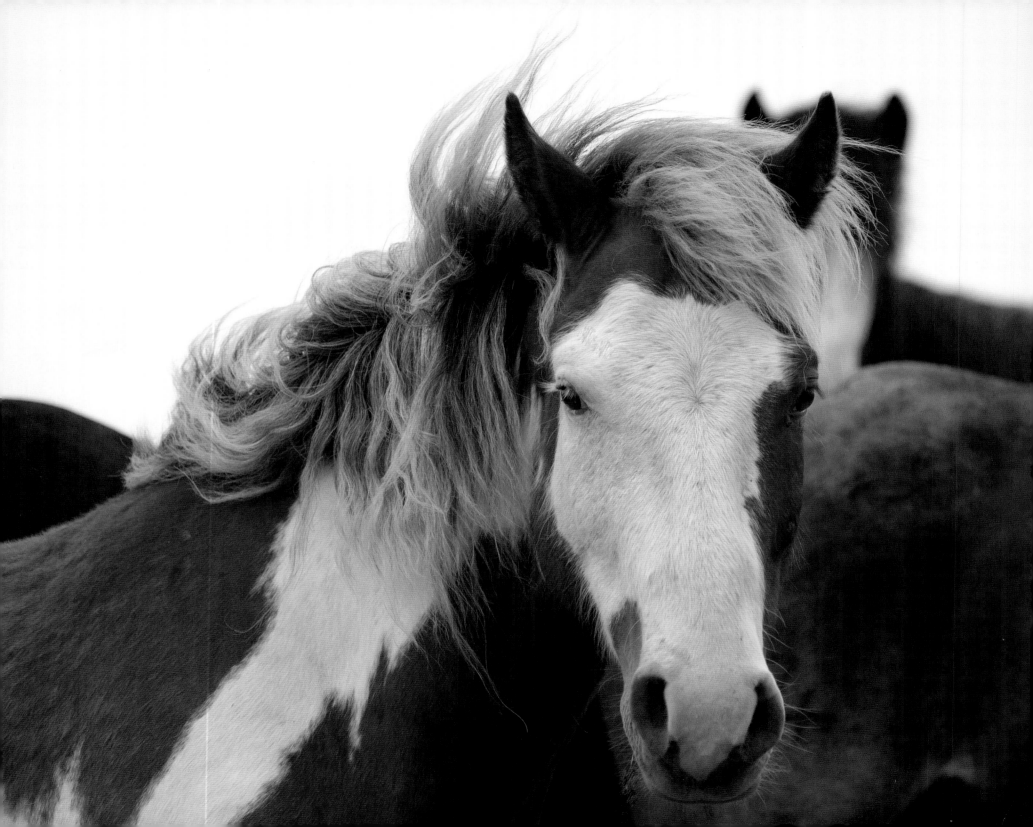

In Linton, the Nokota Horse Conservancy continues to cultivate its breeding program, slowing birth rates until the market regains its footing. Also, there is much more to accomplish in the region. An issue that continues to dog the conservancy is the fact that—despite Castle's comprehensive research and that of other respected historians—the NPS still refuses to recognize the Nokotas as a breed or acknowledge the horses' connection to Sitting Bull and his followers. Frank believes that the NPS doesn't acknowledge the breed or want to return Nokotas to the park because doing so would draw attention to the larger issue at stake: the legitimacy of wild horses on public lands. Returning Nokota horses to the park would set a precedent for wild horse advocates in other regions, who often challenge the false claim by government agencies that equines are nonnative species and that they compete with other wildlife and domestic livestock for resources. If that stance were to change, and the NPS were to express interest in maintaining a herd of wild Nokota horses at Theodore Roosevelt National Park, the Kuntzes would gladly provide several Nokotas as breeding stock to rebuild the wild herd. Frank would also suggest that the wild horses currently roaming the park, which primarily come from domestic stock, should move to local reservations for equine programs.

Butch Thunderhawk, former Nokota Horse Conservancy board member and Lakota artist, agrees. He teaches tribal arts at the United Tribes Technical College (UTTC) in Bismarck and cites the omnipresence of horses in native arts, stories, and spirituality. He would like to see more programs that expose Native American youths to their ancestral connection with horses. For a decade, he headed Horses on the Prairie Camp, a monthlong summer day camp offered through UTTC and funded in part by NASA. Native and nonnative American youths learned about regional native culture, art, and religion; the significance of horses and other animals; and plants, soil, and water. The campers spent several days on the Kuntz ranches in Linton, studying the Nokota horses, land, and vegetation. The program was a success, and it was growing in popularity among local youths when its funding was cut—another casualty of the recession. Both Butch and the Nokota Horse Conservancy would like to see the program return and expand into other communities.

It has taken nearly 30 years for the Nokota Horse Conservancy to bring the Nokota horse from the brink of extinction to international acclaim. The Kuntzes have managed to accomplish this on a shoestring budget, at the expense of their personal lives. Throughout the years, they have often been quoted as saying that they hadn't planned to spend their lives in this line of work; if they had known then what they know now, they might have walked away. That would have left the fate of the Nokota horses in the hands of the NPS, assuring their demise. Instead, the Nokotas got under the Kuntzes' skin and touched their hearts. They have that effect on people. Hannah Cooper, a family friend and volunteer, said that Frank and Leo live and breathe the horses and their history. That kind of passion and focus toward one goal is truly rare—as rare and beautiful as the Nokotas themselves.

A colorful, calm-eyed Nokota pony cross shares a paddock with a sizable group of older studs.

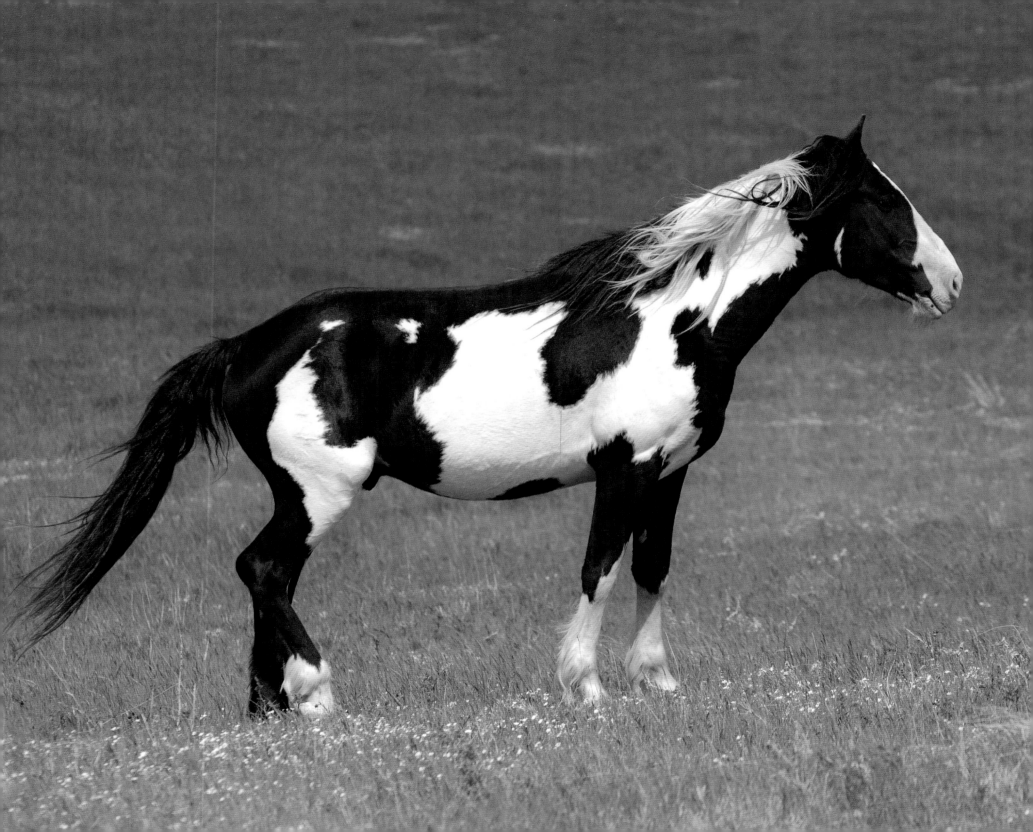

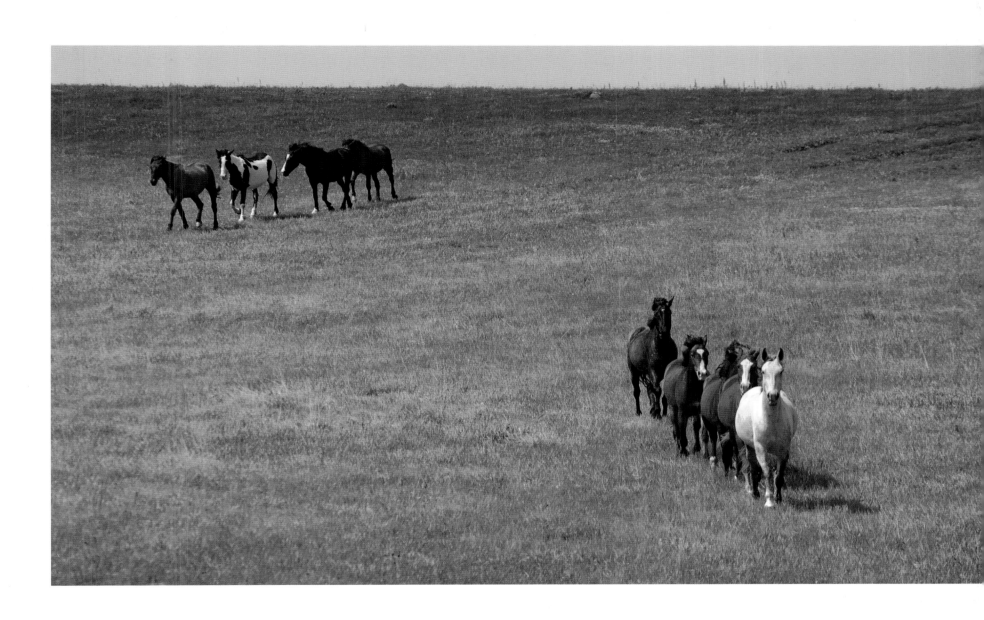

OPPOSITE: A striking tovero stallion faces into the wind. ABOVE: The stallion joins his pasturemates, all stallions, as they file into two remarkably precise diagonal lines downhill.

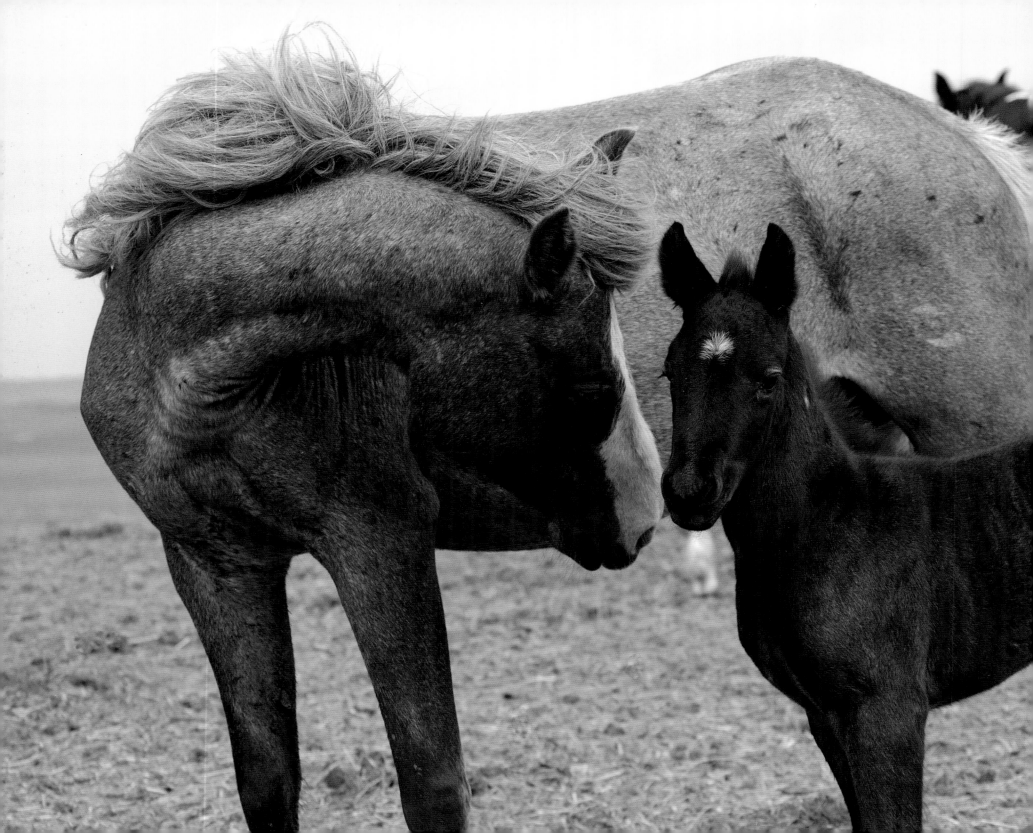

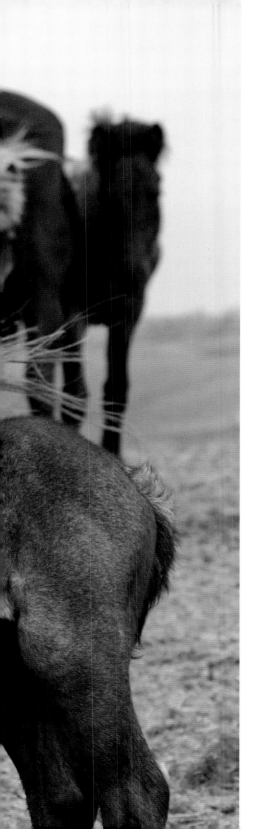

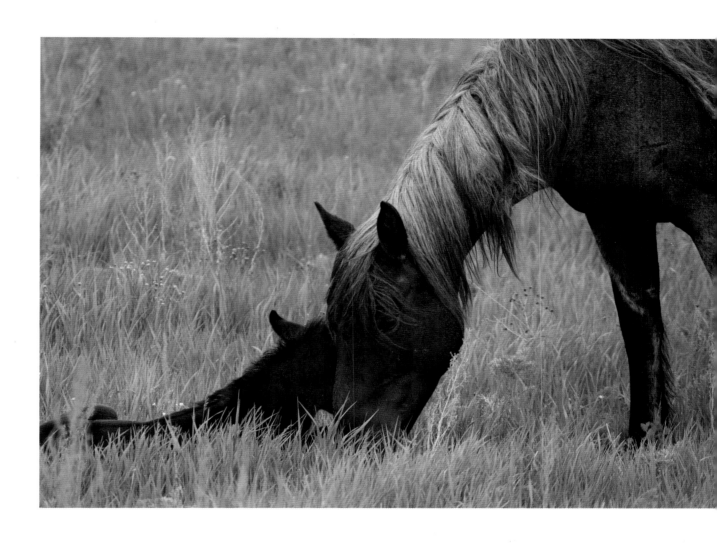

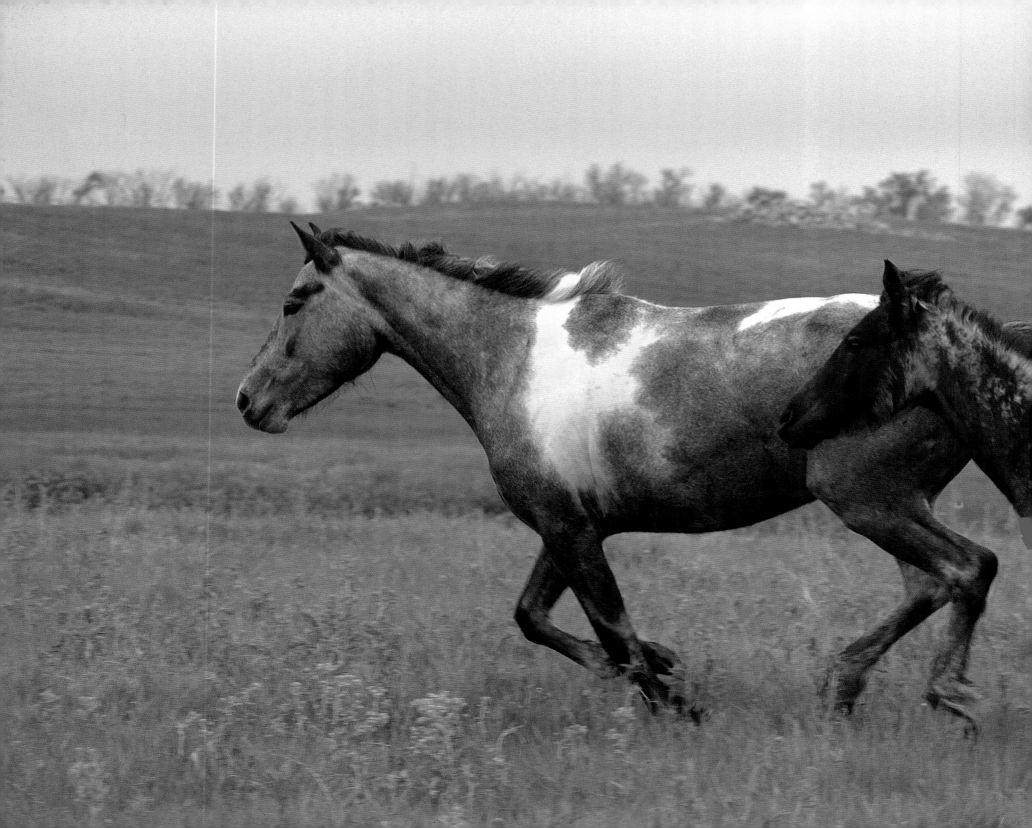

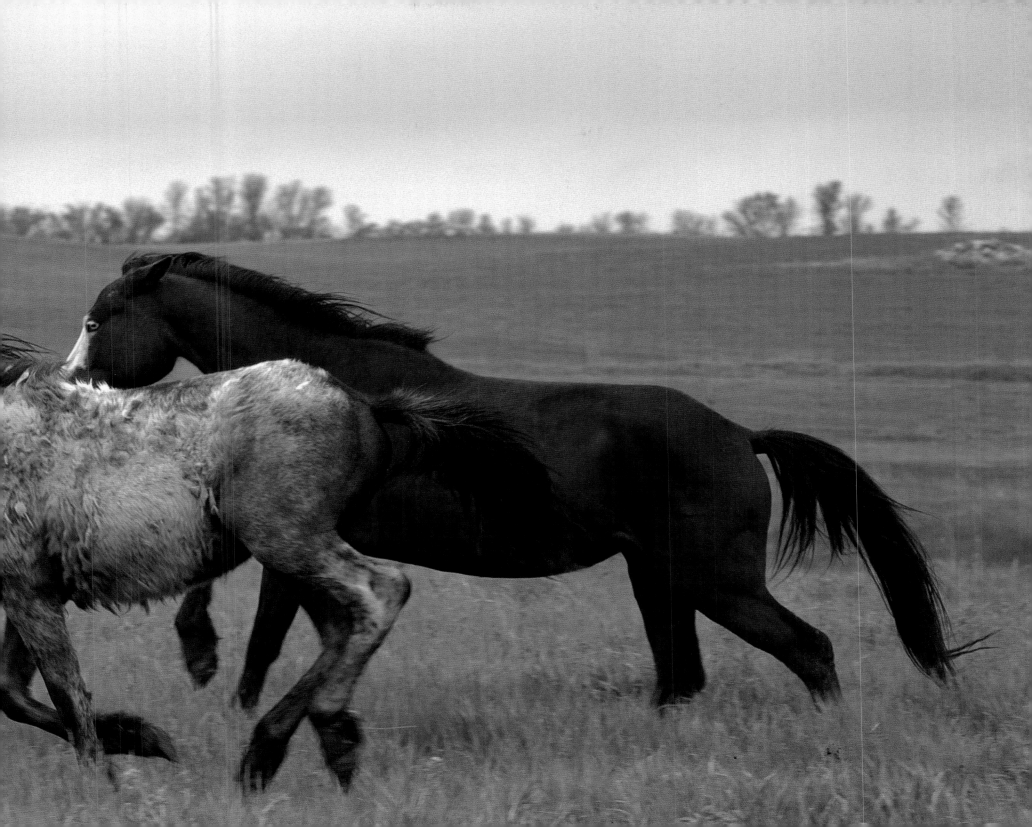

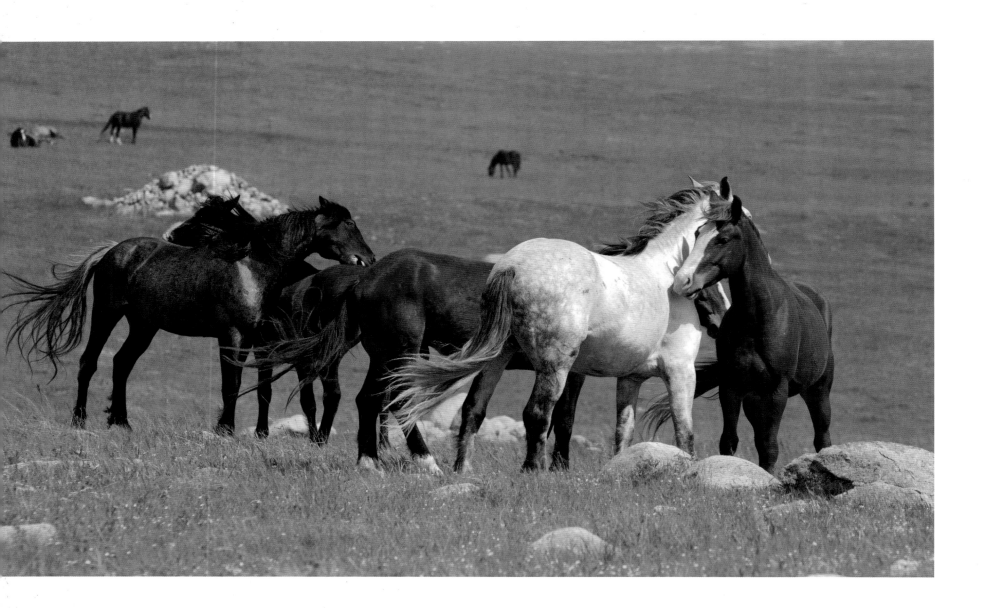

ABOVE: Pairs of Nokota stallions engage in mutual grooming. OPPOSITE: Older stallions in closer quarters enjoy the same bonding activity.

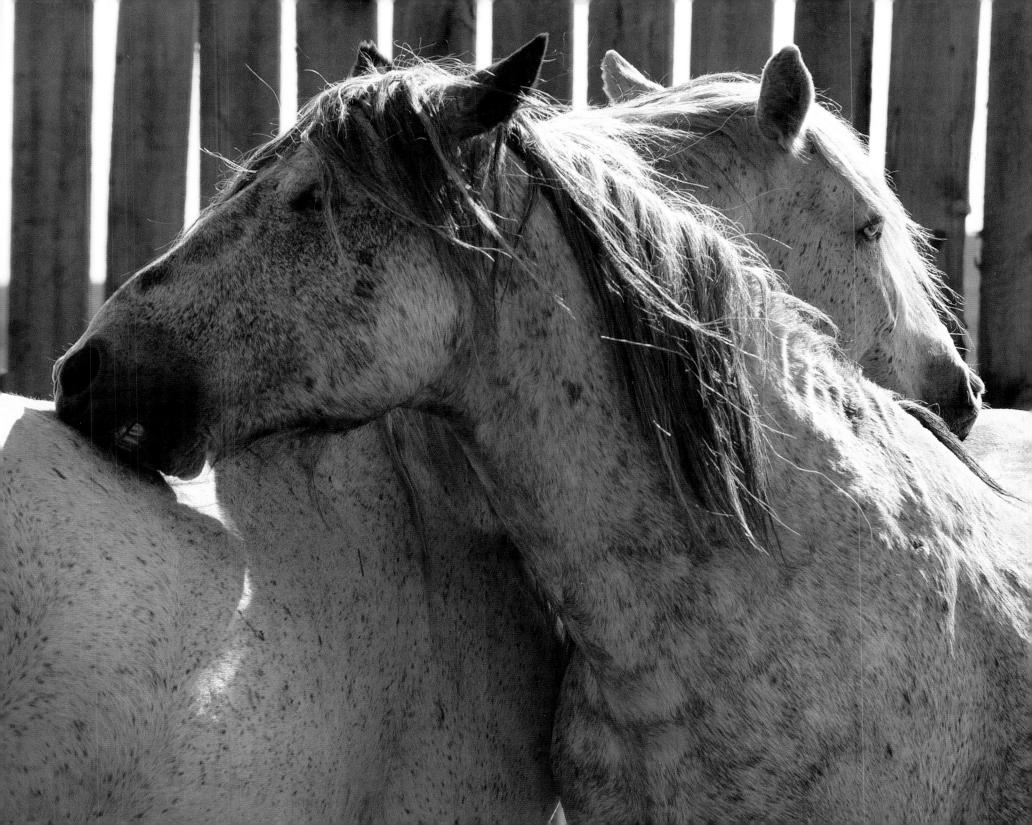

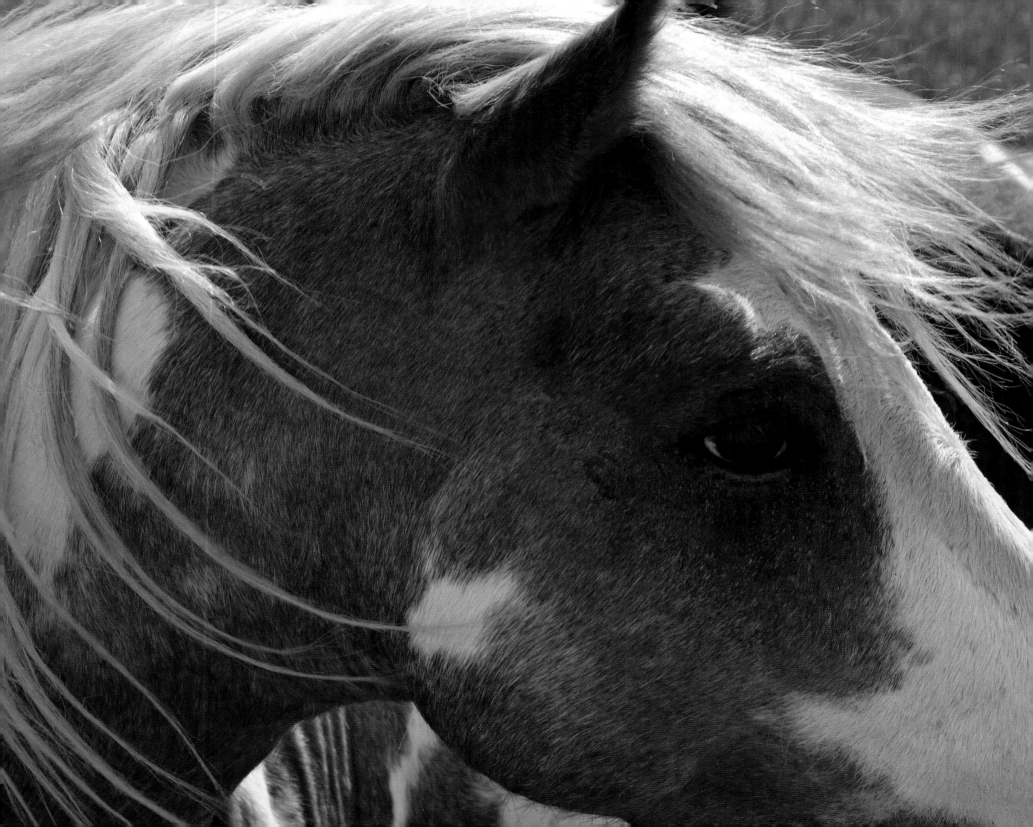

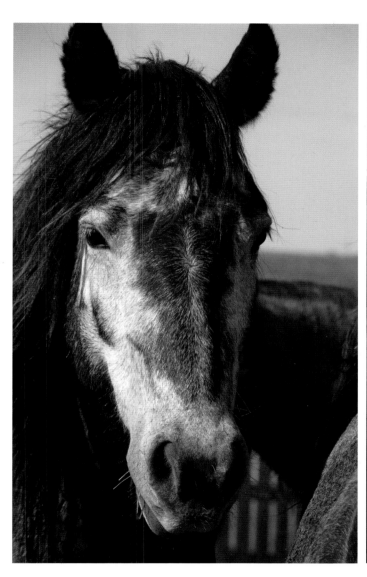

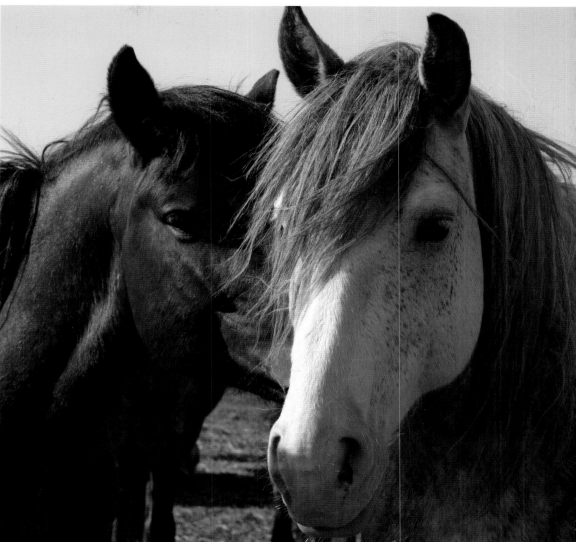

OPPOSITE: A strawberry roan overo lifts his head to the wind. ABOVE: Nokotas exhibit a wide variety of colors and patterns; their manes and tails tend to be long and thick.

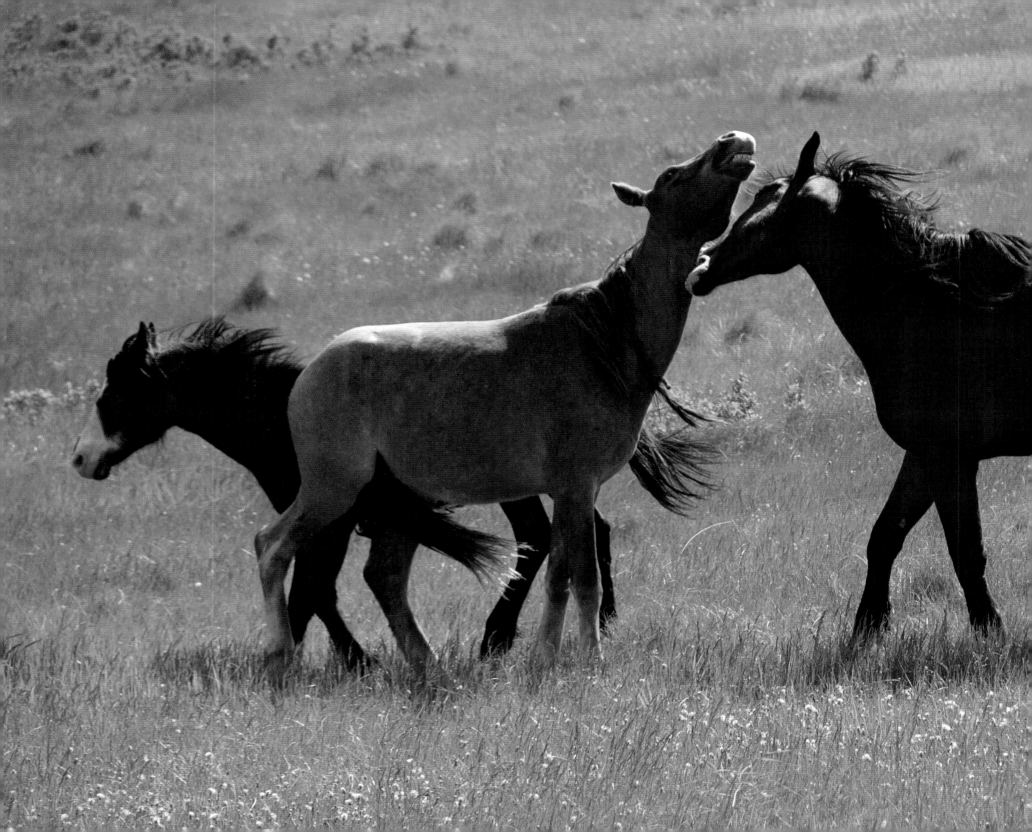

Dominance games establish at least a temporary
hierarchy among young Nokota stallions.

PEACEFUL VALLEY DONKEY RESCUE

Ask Tracy Miller about donkeys and the first thing he will tell you is that they are sorely misunderstood. Then, he will expound on their intelligence, sensitivity, and character. He resents the way that donkeys have been unjustly stereotyped in literature and movies. "What did Pinocchio turn into? A donkey. When someone is acting stupid, he's called a jackass. All such remarks are derogatory," said Tracy with disgust. "I tell people there are no stubborn donkeys. A donkey's refusal to respond to a command is based on

a logical thought process; the donkey has determined that what's being asked of him or her, like stepping into a trailer, isn't beneficial. The donkey has to feel comfortable with the outcome of what you're asking him or her to do."

Tracy is an encyclopedia of information concerning equines; he has had a horse for most of his life and a companion donkey for nearly two decades. He worked as a farrier for years, learning to care for donkeys' hooves, and now manages the Peaceful Valley Donkey Rescue facility in Tehachapi, California. He thoroughly enjoys the company of donkeys, which makes it difficult for him to resist the urge to stop dozens of times a day to scratch a head or hug an elderly jenny (a female donkey). Nonetheless, with more than 500 donkeys and a variety of other domestic animals to care for at the high desert ranch, he would accomplish nothing else if he spent his days doling out affection.

Although he downplays his gift, Tracy has a special way with donkeys. "It's all about reading their body language," he said. His skills were evident the evening we watched him catch Grump, a handsome burro with a dark dorsal stripe who was rounded up and removed from a Nevada range with his herd. Grump was kept in a pasture with ample grazing, but on occasion he preferred the grass on the other side of the fence. He was surprisingly relaxed for a burro recently removed from the range, but his demeanor didn't fool Tracy into letting his guard down. With a rope and halter hidden behind his back, he made a wide circle, then moved in toward Grump's left

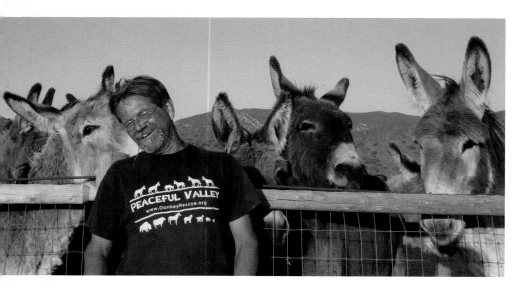

ABOVE: Tracy Miller, western states regional manager and caretaker for more than 500 donkeys, is the object of much long-ear attention and affection. OPPOSITE: Donkeys are unfailingly curious about visitors.

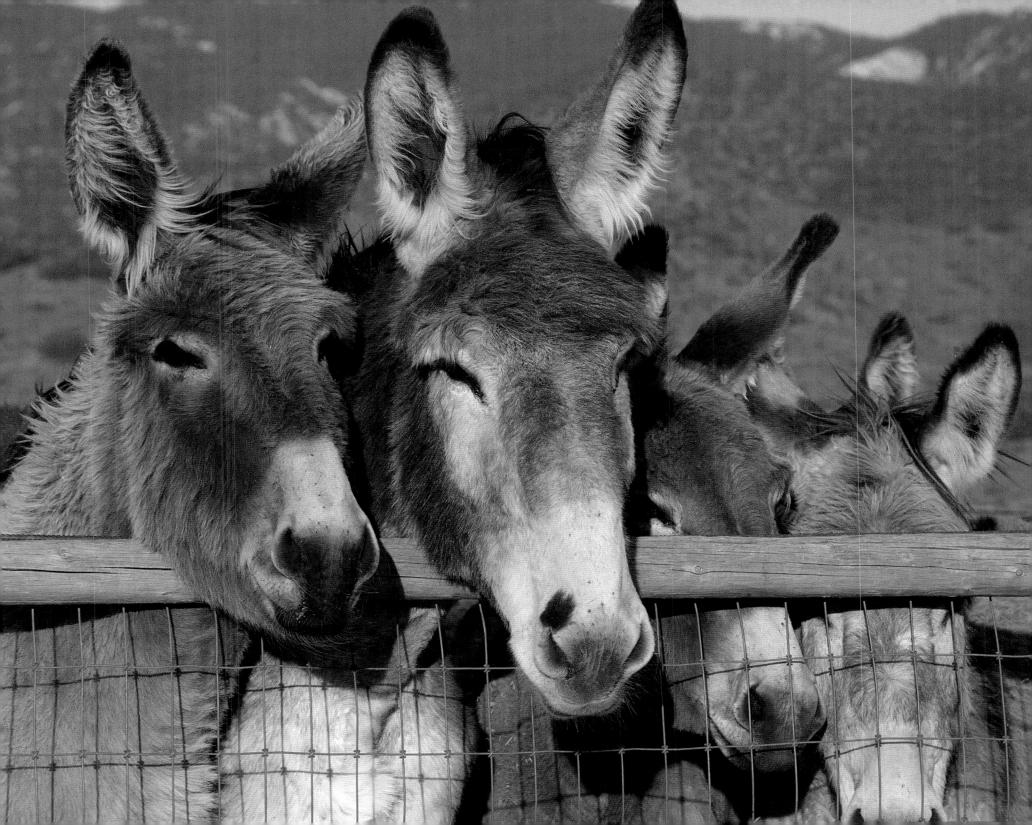

side. His steps were slow and relaxed, his voice soft. The burro appeared to consider his escape options, but instead stayed in place, dropping his head to tug on a few dry blades of desert grass. He barely flinched as Tracy slipped the rope around his neck. Tracy gave him a treat and several affectionate pats on the neck before slipping the halter on his head and leading him back up the hill to an adjacent, more secure paddock.

Since his early days as manager, Tracy has had many favorite donkeys on the ranch. Some he bonded with had had a traumatic experience, such as an injury or illness; others won him over with their extraordinary compassion, sense of humor, or will to survive. Tracy told a story of one particularly willful young jenny that became ill soon after arriving at the Tehachapi ranch after having been rescued from a terrible situation in Washington. For two months, Gidget—named for her strong will—lay on her back, unable to get up without help from Tracy and his ranch hands. Five times a day they lifted her off the ground, only to find her back down within 20 minutes. Tracy treated Gidget with medication several times a day, and when she refused to stay in her shelter, he would lovingly cover her up with a tarp to protect her from the elements. There were many mornings when he returned to the paddock expecting to find her lifeless body, but Gidget prevailed, regaining her health and strength over several weeks.

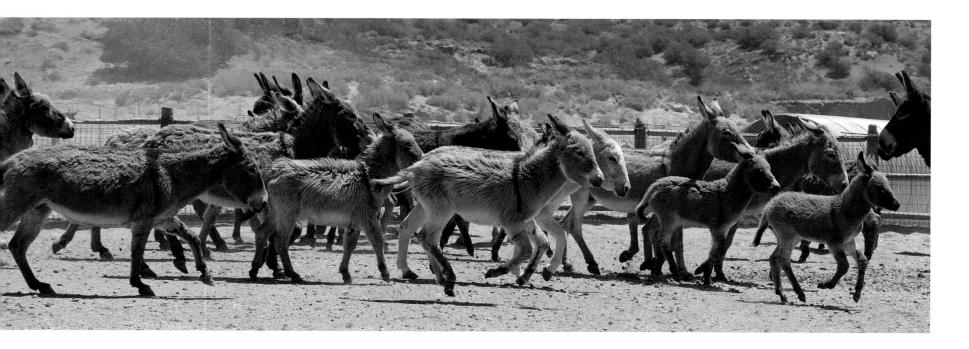

Young donkeys resist the necessary separation from their mothers. Because they will be moved to other paddocks and separated by sex, they are sprayed with color to distinguish the jacks from the jennys.

Eventually, a woman and her son adopted the young jenny. She now lives in Big Bear, California, where she keeps company with a horse. Tracy admitted that he shed a tear when he watched the trailer carrying Gidget turn out of the driveway. "I hate to see them go, but they deserve attention all day long, and I don't have that kind of time," he said.

Hundreds of donkeys pass through Peaceful Valley each year. In 2011, nearly 300 donkeys were adopted from the Tehachapi ranch. That same year, Peaceful Valley received dozens of wild donkeys from Bureau of Land Management (BLM) roundups. Surprisingly, many of the wild donkeys were approachable after several months and willing to be gentled and trained, albeit on their own terms. Peaceful Valley staff members use a technique that helps determine which donkeys are most likely to adapt to domesticity: they sit on the ground, head tucked between bent knees, and wait. A curious donkey will come forward, possibly even touching his or her muzzle to the person's head, shoulder, or back. After repeating this strategy over several days, the staff member will extend a hand for the donkeys to inspect. Next, he or she will offer treats, and in time, the curious donkeys will approach the person who enters the paddock. Then, the person will introduce a halter and lead. The final step is to remove gentled donkeys from the herd and place them with a group in training. It's a slow process, but it has proved to be the most reliable and humane method of working with donkeys that have spent most of their lives shying away from people.

A SAFE HAVEN FOR DONKEYS

In 2000, Mark and Amy Meyers launched Peaceful Valley Donkey Rescue at their California home after witnessing the frequent abuse, neglect, and misunderstanding of donkeys. Now zealous advocates, the couple has expanded Peaceful Valley into a nationwide nonprofit rescue and education organization with two main hubs—the corporate headquarters in Tehachapi and the national operations center in Miles, Texas—and 13 satellite farms located throughout the United States. Mark and Amy are at the helm of the organization as executive director and chief financial officer, and are guided by a dedicated board of trustees. Tracy Miller oversees the Tehachapi facility and is regional manager of the western states.

In addition to the rescue of abused, neglected, and abandoned donkeys, Peaceful Valley operates an expansive program to save wild donkeys on public and private lands. The Wild Burro Capture Program allows Peaceful Valley to capture and remove wild burros safely using baited traps or mounted wranglers. The burros, a Spanish term referring to wild donkeys, are delivered to one of the ranches, where they are given medical treatment as needed, vaccinations, and hoof care. Jacks (male donkeys) are gelded, and pregnant jennies are separated from the herd. The burros that show potential for gentling are singled out and trained for adoption, but those that refuse to be gentled are transported to the Peaceful Valley sanctuary in Texas, where they will live relatively free of human contact and safe from BLM roundups.

In general, Mark shuns public interaction to focus on his widespread and effective fund-raising efforts, rescue campaigns, and the growth of Peaceful Valley. Nevertheless, he's a savvy campaigner and recognizes the value of media attention. Since launching Peaceful Valley, he has been featured in dozens of print, television, and radio stories, as well as two documentary films. He has also written three books. He said his goal is to improve the plight of the American donkey and to change society's misguided opinion about the animal. In the third edition of his book *Talking with Donkeys: Saving Them All*, Mark wrote "the hardest part of donkey rescue is convincing people why donkeys are worth saving."

Many of the domestic animals that come to Peaceful Valley are malnourished and suffer from various skin diseases and parasites. Some are physically and emotionally wounded from the abuse they have suffered at the hands of ignorant and cruel owners. Most of the donkeys have severely overgrown hooves, which causes gross disfigurement and lameness. It's not unusual to see donkeys ambling about the ranch on their ankles, a crude adaptation they've been forced to make due to a former guardian's neglect.

Unlike the Texas facility, and another large one in Oklahoma, the California ranch doesn't have the acreage for a large sanctuary. In fact, the entire operation, set in a narrow canyon in the Tehachapi Mountains, is only 140 acres, but the efficient layout makes possible holding, managing, and moving hundreds of donkeys at a time. A visitor center and office near the entrance provides basic facts about donkeys, the history of Peaceful Valley, and the people who make it happen. Peaceful Valley shirts, hats, and other sundries are for sale, and an enchanting exhibition features donkey-themed objects and books donated by staff, volunteers, and visitors. The pastures and paddocks spread out beyond the visitor center, distanced from it by a gully and long gravel drive. At the west end of the property, a center roadway wide enough for a semi-trailer truck or tractor is lined with corrals occupied by donkeys that have been selected and grouped by sex, age, personality, or health condition. The sick or injured are held in adjacent quarantine pens for as long as three weeks. Every animal that arrives at Peaceful Valley is vaccinated, wormed, and microchipped; all available information about him or her is readily accessible through a database developed especially for this purpose.

In the midst of the corrals is a small aviary for rescued fowl, and an adjacent enclosure with squat shelters near the back is home to several potbellied pigs. There are also sheep, goats, llamas, mules, and a former bucking horse named Pippy, all rescues or surrenders, now permanent residents of the ranch. A medical and grain shed contains boxes of antibiotics, salves, wraps, and emergency supplies. A whiteboard lists daily chores, special grain mixtures for the elderly and sick donkeys, and other pertinent information for the ranch hands. Dozens of small pastures consume the majority of the property, the years of use reducing the tough native grass to dust, which is picked up and whipped through the canyon by fierce northwesterly winds that force even the toughest ranch hand to seek shelter.

The animals at the Tehachapi ranch require 6,000 pounds of hay per day, or approximately six large bales, all distributed by one or two ranch hands. This chore must be performed daily, in addition to watering, mucking, moving donkeys, and training. Some days are dedicated to gelding jacks; other days are spent tending to injuries or rounding up donkeys for hoof care, an arduous task that Tracy performs with the help of a local farrier. The list of chores is endless, and Tracy's only help, aside from the ranch hands, are occasional volunteers, and his teenaged son, Austin. At the end of the workday, Tracy dons his administrative cap to respond to questions and adoption requests or to place hay and supply orders. His average workday is 14 hours, seven days a week. At least once a month, he hitches up the trailer to deliver adopted donkeys and pick up neglected or abused animals that have come to the attention of Peaceful Valley. Always on a tight schedule, Tracy drives as far as Washington State and back without an overnight stay. He said he doesn't have the luxury of time; he is responsible for the care and well-being of nearly 600 animals.

When Austin isn't in school, he is often on the ranch helping his father manage and care for the animals. Their home is on the eastern edge of the property, with views of the sprawling ranch and its hundreds of occupants. Austin shares his father's appreciation for donkeys and is an equally gifted

Two young donkeys bond apart from the crowd.

spends so much time on the ranch. During the summer of 2011, he missed only one day of work. Throughout the summer, father and son are nearly inseparable, and when Tracy leaves town for a donkey pickup and delivery, Austin is often on board, keeping company with Tracy during the long drives up and down the West Coast.

A SATELLITE RESCUE IN OREGON

Rhonda and Jim Urquhart knew very little about donkeys when they launched a satellite rescue of Peaceful Valley at their Oregon City farm. Both were animal lovers, and Rhonda had years of horse experience, but their exposure to donkeys was limited to the occasional over-the-fence greeting. Then, they met their neighbor's donkey, Beau. His lonely braying from the other side of the hill captured their attention. Curious to learn more about donkeys, Rhonda went online, where she discovered the Peaceful Valley Donkey Rescue website. A year later, the Urquharts were looking out their kitchen window at their first group of rescued donkeys.

The couple's 40-acre farm outside of Portland, Oregon, is postcard-perfect: whitewashed fences line the drive leading to a red barn; green pastures roll over hills topped with clusters of fir and oak trees. The family dogs keep watchful eyes over their domain, and roaming hens scratch in rain-dampened soil for bugs. It's an idyllic setting, the perfect place for donkeys recovering from physical and psychological abuse. Rhonda recalled the couple's steep learning curve after the arrival of the first donkeys, but their admiration for the animals was immediate. "They're so observant, not flighty like horses," she said. The Urquharts built a donkey barn with adjacent shelters and created several paddocks within view of the house and deck, where they often sit on warm evenings to watch the donkeys

handler. He is at ease walking in a pasture of jacks, loading a resistant jenny, or attending on-site medical procedures. In fact, he's frequently in charge of monitoring the ventilator during geldings or other procedures. "Austin's a real natural, the best donkey handler on the ranch," said Tracy with pride. Austin shrugged off the compliment. He admitted that he prefers the company of donkeys to that of most people, which is one of the reasons he

Tracy and his son, Austin, separate a reluctant young jenny from her mother.

kick around an assortment of equine toys. They've learned a lot about their wards by observing them, but they've also spent many hours each day in the paddocks and barn. Rhonda said it's hard to resist them because, unlike horses, donkeys are very affectionate and will accept (and encourage) long grooming sessions with plenty of hugs.

Since the first group of donkeys arrived in 2010, the Urquharts have placed a dozen in new homes, and each time space opened up at their farm, several more donkeys were delivered. A few have come from Peaceful Valley's Tehachapi facility, but most are rescues or surrenders from former guardians in the Pacific Northwest. The vetting process for prospective adopters is thorough, and the Urquharts have turned down almost as many applicants as they have approved. Donkeys must be ensured adequate pasture and shelter, and the companionship of another donkey or horse is essential. A prospective adopter has to provide references and pass a barn and fence inspection, but equally important is the impression the person applying to adopt a donkey makes on Rhonda and Jim. "We can tell right after meeting them. If they ask about bedding or the best paddock size for a donkey, we consider that a good sign," said Rhonda. "The best home is one

 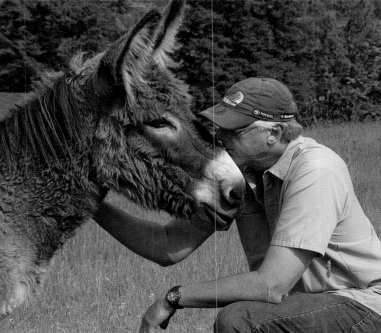

Rhonda and Jim Urquhart, managers of the Peaceful Valley satellite adoption facility in Oregon, discuss matters with their resident long ears.

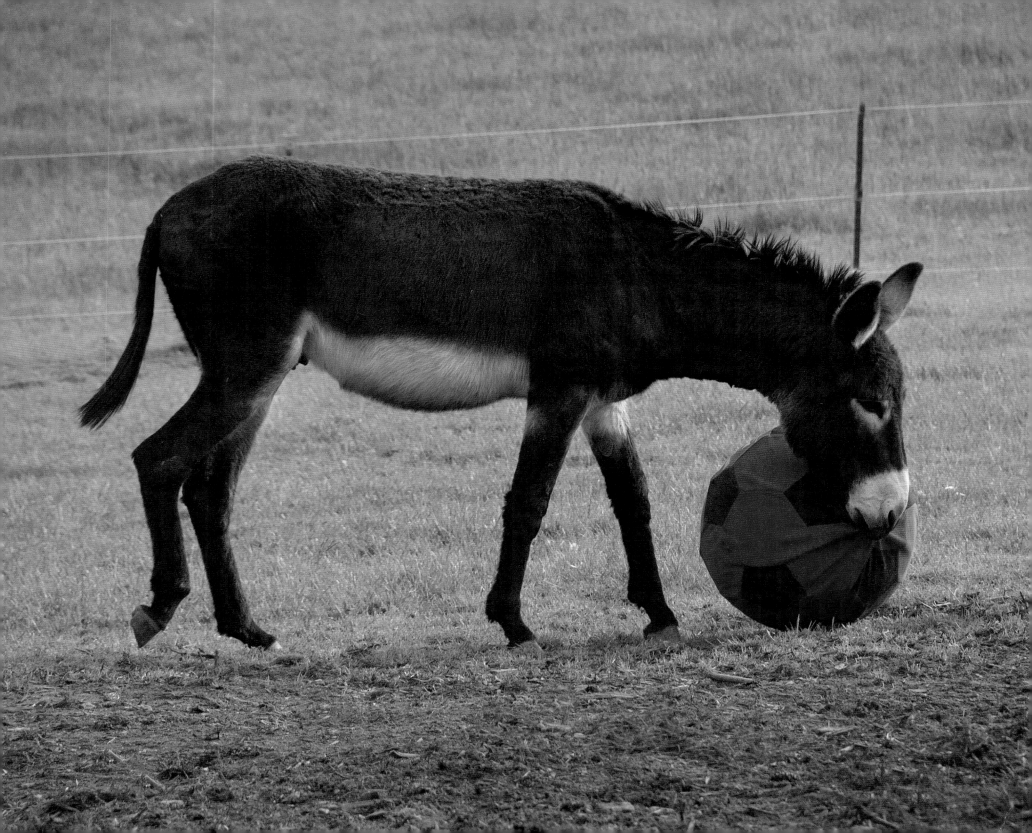

that allows the donkeys to evolve into their lives and where the owners are concerned about what's best for the donkey."

Once donkeys enter the Peaceful Valley system, they remain under the guardianship of the organization for the rest of their lives. This policy ensures that all Peaceful Valley rescues are cared for if unforeseen circumstances endanger their well-being. Financial hardship is the main reason caregivers return donkeys to Peaceful Valley, but it's not uncommon for a death in the adoptive family to put a donkey at risk of neglect. Donkeys can live for 40 years, sometimes outliving their caregivers, which is why the Urquharts also take the age of prospective adopters and donkeys into consideration. Luckily, no donkey has been returned to their facility yet. They hope that none will ever be returned, but they leave space in the barn just in case that should happen.

According to Jim, even under the best circumstances, it's not easy watching the wards go to new homes. "I need three drinks and therapy after taking a donkey to a new home," he joked. The Urquharts have grown so attached to donkeys that they've adopted five themselves. They encourage visitors to come to their farm, and on several occasions have introduced the donkeys to Girl Scout troops and various school groups. Rhonda said most of the donkeys respond to children. Although capable of playful shenanigans like hat swiping, donkeys are especially gentle with children, sensing their vulnerability.

On one occasion, the Urquharts witnessed a young boy with autism approaching Zona, a jenny that had been horribly abused and neglected by her former guardian. Zona was resistant to handling of any kind, including gentle grooming. She stood apart from the other donkeys, not comfortable with the group yet unhappy in her isolation. Rhonda described how the boy entered the paddock and focused his attention on Zona. Without knowing anything about her sad past and resistance to affection, the boy approached the donkey and proceeded to rub her neck and head. Zona remained still. She closed her eyes as the boy scratched between her ears and down the length of her nose. The Urquharts were stunned. The experience encouraged Rhonda and Jim to consider donkeys as therapy animals for other children with disabilities. In fact, the more they learn about donkeys, the more committed they become to championing their attributes. "Education is the key to changing the way people think about donkeys," Rhonda said.

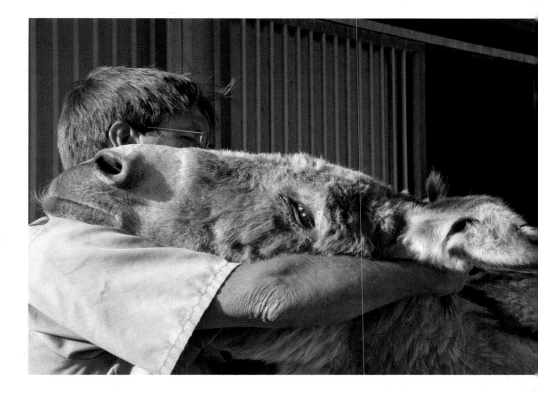

OPPOSITE: Jojo, a playful jack, relishes a game with a ball. ABOVE: Tracy reciprocates his friend Ned's affection with a hug.

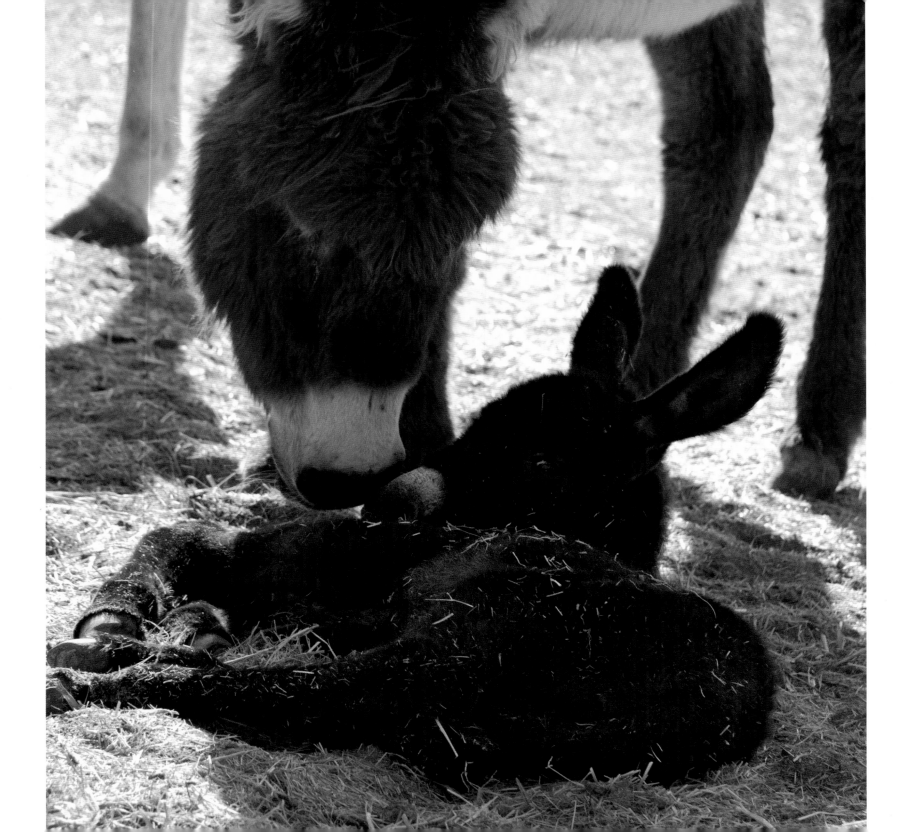

OPPOSITE: Born at midnight of the previous day, Midnight receives his mother's full attention. ABOVE: Joker, also newborn, sits up and soon finds his breakfast.

ABOVE: Matilda, the eldest donkey at the sanctuary, is 46.

OPPOSITE: Honey (right), a particularly endearing jenny, joins her companions as they seek attention.
Tracy took time to trim and shoe her painfully neglected hooves.

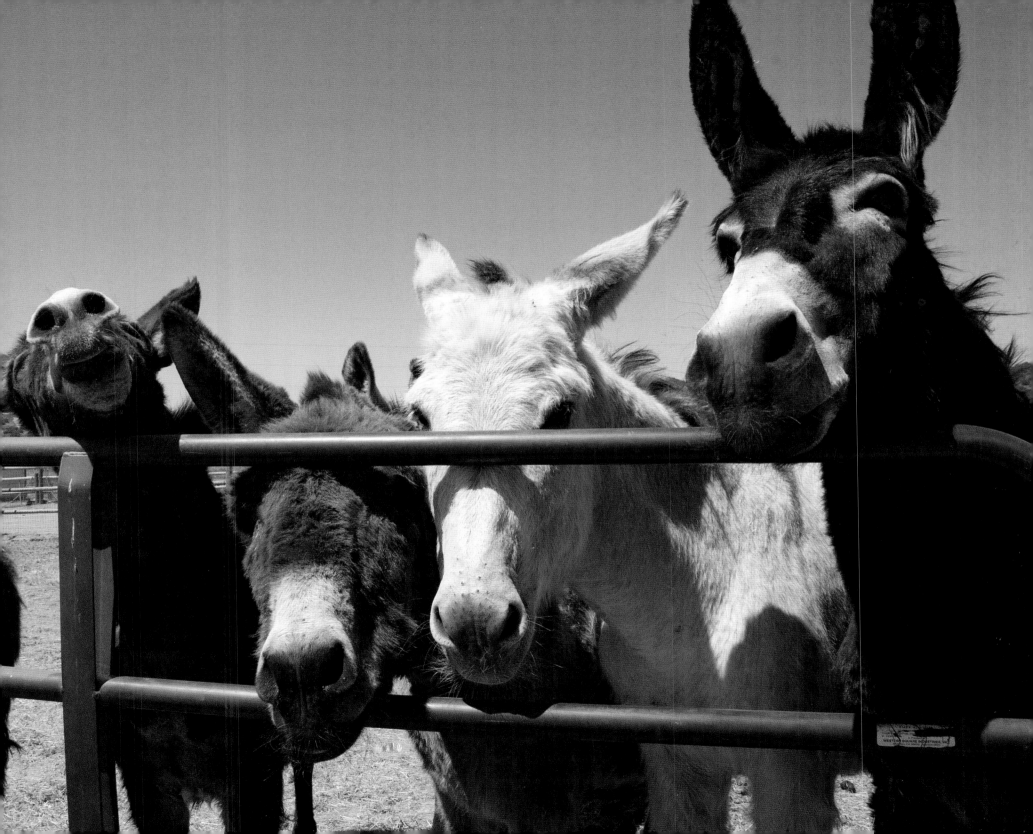

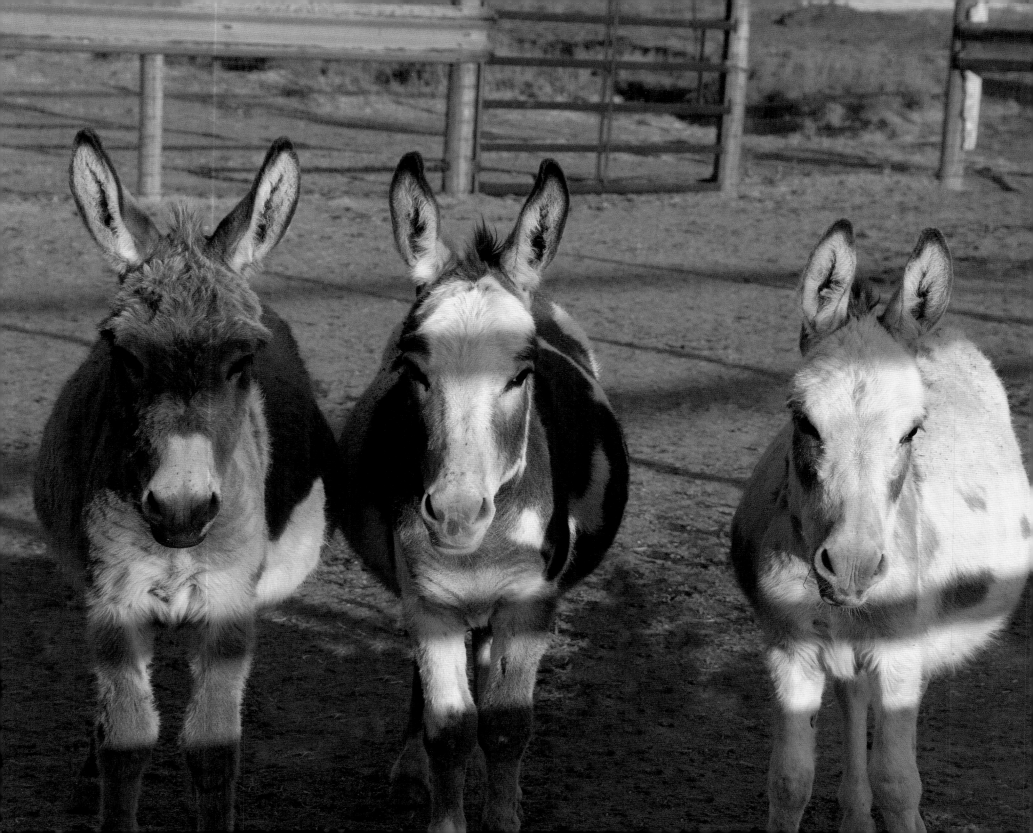

OPPOSITE: Two of the miniature donkeys at the sanctuary are of the relatively rare spotted variety.

RIGHT: Cotton, a shaggy-coated long ear, and a chocolate-colored companion, pause during a stroll to approach visitors.

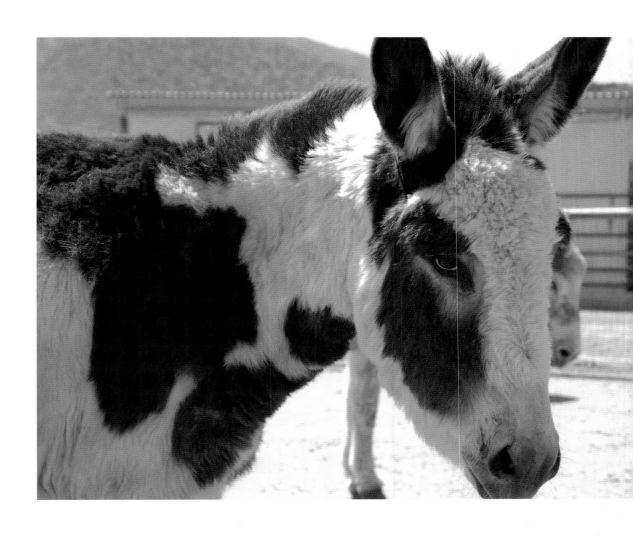

OPPOSITE: Tiny Twiggy, disconsolate after separation from her mother, approaches neighboring Mary, a mule whose broken leg has healed well enough that she can move about.

ABOVE: Moomoo is an especially beautiful spotted jack.

SAVE YOUR ASS LONG EAR RESCUE

SOUTH ACWORTH, NEW HAMPSHIRE

Ann Firestone was born a rescuer. For as long as she can remember, she has been compelled to save animals in need. Her first rescues were three baby squirrels; there were also a number of orphaned birds. Later, she got involved with a greyhound rescue and then helped start one for rabbits. From urban creatures she moved to wildlife rescue, eventually becoming certified as a wildlife rehabilitator by the state of New Hampshire. Now, the

home she shares with her husband, Jeff, is a rescue for all types of winged and four-legged animals: big and small dogs, cats, exotic birds, turtles, and fish. In the adjacent barns, paddocks, and pastures are potbellied pigs, chickens, horses, and, of course, long ears of all shapes, sizes, and ages. They are the wards of Save Your Ass Long Ear Rescue, and now consume the majority of Ann's time and energy.

Evergreen forests and grassy meadows surround the Firestones' 185-year-old farm in South Acworth, New Hampshire. At the edge, a creek runs year-round, disappearing into the thick forest at the bottom of the hill. An assortment of wildlife, including a fox and her kits, makes frequent visits to the farm. Flowers grow tall along the porch of the farmhouse, the bright summer blooms attracting honeybees and monarch butterflies.

It was the classic children's book *Brighty of the Grand Canyon* by Marguerite Henry—a fictionalized account of a burro that carried water in the Grand Canyon—that first sparked Ann's childhood interest in donkeys. Years later, while visiting a petting zoo with her nephew, she observed a donkey named Lula lying on her side, getting a belly scratch from an attendant. It changed Ann's life.

"I saw Lula," Ann said, pointing to a pasture beyond the barn where a group of horses and a small donkey grazed in the afternoon sun. "I said, 'I've got to have that donkey.'" At the end of the summer, Ann purchased Lula and brought her home in a van. "I was smitten! She was so doglike, so different

ABOVE: A raised vegetable garden flourishes in front of the farmhouse. OPPOSITE: Lula peers from behind a clump of goldenrod.

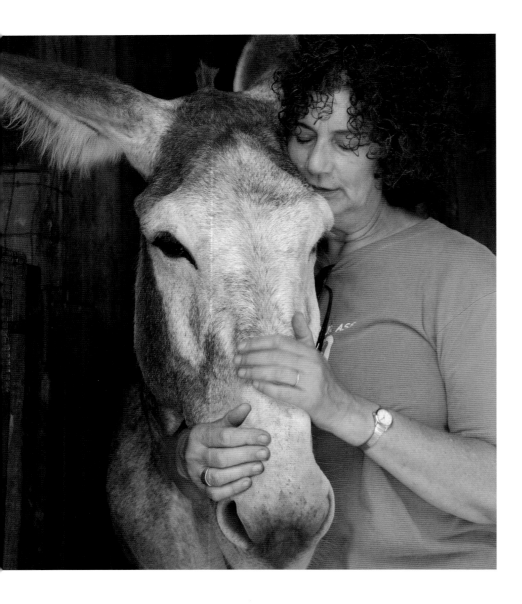

Ann Firestone, founder and director, shares a loving moment with Louise.

from horses. I kept waiting for her to grow up so I could ride her, but she didn't get any bigger than she is today." It wasn't long before Ann was asked to take in another donkey, and then she joined a discussion forum where she met several other women who were also adopting donkeys. "We realized that if we joined forces, we could take in more donkeys," Ann said. In 2007, Save Your Ass Long Ear Rescue was launched.

When applying for nonprofit status, a state representative asked Ann how many rescued donkeys she thought she would be caring for at one time. She said 12, but has had to change that number several times. Now, due to the exorbitant cost of care and feed, eight is the average number of rescues that live at Save Your Ass at one time. The long New Hampshire winters combined with grass pastures eaten down to the roots mean that hay and feed are a year-round food source for the equines. Although a miniature mule requires only two flakes of hay per day, a draft mule needs an entire bale. At approximately $6 a bale, that's considerable stress on the coffers.

Many of the donkeys and mules at Save Your Ass are owner surrenders resulting from financial hardship. Typically, they come to the rescue in the fall or winter when animals move from the fields to barns and shelters where they must rely on hay to survive. A smaller number of long ears come to Save Your Ass from auctions and usually suffer from poor health or injuries. In the short term, they require considerable medical, hoof, and dental care, and some have health problems that may take years to resolve. Training may also be a requirement, depending on the amount of handling a donkey or mule has had in the past. Ann is also a professional dog trainer and applies the same gentle training approach to her equines. The "clicker method" is a psychological technique that connects positive behavior with sound—a click of the tongue or a handheld clicker—and a reward. Ann doesn't set time restraints on learning; according to her, each donkey and mule advances at

its own pace. It could take days or weeks. Positive reinforcement establishes a foundation of trust in the most jaded animals, which will help them adapt to their new homes.

A QUARANTINE BARN

Just weeks before our visit in late July, Save Your Ass volunteers completed most of the work on a new hay barn that doubles as a shelter for donkeys in quarantine. (Like most Save Your Ass events, barn building is as much a party as a workday. There's always plenty of food and drink and music.) The town of Acworth generously gave the rescue a $1,500 grant, and a local lumberyard gave them a considerable discount on building materials.

Darlin' Teddy was one of three new arrivals in quarantine. He stood close to the new barn in the shade of the long roof. Days before, he had been rescued from an auction in Pennsylvania. Withdrawn and in need of grooming and hoof care, Teddy's past was a mystery, except for one very obvious clue that pointed to a difficult life: he was missing the top half of his glorious donkey ears. At some point in his past, someone had cut Teddy's ears down to stubs, less than half the length of their normal size. Although frostbitten ears aren't unheard of in cold climates, Ann—who has been a vet tech for 35 years—ruled out that possibility for Teddy. "These ears have been cut off," she said, shaking her head in disbelief. "This is what makes me cry."

In spite of his troubled past, Teddy seemed to know he had arrived at a safe place. He allowed us to gather around him and accepted our reassuring rubbing and scratching. His eyes closed, his body relaxed. Volunteer Annie Kellam leaned into him and hugged his thick neck. She was there when Teddy arrived. "He was so worried and scared," she said. "But he knew how much we wanted to help him."

Darlin' Teddy, in quarantine the day after he arrived at Save Your Ass, had been cruelly robbed of a donkey's most striking feature.

Like all newcomers to Save Your Ass, Teddy, Ezra, and Asia were quarantined for three weeks before being released with the others in the adjacent pasture and paddocks. Many animals that come from auctions have a combination of worms, lice, skin diseases, and other ailments. They're also stressed, and introducing them to a group of happy-go-lucky equines is a lot to ask. But Ann knows that soon after they relax into their new environment, they will become curious; that's when she presents them to the rest of her long ears. If the donkeys or mules are owner surrenders and come from a good background, Ann will keep their previous names. The less fortunate ones, like Teddy, Ezra, and Asia, receive new names to indicate a fresh start. This process also aligns with Ann's mantra—"That was then, this is now"— which she often repeats to herself and others as a reminder to avoid letting the animals' tragic pasts overwhelm them with grief.

DEDICATED VOLUNTEERS

Teddy was transported to Save Your Ass with Ezra, a good-natured Haflinger mule, and Asia, a stunning paint mule. The three would have gone to slaughter in Canada if Save Your Ass hadn't rallied enough financial support through Facebook to save them. As we lavished attention on Teddy, Asia remained on the periphery of the paddock, curious but also wary of our motives. Ezra came in close for a carrot, and then backed away to watch from a distance. His background was just as mysterious as Teddy's, but after a medical exam, Ann learned that Ezra suffered terribly from fused vertebrae in his neck caused by severe osteoarthritis. That explained his inability to lift his head above the shoulder and may have been the reason his former owner sold him at auction. Ann manages his pain with a combination of medications and herbal remedies, but Ezra will also require long-term acupuncture and chiropractic care.

In a separate paddock, five miniature donkeys surrounded us, anticipating attention, treats, or both. Their hooves were so dainty that a step on our toes barely registered. Tiny, soft muzzles grabbed at our clothes and bags. Little Pea was bold; her mother, Piccolina, and a pretty jenny named Dinah were more reserved. Piccolina and Little Pea came to Save Your Ass with a young gelding who was adopted soon after arriving. Their relaxed nature and fondness for human contact made volunteer Annie think that the person who surrendered them was very kind and attentive. Aubrey and Zanzibar, on the other hand, hadn't been handled at all when they were rescued from an auction in January 2011. They would hide in the corner of the barn, pretending to be invisible. "We called them the fawns," said Annie. "Within a week, these two boys were coming up and giving me a kiss. I have it marked

ABOVE: Asia, newly arrived and grazing peacefully in quarantine, is still wary of visitors' overtures. OPPOSITE: On his first full day at the rescue, Ezra rests his painful neck on the ground.

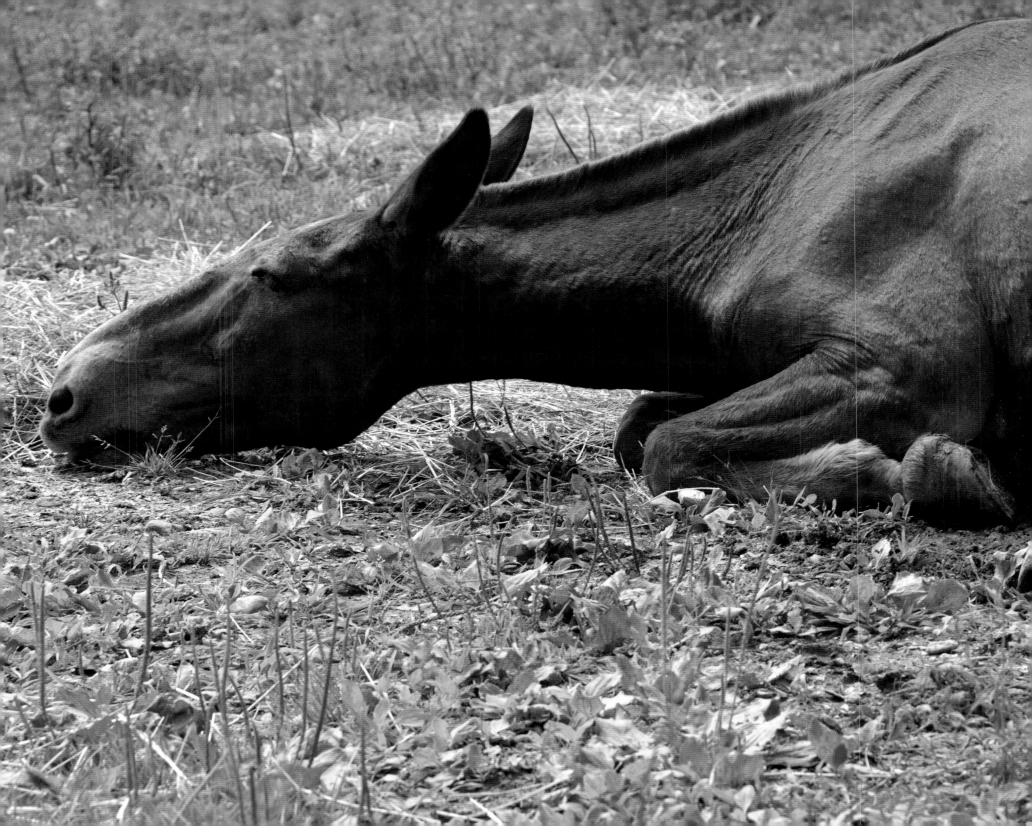

on my calendar: 'Zanzibar gave me a kiss.'" She said she always gives new donkeys and mules time to adjust before approaching them. "We let them approach us when they're ready. If within a week they're taking food out of our hands, that's really rewarding," she added.

Alison Wright has been involved with Save Your Ass as a volunteer for two years and recently became a board member. She has also adopted four long ears—Egypt, Scout, Jenny, and the miniature, Dinah. They'll live in Massachusetts, where Alison and her husband are wrapping up renovations on a home and barn for their small herd and eight dogs they adopted from a shelter in Dubai. (Alison's husband was stationed there with the British Army.) Their new home is a two-hour drive from Save

Your Ass, but close enough that Alison can stay involved. In particular, she has committed to helping develop more extensive fund-raising strategies. As a young organization, Save Your Ass has survived mainly by means of individual donations and merchandise sales, as well as proceeds from the annual Donkey and Mule Benefit Show. But as with all burgeoning nonprofit organizations, funding diversification is essential to long-term survival. Save Your Ass has considered a number of options, including more events (which they do well), securing sponsors, and a legacy program.

While waiting for her new home to be finished, Alison's mule, Jenny, is a perfect stablemate to Marlin, a Belgian mule that has become the permanent Save Your Ass ambassador. Ann is especially fond of him, pointing out his blonde "surfer boy" good looks and laid-back personality. Marlin and Jenny—both in their 20s—had worked for the Amish in the fields and pulling carriages, but like so many Amish draft animals, were sent to auction for slaughter and replaced by younger mules when they were no longer useful. Both bear the scars on their necks and shoulders from harnesses that were too tight and were never or rarely removed. "Marlin was scheduled to be transported to slaughter on Christmas Eve," said Alison. "It was like saying, 'Thanks for all your hard work, now off you go!'"

"Lotions, potions, or vegetables, they line up when they see Annie coming," said Alison. Annie was dabbing a thick yellow gel made from goldenseal and myrrh on a small wound on Grayson's neck. She's an herbalist at heart and always has a natural remedy available to treat wounds and ailments. A donkey and horse owner for many decades, Annie met Ann at a local feed store in 2009 and within weeks she was volunteering at Save Your Ass. Once or twice a week she commutes nearly 30 miles each way to muck out the barns and paddocks or groom thick winter coats. (Donkeys in cold climates barely have time to enjoy sleek, summer coats; their protective

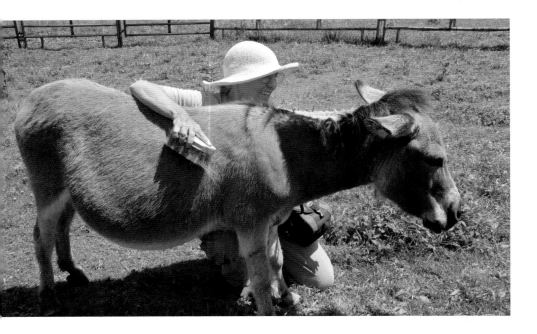

Annie Kellam, an enthusiastic and steadfast volunteer, kneels to brush the miniature donkey Piccolina.

winter fur doesn't shed out until mid-summer, and by September it's growing back in.) Annie comes with armfuls of seasonal snacks—carrots, apples, even horseradish—and she makes the drive no matter what the weather conditions, an impressive feat considering that at the height of winter some county roads are nearly impassable.

"Annie is amazing," said Ann. Save Your Ass has a limited number of volunteers to call on—Annie, Alison, and Richard Nash are the most consistent. It's not only Annie's reliability that impresses Ann, but also her relationship to the donkeys and mules. She respects their individual boundaries and indulges their peculiar habits. She almost always carries a camera so that she won't miss out on an extraordinary event or exchange between the donkeys, mules, and other creatures of the farm and forest.

In the paddock shared by Jenny and Marlin, Annie vigorously brushed Vito in preparation for his photographs. His best friend, Joe, was nearby, but apparently he was comfortable letting Vito be the center of attention. In 2010, a family from a nearby state adopted the pair, but within eight months Ann received a call asking if she would be willing to take them back. Without hesitating, she drove to the farm where they'd spent a winter and was stunned to find them in terrible condition. Vito had lost considerable weight and hair, and both had lice and ringworm. Ann was troubled by the experience. After all, she felt responsible for their well-being beyond the gates of her farm. Since then, she has changed her adoption protocol. Now, she not only requires perfect references, but also relies on old-fashioned instinct. "I'm the advocate for these guys. I have to speak up," she said. "When I first started Save Your Ass, I wasn't sure how I was going to tell someone they're not fit to adopt a donkey. Now, I have no problem."

Ann has to remind people that donkeys and mules are not the same as horses. They don't do well with dogs because they see them as predators.

They like to chew wood (Ann often gives them apple and willow branches to satisfy this impulse). There's a list of psychological differences and, of course, size. But mainly, she wants people to know that donkeys and mules aren't stubborn or stupid. Ann described them as gentle, intelligent animals with a keen sense of humor. They're also incredibly curious and trusting of those they consider trustworthy. "They just have to feel safe," she said.

And they do feel safe at Save Your Ass Long Ear Rescue. In spite of the appalling histories of some of the donkeys and mules at Ann's farm, the animals seem to know they've beaten the odds and landed in a place where they are understood and loved. As if expressing this very thought, Marlin let out a magnificent long bray, and Vito joined in.

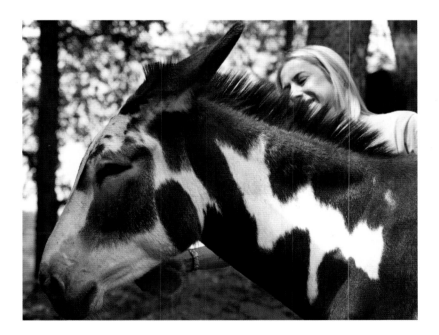

Alison Wright, a Save Your Ass board member, grooms her newly adopted spotted donkey, Little Egypt.

LEFT: Dinah, a lovely and affectionate miniature, has been adopted by Alison Wright.

OPPOSITE: Three of the miniature donkeys at their run-in shed.

OVERLEAF: Piccolina rolls in the dirt (left). Joe grazes near the fence (right).

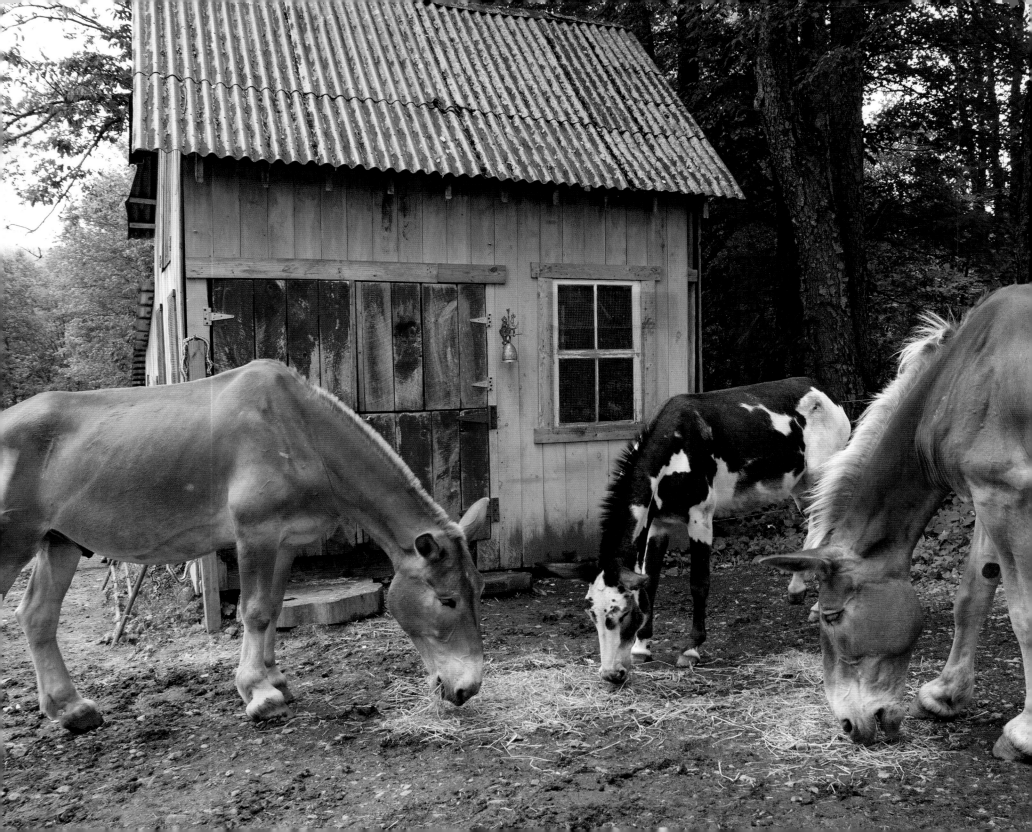

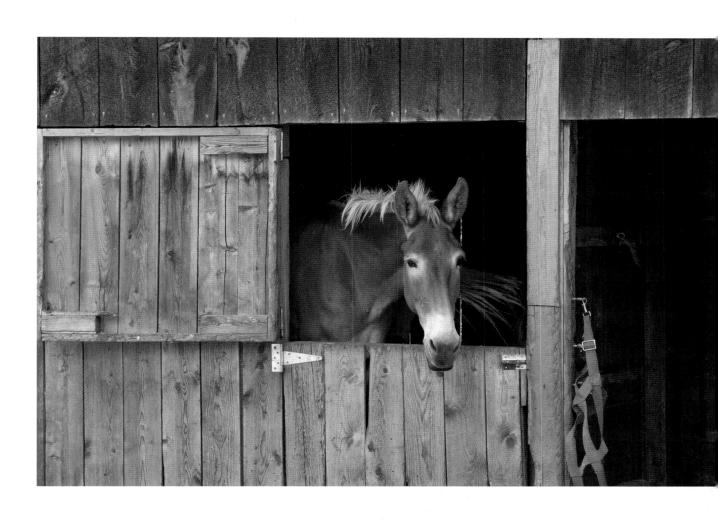

OPPOSITE: Marlin (left), a 21-year-old Belgian mule and rescue ambassador, Little Egypt, 7, and Jenny, 20, enjoy a companionable snack.

ABOVE: Jenny watches the new arrivals in the quarantine area from the barn window.

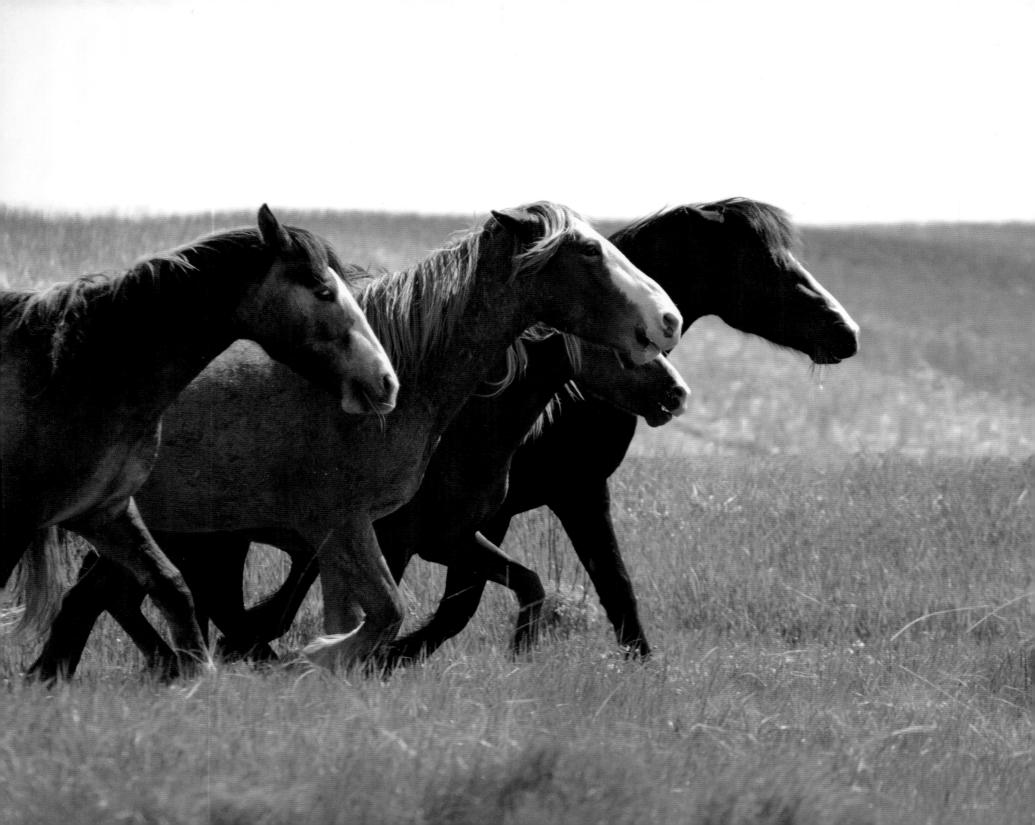

SANCTUARY CONTACT INFORMATION

BLACKBURN CORRECTIONAL COMPLEX
3111 Spurr Rd.
Lexington, KY 40511
T: 859-246-2366
www.trfinc.org/c10/Blackburn-Correctional-Complex-c11.html

BLACK HILLS WILD HORSE SANCTUARY
PO Box 998
Hot Springs, SD 57747
T: 800-252-6652 or 605-745-5955
E: iram@gwtc.net
www.gwtc.net/~iram
www.spanishmustangspirit.com

CATSKILL ANIMAL SANCTUARY
316 Old Stage Rd.
Saugerties, NY 12477
T: 845-336-8447
E: info@casanctuary.org
www.casanctuary.org

THE EQUINE SANCTUARY
1187 Coast Village Rd., Ste. 485
Santa Barbara, CA 93108
T: 805-453-4567
E: info@theequinesanctuary.org
www.theequinesanctuary.org

EQUINE VOICES RESCUE & SANCTUARY
PO Box 1685
Green Valley, AZ 85622
T: 520-398-2814
E: karen@equinevoices.org
www.equinevoices.org

FRONT RANGE EQUINE RESCUE
PO Box 307
Larkspur, CO 80118
E: info@frontrangeequinerescue.org
www.frontrangeequinerescue.org

HORSE HARBOR FOUNDATION
PO Box 3068
Silverdale, WA 98383
T: 360-692-2851
E: harmonyhorses@yahoo.com
www.horseharbor.org

LAST CHANCE CORRAL
5350 US Hwy. 33
Athens, OH 45701
T: 740-594-4336
www.lastchancecorral.org

LOPE TEXAS
1551 Hwy. 21 West
Cedar Creek, TX 78612
T: 512-565-1824
www.lopetx.org

LUCKY HORSE EQUINE RESCUE
185 Century Mill Rd.
Bolton, MA 01740
T: 978-293-6153
E: luckyhorseequinerescue@gmail.com
www.luckyhorse.org

NOKOTA HORSE CONSERVANCY
208 NW 1st St.
Linton, ND 58552
T: 701-254-4205
E: info@nokotahorse.org
www.nokotahorse.org

PEACEFUL VALLEY DONKEY RESCUE
National Operations Center
PO Box 216
Miles, TX 76861
T: 866-366-5731
www.donkeyrescue.org

SAVE YOUR ASS LONG EAR RESCUE
Broomtail Farm
23 Saw Mill Rd.
South Acworth, NH 03607
T: 603-835-2971
E: contact@saveyourassrescue.org or awfirestone@gmail.com
www.saveyourassrescue.org

ADDITIONAL SANCTUARIES AND RESOURCES

The following list of additional sanctuaries and rescue facilities describes the work of well-established nonprofit organizations that have come to our attention during our research for this book, only a few of which we have been able to visit. An excellent Internet guide by state to such facilities may be found at www.ghostfleetfarm.com. Each year many poorly funded rescue organizations are bankrupted by the ever-increasing costs of hay and grain, fuel, and medical care; an inadequate base of volunteers and donors; an overly ambitious rescue effort; or poor management. A number of the organizations listed here offer adoption and equine therapy programs and are involved in equine advocacy efforts. Another useful resource for rescue information is www.rescuesworthnoting.blogspot.com.

Verification and accreditation by the Global Federation of Animal Sanctuaries (www.sanctuaryfederation.org) is an exacting and difficult process, and is a highly prized attribute of any facility that has achieved it. Both accredited and verified sanctuaries provide humane and responsible care of the animals, as confirmed by an on-site visit. A "verified" status as opposed to an "accredited" status often reflects constrictions imposed by financial resources or the not-yet-fully-evolved growth of a newer sanctuary. Sanctuaries that are GFAS-accredited are noted below with one asterisk (*); sanctuaries that are GFAS-verified are noted with two asterisks (**).

ANGEL ACRES HORSE HAVEN RESCUE *
PO Box 62
Glenville, PA 17329
T: 717-965-7901
E: angelacreshorsehaven@yahoo.com
www.saveahorsenow.org

Since 2003, Angel Acres has tackled the issue of homeless and abused horses, especially Thoroughbreds, by assisting horse owners experiencing economic hardship, rescuing horses from the kill pen, retraining them for new vocations, and placing them in adoptive homes.

CALIFORNIA EQUINE RETIREMENT FOUNDATION *
34033 Kooden Rd.
Winchester, CA 92596
T: 951-926-4190
E: cerf1@earthlink.net
www.cerfhorses.org

CERF was founded in 1986 to provide charitable assistance to former race and performance horses upon the conclusion of their careers through permanent retirement or retraining for other vocations.

THE COMMUNICATION ALLIANCE TO NETWORK THOROUGHBRED EX-RACEHORSES
E: nancyk@canterusa.org
www.canterusa.org

CANTER is a volunteer organization that was established as a strategy for helping racehorses find new careers by connecting buyers and sellers through postings of racehorses for sale on the Internet. See individual affiliate websites for contact information.

CASTLETON RANCH HORSE RESCUE
12103 E. Avenue H
Lancaster, CA 93535
T: 661-361-4963
E: castletonranch@hotmail.com
www.castletonranchhorserescue.com

Castleton Ranch was founded in 2004 to rescue horses exploited by the pregnant mare urine (PMU) drug industry, discarded racehorses, horses sent to auction, abandoned horses, and horses whose owners cannot afford to keep them. Rescued horses are retrained for new vocations or retired at the ranch.

CENTRAL NEW ENGLAND EQUINE RESCUE
1510 South St.
Barre, MA 01005
T: 978-621-6717
E: bkindtoanimals@centralnewenglandequinerescue.com
www.cneer.com

CNEER was established in 2003 to rescue abused, abandoned, and neglected horses and to prevent abuse through education concerning the exploitation and destruction of horses by the PMU drug industry.

THE CLOUD FOUNDATION
107 S. 7th St.
Colorado Springs, CO 80905
T: 719-633-3842
www.thecloudfoundation.org

The Cloud Foundation is dedicated to preventing the extinction of the Pryor Mountain (Montana) wild mustang herd—documented for PBS in three films by Ginger Kathrens—through education, media events and programming, and public involvement.

**DREAM CATCHER THERAPY CENTER
AND END OF THE TRAIL HORSE RESCUE** * *
5814 Hwy. 348
Olathe, CO 81425
T: 970-323-5400
E: khamm@dctc.org
www.dctc.org

Dream Catcher Therapy Center, founded in 2006, provides comprehensive therapies using the horse as a tool. Through its End of the Trail Horse Rescue, Dream Catcher rescues, rehabilitates, and provides foster and adoption services for horses, and educates the community on the link between animal abuse and domestic violence.

**DREAMCATCHER WILD HORSE
& BURRO SANCTUARY**
PO Box 9
Ravendale, CA 96123
T: 530-260-0148
E: mustangsb@hughes.net
www.dreamcatcherhorsesanctuary.org

Established in 2001, DreamCatcher provides permanent sanctuary for previously rounded up or adopted wild mustangs and burros. Its mission is to return them to a life similar to the one they experienced in the wild and to let the public experience what will be lost if roundups and adoptions continue.

DUCHESS SANCTUARY *
The Fund for Animals, in partnership with the Humane Society of the United States
1515 Shady Oaks Ln.
Oakland, OR 97462
T: 541-459-9914
E: jkunz@humanesociety.org
www.humanesociety.org/animal_community/
shelters/duchess_sanctuary.html

Established in 2008 to rescue 159 mares exploited in the PMU drug industry and headed for slaughter, the 1,120-acre sanctuary now cares for hundreds of horses of various types who have experienced dire circumstances.

EQUINE ADVOCATES RESCUE AND SANCTUARY
PO Box 354
Chatham, NY 12037
T: 518-245-1599
www.equineadvocates.org/sanctuary.php

Founded in 1996, Equine Advocates operates a 140-acre rescue facility and sanctuary and Humane Equine Education Center.

EQUINE OUTREACH * *
63220 Silvis Rd.
Bend, OR 97701
T: 541-419-4842
E: info@equineoutreach.com
www.equineoutreach.com

Equine Outreach, established in 2002, facilitates the rescue, rehabilitation, and permanent placement of abused and neglected horses in Deschutes County and central Oregon. The organization also works to foster compassion for equines and responsible horse guardianship.

GENTLE GIANTS DRAFT HORSE RESCUE
17250 Old Frederick Rd.
Mt. Airy, MD 21771
T: 443-285-3835
E: info@gentlegiantsdrafthorserescue.com
www.gentlegiantsdrafthorserescue.com

Gentle Giants is committed to saving draft horses from slaughter, abuse, and neglect and to finding them suitable adoptive homes. The rescue promotes the benefits and uses of draft horses of all breeds as trail mounts, schooling mounts, and competition mounts.

HABITAT FOR HORSES *
PO Box 213
Hitchcock, TX 77563
T: 409-935-0277
E: office@habitatforhorses.org
www.habitatforhorses.org

Founded in 1997, Habitat for Horses is a multi-site facility with its primary ranch in Texas. The organization was founded to promote and secure the safety and well-being of horses, to encourage education, to explore and establish connections with young adults who can benefit emotionally from involvement with horses, and to promote proper horse training.

HIDDEN SPRINGS EQUINE RESCUE * *
4883 Bevan Ln.
Marianna, FL 32448
T: 850-526-2231
E: horserescue@live.com
www.floridahorserescue.com

Established in 2008, Hidden Springs is dedicated to saving horses from abuse and neglect and finding caring adoptive homes for them. In 2012, Hidden Springs formed a partnership with Southern Valley Ranch and Rescue in Fort Valley, Georgia, to bring equine rescue services to southern Georgia.

HOPE EQUINE RESCUE * *
1200 Dixie Dr.
Auburndale, FL 33823
T: 863-287-7503
E: hopeequinerescue@yahoo.com
www.freewebs.com/hopeequinerescue

Founded in 2008, Hope Equine Rescue is devoted to the care and placement of unwanted, abused, and neglected horses. Adoptive homes are carefully screened, and a number of horses are given permanent sanctuary at the rescue.

HOPE FOR HORSES
PO Box 1449
Leicester, NC 28748
T: 828-683-0160
E: hopeforhorses@aol.com
www.hopeforhorses.org

Hope for Horses works with animal-control officials in Buncombe and surrounding counties by assisting in rescues and providing valuable rehabilitation and adoption services throughout western North Carolina.

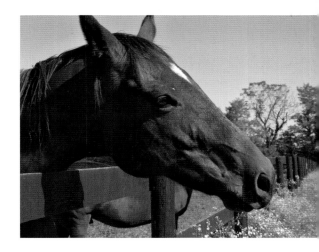

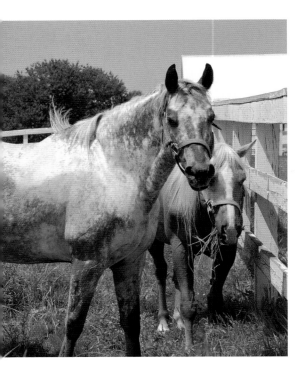

HOPE FOR HORSES EQUINE RESCUE
9381 County Rd. 470
Blue Ridge, TX 75424
T: 972-734-6218
E: info@hopeforhorses.com
www.hopeforhorses.com

Founded in 2003, Hope for Horses seeks to educate the public to end horse abuse; to rehabilitate neglected and abused equines; to offer help to equine owners in times of need; to assist law-enforcement officers in seizing, fostering, and adoption of equines in order to protect them from further abuse; and to find homes for horses rescued from the PMU drug industry.

HYTYME EQUINE RESCUE
29979 S.E. Heiple Rd.
Eagle Creek, OR 97922
T: 503-816-3991
E: hytymejim@gmail.com
www.hytyme.blogspot.com

Located on 104 acres, Hytyme Equine Rescue provides sanctuary to abused, abandoned, and neglected horses of all ages, sizes, and shapes. Equines that can be rehabilitated or retrained for new vocations are available for adoption.

LIFESAVERS WILD HORSE RESCUE * *
23809 E. Avenue J
Lancaster, CA 93535
T: 661-727-1205 or 661-727-0049
E: info@wildhorserescue.org
www.wildhorserescue.org

Founded in 1997, Lifesavers is dedicated to saving wild and domestic horses from abuse, neglect, and slaughter. This large rescue effort supports horses at three locations, two in California and one on the Pine Ridge Lakota Reservation in South Dakota.

LIGHTHOUSE FARM SANCTUARY
36831 Richardson Gap Rd.
Scio, OR 97374
T: 503-394-4486
E: info@lighthousefarmsanctuary.org
www.lighthousefarmsanctuary.org

Founded in 2007, Lighthouse Farm Sanctuary rescues and provides sanctuary for abused, neglected, and abandoned farm animals and equines. Lighthouse rehabilitates rescued equines and places them in suitable adoptive homes.

LINN COUNTY ANIMAL RESCUE * *
PO Box 2669
Lebanon, OR 97355
T: 541-258-3422
E: linncountyanimalrescue@yahoo.com
www.lcarhorse.org

LCAR is an all-volunteer organization established in 2008 that works closely with the Linn County Sheriff's Office Livestock Investigation Team, the Oregon Hay Bank, and the public to rescue abused and abandoned equines.

LIVE AND LET LIVE FARM
20 Paradise Ln.
Chichester, NH 03258
T: 603-798-5615
E: info@liveandletlivefarm.org
www.liveandletlivefarm.org

Established in 1996, Live and Let Live Farm rescues abused and unwanted animals—mainly horses—rehabilitates and retrains them, and offers them a temporary or permanent haven.

MAINE STATE SOCIETY FOR THE PROTECTION OF ANIMALS
PO Box 10
South Windham, ME 04082
T: 207-892-3040
E: info@msspa.org
www.msspa.org

MSSPA is New England's largest equine rescue and rehabilitation facility. Originally formed in 1872 to protect the horses that pulled Portland's streetcars, the society maintains nearly 100 equines on its farm facilities.

MID-ATLANTIC HORSE RESCUE * *
PO Box 407
Chesapeake City, MD 21915
T: 302-376-7297
E: bev@midatlantichorserescue.org
www.midatlantichorserescue.org

For 25 years, Mid-Atlantic Horse Rescue has been buying slaughter-bound former racehorses at livestock auctions, evaluating them, starting them for new vocations, and finding them suitable adoptive homes.

MONTANA HORSE SANCTUARY
PO Box 10
Simms, MT 59477
T: 406-264-5300
E: info@montanahorsesanctuary.org
www.montanahorsesanctuary.org

Montana Horse Sanctuary, located on a 1,200-acre ranch in western Montana, was established in 2004 to improve the lives of horses in crisis. It provides a wide array of educational opportunities and workshops for horse owners, and helps owners in crisis with hay and euthanasia grants.

MOUNTAIN VIEW RESCUE
PO Box 1542
Columbia, KY 42728
T: 270-250-4076
E: mountainviewrescue@yahoo.com or helpinghorses@mountainviewrescue.com
www.mountainviewrescue.com

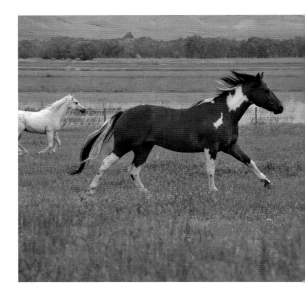

Established in 2007, Mountain View Rescue works to rehabilitate, re-school, and find suitable permanent homes for unwanted, neglected, and mistreated equines. It offers sanctuary to off-track Thoroughbreds, orphaned foals from nurse-mare farms, and other horses in need.

NEW VOCATIONS RACEHORSE ADOPTION PROGRAM
Standardbred and Administration Office
3293 Wright Rd.
Laura, OH 45337
T: 937-947-4020

Thoroughbred and Adoption Office
13580 Leeper-Perkins Rd.
Marysville, OH 43040
T: 937-642-3171

E: dot@horseadoption.com
www.horseadoption.com

Founded in 1992, New Vocations provides a safety net for retired, often injured, racehorses through rehabilitation, training in new skills for the transition from racing, and placement in qualified, experienced, caring homes.

OLD FRIENDS EQUINE * *
1841 Paynes Depot Rd.
Georgetown, KY 40324
T: 502-863-1775
E: contact@oldfriendsequine.com
www.oldfriendsequine.org

Old Friends brings racehorses whose racing and breeding careers have come to an end to its farm near Lexington to provide them with a dignified retirement. The farm is open to the public for tours.

ORPHAN ACRES
1183 Rothfork Rd.
Viola, ID 83872
T: 208-882-9293
E: orphanacres@hotmail.com
personal.palouse.net/orphanacres

Established in 1975, Orphan Acres works to provide care and rehabilitation for abandoned, neglected, abused, and malnourished horses while educating the public regarding the issues surrounding rescue and rehabilitation, including all aspects of horse guardianship and care.

REDWINGS HORSE SANCTUARY
PO Box 58
Lockwood, CA 93932
T: 831-386-0135
E: info@redwingshorsesanctuary.org
www.redwinghorsesanctuary.org

Established in 1991, Redwings Horse Sanctuary works to eliminate the causes of equine suffering through education and community-outreach programs. It rescues abused and neglected equines and provides them with permanent sanctuary or selected foster homes.

RERUN HORSE RESCUE
PO Box 374
Lakehurst, NJ 08733
T: 315-402-2123
www.rerun.org

ReRun was founded in 1996 to rehabilitate, retrain, and find suitable homes for Thoroughbreds whose racing careers are over. ReRun operates adoption services in Arkansas, Kentucky, Maryland, Illinois, New Jersey, New York, North Carolina, and Virginia.

RESCUE 100 HORSES FOUNDATION
RPO Nottingham
PO Box 92555
Sherwood Park, AB T8A 3X4
Canada
T: 780-464-9988
E: info@rescue100.ca
www.rescue100.ca

Founded in 2008, Rescue 100 Horses Foundation assesses, rehabilitates, and places in adoptive homes abused, neglected, and mistreated horses seized in Alberta, Canada, by local law-enforcement officials.

SHILOH HORSE RESCUE
777 E. Quartz, No. 9005
Sandy Valley, NV 89019
T: 702-249-8987
E: shilohhorse@aol.com
www.shilohhorserescue.com

Established in 2003, Shiloh rescues, rehabilitates, and rehomes abused, neglected, and slaughter-bound horses of all types. Those horses that are deemed unadoptable as a result of advanced age, illness, or injury are given permanent sanctuary.

SOUTH JERSEY THOROUGHBRED RESCUE & ADOPTION
680 Garwood Rd.
Moorestown, NJ 08057
T: 609-354-2014
E: sjtr@comcast.net
www.sjtr.org

Established in 2005, South Jersey Thoroughbred Rescue & Adoption is dedicated to offering adoption services for rescued Thoroughbred horses. Many of its horses have come through the Philadelphia Park Retirement Program, Turning For Home.

SOUTHERN WINDS EQUINE RESCUE AND RECOVERY CENTER * *
4447 2nd Rd.
Udall, KS 67146
T: 316-858-3233 or 316-830-0013
E: victorsr@hughes.net
www.southernwindsequinerescue.org

Southern Winds Equine Rescue and Recovery Center was established in 2002. An all-volunteer organization, it has rescued, assisted in placement of, or found suitable adoptive homes for 212 horses since it was founded.

TRIPLE ACRES HORSE RESCUE
51110 Olson Rd.
Boone, CO 81025
T: 719-924-5101
www.3ahr.org

Triple Acres works to save, protect, and rehabilitate horses in need, to place them in new homes, and to provide support to owners and potential owners. In collaboration with a local hospice, Triple Acres has undertaken an equine therapy program for adolescents struggling with grief and loss.

UNITED IN LIGHT
101 Billman Ln.
Livingston, MT 59047
T: 406-222-7982
www.draftrescue.com

Founded in 2003, United in Light is a sanctuary for draft horses of all breeds. All of the horses at the sanctuary have been rescued from slaughter and are mature individuals who are not considered adoptable because of their age, injuries, or lack of training.

FOR FURTHER READING

Baur, Gene. *Farm Sanctuary: Changing Hearts and Minds about Animals and Food*. New York: Touchstone, 2008.

Bowles, Melanie Sue. *The Horses of Proud Spirit*. Sarasota, FL: Pineapple Press, 2003.

Budiansky, Stephen. *The Nature of Horses: Exploring Equine Evolution, Intelligence, and Behavior*. New York: Free Press, 1997.

Dines, Lisa. *The American Mustang Guidebook: History, Behavior, and State-by-State Directions on Where to Best View America's Wild Horses*. Minocqua, WI: Willow Creek Press, 2001.

Dobie, J. Frank. *The Mustangs*. New York: Curtis Publishing, 1934.

Franzen, Jens Lorenz. *The Rise of Horses: 55 Million Years of Evolution*. Translated by Kirsten M. Brown. Baltimore: Johns Hopkins University Press, 2010.

Hansen, Skylar. *Roaming Free: Wild Horses of the American West*. Flagstaff, AZ: Northland Press, 1983.

Harris, Moira C. *Wild Horses of the World*. London: Hamlyn, 2009.

Henry, Marguerite. *Brighty of the Grand Canyon*. New York: Rand McNally, 1953.

——. *Misty of Chincoteague*. New York: Rand McNally, 1947.

——. *Sea Star, Orphan of Chincoteague*. New York: Rand McNally, 1949.

Hockensmith, John S. *Spanish Mustangs in the Great American West: Return of the Horse*. Georgetown, KY: Fine Art Editions Gallery & Press, 2009.

Höglund, Don. *Nobody's Horses: The Dramatic Rescue of the Wild Herd of White Sands*. New York: Free Press, 2006.

Horse Capture, George P. and Emil Her Many Horses, eds. *A Song for the Horse Nation: Horses in Native American Cultures*. Golden, CO: Fulcrum Publishing, 2006.

Hyde, Dayton O. *All the Wild Horses: Preserving the Spirit and Beauty of the World's Wild Horses*. St. Paul: Voyageur Press, 2006.

——. *The Pastures of Beyond: An Old Cowboy Looks Back at the Old West*. New York: Arcade Publishing, 2005.

Kathrens, Ginger. *Cloud: Challenge of the Stallions*. Colorado Springs, CO: The Cloud Foundation, 2010.

Keiper, Ronald R. *The Assateague Ponies*. Centreville, MD: Tidewater Publishers, 1985.

Kohanov, Linda. *The Tao of Equus: A Woman's Journey of Healing and Transformation through the Way of the Horse*. Novato, CA: New World Library, 2007.

Meyers, Mark S. *Talking with Donkeys: Saving Them All*. 3rd ed. Tehachapi, CA: Peaceful Valley Donkey Rescue, 2008.

Morin, Paula. *Honest Horses: Wild Horses in the Great Basin*. Reno: University of Nevada Press, 2006.

Mortensen, Ky Evan. *Horses of the Storm: The Incredible Rescue of Katrina's Horses*. Lexington, KY: Eclipse Press, 2008.

Pomeranz, Lynne. *Among Wild Horses: A Portrait of the Pryor Mountain Mustangs*. North Adams, MA: Storey Publishing, 2006.

Reardon, Lynn. *Beyond the Homestretch: What Saving Racehorses Taught Me about Starting Over, Facing Fear and Finding My Inner Cowgirl*. 2nd ed. Novato, CA: New World Library, 2011.

Richards, Susan. *Chosen by a Horse: A Memoir*. New York: Soho Press, 2006.

Ryden, Hope. *America's Last Wild Horses*. New York: Ballantine Books, 1970.

——. *Wild Horses I Have Known*. New York: Clarion Books, 1999.

Scott, Traer. *Wild Horses: Endangered Beauty*. London: Merrell Publishers, 2008.

Sewell, Anna. *Black Beauty*. Norwich, 1877.

Spragg, Mark, ed. *Thunder of the Mustangs: Legend and Lore of the Wild Horses*. San Francisco: Sierra Club Books, 1997.

Stevens, Kathy. *Animal Camp: Lessons in Love and Hope from Rescued Farm Animals*. New York: Skyhorse Publishing, 2010.

——. *Where the Blind Horse Sings: Love and Healing at an Animal Sanctuary*. New York: Skyhorse Publishing, 2007.

Stillman, Deanne. *Mustang: The Saga of the Wild Horse in the American West*. New York: Mariner Books, 2009.

Stromberg, Tony. *The Forgotten Horses: The Beauty of America's Unwanted Horses*. Novato, CA: New World Library, 2008.

Urquhart, Bonnie S. *Hoofprints in the Sand: Wild Horses of the Atlantic Coast*. Lexington, KY: Eclipse Press, 2002.

ACKNOWLEDGMENTS

The directors, barn managers, staff, and volunteers of the facilities described in this book represent many hundreds of women and men who work tirelessly and heroically to ease the lives of horses, donkeys, and mules that have experienced dire circumstances. These rescuers provide long-term safety to thousands of equines in a perilous world and in an increasingly challenging economic environment.

We would like to express our profound gratitude to the many sanctuary folk we met for their kindness in allowing us to document their day-to-day efforts on behalf of the animals in their care and for their patience in answering our many questions about how they go about their endless tasks of raising funds; finding, rescuing, healing, and retraining equines; and locating and interviewing potential adopters. In addition to these tasks, many operate therapy and educational programs that benefit members of their communities and work to educate the public and effect positive government policy changes for the well-being of equines.

We are particularly indebted to the following people for helping us with our project: At **Blackburn Correctional Complex**: Lynda Dyer, Dr. Ashley Embly, Diana Pikulski, Keren Bachi, Donny Bratcher, Jonathon Bryant, Dartanya Coleman, Travis Holland, Anthony Johnson, John Lopez, Stephen Piercy, Randall Sorrell, Dexter Welch, and DeWayne Wright; at **Black Hills Wild Horse Sanctuary**: Dayton O. Hyde, Susan Watt, Karen Parker, Mark Keffele, Roger Horton, Karla LaRive, Mike Rash, and Susan Richardson; at **Catskill Animal Sanctuary**: Kathy Stevens, Sarah Hamilton, Betsy Messenger, Melissa Bamford, Carol Sas, Donna Albright, Teddy Blake, Zoe Gold, and Leah Craig; at **The Equine Sanctuary**: Alexis Ells, Hayley Brewster, Leslie Velez, Rhonda Tyacke, Sandy Horning, Debbie Fair, and Horse Soldiers Mike Kelly and Richard Wheeler; at **Equine Voices Rescue & Sanctuary**: Karen Pomroy, Tom O'Neil, Kristin Carrington, Jean Hamilton Welch, Jerry Tucker, and Carol Grubb; at **Front Range Equine Rescue**: Hilary Wood, Michelle Conner, Marion Nagle, Andrea Ver Meer, Joanne Pavlis, Dr. Randy Parker, Leslie Norvell, and Gretchen Sutherland; at **Horse Harbor Foundation**: Allen Warren, Maryann Peachey-Warren, Aria Peachey-Warren, Dr. Jan Richards, Brant Crittenden, Kristin Vining, Isabelle Minisian, Emma Winkler, Chloe Wightman, Chrissie Dommer, Cathy Grisdale, Philip Grisdale, Olivia Huff, Jennifer Mullis, and Deondre Perry; at **Last Chance Corral**: Victoria Goss, Leni Sheeks, Dr. Ryan Rutter, Pamela Martin, Jackie Deddens, and Chuck Forsythe; at **LOPE Texas**: Lynn Reardon, Marcia Hermann, Meg Tanner, and Suzanne Whitman; at **Lucky Horse Equine Rescue**: Jai Rezac, Jenifer Vickery, Christine Peters, April Clow-Gelina, Cindy and Bill Stevens, Jess McKinley, Aileen Whitty, Ellie Kittler, Adrienne Zicht, Karen Morang, Laurie Indresana, Nicole Anderson, and Marvin Labbe; at **Nokota Horse Conservancy**: Frank and Leo Kuntz, Shelly Hauge, Dr. Castle McLaughlin, Butch Thunderhawk, Charlie Fleischmann, Hannah Cooper, and Seth and Emma Ziegler; at **Peaceful Valley Donkey Rescue (California)**: Tracy and Austin Miller; at **Peaceful Valley Donkey Rescue (Oregon)**: Jim and Rhonda Urquhart; at **Save Your Ass Long Ear Rescue**: Ann Firestone, Annie Kellam, Richard Nash, and Alison Wright; at **Old Friends**: Michael Blowen; at **Montana Horse Sanctuary**: Jane Heath, Vic Andersen, Kathy Cross, Patricia Gamble, Jess Holloway, and Spencer Dominick; and at the **Maine State Society for the Protection of Animals**: Becky Jones.

Karen would like to express her appreciation to the dear and welcoming friends who stabled her so comfortably at many points along her 16,000-mile sojourn for this book: Carolyn Christy, Helen Spencer, Judith Many Bears Anderson, Chuck and Shirley Rader, Debbie Rogow, Diane Leigh, Diane Anderson, Steve Weislogel, Dawn Graf and Ken Thiessen, Katherine Mindlin Reinleitner, and Patti Leota Genack. A heartfelt thank-you to Leo Pando, author of *An Illustrated History of Trigger*, who has been hugely supportive of this book project. Allison would also like to thank Rebecca Epstein for her encouragement and unwavering support, Jiyeon Yoo for her thoughtful comments, and Bob Fisher for sharing his knowledge and resources.

This book—our wildest dream—became a reality thanks to the efforts of our extraordinary literary agents, Lyn Delliquadri and Jane Lahr, and our visionary editors at Rizzoli, James O. Muschett and Candice Fehrman. A resounding accolade is due to Susi Oberhelman for her magnificent design and layout. No creative team could hope for more gifted and supportive collaborators.

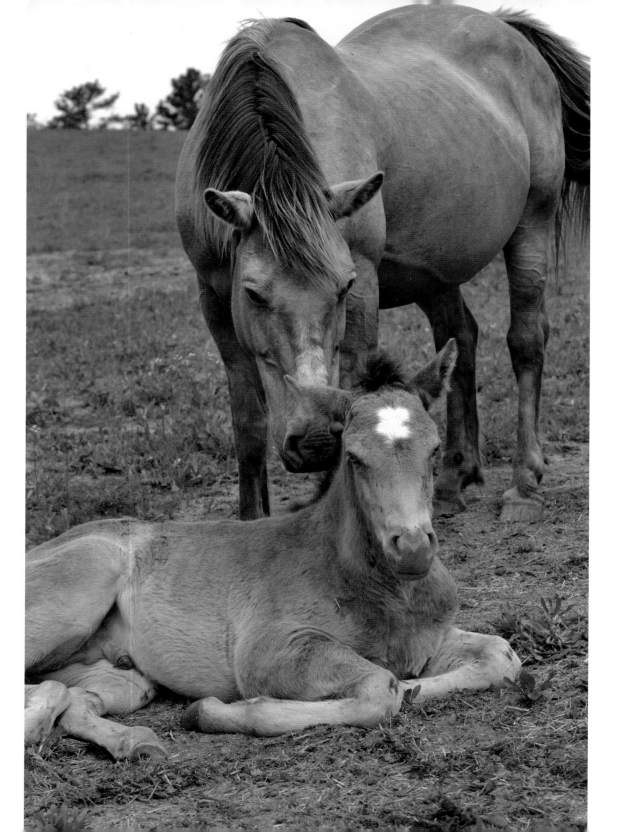

Published by Universe Publishing
A Division of Rizzoli International Publications, Inc.
300 Park Avenue South
New York, NY 10010
www.rizzoliusa.com

Foreword © 2013 Temple Grandin
Text © 2013 Allison Milionis
Photographs © 2013 Karen Tweedy-Holmes

Project Editor: Candice Fehrman
Book Design: Susi Oberhelman

2013 2014 2015 2016 / 10 9 8 7 6 5 4 3 2 1

Printed in China

ISBN-13: 978-0-7893-2478-8

Library of Congress Catalog Control Number: 2012948493